Younger Than Jesus *The Generation Book*

D0995441

University of the
Arts London
Wimbledon

Three week loan

late return of this item will incur fines.
renew online: http://www.arts.ac.uk/libr
renew by phone: 020 7514 9690

Younger Than Jesus

The Generation Book

Edited by

Lauren Cornell

Massimiliano Gioni

Laura Hoptman

Brian Sholis

New Museum New York *Steidl*

Table of Contents

First edition published in February 2009

Here:

Director's Foreword

This exhibition and book inaugurate a new Triennial at the New Museum that focuses on innovative contemporary art created by the newest voices all over the world, "The Generational." Our time is replete with international exhibitions tied to cities, countries, or curators. "The Generational" is the only international show of its kind in New York, the only one dedicated to an emerging generation.

This exhibition has been envisioned by the curatorial team of Lauren Cornell, Massimiliano Gioni, and Laura Hoptman. They conceived not only a show, but also identified the beginning of a new network of artists, curators, and professionals. The New Museum curators created a flexible structure for gathering information about young artists everywhere by calling on more than 150 colleagues who submitted materials and names of artists born after 1975. Out of this wealth of information—a veritable census of the most interesting art being produced today—they selected the work of fifty artists who are presented both in the exhibition "Younger Than Jesus" and in this publication.

This exhibition and its accompanying catalogue are the first attempt to come to terms with a generation that has already excited the curiosity of sociologists, theorists, journalists, marketing experts, and intellectuals. Variously dubbed the "Millennials," "iGeneration," "Generation Y," and "Generation Me," this group has already revolutionized many aspects of our culture, both in the Western world and in fast-growing demographic powers like China and India. At ease with new technologies and new languages, this population—which has its beginnings around 1976—has had a tremendous impact on the way we acquire, distribute, produce, and consume information, knowledge, and culture. And yet no exhibition and no art institution has yet attempted to identify the work of this particular generation of artists.

At the New Museum, we believe in the need to face the most challenging creations of young artists. Keith Haring was twenty-two **7**

when he first exhibited at the New Museum; Jeff Koons was twenty-five; Richard Prince thirty-one and Adrian Piper thirty-two. We have always championed the new, while expanding the global scope of our vision. And yet we do not want to create empty hype or package a "hot young scene." Instead we want to understand, learn, support, and encourage a nascent group of artists. The wealth of materials, texts, and essays collected in this book stand as a clear sign of our commitment to capture and decipher the signals of a generation that is discovering its own new voices. In fact, this exhibition and this book aim to prove that generations are complex and nuanced social agents that cannot be reduced to a formula or a slogan. We want to understand what our future will look like, but we also want to preserve its complexity and diversity.

This project, begun barely a year ago, has been a massive challenge that the staff at the New Museum has embraced wholeheartedly. Massimiliano Gioni, Director of Special Exhibitions, has led a team that includes Lauren Cornell, Executive Director of Rhizome and Adjunct Curator at the New Museum, and Laura Hoptman, Kraus Family Senior Curator. Jarrett Gregory, Curatorial Assistant, has orchestrated the gathering of artists' materials for the publication and has coordinated the entire exhibition organization, working closely with Hendrik Gerrits, Exhibition Manager, Shari Zolla, Registrar, and John Hatfield, Deputy Director. Gregory also coordinated a team of dedicated researchers including Anna Clifford, Martha Kirszenbaum, and Cloé Perrone, all of whom also contributed to the realization of the exhibition. The anthology of texts that is the backbone of this publication was compiled by Brian Sholis with the collaboration of Chris Wiley, the exhibition curators, and Jarrett Gregory. The publication was edited by Sarah Valdez, Senior Editor, and its production supervised by Karen Hansgen, Head of Publications. It would not have

been possible without the help of Karen Wong, Director of External

Affairs, the entire External Affairs department, and Regan Grusy, Director of Development.

I want to extend my deepest gratitude to the Andy Warhol Foundation for the Visual Arts who provided an extraordinary grant to support this exhibition. A special thank you also goes to our remarkable Friends of the Generational–a group of passionate supporters who share an interest in supporting artists who are shaping the next wave–co-chaired by Maja Hoffman and Dakis Joannou; Steering Commitee Members Lonti Ebers and J. Bruce Flatt, Lorinda Ash Ezersky and Peter Ezersky, Ken Kuchin, and Randy Slifka; and Friends Shelley Fox Aarons and Phil Aarons, Hillary and Peter Hatch, Gael Neeson and Stefan Edlis, Toby Devan Lewis, and Lisa Schiff.

We also greatly appreciate the significant support of the Leadership Council of the New Museum, the Fundación Almine y Bernard Ruiz-Picasso Para El Arte, the Horace W. Goldsmith Foundation, the J. McSweeney and G. Mills Publications Fund, the Toby Devan Lewis Emerging Artists Exhibitions Fund, The Robert Mapplethorpe Photography Fund, and the Trust for Mutual Understanding. We are also grateful to the Cultural Services of the French Embassy in the United States, the Mexican Cultural Institute of New York, and the office for Contemporary Art Norway, who helped with artist travel and shipping.

The book would not have been possible without the partnership of Steidl, to whom we owe our thanks, especially Gerhard Steidl, designers Sarah Winter and Katharina Staal, Julia Braun, and Bernard Fischer.

Finally, the New Museum salutes all the contributors, authors, and all of the participating artists for creating a book that we hope will serve as an introduction to the future of contemporary art.

Lisa Phillips *Toby Devan Lewis Director*

9

Ziad Antar,
La Marche Turque, 2006.
Digital video featuring Matea Marras, 3 min.
Courtesy the artist
(Detail)

Introduction

Brian Sholis

The generation represented by the artists in this exhibition cannot yet be defined. Young people dubbed members of "Generation Y" or the "Millennial Generation" (I'll use the latter term) are still fashioning a historical identity for themselves, and are still exhibiting enough contradictory behavior–on the epic scale at which generations coalesce in the historical imagination–to make others' attempts to pin them down akin to playing darts while blindfolded. Rather than slotting members of this cohort into foreordained categories, "The Generational: Younger Than Jesus" gathers a representative (though by no means definitive) sample of its artists to discover what commonalities emerge from their practices. Curators Lauren Cornell, Massimiliano Gioni, and Laura Hoptman have each written essays that address the exhibition's artists and their concerns. Their texts are followed by images of the artists' work. At the back of the catalogue is a selection of articles, essays, and reports that I compiled with the assistance of Chris Wiley and the curators. The research conducted to put together the collection emphasized from the very beginning the quixotic nature of attempting to define young people today. This anthology has two aims: to provide some definitions of the concept of "generations" drawn from the social sciences and to sample journalistic representations of the Millennial Generation and its concerns. What we've brought together is neither meant to be comprehensive nor to focus explicitly on art and artists. (The selection from Pierre Bourdieu's *The Field of Cultural Production* is the one exception that directly addresses visual art.) Instead, we roamed fairly widely, and hope that the texts we have compiled shed light in oblique yet still illuminating ways on the interests of young artists in general and on the artists in "Younger Than Jesus" in particular. The bibliography at the end contains further relevant reading.

Examine the surface of this topic and one encounters marketers and management gurus. The former group hopes to capitalize on the fact that members of the Millennial Generation were raised during a period of nearly uninterrupted Western prosperity and accelerating economic development around the world. They have established sophisticated ways to counter the increasing sophistication of the young consumers they covet. They wrestle with appealing to a group whose relationship to the world at large is mediated, thanks to computers, in ways unlike any previous generation. The latter group wants to help corporations to bridge the social and cultural gap that parallels the generational divide. These writers attempt to explain how the Millennial Generation's values and mores shape its attitude toward work. Both the marketers and the managers seek to integrate young people into adult society as seamlessly as possible, turning them into competent, amiable workers and reliable consumers.

Only one example of this vast, alternately beguiling and off-putting body of literature, about the marketing of a fragrance by Calvin Klein, is included here. But much of it that we encountered is predicated on the work of William Strauss and Neil Howe, who since 1991 have developed a theory about a recurrent cycle of generations in American history, and who popularized the term "Millennial Generation" with their book *Millennials Rising* (2000).[1] (In an earlier book, they define "Generation Y" as those born between 1982 and 2001. Most experts roughly agree with them, though some experts peg the beginning of this generation as early as those born in 1978 and others suggest it has not yet reached its cutoff birth date.) Readers will here find a brief section of *Millennials and the Pop Culture: Strategies for a New Generation of Consumers* that succinctly outlines Strauss and Howe's characterization of the Millennial Generation. Strauss and Howe's work should not be considered academic, but it is based on extensive surveying, interviews, and research, and can therefore be seen as a

kind of bridge between the sociological theory and the contemporary journalism included in this selection of texts.

Though rich bodies of writing on the topic of generations exist in anthropology, biology, psychology, and other sciences both "hard" and "soft," we have opted to focus on sociological discourse. Nearly all recent sociological inquiry into the concept of generations engages with two pioneering theorists who published foundational texts in the 1920s: Karl Mannheim, the Hungarian-born German sociologist, and José Ortega y Gasset, the Spanish philosopher. Mannheim, who warns in "The Problem of Generations" against the over-organization of the social and cultural sciences, believes that sociology is best suited to "the task of sketching the layout of the problem."[2] He then does precisely that, identifying the "concrete group" (or social location) of a cohort of people, exploring the biological and sociological formulations of the problem, outlining the limitations on experience created by being part of a dynamic social and historical process, and listing which features of social life result from the experience of generations. The two great emphases of his conception are limitation (the members of any one generation "can only participate in a temporally limited section of the historical process") and dynamism (the "continuous emergence of new participants" and the "withdrawal of previous participants" in the process of culture). Ortega y Gasset, too, was a dialectical thinker, and his conception of generations reflected this in its emphasis on active negotiation. He believed that the immediate past "contains in concentrated form everything anterior to the present," and that the "generation is a dynamic compromise between mass and individual, and is the most important conception in history."[3] This is a microcosm of his grander philosophy, encapsulated in the maxim " *Yo soy yo y mi circunstancia*" ("I am myself and my circumstance"). Ortega y Gasset also believed that a generation must both receive what "has

had life already" and liberate "the creative genius inherent" in it.[4] A significant portion of Mannheim's lengthy essay and all of Orgtega y Gasset's brief analysis, which is titled "The Concept of the Generation," are included here, as are a few other essays that develop and critique their ideas.

The bulk of the texts, however, are journalistic reports published in the last few years that focus on today's young people—the same generation surveyed by "Younger Than Jesus." (This is, perhaps I should add, my generation, too). Let me reiterate that any portrait of this generation, no matter the birth years one believes define it, is at this point necessarily incomplete and skewed: We simply do not have the necessary perspective, which is only allotted by the passage of time, to understand what defines this age cohort. Nonetheless, pushing beyond those who aim to sell products to the Millennial Generation and those who hope its members will work well with elders, a few themes emerged during the course of our research. There is, of course, the overwhelming influence of technology on the lives of Millennials, and the attendant shifts this causes in the definitions of privacy, publicness, and celebrity, and on how young people consume and produce information. Essays and articles by Caleb Crain, Clay Shirky, Clive Thompson, Lakshmi Chaudry, and Allen Salkin address these issues. There is also the increasing centrality of both religion and politics in the lives of young people. The former is examined, in the articles included here by the *New York Times* journalist Sabrina Tavernise, in the context of the Middle East, where religion arguably plays an even greater role in the lives of young people than it does in the West. The latter, as evidenced here in the article by Evan Osnos, takes the particular form of an unexpected surge of nationalist sentiment in an era marked by transnational flows of information, goods, services, and capital.

(Commentary on the youth participation in the 2008 United States

14 presidential election, easily accessible and therefore not selected for

inclusion in the reader, can be found among the entries in the bibliography.) Elsewhere in the reader, politics connect with technological developments in Ethan Zuckerman's musings on the use of mobile phones in the service of political activism.

Political agitation reappears in a series of brief interviews with young Tibetan activists. Along with articles on "virtual sweatshops" in Romania, Chinese youth slang, intergenerational rivalry in the Ukraine, eighteen-year-olds in India, and the previously mentioned articles on religion in the Middle East, this forms our attempt to look beyond Anglo-American examples of the Millennial Generation's experiences. This was perhaps the most difficult aspect of our undertaking, not least because of language limitations. It also provoked broader questions. To what extent does worldwide communications technology actually foster unified experiences for geographically dispersed members of a generation? Are the inflections given historical events by local contexts translatable to other regions of the world? If the generation preceding the Millennials created the "flat" world, what will characterize the world Millennials make? And, specific to the present context, what role will visual artists have in shaping that world?

As for historical events, many sociologists suggest that common experience of them binds together an undifferentiated cohort of people and creates a conscious acknowledgment of generational ties; it is often trauma that gives birth to generational consciousness. In our time, the terrorist attacks of September 11, 2001, and the ensuing wars in Iraq and Afghanistan constitute such entries into the historical register. The *New York Times* article by David M. Halbfinger and Steven A. Holmes, on the class and regional makeup of the United States's all-volunteer military, raises similar questions to the ones asked above, but within the context of this nation in particular. Put simply: How does class affect the range of experiences available to young people today? Class

issues are rarely addressed in the extant literature on the Millennial Generation, but such inquiries become increasingly pertinent as we face what, at the time of this writing, seems like the beginning of a long-term recession. To that end we have included an article from *The Guardian* that presents interviews with students at Birmingham University about how they plan to cope with the world's downward-spiraling economic circumstances.

Managing one's finances during the first recession of one's life or the class makeup of the United States military may seem very far removed from the subject of an article also included here: a young man who is famous for posting sarcastic comments to various weblogs. The cognitive dissonance such a juxtaposition might provoke was acknowledged by Geraldine M. Doetzer, a *New York Times Magazine* reader who wrote a letter to the editors concerning two stories, not included here, published in the May 25, 2008, issue. One was a first-person narrative of blogging and online romance, while the other told the story of a soldier badly injured in Iraq.

The juxtaposition of your cover story on blogger Emily Gould with Daniel Bergner's much shorter article on Sgt. Shurvon Phillip was at once wrenching and revelatory. For the last five years, most Americans of my generation have been content to amuse ourselves with Facebook, celebrity train wrecks and "America's Next Top Model," while a tiny minority volunteer to serve in the armed forces, deploy to war zones and come back forever changed to a society that barely registers their existence or that of the conflict that drew them overseas. Nearly the same age and separated by a few columns of newsprint in your magazine, Sergeant Phillip and Gould may as well have been born on different planets.[5]

How can we reconcile these different planets? Or, following Ortega y Gasset, how will history, as it consolidates the experience we shape

by action, reconcile differences for us? In a series of lectures delivered at New York's Museum of Natural History in March 1969, anthropologist Margaret Mead, reflecting upon mid-twentieth-century technological development, World War II, and the youth uprisings of 1968, suggested that the young people of that era were both unalterably separated from earlier generations and inextricably linked together.[6] Because of this split, and in the midst of epic social, cultural, and political upheavals, Mead conjectured that a "crisis in faith" stemmed from the fact "that there are now no elders who know more than the young themselves about what the young are experiencing."[7] Mead suggested, somewhat hopefully, "young dissidents realize the critical need for immediate world action."[8] Consequently they would develop a new kind of culture, one in which, as against the disappearing culture of historical continuity in which their forebears had learned from *their* forebears, the youth of the 1970s would "lead their elders in the direction of the unknown."[9] It is perhaps still too soon to determine with certainty whether Mead's theory was correct. But it is tempting to believe that a similar—perhaps even more acute—rupture marks our own time, which adds a note of urgency to the questions addressed by the authors of the following articles and to the subjects addressed by the artists in "Younger Than Jesus."

1 For more on Strauss and Howe, see the Web site of the company they founded, LifeCourse Associates: lifecourse.com.
2 Karl Mannheim, "The Problem of Generations" (1928), *Essays on the Sociology of Knowledge* (New York: Routledge, 1952 and 1957).
3 José Ortega y Gasset, "The Concept of the Generation," *The Modern Theme* (New York: W.W. Norton, 1923/1933).
4 Ibid.

5 Geraldine M. Doetzer, "Letters: Exposed," *New York Times Magazine*, June 8, 2008.
6 Margaret Mead, "The Future: Prefigurative Cultures and Unknown Children," *Culture and Commitment: A Study of the Generation Gap* (New York: Natural History Press and Doubleday & Company, Inc., 1970).
7 Ibid.
8 Ibid.
9 Ibid.

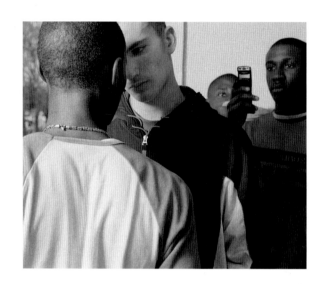

Mohamed Bourouissa,
Le telephone, from the "Périphéries" series, 2006.
Color Lambda print on aluminum in frame,
23 5/8 x 31 1/2 in (60 x 80 cm) and 35 1/2 x 47 1/4 in
(90 x 120 cm).
Courtesy Galerie les filles du calvaire, Paris
(Detail)

New Age Thinking

Lauren Cornell

The elusive state of relevance, in which art becomes worthy of attention, is informed by intergenerational tension. Practices of emerging artists call older or less-well-known ones into prominence. People hit their so-called strides when receptive forces are favorably aligned, and artists, in general, glean and reject ideas from different movements and moments. Therefore, bracketing artists along lines of age alone is, from the outset, a narrow proposition, but one that serves to push important concepts, histories, and positions into a larger conversation, and throws the complex evolution of contemporary art into relief.

The generation in question–"Gen Y"–is born somewhere between 1976 and 1980 (exact year pending the source). Hence this exhibition presents artists born after 1976, to look at a demographic currently being scrutinized by marketers, sociologists, and educators alike. Key issues from the time in which they (and I) came of age–the '80s and '90s–resonate contextually within the exhibition: American dominance in global relations, the saturation and increased importance of the media, and the strengthened role of technology and innovation on an international scale. This was a time in which overly simplistic terms like "global village" became common parlance, and the advent of "new media"–a.k.a. the Internet and its attendant devices–seemed to signal an incoming transformation in industry and communication.

These have now lost their Utopian sheen: global village, or the idea of a citizenry united across geography and nationality, for its overlooking of critical differences related to economics, culture, and religion, and for its underlying tie to American imperialism; and, new media for its inability to, alone, deliver an entirely new social order.

It is logical then that, in 2008, a distancing from such concepts is broadly evident as is an embrace of more complicated notions of identity and national boundaries–most aptly expressed in the election of Barack **19**

Obama. In an effort to describe this new outlook, philosopher and cultural theorist Kwame Anthony Appiah offers the term of "cosmopolitanism." He writes: "People are different, the cosmopolitan knows, and there is much to learn from our differences. Because there are so many human possibilities worth exploring, we neither expect nor desire that every person or every society should converge on a single mode of life. Whatever our obligations are to others (or theirs to us) they often have the right to go their own way. As we'll see, there will be times when these two ideals–universal concern and respect for legitimate difference–clash. There's a sense in which cosmopolitanism is the name not of the solution but of the challenge."[1]

This challenge underlines this exhibition and our curatorial process. Our intention was not to present a global picture but, instead, to look for shared practices and perspectives among the hundreds of portfolios recommended by an informal network we organized–a network that doesn't reflect the art world in total but our own professional limits and reach. The resulting exhibition glimpses a generation that is diverse, and deflects a rigid age-based determination by pulling in a myriad of influences across history, territory, and art to present a multifaceted picture of artistic practice, one that is cross-disciplinary and fluid. This corresponds with the aforementioned challenge but also the strength of art world in the '00s, which enabled a plethora of young artists to emerge. Showing artists with varied exhibition histories, but all at the start of their careers in early 2009, when this flush and fertile moment has ended, turns this exhibition into a bridge from one reality in art to the next, which as of this moment is completely uncharted.

This exhibition is underpinned by many loose themes: some representing emergent directions in contemporary art, whereas others reiterate or engage extant art practices. I outline three below.

Directing Collective Action

One trend in recent years that resounds with Appiah's notion of cosmopolitanism is a new kind of localism, with groups of likeminded artists working collectively, around ideas and across borders, while maintaining individual practices. Artists in this show have worked in collectives, including Das Institut (Kerstin Brätsch), LTTR (Emily Roysdon), Barr (Brendan Fowler), Nasty Nets (Guthrie Lonergan), AIDS-3D (Daniel Keller and Nik Kosmos), and the list goes on. Each one has an entirely different structure and purpose, but shares the ability to resist quick commodification and to project a vision larger than one individual artist's. It is unsurprising then, given this surge towards collaboration, that artists have moved towards the theatrics of collectivity and work as producers, either of open-ended content or tightly directed works, to examine identity.

Ryan Trecartin's films require mass collaboration and feature hysterically idiosyncratic characters that are mutable and interchangeable at the same time, appearing with different personas, sexual tendencies, and opinions in varying contexts, continually vulnerable to identity theft and transformation. A new brand of selfhood is at play in Trecartin's work, in which stable preferences are a thing of the past, and personas can be picked up, played out, and tossed aside on a month-to-month or moment-to-moment basis. These personalities reflect an emergent, international queer politics that are interested in liminal, permanently transitioning identity. In Trecartin's work, these tendencies collide with the pluralism of the Internet and the ubiquity of technology. His characters juggle in-person conversations with chat room encounters, YouTube-style confessionals and cell phone calls, all in real time, in a way that dramatizes the concurrent multiple contexts and calls to order that surround us. **21**

Similar to Trecartin's work, in which identity is a continual, negotiated performance, Emily Roysdon's practice includes both small- and large-scale productions that overturn notions of static identity through what the artist describes as "social choreography." *Four Screens as Dialogue (pioneering, devotional, familiar, invasive)* (2008) includes four large, movable screens, each imprinted with partially rendered images: a picture of an artist's studio, hands probing the inside of a mouth, an inflatable dildo. The screens function both as stand-alone sculptural objects and integral parts of performances, in which they are continually repositioned by actors, while Roysdon gives prompts to the audience such as "when an image looks familiar say 'again.'" This live chorus punctuates the performance to create an evolving series of photographic tableaux that evokes the negotiation between individual agency, language, and collaboration.

In the tradition of Franz West's "Passstuecke" sculpture or Yayoi Kusama's performances within her installations, artists' direct action upon staid objects can activate them or open them up to chance encounters. Both Mariechen Danz's *Fossilizing the Body Border Disorder* (2008), a three-dimensional diorama that blends science fiction fantasy with what looks like an archaeological dig, and Kerstin Brätsch's large-scale paintings are enlivened and altered by performances in the gallery. Liz Glynn's *The 24 Hour Roman Reconstruction Project, or, Building Rome in a Day* (2008–09) is a different model: a participatory project that is built by the artist and an army of volunteers in twenty-four hours, and then exists as ruins throughout the run of the show. These works point to the recurrence of ancient orders and the fragility of our own social fabric.

Mohamed Bourouissa stages more contemporary portraits of delicate social orders: young people hanging out in the *banlieu* of Paris. His photographs depict intimacy, camaraderie, and minor conflict, each one a mundane moment tinged with volatility evident in the characters' expressions–

22

or more literally with fires or fights breaking out at the edge of the frame. The tension of an individual within a group is at work here, but Bourouissa's deft merging of personal situations with contextual details brings the larger socioeconomic context in as a player within a larger drama.

Media is Everything and Nothing

As I write this, I've just received notice via e-mail that students with clear demands of their administration are occupying the New School's graduate facility. There are riots in the streets of Athens. And, Mumbai is recovering from what has been crassly termed "their 9/11." Above my desk is a stack of the "fake *New York Times*," an artist-designed and -distributed copy of the original with a headline–"IRAQ WAR ENDS"–that stirred hope and possibility among those who picked it up on the morning of November 12, 2008 and believed for a moment that it was true. This week, I received invitations to join four Facebook groups: one for those against Prop. 8; another called "I Still Think Marriage is the Wrong Goal"; another for W.A.G.E., an activist group "formed to address the growing inequalities in the arts, and to resolve them"; and one inane plea for Facebook users who protest the current Facebook design–which had the highest amount of registered advocates. This small snapshot reveals not only my own position but also the range of forms contemporary politics take, from widescale protest to more strategic, temporary alliances around goals, all tied inextricably to media. This connection is significant to the way artists engage politics today, particularly in regard to appropriation.

Appropriation is nothing new or specific to this generation; it has a rich history that runs back to the use of stock footage in the first decade of the twentieth century and up through the Internet mash-ups of **23**

today.[2] What is new is the way media's production and distribution has become radically democratized. Today, media is everywhere and nowhere, of the utmost importance and totally meaningless, in a constant state of flux and endless tweaking. Curator and critic Ed Halter wrote: "When artists use appropriation now, they do so in greater context of re-editing as a popular amateur pastime, e.g. Something Awful, Hillary's Downfall and its imitators, LOLcats, etc. In some cases artists' work may circulate within these contexts 'natively'–in a sense as full participants, rather than ironic interlopers."[3] Media's ubiquity and this coexisting lack of ironic distance marks a distinct break in the history of appropriation; now, artists and activists are required to work tactically, navigating between participation, embrace, and also criticism of larger media systems, in order to locate stakes or ascribe meaning.

This tendency is a significant one in contemporary art and underlines important works not included in the show: the media activism of the Yes Men (co-creators of the "fake *New York Times*"), and the more formal interventions of artist Michael Bell-Smith, whose painterly digital landscapes, sewn from images sourced from the Web, ascribe meaning where there was none to found imagery. Within the show, there are several distinct approaches to media. Ida Ekblad's collage points to the copy-and-paste culture of the Web, in which divergent histories and culture are often offered up without context, and images pass through so many virtual hands that their original meaning gets lost. Works, such as the "On Otherness" series (2008), which pairs found images of half-clothed men and women with hand-painted words in the style of graffiti that read "primitive" or "multicultural," illuminate this kind of free-form appropriation in relation to style, and question its integrity. In *Untitled (M)* (2008), Ekblad plays with the iconic McDonalds logo, ripping it out of context, repeating and re-framing it to explore whether its meaning can be lost or

changed. In soft colors amidst an eight-panel grid, interspersed with abstract patterns, the "M" logo fades in and out of recognition. Patricia Esquivias exploits this same careless circulation of cultural artifacts, but with an emphasis on history. Her lectures and installations create irreverent timelines through appropriated documents, in which she takes the liberty to tell the story of a country through the life of a superstar or a personal incident, mixing fact with her own highly subjective opinion, taking the forgetfulness and bias in the media to a comic, and hyper-personal, extreme.

Artists' work also reflects the breadth of cultural material available, often working to distill bigger stories through the hundreds of fragments they find. Tigran Khachatryan and James Richards curate found footage into psychologically dense narratives, each one pulling out shared cultural tendencies latent throughout the footage they find. In Khachatryan's case, it is violence, recklessness, and undirected fighting among men evidenced in hundreds of intertwined clips edited together à la Sergei Eisenstein's *Battleship Potemkin* to demonstrate the daily reverberations of war and conflict. Richards's *Active Negative Programme* (2008) highlights the presentation and control of images. The work opens with an advertisement for a new kind of image technology that allegedly allows people to control what they see on a computer through eye movement alone, and then proceeds through a collage of video, largely pulled from instructional videos, that is at once pedagogical and, due to the material's lack of context, completely unreadable. Both artists trace a narrative through a media world that seems to have exploded into short clips, and create cinematic environments to present and elevate works made out of detritus to a more auratic screening context.

Escaping the Innovation Trap

In an essay entitled "The Innovation Trap," curator David Ross writes about how the glorification of innovation can create negative expectations on artists working with technology: "We privilege those artists for whom innovation is central, and generally consider someone who consistently innovates a genius. This kind of innovation worship, like other belief systems and similar to most formalist strategies, has its value, but also has its limits. Of course we should value significant innovation, but similarly we should value and honor those who seek to expand upon and deepen (or transform) our understanding of existing structures and systems."[4]

Among this generation of artists, who have come of age in tandem with the Internet's broader assimilation, experienced globalization, and now wade through the hype, possibility, and limits of phenomena like the Web 2.0, a term used to describe evolved forms of participation online, there is a healthy skepticism towards innovation. In line with artists such as late video pioneer Nam June Paik or computer artists JODI, whose goal was—and is—to transform new technologies into art. While the history of technology has often been, and continues to be propelled by artists, there is also a healthy skepticism of the cultural privileging of innovation and a conviction that some of the most revealing aspects of technology are found at its edges, in its glitches or history. This skepticism is most iconic as expressed in *OMG Obelisk* (2007) by AIDS-3D, which features a large plinth emblazoned in neon with the letters "OMG" and surrounded by burning stakes. A mock shrine, the work criticizes technological Utopianism by substituting religion for an empty sign of technological progress: OMG, the ubiquitous acronym for "Oh My God" hatched out of the abbreviated communication of chat and text messaging, which appears in the place of a god or saint.

This trend away from innovation is also at play more subtly in works that address the Web and outdated technologies. The practice of Los Angeles-based artist Guthrie Lonergan entails surfing the Web, collecting, sharing, and pointing to material he finds online, instead of the creation of original material. Of this practice, he writes: "Part of it is the feeling that there's so much stuff out there already that it seems pointless to make something new, from scratch–which is perhaps a bit of a cliché response, but not untrue. The ephemeral nature of the Internet inspires a kind of disrespect for objects–for whole, perfect, 'created' things… I'm pretty skeptical of the goals of Web 2.0, the almost religious obsession with freedom, all the utopian democratic nonsense."[5] His work is concerned with the tension between creativity and the platforms that dominate the Web, in places like YouTube, MySpace, and Twitter, to name a few. His *MySpace Intro Playlist* (2007) is a presentation of twelve video "intros," or short personal documentaries the artist found and selected, uploaded to individual MySpace pages. The work highlights new forms of confession, privacy, and self-disclosure, as well as a way of working in which artists are organizers, not creators, of visual material.

With the rapid turnover of technology, artists increasingly work like historians or archaeologists to present powerful statements about technology's current and future status by turning to its recent past. Artist and game designer Mark Essen creates wildly imaginative, intentionally frustrating games out of the program Game Maker, which was developed in 1999 but, in its palette and graphics, seems eons away from contemporary games like Grand Theft Auto or Second Life. In *Flywrench* (2007), a player escalates through spare worlds in which abstract, geometric patterns animate at less-than-hi-def resolutions. Here, Essen makes use of inexpensive software available to him by pushing the game's limited palette and interactive capability outside of its intended

range–turning an obsolete commercial technology into art. Other artists comment on the passing of technological protocol. Featured prints by Tauba Auerbach's capture signals from an analog television, a broadcast format that will cease to exist before this exhibition opens, and makes them unrecognizable by blowing them up large and reframing them. Two works by Cory Arcangel extend his interest in the life cycle of technologies, while taking formalism and media specificity to the extreme. One work, *Panasonic TH-42PWD8UK Plasma Screen Burn* (2007), an inactive screen which presents an image of the work's title, edition number, and the contact information for the artist's gallery, points to this popular presentation device's vulnerability to burning, i.e. the ingraining of a static image onto a screen if left on too long. The work is a showcase for current screen technology, though points to its own soon-to-be-realized obsolescence. On a different note, works by Wojciech Bąkowski, films that animate watercolor drawings, turn away from new and networked technologies to capture contemporary states of anxiety, dissolution, and melancholy in earlier forms.

The book *AMERICAMERICA* (2008) by Matt Keegan bridges generations in art, and illuminates issues across the aforementioned themes. Using the 1986 charity event Hands Across America, in which seven million people held hands for fifteen minutes to raise money for hunger, the book combines interviews conducted with New York artists working at that time with cultural material–reproductions of their art, advertisements for satellite space innovation, cartoon renderings of "the contras," mainstream coverage of the AIDS crisis, and the oppositional iconography of activist organization ACT UP–to re-present the time through the artist's vantage point and through material around him. In a related installation featured in the exhibition, he pairs objects evocative of this material with a series of color photographs entitled *23 portraits of 22 year-olds* (2008), actual portraits of New York-based

students, to emphasize the negotiation and muted legacy of this recent political moment.

Like other works in this exhibition, Keegan's project looks back to craft a more nuanced picture of the present. How do twenty-two-year-old artists born in 1986 inherit the muted legacy of the AIDS crisis, the stratification of Cold War politics, and the challenges laid down by earlier generations of artists? Keegan's multifaceted project implies that it is a nonlinear inheritance, in which certain histories get amplified and others fall away. The works in this exhibition look forward; in them are different appearances of the future in contemporary art, but they are also carrying the challenges and aspirations of all that came before them, well aware that while the urgency or significance of their work may last, steadily or in waves, its newness is both powerful and fleeting.

1 Kwame Anthony Appiah, Cosmopolitanism: Ethics in a World of Strangers (New York: W.W. Norton, 2006).

2 See Ed Halter, "Recycle It," Moving Image Source, July 10, 2008 <http://www.movingimagesource.us/articles/recycle-it-20080710/> (accessed December 22, 2008).

3 Quote excerpted from an e-mail exchange with the author.

4 David Ross, "The Innovation Trap," Rhizome.org, August 9, 2007 <http://rhizome.org/events/tenyear/> (Accessed December 22, 2008).

5 Thomas Beard, "Interview with Guthrie Lonergan," Rhizome.org, March 26, 2008 <http://www.rhizome.org/editorial/5/> (accessed December 22, 2008).

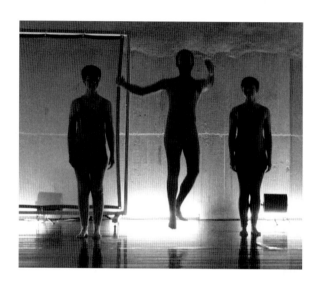

Emily Roysdon,
*Four Screens as Dialogue (pioneering, devotional,
familiar, invasive)*, 2008.
Performance, duration variable. Courtesy the artist
(Detail)

We Are Too Many

Massimiliano Gioni

In his classical study on generations, sociologist Karl Mannheim constructs a mental experiment that has almost a dark, science-fiction tone to it:[1] What would our societies look like if one generation would live forever? What would we remember? How would we forget? How would we expand our knowledge? And who would fight our wars or pay for our peaceful retirement?

In some countries, Mannheim's prophecy might have already come true: Stuck at negative growth, Italy, for example, seems completely unable to even imagine a future. Elsewhere though, this new century has marked the emergence of a new social actor, the coming of age of a new generation onto which sociologists, marketing experts, prophets, and priests seem to project high aspirations. Born roughly around 1980, this generation has already been scrutinized, categorized and labeled: Generation Y, iGeneration, the Millennials, and Generation Me are just a few of the terms that attempt to describe these new demographic ranks. In the US this is the largest age group since the days of the baby boomers, and yet this demographic transformation is not just an American phenomenon. China and India–two of the new global superpowers–are also caught up in an explosion of curiosity regarding the generation that is shaping this new century. In these countries this generation's influence is overwhelming: Just consider the fact that over half the Indian population is under twenty-five years of age and you will see that this is a veritable sea change, not just a matter of fashion.[2]

But then again, much of the flexing of analytical muscle that seems to be stimulated by this generation is driven precisely by economic interests and marketing strategies. More than any other generation before them, the Millennials seem to have piqued the interest of sociologists and experts above all because they have started spending sooner than their elder siblings. After all, today's Millennials are the tweens of a few years ago, an immense

31

reservoir of consumers who have already transformed the entertainment industry over the last two decades.

Browsing through the articles, essays, and books that try to explain this generation, an absolutely new anxiousness of interpretation comes to the surface: It is not the portrayal of a generational conflict, as in the literature of the '60s, nor is it about coming to terms with the astonishment at the outlandish behavior of the so-called Generation X. Instead, it looks like the pundits are trying to construct an equation, a secret formula that might explain the tastes, preferences, and habits of the Millennials, in the hope of selling them something. A special literary genre has taken form to sort out this generation, a blend of tabloid sociology, self-help manuals, and advertising. A sort of sociological soothsaying that seems to be more interested in this generation's wallets than its anthropological metamorphoses and related cultural transformations.

After all, many European nations today are elderly societies and compensate for their doddering majority by indulging in an almost morbid fascination with youth–an appeal that is also ironically addressed by the title of this exhibition. The focus on the Millennials might also be the result of this senescence of the Occident, which tries to revive itself through an act of vampirism.

This generation, in the end, seems to be more of a problem for its parents and siblings than a real vexation for its own members. But maybe that's the paradox of any generational turnover: Parents are plagued by the desire to understand their offspring, while the latter just try to escape, proudly declaring themselves extraneous, different. If we read between the lines of the pages and pages of prose on every tremor or hiccup of the Millennials, the curiosity seems to be mixed with fear. But maybe that same combination is always there, in the passage from one generation to the next.

The idea of looking at art in terms of generations is certainly nothing new: It's been with us since the days of Vasari, with his model of biological development, from childhood to maturity, and the intuition that those who belong to the same period share a tradition that must be endlessly enriched and improved upon. The very idea of "manner" is an expression of generational synchronicity: The manner is the sharing not only of a style, but also of a certain knowledge that is destined to be refined with the passing of time and the arrival of new generations, wiser than their predecessors.

In the twentieth century the Oedipal complex, with its generational clash, becomes the model of reference for art history. The artist is the eternal adolescent who has to kill the father. The history of art is transformed into a history of revolutions. The avant-garde is the fountain of eternal youth.

In more recent times things have only apparently become more complicated. In the narration of the postmodern, with its anti-Oedipal philosophy and movements toward deterritorialization, space takes the place of time: Where you come from, the community to which you belong, counts more than any generational distinction, as artists shape their identity on the figure of the foreigner rather than on the model of the young. But actually statelessness and youth are not so different: Both speak a foreign tongue, a jargon comprehensible only to their peers.

Furthermore, as Mannheim reminds us, one belongs to a generation whether one might like it or not. Mannheim compares generations to classes: Belonging to a class doesn't imply having a class consciousness, but both our class and our generational location will always impart a series of limits, a set of values, and an array of potential resources. Which neither means that generations are enclosed systems nor that anybody born in a certain time will always behave in the same way. One has to image the relationship between generations **33**

and individuals as something similar to the relationship of language as an abstract set of rules on one hand, and language as speech, as its actual use on the other. Speaking the same language means participating in a community that shares the same rules and values, but it also means having the absolute freedom of transforming and innovating, the freedom of creating and finding one's own personal voice, or of learning a foreign tongue. Paraphrasing linguist Roman Jakobson, one could say that generations function like languages do: They distinguish themselves not so much on the basis of what they can do, but more on the basis of what they can not avoid doing.[3]

Quite significantly, a new obsession with language seems to emerge precisely from the works of many artists born in and around the '80s. There is a linguistic explosion on all sides, an unstoppable flow of words. A hypertrophic growth of language seems to flourish from the works of very different artists like Keren Cytter, Patricia Esquivias, Luke Fowler, Ryan Trecartin, and Tris Vonna-Michell. Each in their own way, these artists construct works and narratives that are perpetual motion machines, in which narrators and characters hold forth in bizarrely elaborate descriptions, reckless monologues, intricate dialogues. Though highly various in form and content, all these works—and many others produced today—seem to have been rushed into velocity: They chase vitality at all costs. It is something akin to what the literary critic James Wood has called "hysterical realism": a form of narration peculiar to our time, based on an excess of storytelling and on a hyperconnection between characters, stories and substories.[4]

These works reflect the flow of unconsciousness of chat rooms and blogs, the avalanche of words that shakes our millennium based on idle talk. Stillness is abolished, silence shameful, and information has become a character in itself.

Naturally, important differences do exist among these artists. Trecartin draws liberally on digital culture and, in a certain sense, appears to be the artist who most clearly embodies the stereotype of a new, constantly connected generation. Fowler, on the other hand, focuses more on psychiatry and psychoanalysis than Web culture–for him, language is a riddle that offers access to the unconscious. Cytter seems to be fascinated by the utterly European tradition of chamber theater, while Vonna-Michel mixes the legacy of Fluxus with film noir atmospheres. Esquivias rewrites history in a minor key. With their spewing flow of verbiage these artists wind up creating narratives that have something of the melodrama: They are visceral but at the same time carefully staged, maniacally affected. They are drama queens.

Strangely enough, all these artists use the first-person singular. The desire to say "I" again seems to arrive from multiple sides of this generation. But of course the "I" used by these artists and their contemporaries is a completely transformed first person–it is already a collective "I." Without indulging too deeply in technological metaphors, we might say that for this generation of artists "I" is better written in the lower case, as it is appears in the prefix of the iPhone and the iPod. It's an individual voice, but one that is thought of as immediately sharable, interchangeable, highly compatible and, as such, hopelessly compromised, alienated, massified. It is an "I" that performs for the entertainment of others.

In his acute analysis of life in post-Fordist society, Italian philosopher Paolo Virno has described today's prevalent mode of being as that of a multitude: The multitude is born out of the complete erasure of any distinction between the collective and the individual. Speaking in the first person today is a form of fiction, of performance, not only because it is impossible to say where collective experience ends and private experience begins, but also because **35**

talk is the ultimate commodity in a society that is based on the production of communication by means of communication.[5]

This fluid overlap between the individual and collective dimensions also seems to be reflected in a certain lack of stability in the status of the object. For many young artists today, an artwork should not be a finite, concluded object. Or better, it may be a precise physical object, with relatively clear borders–after all, many young artists seem to be completely comfortable with paintings and sculptures–but it is also an object that can play a variety of roles, taking on the guise of a set, a theatrical prop, the incipit of a story, the platform for a performance.

The object and the artwork are not the residual result of an action. Instead, it is the object that triggers an action–the action unfolds from the object, not vice versa. As a formula, we might say that today's artists seem to be interested in inverting the slogan of process art: not attitudes that become forms, but forms that become attitudes.

This exhibition contains many examples of this strategy, and many other examples can be found in the output of other artists at work today. The recent art world crush for anything that has to do with dance and performance is probably a clear symptom of this paradigm shift.[6]

And it is significant that many artists who operate in this way do not seem to worry at all about the distinction between individual work and collective practice. Among the artists in the show, for example, AIDS-3D, Kerstin Brätsch, Mariechen Danz, Faye Driscoll, Liz Glynn, and Emily Roydson work both individually and as part or catalysts of groups, which may be structured as more or less fictitious enterprises–as is the case of Kerstin Brätsch and her Das Institut–or as informal social networks.

Besides making works and installations that are relatively traditional, these artists—to whom we could add Dineo Seshee Bopape and Chu Yun—also operate as directors of performances and situations that unfold inside their works or make use of their works as sets or props. The result is an intriguing form of lived-in art, where the performance is not the climax of the work, but a moment that can be stretched out in time, postponed, enacted before the opening of the exhibition, or repeated at more or less random intervals throughout. This stretching and fragmenting of the drama of performance may be one of the most typical aspects of this generation of artists, who seem to be fascinated by the search for new forms of distribution and packaging.

Something similar also happens in the works of Loris Gréaud, who has choreographed entire exhibitions as if they were opera libretti. To Gréaud an exhibition is not just an immersive experience that resembles a vaguely futuristic total work of art, but also something akin to a musical score, a composition that can be played with different instruments in different settings, radically changing each time, but without losing its intensity.

Ryan Gander's work doesn't rely on a completed form with a strong center either. This fluidity is also evident in the freedom with which Gander passes from the role of the artist to that of the curator and organizer of spaces and events. In his artworks Gander has often used references to detective novels and crime fiction: He proceeds by leaving clues and traces the viewer must follow and reconstruct in meaningful unity. In *This Consequence* (2005), Gander plays with these elements in an even more explicit way, having his work—a track suit with carefully embroidered blood stains—worn by a museum guard, who is thus both a protagonist and an extra in the show's narrative.

This focus on what happens at the edge of the action is another recurring factor in the work of many artists of this generation. A sizeable number seems to be interested in proceeding by means of lateral shifts, developing their work like a fugue, an infinite variation on a theme that finally contradicts the very notion of a center. This attitude is particularly evident in the work of certain painters, like Tauba Auerbach, Kerstin Brätsch, and Josh Smith, for example. Each one, in a very personal way, has absorbed the vocabulary of abstract painting, recovering precisely those traditions that have been forgotten and repressed because they were considered too commercial, compromised, cheap. Op Art, a certain abstract lyricism completely demoted to the level of kitsch, a kind of materic painting that contains grafted memories of feminist art and Art Brut, are some of the legacies these artists incorporate in their production. New energy is injected into these references, in a form of recycling of a minor past that doesn't exactly function as a tribute. By persisting with repetition and by working in series, by painting with obstinate precision, as in the case of Auerbach, or with a carelessness bordering on the mindless, as in the case of Smith, these artists take painting to a new level of inflation, as though they were to compete with the industry of digital imagery.

A profound metamorphosis has happened in the DNA of images. When over three billion photos crowd the pages of Flickr and hundreds of millions of users click on the same video on YouTube, it becomes clear that art has lost any central role with respect to the image-making machine. Redefining the role of the artist in relation to this radical transformation of the image will not be a job only for this generation: It will be one of the most important challenges for the new century.

Some younger artists try to come to grips with this change through a mixture of irony and lightness. Cory Arcangel, Mark Essen, Guthrie

Lonergan, and in some ways also Cao Fei and Shilpa Gupta, rather than discussing the status of the image seem to be interested in amplifying the symptoms of this cultural mutation. In Cao Fei's portraits or in Lonergan's do-it-yourself videos, for example, a humanity emerges that has almost been reduced to a caricature of itself: Confused between reality and representation, these characters surface from screens and dreams in Technicolor, with the immateriality of a poltergeist. In his video essays, on the other hand, James Richards seems to explore the relationship that links our gaze, the technology of the image, and the representation of death. His characters too have something ectoplasmic about them, as if our gaze had sucked the life out of them. Rather ghostly are also the portraits of Elad Lassry. His photos, recycled icons, and appropriated materials speak of a hyper-artificial universe in which images exist in a vacuum, without oxygen and without any relationship to life–the sex appeal of the inorganic.

Elsewhere, artists are still pursuing the possibility of an authentic, intimate relationship with their subjects. After all, digital technology has also paved the way for a candid immediacy that seems to inspire a number of young artists. This is almost the opposite of hysterical realism, but a complementary opposite: a kind of micro-emotional realism. Artists like Ziad Antar, Ciprian Muresan, Ahmet Öğüt, and Alexander Ugay use video and photography to construct situations and stories that narrate little gestures and everyday epiphanies. We can also see a renewed interest in photography in the work of other young talents. In very different ways, Mohamed Bourouissa and LaToya Ruby Frazier return to the tradition of reportage, but in a version that is carefully composed, with clear references to cinema and theater.

The works of these artists are also concerned with the representation of the family, which is another of the central subtexts of this exhibition. **39**

This insistence on family relationships is a generational factor, perhaps, or maybe it is simply a theme that has greater impact on younger artists. Certainly the idea of family portrayed by today's artists is quite varied, ranging from the alternative tribe in the videos of Ryan Trecartin to the barbarically patriarchal society imagined by Tala Madani in her paintings. In her smaller canvases, painted with cursive gestures, abuses of power and acts of violence are perpetrated by paternal, masculine figures of questionable moral fortitude.

In the work of Kateřina Šedá, on the other hand, parents and grandparents are the keepers of a knowledge that must be preserved at all costs. This is just the opposite of the Oedipus complex: Instead, we see the artist willingly self-sacrifice to the anxiety of influence and try to bridge the gap that separates generations. Her total abnegation is aimed at conserving the memories of her predecessors before they are lost forever. In *It Doesn't Matter*, Šedá's most ambitious work, composed of 600 drawings made by her grandmother as an exercise to react against a form of depression and apathy, the artist creates a family saga of touching simplicity, a sort of archaeology of the soul.

Every new generation imagines the future while also rewriting its own past. In her films and collages Haris Epaminonda restages fragments of memory and flashbacks from a past she is too young to have experienced directly. It is an imaginary rewriting of history that is also tinged with nostalgia, a sentimental yearning all the more tragic because it has never really possessed what it misses.

This recovery of a simultaneously unknown and longed-for past also appears in the videos of Anna Molska, who tries to rediscover the aesthetics of early twentieth century Soviet modernism, and turns it in a contemporary version that is tinted with neo-Futurist overtones, as in the video *Tangram*.

40 Another Polish artist, Jakub Julian Ziolkowski, revisits both folkloric

atmospheres and that peculiar combination of abstraction and fairy tale symbolism that defined early twentieth-century art, particularly in Eastern Europe. Stephen G. Rhodes storms the backyard of American history, unearthing a demented past permeated by Civil War cruelties and dark moods that also recall the most psychotic works of Mike Kelley and Paul McCarthy. Kitty Kraus, instead, confronts the grammar of Minimalism and reveals both its inherent violence and its latent fragility.

In his videos Cyprien Gaillard portrays buildings of the '60s as if they were the submerged ruins of ancient civilizations. In *Desniansky Raion*–his best-known piece–Gaillard juxtaposes these sublime landscapes with scenes of violence among hooligans. Seen in this context, they are transformed into strange rituals of an extinct people.

Ruth Ewan conducts an equally systematic research on memory, with the persevering care of an archivist who has collected hundreds of songs of protest and dissent for many years. This is a form of political activism based on a spontaneous, destructured aggregation, a form of choral participation–once again, a multitude.

Glimpses of the possibility to define a political dimension for this generation are also found in the very disparate works of Carolina Caycedo, Liu Chuang, and Matt Keegan. Caycedo stages a carnivalesque form of engagement in which political slogans are camouflaged behind festive situations, while Keegan tries to reconstruct the events that have marked his generation in an attempt to shape a sense of commonality. With his compositions of objects acquired by immigrants, students, and passersby, Liu Chuang creates portraits in absentia–portraits without subjects–that possess an almost sacred dimension, composed as they are only of relics. His installations of private belongings, clothes, and objects are also generational cutaways that narrate habits, behaviors, **41**

dreams, and fears of his age group. Like the sociologists, scholars, and market-
ing experts who strive to formulate theories and forecasts of the desires of the
Millennials, Liu Chuang reminds us that we are what we buy. But with their
touching simplicity, their almost funereal austerity, the portraits of Liu Chuang
capture a subtle tension no schematic sociological theory will ever be able to
convey in all its complexity: These portraits are reminders of the paradox that
each of us inhabits, of being bound to the particularity of an individual while
also taking part in a universal condition.

1 Karl Mannheim, "The Problem of Generations" (1928),
Essays on the Sociology of Knowledge (New York: Routledge, 1952
and 1957). See p. 159.
2 For the statistics and the demographic data in this
paragraph see the CIA, *The World Factbook*
<https://www.cia.gov/library/publications/the-world-fact-
book/index.html/> (accessed December 19, 2008).
3 Roman Jakobson, "On Linguistic Aspects of Translation,"
in *On Translation*, ed. Roman A. Brower (Cambridge:
Harvard University Press, 1959, 232–39).
4 James Wood, "Hysterical Realism," in *The Irresponsible Self:
On Laughter and The Novel* (New York: Picador, 2005, 178–94.
Wood coined the expression "hysterical realism" in 2000 as a
pejorative description of the literary works of Salman Rushdie,

Thomas Pynchon, Don DeLillo, David Foster Wallace, and
Zadie Smith. Though its final assessment is negative, Wood's
essay remains one of the most accurate descriptions of the new
American novel at the turn of the millennium.
5 Paolo Virno, *A Grammar of the Multitude* (New York:
Semiotext(e), 2004). Also see Daniel Birnbaum, *Under Pressure.
Pictures, Subjects, and the New Spirit of Capitalism*, ed. Isabelle
Graw (Berlin: Sternberg Press, 2008).
6 Many exhibitions and texts could serve as evidence of the
recent explosion of interest in the relationship between
contemporary art, dance and performance. See for example:
Catherine Wood and Jessica Morgan, *The World as a Stage*
(London: Tate Publishing, 2007) and Melanie Gilligan, "The
Beggar's Pantomine," *Artforum* (Summer 2007, 426–33).

Cory Arcangel,
Untitled (After Lucier), 2006.
Digital work on Mac Mini support, dimensions variable.
Courtesy the artist and Team Gallery, New York
(Detail)

Them

Laura Hoptman

One generation got old
One generation got soul

 — Jefferson Airplane, "Volunteers"

I am a visitor to this new Millennial Generation, a generational tourist, come from the far end of the previous generation, which is now pretty well on in years, and also studied, packaged, targeted, and even historicized. I've come to gawk, I've come to praise, and I've come to question how we correlate generalizations about generations with the visual culture that emanates from them. Not in by asking "Can we?" (Of course we can!), but more specifically: *How* can we see the relationship of a work of art to the time that it is made, or more to the point of this exhibition which focuses on a particular sociological demographic born after 1976, to the period in which the maker comes to maturity.

A cursory Web search of the vast amount of data that describes the Baby Boom Generation (b. 1946–64); Generation X (b. 1965–76); and the Millennials (b. 1976–) finds the following:

Baby Boomers are: optimistic, techno-savvy, focused on self, value higher education, believe in the ownership society, and are devoted to freedom of choice and instant gratification.

Generation X are: dislocated, but still optimistic, techno-savvy, self-absorbed, highly educated, devoted to ownership, choice, and want what they choose to own immediately.

The Millennials are: very optimistic (!), totally wired, self-absorbed but socially conscious, presume wealth and are born consumers, and want what they consume immediately.

In other words, in the general constructs of pop analysts, there isn't a whole lot of difference between you, the Boomer, you the Slacker,

45

or you the person under thirty-three who is curiously flipping through this book to see if you might find the visual-culture equivalent of yourself somewhere in these pages. Like reading daily horoscopes in which the predictions for Libra can just as easily signify for Leo, descriptions of the postwar generations seem suspiciously nonspecific, although we long for them not to be. It is a truism that every generation believes itself utterly different from the generation that has come before it, and in visual culture, in this century, even more than in the last, artists have wrestled with the past sometimes with murderous intent, sometimes with contempt, and lately, with something closer to sympathy, if not appreciation.

It can be argued that in the first two thirds of the twentieth century there was an obsession in visual arts with discovery and creation of new forms that had no precedent in anything that came before them. Towards the end of the century, the belief in the new was rejected by some, replaced by a sometimes-bitter nostalgia often manifested as ironic appropriation of the dated and obsolete. In this first decade of the new millennium, the Oedipal competition and anxiety might well have dissipated to an extent, replaced by an inclusive embrace of history, an absorption with the visionary, and a romance not so much with the future, but with a kind of futurological fantasy, cinematic in its detail.

In this exhibition, a number of artists manifest a fascination with obsolescence, but with a disinterest in appropriation and an absence of irony. Icaro Zorbar of Bogotá, a kind of Rube Goldberg with a romantic edge, and Cory Arcangel, American avatar of the nexus between contemporary art and the Internet, look back on a mechanical past, and a clumsy digital one, respectively, not with scorn but with affection for the element of hope that is embodied in every invention, every innovation, artistic and otherwise. Zorbar's elegant

contraptions constructed out of magnetic tape and stereo turntables

playing records are essentially music boxes. Marrying this eighteenth-century technology with recorded sound on vinyl–a mid-twentieth-century one–Zorbar shows his aesthetic appreciation of the notion of progress, but also delights in the repetitive rhythms of failure that always dogs its ascent. A single song plays on the multiple turntables, but un-synched, so that the results are part round, part echo. Significantly, Zorbar's works can only function with assistance; the multiple arms of the record players must be positioned by human intervention once every three minutes or so. This can be seen as an enormous flaw in the carefully designed system, or a caveat to the will to perfection.

Arcangel is a connoisseur of technological limits as well, but his specialty is the extraction of found modernism in the extraordinary technologies emanating from the integration of the computer in to daily life. With the patience of a craftsman replacing tesserae in a mosaic and the loony concentration of a mad scientist tapping at multiple computer screens, Arcangel digitally recreates the visual monuments of the avant-garde, from structuralist films to hard-edge abstraction. He does this neither to denigrate, nor recreate the epiphany that comes with the discovery of something genuinely new, but rather to describe its newness in the most contemporary language possible, and, in the end, remember it with love. Like Zorbar's sculptures, Arcangel's objects require ingenuity and much labor in their re-creation. They are not jokes at the expense of the hope of discovery, but in a humorous way, homages to it.

This inspired use of the obsolete finds its complement in a strain of exuberant fantasy futurology that includes the envisioning of entire parallel universes, poised precariously in some tense neither past, present, or future. Artists like Ryan Trecartin, Keren Cytter, and Emre Hüner are focused squarely on the future conditional–what could be. Trecartin's multitude of films chronicling the life and times of an entire community of characters seem to

ask, What if we comported ourselves as if we were the authors of our own universe—as if we were in a movie? What if we created our own religions, our own political movements, our own countries, even? In Trecartin's world all boundaries—between genders and sexual proclivities, between humor and horror, home and some alien dream scenario—evaporate. What is wishful thinking and what appears to be are conflated, so that we are unsure whether we are watching a performance of a fantasy or the actual fantasy itself in real time. Offering us a window into this other world embedded in a three-dimensional version of that world, as he does in the present exhibition, is an act of generosity on Trecartin's part, as well as an act of faith in the inclusivity of a created environment that is in startlingly free opposition to all norms.

Cytter's films succeed in building a similar parallel world using a completely different strategy. Although not as ecstatic, it is possible to see her stark universe as a kind of ideal. Stripped to a minimum of characters who speak in terse, Goddardian statements in a number of languages, Cytter's narratives are purposefully generic setups in which profound and epic encounters occur, normally, almost off-handedly, with a minimum of theatricality. Hüner works in animation, a discipline more clearly suited to the minute description of imaginary worlds. This he does with the close attention and the sure draftsmanship of botanical illustrator. *Panoptikon* is a work that offers an all-inclusive view of an ecosystem—or a civilization—populated by what seems to be hybrids of flora and fauna. Whether that view is from the inside or outside, though, is open to question. As its title suggests, the artist's pen is omniscient, but peculiarly able to simultaneously explore and describe both microscopic and macroscopic landscapes.

Art history is a discipline whose structure is based on periodization, the building of progressive histories or teleologies of visual culture through the chronological comparison of one kind of art with another.

Being an Enlightenment discipline with a Hegelian cast, art historical comparisons tend to be starkly definitive, and quite often dialectical: classicism versus romanticism, romanticism versus realism, realism versus the tendency towards abstraction, and so forth. Most importantly though, these tendencies emanate from the evidence of objects.

For marketers the differences between generations lie in the details (no doubt available for a fee, on the Web sites that I consulted); all of us postwar types are optimistic, but where does our particular brand of optimism lie? All of us are part of the ownership society in search of instant gratification, but what kind of things do we want to own? And once owned, what would be most instantly gratifying? Unlike art historical divisions that are based on the analysis of artistic production, generational divides are most often defined through patterns of consumption. It should surprise no one that most analytical research available on generations is focused squarely on the common characteristics of its consumables, rather than on the political, ideological, social, and cultural commonalities of what common experience produces. Consumables—picture perfect and in Technicolor—are the putative subjects of Elad Lassry's small format photographs. Even-featured youths with Pepsodent smiles as bright as their primary colored outfits, and foodstuffs with colors so perfect they could not possibly found in nature are both pictures of luscious objects and luscious objects themselves. That Lassry's photos have about them the whiff of the old fashioned, paradoxically, also gives them a youthful aspect. However ersatz they are beguilingly naïve. Mute and perfectly composed like a Lifesaver candy, you know you want one. Adriana Lara's interventions also recognize art's indubitable identity as a consumable, but, in contradistinction to Lassry, the works themselves are kind of booby traps to frustrate consumption. Whether it is the simple and hilarious gesture of placing a banana peel in just **49**

the spot where it would most likely be stepped on by viewers, or the more complicated one of creating a an invisible work that consists of all the hours that the exhibition in which it participates is open, Lara's works are not meant to be experienced, but rather, understood.

One of the dangers then, of placing generational parameters on contemporary art is the temptation to treat it like the consumable that it is, by extracting generalizations about it through its most popular manifestations. In terms of the Millennial Generation in particular, there is no need for a museum exhibition to do this; the contemporary art market has done it for us very thoroughly over the past decade. The history of art has reminded us though, again and again (Bouguereau! Buffet! Thomas Kincaid: Painter of Light©!) that the most popular visual artists are not necessarily those that produce the icons of their age. In fact, since World War II, at least in the US and in Europe, cultural exemplars of one generation or another have come from the *genuinely popular* arts—from the worlds of jazz and rock and roll, film, even comics, and rarely from traditional non-mass-reproducible mediums like painting, sculpture, drawings, prints, etc. One of the most notable developments in contemporary art at the end of twentieth century and the beginning of the twenty-first is steady erosion of the divisions between popular culture, mass culture, and "high" culture. In the past decade, the explosion of affordable and accessible technologies has created entire subgenres of artistic expression that can have real-world applications and also exist as fine art. Mark Essen is a designer of video games that are also visually and conceptually exciting abstractions, their visual complexity abetting the high level of difficulty they offer to the sophisticated gamer. Cao Fei has recognized the epic grandeur of role-playing fantasy games, in virtual settings like Second Life, as well as in real-world ones. Her color photographs of

costumed participants in role-playing games succeed in blurring the

boundaries between the fantasy and reality, allowing us, the viewers, a taste of the thrill of competing in such tournaments in an actual urban landscape. Both of these artists do not simply mine popular cultural forms for inspiration–they participate in those forms with such virtuosity as to elevate them, inarguably, to the level of art.

There have been attempts to sum up generations with contemporary art–with Jackson Pollock and the so-called "Irascibles" of the New York School touted as the testosterone-fueled poster boys of the American century, or with the "Frieze" or "YBA" toughs of London, at the beginning of the 1990s, who were called the face of a newly democratized art world. But rarely do these stylistic or regional affinity groups conform chronologically, or even, for that matter, ideologically, to the generations mapped out by the sociologists or market analysts. More importantly, artistic production is not an adequate replacement for a worldview based on common lived experience. World War I, for the Generation of 1914 who fought in it, was such an experience, but out of that generation came not only Dada–which can legitimately be linked to the absurdities and depredations of war–but also Cubism, which decidedly cannot. There is a crucial gap between experience and a work of art made in its proximity. Artists are not reporters, and their works are not always mirrors that reflect context of their making. Just compare still lifes painted by Pablo Picasso in the early 1940s in Nazi-occupied Paris with still lifes by Giorgio Morandi from the same period painted in Fascist Italy. Both artists were living in the depth of the world's greatest depravity, but relatively removed from direct involvement. Picasso used the tradition of the still life as a memento mori, as a stealth strategy to make a seemingly benign subject matter relevant to the terrible period from which it was conjured. *Guernica* they were not, but his series of still lifes utilizing a black-and-gray palette and often a human skull placed prominently 51

among more benign comestibles and utensils was a unambiguous reference to the inevitability of and ubiquity of death and dying, and clearly communicated the sense of dread that permeated even the most quotidian activities during that period. Morandi's meticulous arrangements of bottles, vases, cans, and other receptacles painted during wartime are virtually unchanged from the work he undertook before the war or after it. In Morandi's work, there is a refusal to engage with, or even acknowledge contemporary circumstances, a willful hermeticism that was purposefully and unquestionably out of sync with the period of its making.

All art is part of its contemporary circumstances whether the artist chooses to engage directly with history or the headlines or not. Although they have grown up in a time of political realignments, unrest, and all-out war in many parts of the world, in the group of Millennials in this exhibition, none make work that refers directly to historic events like the dissolution of the Soviet Union, the attack on the World Trade Center, or America's wars on the Muslim world. Some seem to take a wider view of the history that has formed them. AIDS-3D, a Berlin-based collective, and Brendan Fowler both embrace the phenomenon that marked the birth of their generation—the worldwide AIDS pandemic. Without pretending to have experienced it, their references to it is their way of owning the circumstances that formed them. Similar to European artists and writers born during and immediately after World War II, the very act of integrating generational disaster in to their work is provocative, although there is no question of being "for" or "against" the disease and its ravages. This said, their take on the invocation of the AIDS crisis in visual art is entirely at odds. In their primitivistic monuments featuring piles of fabricated body parts, torches, and ominous neon portents, AIDS-3D's installations both capture the air of doom that has marked much of the past thirty years, and renders it part of the fabric of popular culture. Fowler would not approve. His performance works as well as his

objects take the form of oral histories, often personal, but always aimed at a more general resonance. The work he has included in the exhibition chronicles his fight to publicly censure a rock band that provocatively calls itself "AIDS Wolf." For Fowler, recent history, especially one so tragic, sexually and politically fraught as that of the progress of the international AIDS epidemic, must be chronicled, historicized, owned, but not taken lightly, or in vain.

This desire to understand the period in which one was born in a broader, more nuanced way, and with that understanding, shape one's own historical context is married with a fascination with the recent past in Matt Keegan's multipart project to research and document Hands Across America, a 1986 national fundraising effort to help the homeless. Taking the form of a human chain that was supposed to reach from coast to coast, Hands was both an ambitious, but purely symbolic effort to bring the country together around an important social issue, as well as an example of the corporatization and spectacularization of activism that began in the mid-1980s, just as the American government began to back away from a broad array of social programs. Keegan's appreciation for the Utopian aspects of the Hands project evinces a kind of incredulity but never devolves into anger. Similarly, Carolina Caycedo's banners, which include *Ni Dios Ni Patrón Ni Marido* (which translates to "Neither Gods Nor Boss Nor Husband"), *Don't Pay Taxes*, and *Trust Each Other* don't call for struggle, although formally they evoke the militant banners of myriad protests of the past. In fact, they don't even really complain, but exhort us rather, towards an ideal society broadly based on individual responsibility and mutual respect. Keegan and Caycedo make work that has a definite activist cast; although opinionated, notably, it is neither militant nor proselytizing. Neither are Adam Pendleton's recent paintings, though they seek to renovate a supposedly revolutionary moment in art history to reflect the realities of the new millennium. Reaching **53**

back to Dada, and melding it with the portentiouness of postwar high modernism Pendleton's paintings are mash-ups that completely re-interpret–or perhaps more accurately, creatively misinterpret two canonical and opposing art historical periods. Elegantly composed of vast areas of monochromatic black alternating with white, they refer not unironically to both to the supposed neutrality of abstraction, as well as to the tendency to read too much in to colors already freighted with meaning. By calling this group of works "Black Dada," Pendleton may be claiming a potently anarchic historical movement for today's artists of color, or simply making punning comment on black, the symbolic color of choice for the anarchist movement.

There is no doubt about it: Generational parameters are flawed, even arbitrary tools for the analysis of contemporary art. In terms of art, a generation, particularly on a global level, cannot be defined by the visual culture it consumes, but only by what it produces. Scrutinizing the most contemporary material for stylistic or narrative connections between objects and equivalencies–objective and metaphoric–with contemporary philosophical, religious, or political developments, or resonance with contemporary experience, is imprecise, quixotic, and highly mediated by the analyzer(s). But it also yields results that describe a narrative connected to, but subtly different from those that came before it. In work from this latest generation, the Millennials, still younger than Jesus at least until next year, we can begin to discern these differences, perhaps even historicize a bit. But at the same time we also feel a cool hand that gently but firmly pushes us away with a whispered, "Not yet!"

Plates

AIDS-3D / Ziad Antar / Cory Arcangel / Tauba Auerbach / Wojciech Bąkowski / Dineo Seshee Bopape / Mohamed Bourouissa / Kerstin Brätsch / Cao Fei / Carolina Caycedo / Chu Yun / Keren Cytter / Mariechen Danz / Faye Driscoll / Ida Ekblad / Haris Epaminondav / Patricia Esquivias Mark Essen / Ruth Ewan / Brendan Fowler / Luke Fowler / LaToya Ruby Frazier / Cyprien Galliard Ryan Gander / Liz Glynn / Loris Gréaud / Shilpa Gupta / Emre Hüner / Matt Keegan / Tigran Khachatryan / Kitty Kraus / Adriana Lara / Elad Lassry / Liu Chuang / Guthrie Lonergan / Tala Madani / Anna Molska / Ciprian Muresan / Ahmet Öğüt / Adam Pendleton / Stephen G. Rhodes James Richards / Emily Roysdon / Kateřina Šedá / Josh Smith / Ryan Trecartin / Alexander Ugay Tris Vonna-Michell / Jakub Julian Ziolkowski / Icaro Zorbar

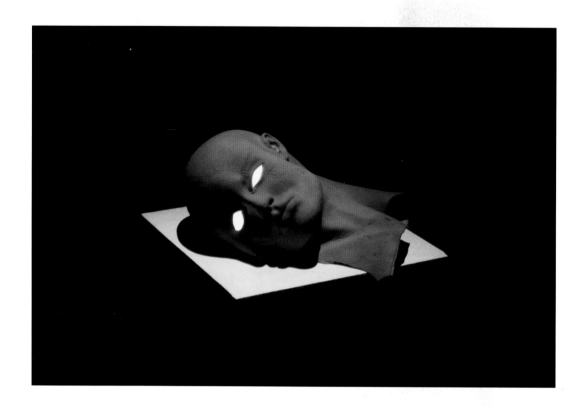

AIDS-3D, *The Last Cyborg,* 2008.
Insulation foam, paint, cement dust,
LEDs, and vellum
23 5/8 x 47 1/4 in (60 x 120 cm)

AIDS-3D, *Burning Bluetooth (Hotspot)*, 2008.
Inkjet print,
35 1/2 x 23 5/8 in (90 x 60 cm)

Ziad Antar with Ayman Abdel Hafez, *La corde*, 2007.
Digital video featuring Ayman Abdel Hafez, 3 min.
Courtesy the artist

Ziad Antar, *WA*, 2004.
Digital video, featuring Nathalie and Mohamed Bsat, 3 min.
Courtesy the artist

Cory Arcangel, *Colors*, 2006.
Digital work on Mac Mini support, dimensions variable.
Courtesy the artist and Team Gallery, New York

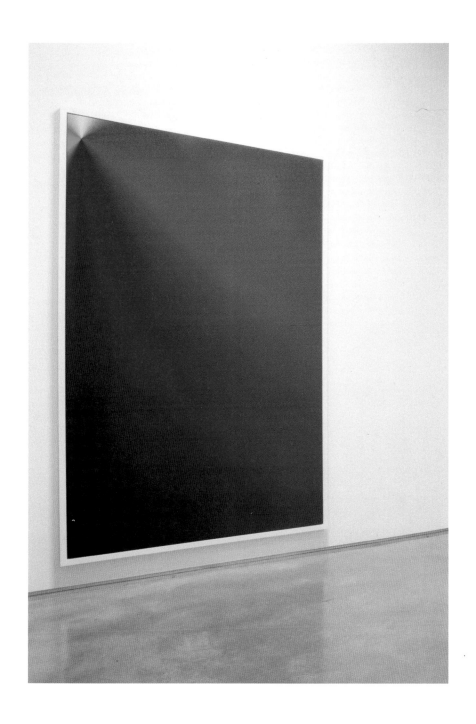

Cory Arcangel, *Photoshop CS: 110 by 72 inches, 300 DPI, RGB, square pixels, default gradient Spectrum , mousedown y=1098 x=1749.9, mouse up y=0 x=4160,* 2008. Unique chromogenic print, 110 x 72 in (279.4 x 182.9 cm). Courtesy the artist and Team Gallery, New York

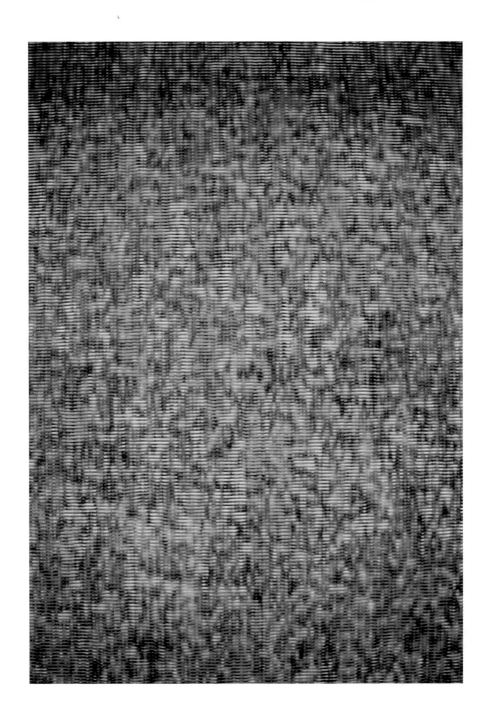

Tauba Auerbach, *Static IV*, 2008.
Chromogenic print,
60 x 42 in (152.4 x 16.7 cm)
Courtesy Deitch Projects, New York

Tauba Auerbach, *The Answer/Wasn't Here (anagram III)*, 2007.
Gouache on paper,
24 1/4 x 19 1/4 in (61.6 x 48.9 cm)
Courtesy Deitch Projects, New York

Wojciech Bąkowski, *Film mówiony 3 (Spoken Movie 3)*, 2008.
Animation,
9:30 min
Courtesy Leto Gallery, Warsaw

Wojciech Bąkowski, *Film mówiony 1 (Spoken Movie 1)*, 2007.
Animation,
5:22 min
Courtesy Leto Gallery, Warsaw

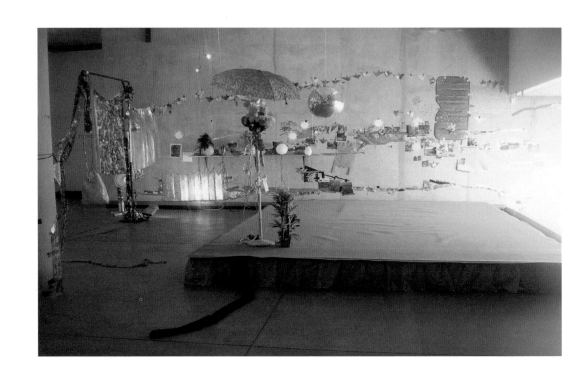

Dineo Seshee Bopape, *grass green/sky blue (because you stood in the highest court in the land insisting on your humanity)*, 2008.
Mixed mediums, digital video, and sound, dimensions variable

Dineo Seshee Bopape, *plug in/plug out*, 2007.
Wooden hat stand, wool, knives, lights, cushion, blush brush,
fabric, and fur, dimensions variable

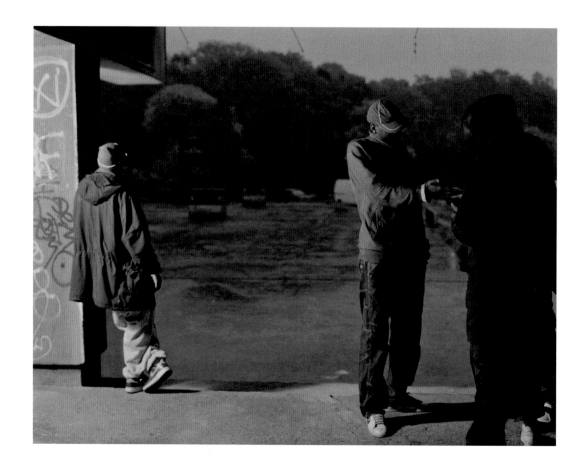

Mohamed Bourouissa, *Le hall*, from the "Périphéries" series, 2007.
Color Lambda print on aluminum in frame,
47 1/4 x 63 in (120 x 160 cm)
Courtesy Galerie les filles du calvaire, Paris

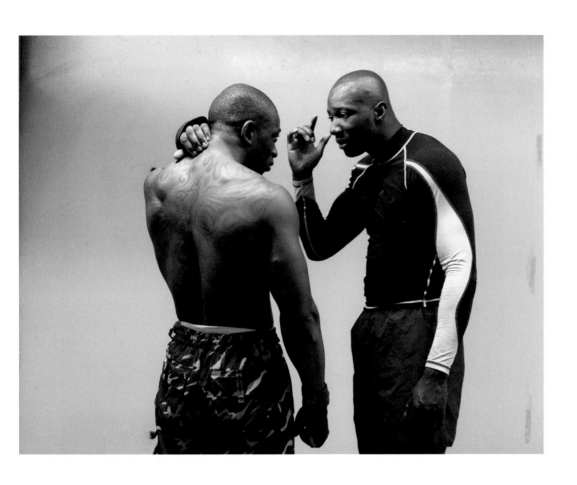

Mohamed Bourouissa, *La fenêtre*, from the "Périphéries" series, 2005.
Color Lambda print on aluminum in frame,
23 5/8 x 31 1/2 in (60 x 80 cm) and 35 1/2 x 47 1/4 in (90 x 120 cm)
Courtesy Galerie les filles du calvaire, Paris

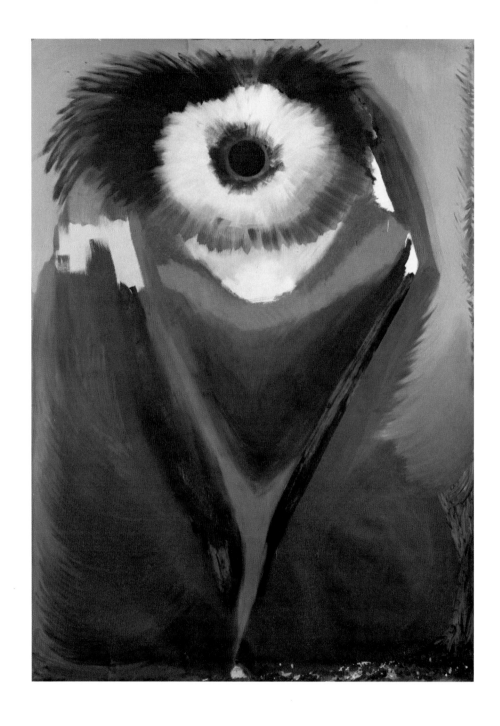

Kerstin Brätsch, *Untitled* from the "Psychic" series, 2008.
Oil on paper, 98 1/2 x 68 7/8 in (250 x 175 cm).
Courtesy BaliceHertling, Paris

Kerstin Brätsch, *Untitled* from the "Psychic" series, 2008.
Oil on paper, 98 1/2 x 68 7/8 in (250 x 175 cm).
Courtesy BaliceHertling, Paris

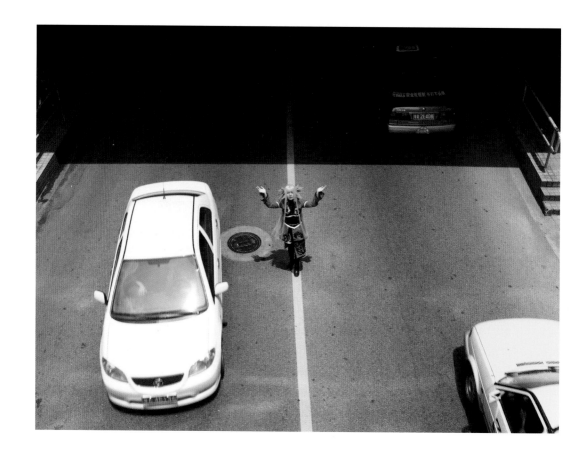

Cao Fei, *She Wish She Knew* from the "COSPlayers" series, 2004.
Digital chromogenic print, 29 1/4 x 39 1/4 in (74.3 x 99.7 cm).
Courtesy the artist and Lombard-Freid Projects, New York

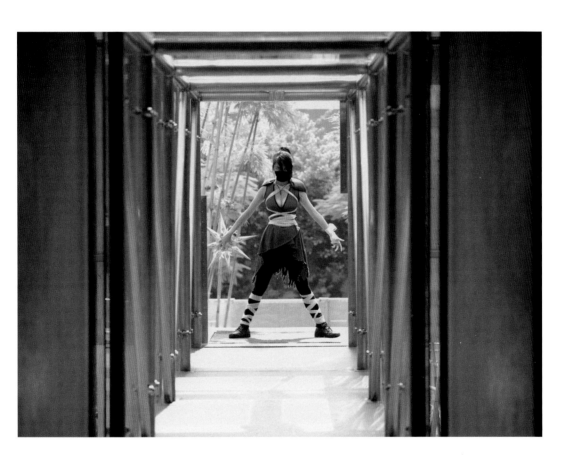

Cao Fei, *Murderess* from the "COSPlayers" series, 2004.
Digital chromogenic print, 29 1/4 x 39 1/4 in (74.3 x 99.7 cm).
Courtesy the artist and Lombard-Freid Projects, New York

78 Carolina Caycedo, *ColomBoricua*, 2006. Carolina Caycedo, *Mexicamerican Flag*, 2007.

Hand-sewn nylon flag, Hand-sewn nylon flag,

24 x 36 in (61 x 91.4 cm). 8 x 5 ft (243.8 x 152.4 cm)

Berezdivin Collection, San Juan

Carolina Caycedo, *US-Iraq*, 2006.
Sewn nylon flag. 24 x 36 in (61 x 91.4 cm).
Berezdivin Collection, San Juan

Carolina Caycedo, *UK-Colombia*, 2006.
Hand-sewn nylon flag, 24 x 36 in (61 x 91.4 cm).
Courtesy the artist

79

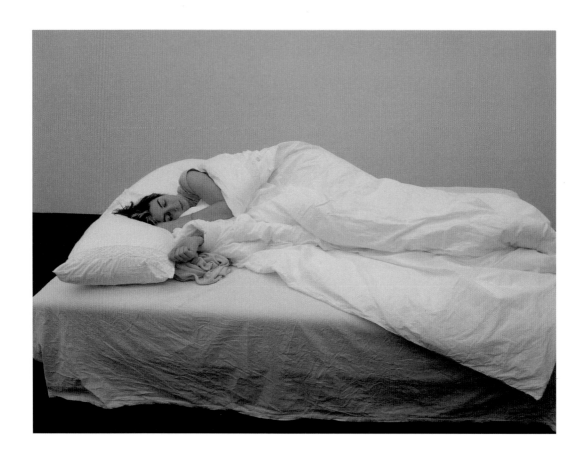

Chu Yun, *This is Emma*, 2006.
Female participant, sleeping pill, and bed, dimensions variable.
La Gaia Collection, Busca, Italy

Chu Yun, *This is Kate*, 2006.
Female participant, sleeping pill, and bed, dimensions variable.
La Gaia Collection, Busca, Italy

Keren Cytter, *Der Spiegel*, 2007.
Digital video, color, sound, 4:30 min
Courtesy Pilar Corrias Gallery, London

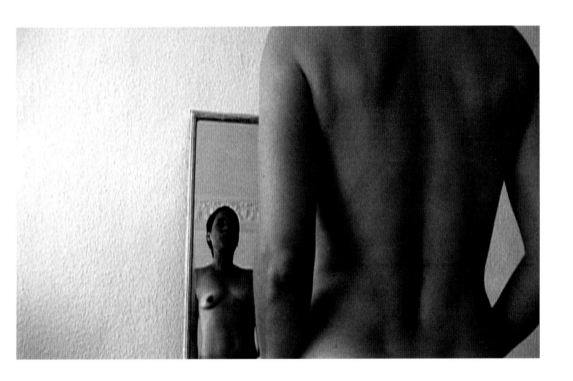

Keren Cytter, *Der Spiegel*, 2007.
Digital video, color, sound, 4:30 min
Courtesy Pilar Corrias Gallery, London

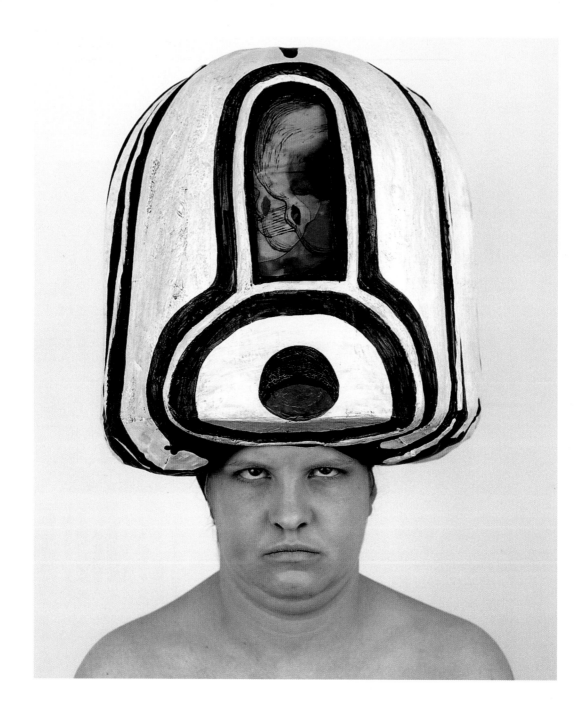

84

Mariechen Danz, *YE (Pilzschiel)*, 2006.
Color photograph mounted on aluminum, 55 1/8 x 39 3/8 in (140 x 100 cm).
Original photo: Andrea Huyoff. Courtesy the artist

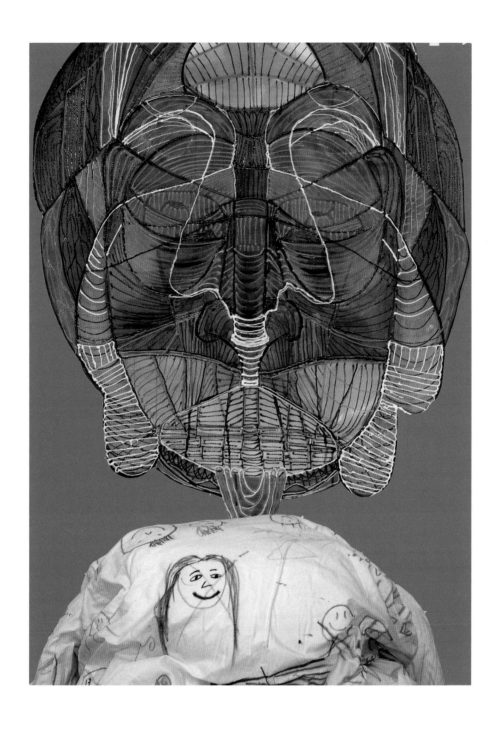

Mariechen Danz, *untitled/maskpuff*, 2008.
Collage with puffpaint on paper, 43 1/4 x 35 1/2 x 3/8 in (110 x 90 x 1 cm);
childrens' drawings on costume, dimensions variable

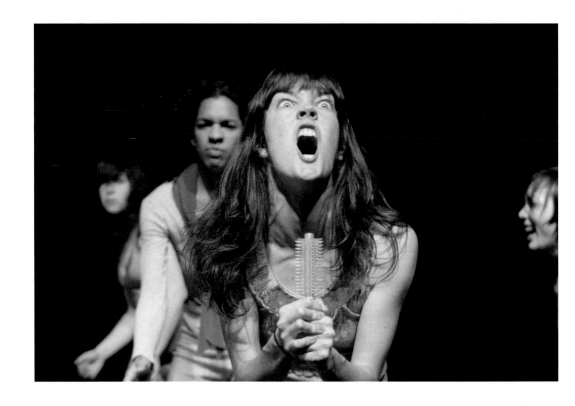

Faye Driscoll, *Wow Mom, Wow*, 2007.
Performance,
duration variable

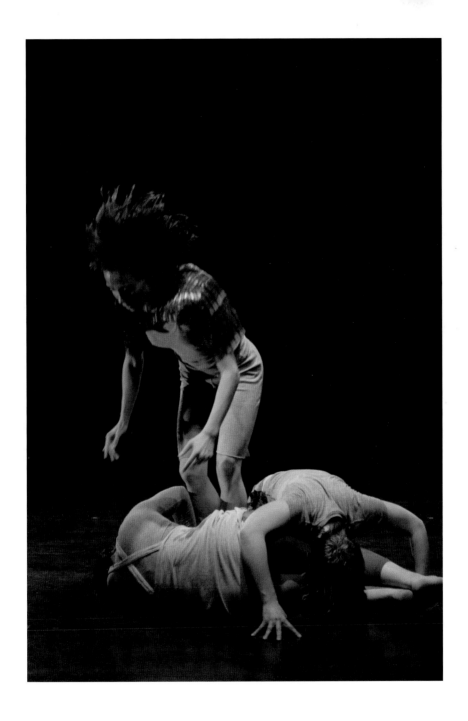

Faye Driscoll, *Wow Mom, Wow,* 2007.
Performance,
duration variable

Ida Ekblad, *Kings Die Too*, 2008.
LightJet print,
66 x 55 in (167.6 x 139.7 cm).

Ida Ekblad, *Untitled (M)*, 2008.
Ink and chlorine on watercolor paper,
7 ft 1 in x 10 ft 7 in (215.9 x 322.6 cm).
Courtesy the artist and Gaudel de Stampa, Paris

89

Haris Epaminonda, *Untitled 009c/g*, 2007.
Collage on paper,
6 7/8 x 4 3/8 in (17.5 x 11.7 cm)
Courtesy Rodeo Gallery, Istanbul

Haris Epaminonda, *Untitled 0012c/g,* 2007.
Collage on paper,
6 1/2 x 4 1/2 in (16.5 x 11.6 cm)
Courtesy Rodeo Gallery, Istanbul

Patricia Esquivias, *Reads Like the Paper I*, 2005-07.
Single-channel video projection,
7 min

92

Patricia Esquivias, *Reads Like the Paper II*, 2005-07.
Single-channel video projection,
5 min

Mark Essen, *Cowboyana*, 2008.
Video game with two controllers,
dimensions variable

Mark Essen, *Flywrench*, 2007.
Video game,
dimensions variable

Ruth Ewan, *Get off your Knees! (copied by Jamie Barker age 13)*, 2006.
Ink on paper, 11 x 8 1/4 in (27.9 x 21 cm).
Courtesy Ancient & Modern, London

Ruth Ewan, *Psittaciformes Trying to Change the World* (detail), 2007.
Parrots and aviary, dimensions variable.
Courtesy Ancient & Modern, London

Brendan Fowler, *Disaster LP*, 2008.
BARR LP, enamel, and custom frames, 23 x 21 in (58.4 x 54.6 cm).
Courtesy the artist

Brendan Fowler, *Cancelled Summer Tour #1*, 2008.
Inkjet print, enamel, glass, UV Plexiglas, and wood, 24 x 20 in (61 x 50.8 cm).
Courtesy the artist

Luke Fowler, *The Way Out*, 2003.
Digital video,
3:10 min
Courtesy The Modern Institute, Glasgow

100

Luke Fowler, *The Way Out*, 2003.
Digital video,
3:10 min
Courtesy The Modern Institute, Glasgow

LaToya Ruby Frazier, *Mom*, 2008.
Silver gelatin print,
16 x 20 in (40.6 x 50.8 cm)

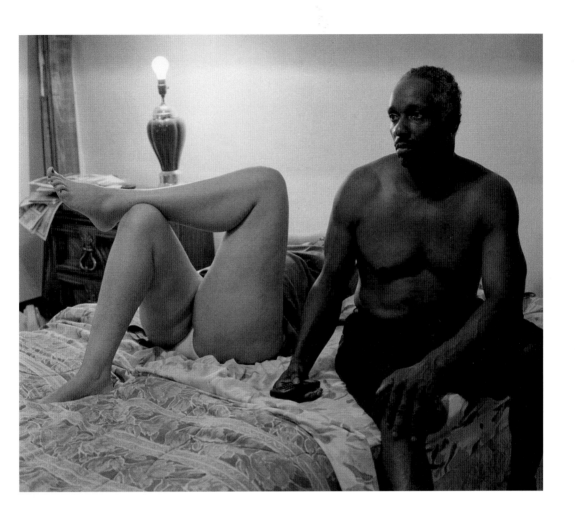

LaToya Ruby Frazier, *Mom and her Boyfriend Mr. Art*, 2005.
Silver gelatin print, 16 x 20 in (40.6 x 50.8 cm).
Harvard University Fogg Art Museum, Cambridge

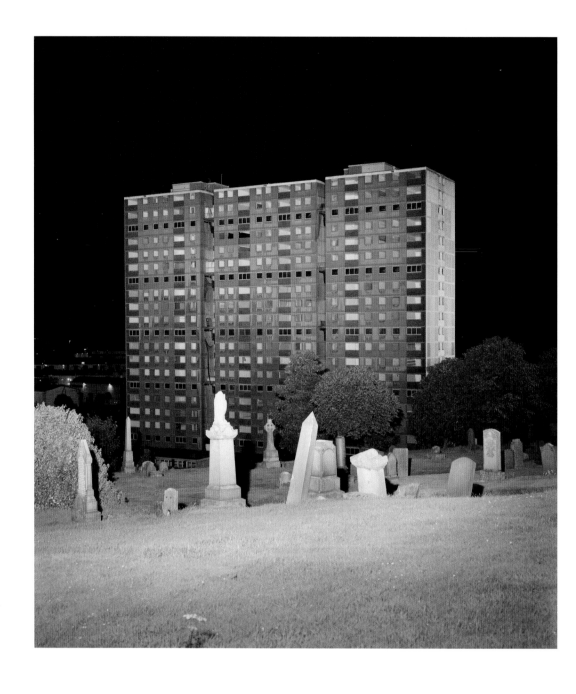

Cyprien Gaillard, *Untitled (Sitehill)*, 2008.
Chromogenic print,
6 ft 11 in x 5 ft 7 in (211 x 170 cm)
Courtesy Laura Bartlett Gallery, London, and
Cosmic Galerie, Paris

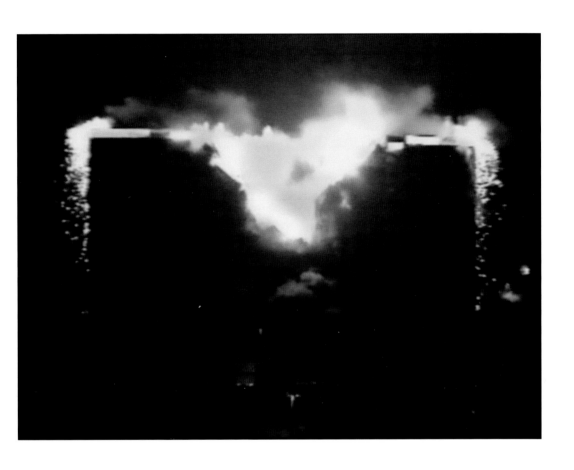

Cyprien Gaillard, *Desniansky Raion*, 2007.
Digital video, color, sound,
30 min
Courtesy Laura Bartlett Gallery, London,
and Cosmic Galerie, Paris

Ryan Gander, *Is this guilt in you too–(Study of a car in a field)*, 2005.
Installation with digital video, white carpet, and sound,
dimensions variable
Courtesy Annet Gielink Gallery, Amsterdam, Tanya Bonakdar
Gallery, New York, and Taro Nasu Gallery, Tokyo
(Detail)

Liz Glynn, *Smash the Solid State/Pick Up the Pieces*, 2008.
Cast plaster floor, 120 x 120 in (304.8 x 304.8 cm).
Exhibition view with reconstruction of floor in process
(Detail)

Liz Glynn, *Circular Processional*, 2008.
20 color slides on loop,
48 x 72 in (121.9 x 182.9 cm)
(Detail)

Loris Gréaud, *Cellar Door*, 2008.
Exhibition view,
Palais de Tokyo, Paris
Courtesy Yvon Lambert, Paris

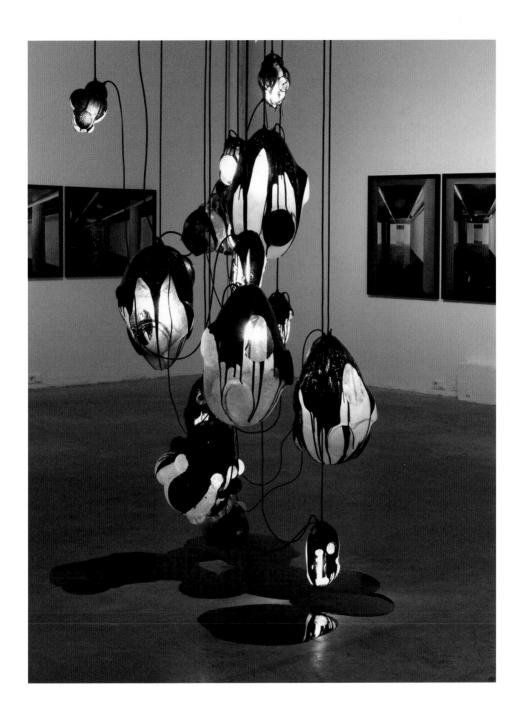

Loris Gréaud, *Cellar Door*, 2008.
Exhibition view,
Palais de Tokyo, Paris
Courtesy Yvon Lambert, Paris

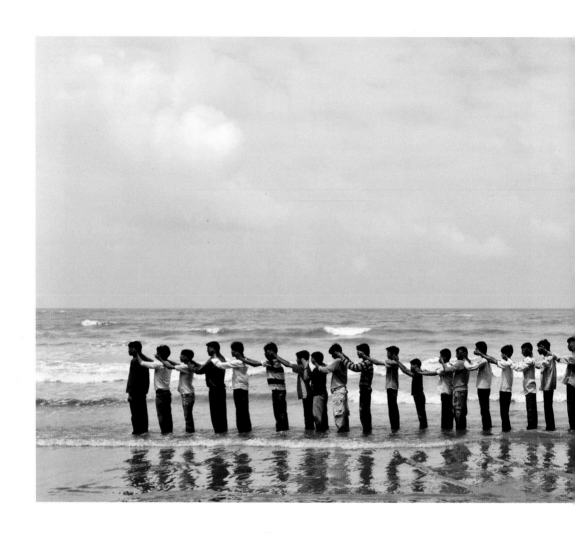

Shilpa Gupta, *Don't See Don't Hear Don't Speak*, 2008.
Chromogenic print on PVC,
120 x 300 in (305 x 762 cm)

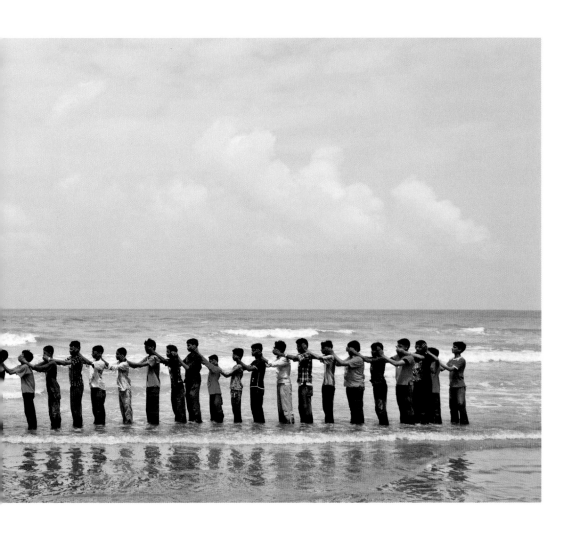

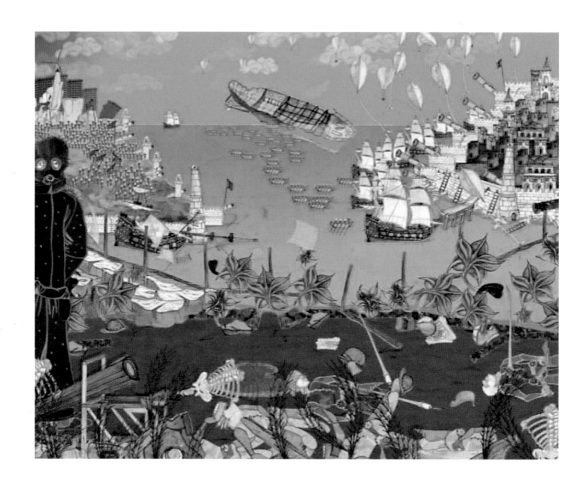

Emre Hüner, *Panoptikon*, 2005.
Animation,
11:18 min
Courtesy Rodeo Gallery, Istanbul

114

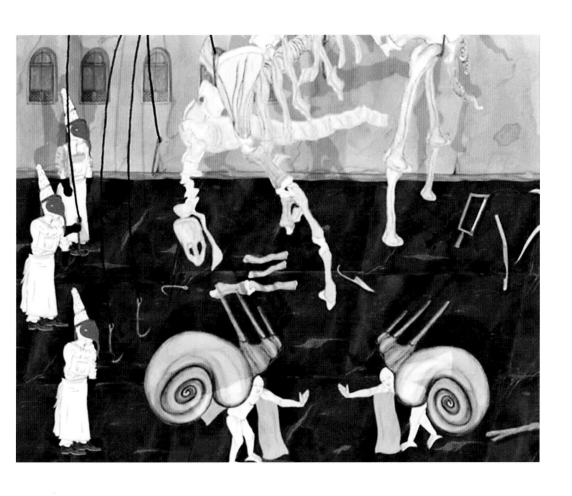

Emre Hüner, *Panoptikon*, 2005.
Animation,
11:18 min
Courtesy Rodeo Gallery, Istanbul

(from top left:) Megan Plunkett, Kyle Thurman,
Rachel Ballinger, Gregory Wazowicz, Amgee Belotti,
Jonathan Basile, Duggu Demir, Matt Vadman,
Jessy Brodsky, Austin Power, Annie Ochmanek,
Daniel Wagner, Alex Gartenfeld, Andrea Lee,
Ryan Reineck, Alexandra Roth, Jonathan Montaos,
Lanya Snyder, Danny Baxter, Adrianne Waite,
Max Staley, Meggie Kelley, Noel Chanyungco.
Photographs by Matt Keegan.

Matt Keegan, *23 Portraits of 22 Year Olds*, 2008.
Chromogenic print,
10 x 8 in (25.4 x 20.3 cm)
Courtesy the artist and D'Amelio Terras, New York

Tigran Khachatryan, *Stalker*, 2004.
Video, 12:33 min
Courtesy the artist

Tigran Khachatryan, *Stalker*, 2004.
Video, 12:33 min
Courtesy the artist

Kitty Kraus, *Untitled*, 2007.
2 pieces of 9 mm pinstripe suit cloth,
46 1/2 x 13 1/4 in (118.3 x 33.6 cm) and 27 5/8 x 17 1/4 in (70.3 x 43.7 cm)
Courtesy Galerie Neu, Berlin

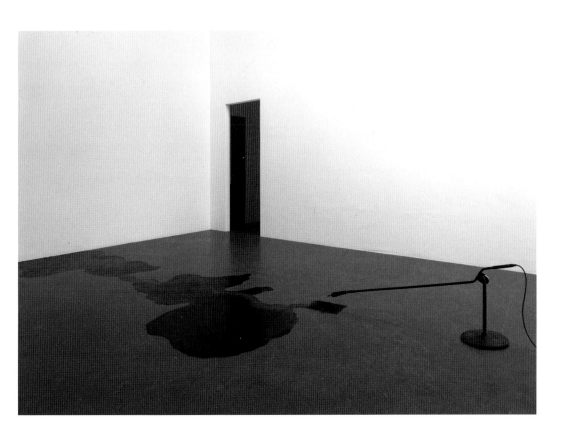

Kitty Kraus, *Untitled*, 2008.
Ice, ink, and underwater microphone attached to speaker system, dimensions variable.
Installation view, Kunsthalle Zürich, 2008
Courtesy Galerie Neu, Berlin

Adriana Lara, *Caracoles/Shells*, 2008.
Shells, paper, and cardboard boxes, dimensions variable.
Installation view, Gaga arte contemporáneo, Mexico City

124

Elad Lassry, *Felicia*, 2008.
Chromogenic print,
14 x 11 in (35.6 x 27.9 cm)
Courtesy David Kordansky Gallery, Los Angeles

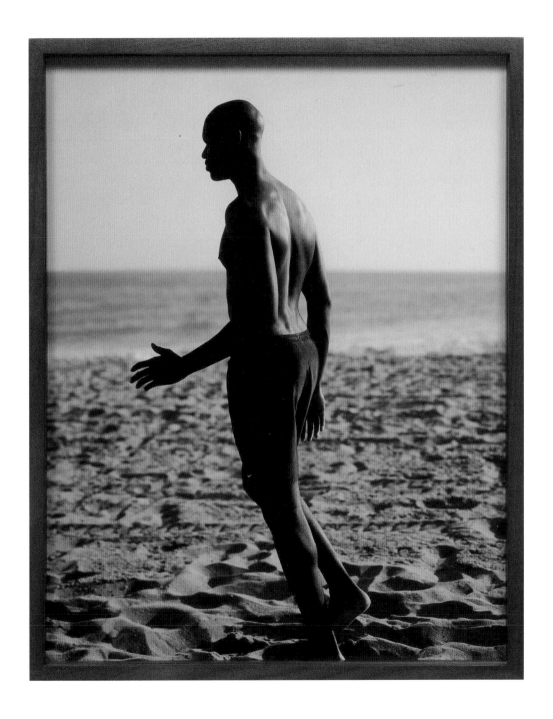

Elad Lassry, *Michael*, 2008.
Chromogenic print,
14 x 11 in (35.6 x 27.9 cm)
Courtesy David Kordansky Gallery, Los Angeles

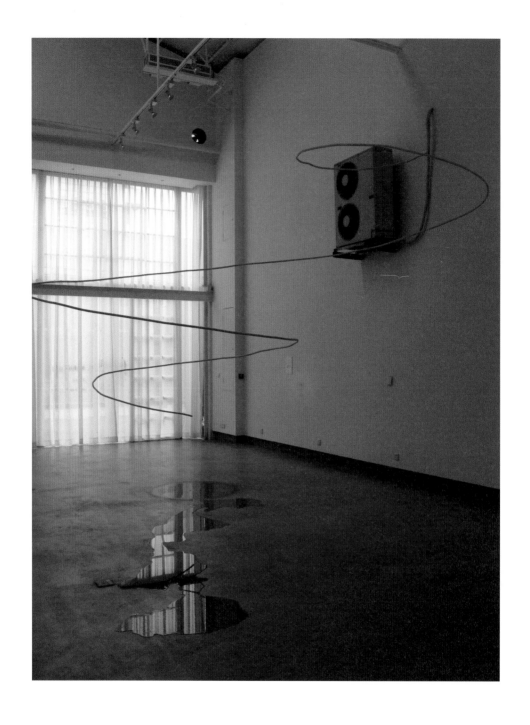

Liu Chuang, *Untitled (History of sweat)*, 2007.
Air-conditioning system,
dimensions variable

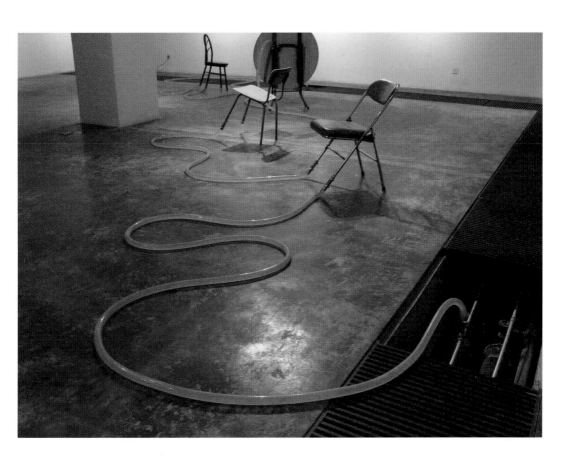

Liu Chuang, *Untitled (Unknown River) II*, 2008.
Water pipe, chair, table,
dimensions variable

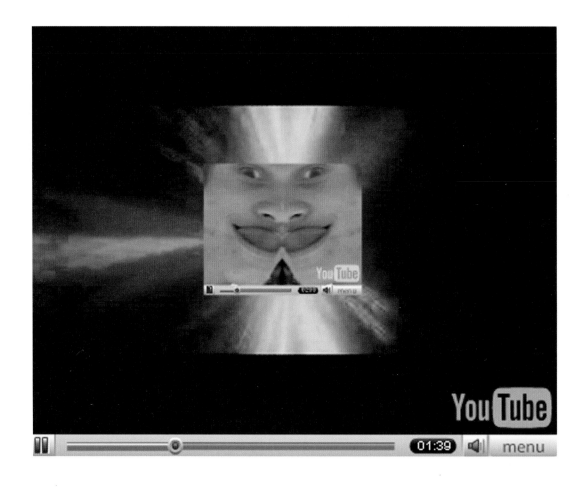

Guthrie Lonergan, *2001<<<>>>2006*, 2007.
Digital video, sound,
3 min

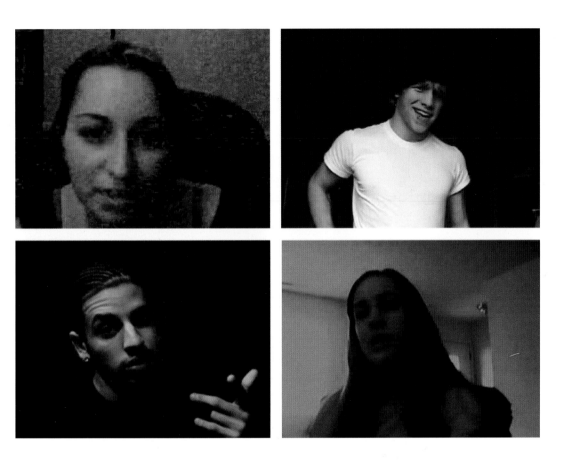

Guthrie Lonergan, *Myspace Intro Playlist*, 2006.
2-channel digital video, sound,
8 min; 13 min

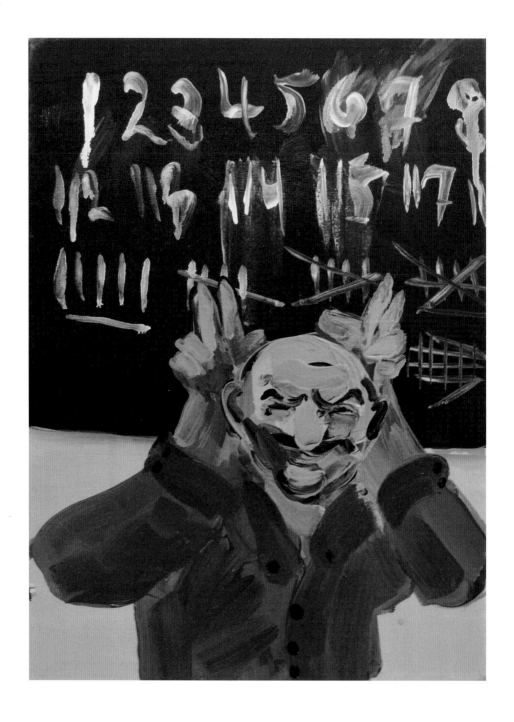

Tala Madani, *Lesson Two*, 2008.
Oil on linen,
14 x 10 in (35.6 x 25.4 cm)
Courtesy the artist and Lombard Freid Projects, New York

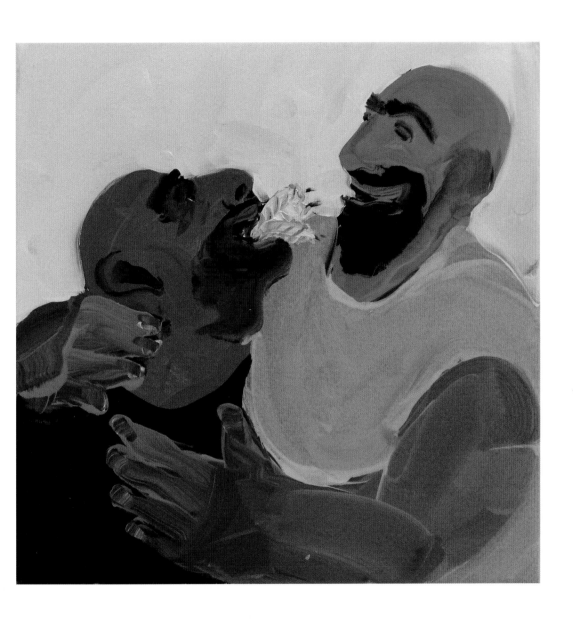

Tala Madani, *Hug*, 2008.
Oil on canvas,
11 3/4 x 11 3/4 in (29.8 x 29.8 cm)
Collection Marcia Eitelberg

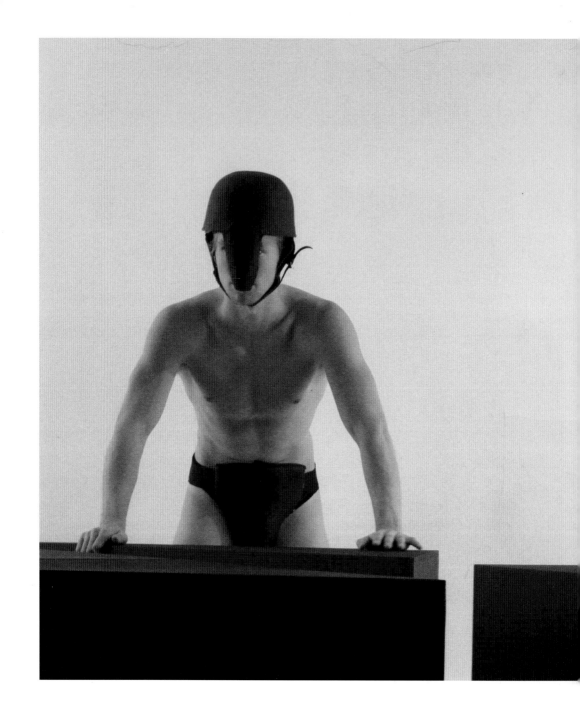

Anna Molska, *Tanagram*, 2006–07.
Digital video, black and white, sound,
5:10 min.
Courtesy Foksal Gallery Foundation, Warsaw

Ciprian Muresan, *Choose*, 2005.
Video, 0:50 min.
Courtesy the artist, Nicodim Gallery,
Los Angeles, and Plan B Gallery, Cluj-Napoca, Romania

Ciprian Muresan, *Stanca*, 2006.
Video, 0:17 min.
Courtesy the artist, Nicodim Gallery, Los Angeles,
and Plan B Gallery, Cluj-Napoca, Romania

136

Ahmet Öğüt, *Death Kit Train*, 2005.
Video on DVD, 2:57 min.
Courtesy the artist

Adam Pendleton, *Black Dada (LK/DDA)*, 2008.
Silkscreen on canvas, 74 x 47 in (119.4 x 188 cm) each, 74 x 95 in (241.3 x 188 cm)
overall (diptych).
Courtesy the artist and Haunch of Venison, New York
(Detail)

Adam Pendleton, clockwise from left:
Black Dada (L/DAA), Black Dada (LK/DDA), Black Dada (LC/AK/AA), 2008.
Silkscreen on canvas, 74 x 47 in (188 x 121.2 cm) (each diptych)
Courtesy the artist and Haunch of Venison, New York

Stephen G. Rhodes, *Your shit is in my mouth*, 2001.
Chromogenic print, 30 x 24 in (76.2 x 61 cm).
Courtesy Overduin and Kite, Los Angeles

Stephen G. Rhodes, *Excerpt (Bush Brooms)*, 2007.
Framed chromogenic print with spray paint, 24 x 30 in (61 x 76.2 cm).
Courtesy Overduin and Kite, Los Angeles

141

James Richards, *Untitled Merchandise (Trade Urn)*, 2008.
Laser etched pewter urn with fake suede sports bag
11 x 6 x 6 in (28 x 15 x 15 cm).

James Richards, *Untitled Merchandise (Trade Urn)*, 2008.
Laser etched pewter urn with fake suede sports bag
11 x 6 x 6 in (28 x 15 x 15 cm).

Emily Roysdon, *Four Screens as Dialogue*
(pioneering, devotional, familiar, invasive), 2008.
Ambrusted mesh, wood frames, and wheels
10 x 6 ft (305 x 183 cm) and 10 x 10 ft (305 x 305 cm) (each),
performance duration variable.
Courtesy the artist.
Support provided by Big Image Systems

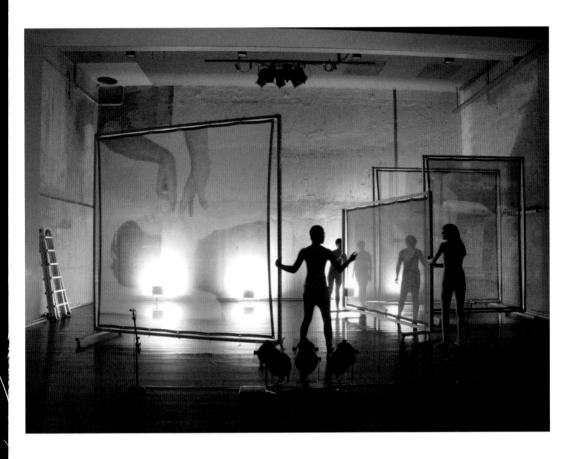

Emily Roysdon, performance still, *Four Screens as Dialogue*
(pioneering, devotional, familiar, invasive), 2008.
Ambrusted mesh, wood frames, and wheels
10 x 6 ft (305 x 183 cm) and 10 x 10 ft (305 x 305 cm) (each),
performance duration variable.
Courtesy the artist.
Support provided by Big Image Systems

Kateřina Šedá, *Her Mistress's Everything*, 2008.
Video, 18:05 min
Courtesy the artist and Franco Soffiantino Gallery, Turin

Kateřina Šedá, *Her Mistress's Everything*, 2008.
Video, 18:05 min
Courtesy the artist and Franco Soffiantino Gallery, Turin

Josh Smith, *Untitled (JSC07346)*, 2007.
Pasted papers, ink, and paint on panel, 48 x 36 in (122 x 91.4 cm).
Courtesy the artist and Luhring Augustine, New York

Josh Smith, *Untitled (JSC08060)*, 2008.
Pasted papers, ink, and paint on panel, 60 x 48 in (152.4 x 122 cm).
Courtesy the artist and Luhring Augustine, New York

149

Ryan Trecartin, *Not Yet Titled*, 2009.
Video, color, sound, approx. 45 min
Courtesy the artist and Elisabeth Dee, New York
The Fabric Workshop and Museum, Philadelphia
Goetz Collection, Munich
The Moore Space–Craig Robins, Rosa de la Cruz
and Silvia Cabiña, Miami

Alexander Ugay, *Untitled* from the "Workers 24 Hours" series, 2008.
Gelatin silver prints, 19 3/4 x 23 1/2 in (50 x 60 cm)

Alexander Ugay, *Untitled* from the "Workers 24 Hours" series, 2008.
Gelatin silver prints, 19 3/4 x 23 1/2 in (50 x 60 cm)

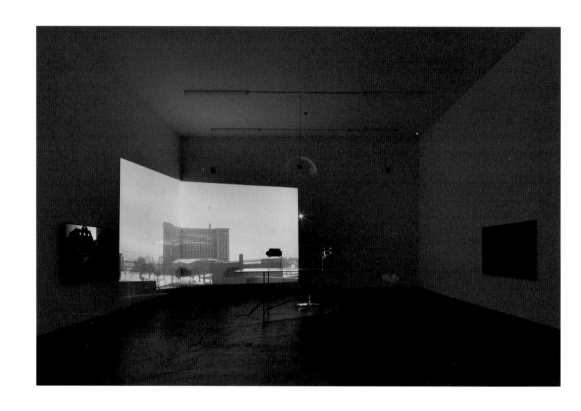

Tris Vonna-Michell, *Seizure*, 2004–08. Installation, dimensions variable.
Installation view Kunsthalle Zürich

154

Tris Vonna-Michell, < >> , 2008.
Mixed mediums, dimensions variable.
Installation view, Cabinet, London, 2008

156

Jakub Julian Ziolkowski, *U-Boot Wachoffizer*, 2007.
Oil on canvas,
8 1/2 x 18 1/8 (21.5 x 46 cm)
Hort Family Collection, New York

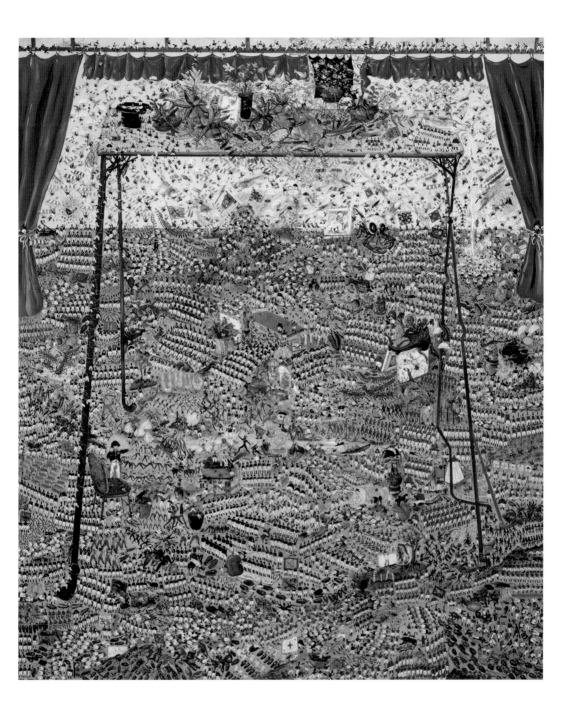

Jakub Julian Ziolkowski, *The Great Battle Under the Table*, 2006.

Oil on canvas,

74 x 65 in (190 x 165 cm)

Zabludowicz Collection

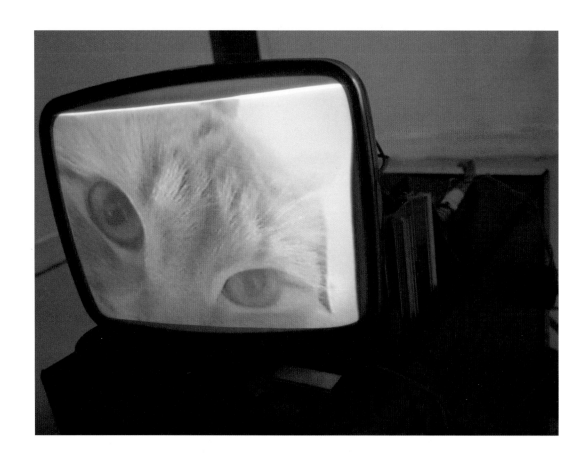

Icaro Zorbar, *nuestra mascota/our pet*, 2005.
7-inch television and digital video,
2 min, 8 x 8 x 10 in (20.3 x 20.3 x 25.4 cm)

Icaro Zorbar, *poco a poco/little by little*, 2006.
2 turntables, disc, and amplifiers,
43 x 27 x 17 in (109.2 x 68.6 x 43.2 cm)

The Generations

Tauba Auerbach,
Crumple I, 2008.
Acrylic on canvas,
80 x 60 in (203.2 x 152.4 cm)
Courtesy Deitch Projects, New York
(Detail)

The Sociological Problem of Generations

Karl Mannheim

The problem of generations is important enough to merit serious consideration. It is one of the indispensable guides to an understanding of the structure of social and intellectual movements. Its practical importance becomes clear as soon as one tries to obtain a more exact understanding of the accelerated pace of social change characteristic of our time. It would be regrettable if extra-scientific methods were permanently to conceal elements of the problem capable of immediate investigation.

It is clear from the foregoing survey of the problem as it stands today that a commonly accepted approach to it does not exist. The social sciences in various countries only sporadically take account of the achievements of their neighbors. In particular, German research into the problem of generations has ignored results obtained abroad. Moreover, the problem has been tackled by specialists in many different sciences in succession; thus, we possess a number of interesting sidelights on the problem as well as contributions to an overall solution, but no consciously directed research on the basis of a clear formulation of the problem as a whole.

The multiplicity of points of view, resulting both from the peculiarities of the intellectual traditions of various nations and from those of the individual sciences, is both attractive and fruitful; and there can be no doubt that such a wide problem can only be solved as a result of cooperation between the most diverse disciplines and nationalities. However, the cooperation must somehow be planned and directed from an organic center. The present status of the problem of generations thus affords a striking illustration of the anarchy in the social and cultural sciences, where everyone starts out afresh from his own point of view (to a certain extent, of course, this is both necessary and fruitful), never pausing to consider the various aspects as part of a single general problem, so that the contributions of the various disciplines to the collective solution could be planned.

163

Any attempt at over-organization of the social and cultural sciences is naturally undesirable: But it is at least worth considering whether there is not perhaps one discipline–according to the nature of the problem in question–that could act as the organizing center for work on it by all the others. As far as generations are concerned, the task of sketching the layout of the problem undoubtedly falls to sociology. It seems to be the task of *Formal Sociology* to work out the simplest, but at the same time the most fundamental facts relating to the phenomenon of generations. Within the sphere of formal sociology, however, the problem lies on the borderline between the static and the dynamic types of investigation. Whereas formal sociology up to now has tended for the most part to study the social existence of man exclusively *statically*, this particular problem seems to be one of those which have to do with the ascertainment of the origin of social dynamism and of the laws governing the action of the dynamic components of the social process. Accordingly, this is the point where we have to make the transition from the formal static to the formal dynamic and from thence to applied historical sociology–all three together comprising the complete field of sociological research.

In the succeeding pages we shall attempt to work out in formal sociological terms all the most elementary facts regarding the phenomenon of generations, without the elucidation of which historical research into the problem cannot even begin. We shall try to incorporate any results of past investigations, which have proved themselves relevant, ignoring those that do not seem to be sufficiently well founded.

1 Concrete Group–Social Location (Lagerung)

To obtain a clear idea of the basic structure of the phenomenon of generations, we must clarify the specific interrelations of the individuals comprising a single generation unit.

The unity of a generation does not consist primarily in a social bond of the kind that leads to the formation of a concrete group, although it may sometimes happen that a feeling for the unity of a generation is consciously developed into a basis for the formation of concrete groups, as in the case of the modern German Youth Movement.[1] But in this case, the groups are most often mere cliques, with the one distinguishing characteristic that group formation is based upon the consciousness of belonging to one generation, rather than upon definite objectives.

Apart from such a particular case, however, it is possible in general to draw a distinction between generations as mere collective facts on the one hand, and *concrete social groups* on the other.

Organizations for specific purposes, the family, tribe, sect, are all examples of such *concrete groups*. Their common characteristic is that the individuals of which they are composed do actually *in concrete* form a group, whether the entity is based on vital, existential ties of "proximity" or on the conscious application of the rational will. All "community" groups (*Gemeinschaftsgebilde*), such as the family and the tribe, come under the former heading, while the latter comprises "association" groups (*Gesellschaftsgebilde*).

The generation is not a concrete group in the sense of a community, i.e. a group which cannot exist without its members having concrete knowledge of each other, and which ceases to exist as a mental and spiritual unit as soon as physical proximity is destroyed. On the other hand, it is in no way comparable to associations such as organizations formed for a specific purpose, for the latter are characterized by a deliberate act of foundation, written statutes, and a machinery for dissolving the organization–features serving to hold the group together, even though it lacks the ties of spatial proximity and of community of life.

By a concrete group, then, we mean the union of a number of individuals through naturally developed or consciously willed ties.

Although the members of a generation are undoubtedly bound together in certain ways, the ties between them have not resulted in a concrete group. How, then, can we define and understand the nature of the generation as a social phenomenon?

An answer may perhaps be found if we reflect upon the character of a different sort of social category, materially quite unlike the generation but bearing a certain structural resemblance to it—namely, the class position (*Klassenlage*) of an individual in society.

In its wider sense class position can be defined as the common "location" (*Lagerung*) certain individuals hold in the economic and power structure of a given society as their "lot." One is proletarian, *entrepreneur*, or *rentier*, and he is what he is because he is constantly aware of the nature of his specific "location" in the social structure, i.e. of the pressures or possibilities of gain resulting from that position. This place in society does not resemble membership of an organization terminable by a conscious act of will. Nor is it at all binding in the same way as membership of a community (*Gemeinschaft*), which means that a concrete group affects every aspect of an individual's existence.

It is possible to abandon one's class position through an individual or collective rise or fall in the social scale, irrespective for the moment whether this is due to personal merit, personal effort, social upheaval, or mere chance.

Membership of an organization lapses as soon as we give notice of our intention to leave it; the cohesion of the community group *ceases to exist* if the mental and spiritual dispositions on which its existence has been based cease to operate in us or in our partners; and our previous class position loses its relevance for us as soon as we acquire a new position as a result of a change in our economic and power status.

Class position is an objective fact, whether the individual in question **166** knows his class position or not, and whether he acknowledges it or not.

Class consciousness does not necessarily accompany a class position, although in certain social conditions the latter can give rise to the former, lending it certain features, and resulting in the formation of a "conscious class."[2] At the moment, however, we are only interested in the general phenomenon of social *location* as such. Besides the concrete social group, there is also the phenomenon of similar location of a number of individuals in a social structure–under which heading both classes and generations fall.

We have now taken the first step towards an analysis of the "location" phenomenon as distinct from the phenomenon "*concrete group*," and this much at any rate is clear–*viz.* the unity of generations is constituted essentially by a similarity of location of a number of individuals within a social whole.

2 The Biological and Sociological Formulation of the Problem of Generations

Similarity of location can be defined only by specifying the structure within which and through which location groups emerge in historical-social reality. Class position was based upon the existence of a changing economic and power structure in society. Generation location is based on the existence of biological rhythm in human existence–the factors of life and death, a limited span of life, and aging. Individuals who belong to the same generation, who share the same year of birth, are endowed, to that extent, with a common location in the historical dimension of the social process.

Now, one might assume that the sociological phenomenon of location can be explained by, and deduced from, these basic biological factors. But this would be to make the mistake of all naturalistic theories which try to deduce sociological phenomena directly from natural facts, or lose sight of the social phenomenon altogether in a mass of primarily anthropological data. **167**

Anthropology and biology only help us explain the phenomena of life and death, the limited span of life, and the mental, spiritual, and physical changes accompanying aging as such; they offer no explanation of the relevance these primary factors have for the shaping of social interrelationships in their historic flux.

The sociological phenomenon of generations is ultimately based on the biological rhythm of birth and death. But to be *based* on a factor does not necessarily mean to be *deducible* from it, or to be implied in it. If a phenomenon is *based* on another, it could not exist without the latter; however, it possesses certain characteristics peculiar to itself; characteristics in no way borrowed from the basic phenomenon. Were it not for the existence of social interaction between human beings—were there no definable social structure, no history based on a particular sort of continuity, the generation would not exist as a social location phenomenon; there would merely be birth, aging, and death. The *sociological* problem of generations therefore begins at that point where the sociological relevance of these biological factors is discovered. Starting with the elementary phenomenon itself, then, we must first of all try to understand the generation as a particular type of social location.

3 The Tendency "Inherent In" a Social Location

The fact of belonging to the same class, and that of belonging to the same generation or age group, have this in common, that both endow the individuals sharing in them with a common location in the social and historical process, and thereby limit them to a specific range of potential experience, predisposing them for a certain characteristic mode of thought and experience, and a characteristic type of historically relevant action. Any given location, then, excludes a

large number of possible modes of thought, experience, feeling, and

action, and restricts the range of self-expression open to the individual to certain circumscribed possibilities. This *negative* delimitation, however, does not exhaust the matter. Inherent in a *positive* sense in every location is a tendency pointing towards certain definite modes of behavior, feeling, and thought.

We shall therefore speak in this sense of a tendency "inherent in" every social location; a tendency which can be determined from the particular nature of the location as such.

For any group of individuals sharing the same class position, society always appears under the same aspect, familiarized by constantly repeated experience. It may be said in general that the experiential, intellectual, and emotional data that are available to the members of a certain society are not uniformly "given" to all of them; the fact is rather that each class has access to only one set of those data, restricted to one particular "aspect." Thus, the proletarian most probably appropriates only a fraction of the cultural heritage of his society, and that in the manner of his group. Even a mental climate as rigorously uniform as that of the Catholic Middle Ages presented itself differently according to whether one were a theologizing cleric, a knight, or a monk. But even where the intellectual material is more or less uniform or at least uniformly accessible to all, the *approach*, to the material, the way in which it is assimilated and applied, is determined in its direction by social factors. We usually say in such cases that the approach is determined by the special traditions of the social stratum concerned. But these traditions themselves are explicable and understandable not only in terms of the history of the stratum but above all in terms of the location of relationships of its members within the society. Traditions bearing in a particular direction only persist so long as the location relationships of the group acknowledging them remain more or less unchanged. The concrete form of an existing behavior pattern or of a cultural product does not derive from the history **169**

of a particular tradition but ultimately from the history of the location relation-
ships in which it originally arose and hardened itself into a tradition.

4 Fundamental Facts in Relation to Generations

According to what we have said so far, the social phenomenon "generation" rep-
resents nothing more than a particular kind of identity of location, embracing
related "age groups" embedded in a historical-social process. While the nature
of class location can be explained in terms of economic and social conditions,
generation location is determined by the way in which certain patterns of expe-
rience and thought tend to be brought into existence by the *natural data* of the
transition from one generation to another.

The best way to appreciate which features of social life result from the exis-
tence of generations is to make the experiment of imagining what the social life
of man would be like if one generation lived on forever and none followed to
replace it. In contrast to such a Utopian, imaginary society, our own has the fol-
lowing characteristics:[3]

(a) New participants in the cultural process are emerging, whilst
(b) Former participants in that process are continually disappearing;
(c) Members of any one generation can participate only in a temporally
 limited section of the historical process, and
(d) It is therefore necessary continually to transmit the accumulated
 cultural heritage;
(e) The transition from generation to generation is a continuous process.

170

These are the basic phenomena implied by the mere fact of the existence of generations, apart from one specific phenomenon we choose to ignore for the moment, that of physical and mental aging.[4] With this as a beginning, let us then investigate the bearing of these elementary facts upon formal sociology.

(a) The continuous emergence of new participants in the cultural process

In contrast to the imaginary society with no generations, our own–in which generation follows generation–is principally characterized by the fact that cultural creation and cultural accumulation are not accomplished by the same individuals–instead, we have the continuous emergence of new age groups.

This means, in the first place, that our culture is developed by individuals who come into contact anew with the accumulated heritage. In the nature of our psychical makeup, a fresh contact (meeting something anew) always means a changed relationship of distance from the object and a novel approach in assimilating, using, and developing the proffered material. The phenomenon of "fresh contact" is, incidentally, of great significance in many social contexts; the problem of generations is only one among those upon which it has a bearing. Fresh contacts play an important part in the life of the individual when he is forced by events to leave his own social group and enter a new one–when, for example, an adolescent leaves home, or a peasant the countryside for the town, or when an emigrant changes his home, or a social climber his social status or class. It is well known that in all these cases a quite visible and striking transformation of the consciousness of the individual in question takes place: a change, not merely in the content of experience, but in the individual's mental and spiritual adjustment to it. In all these cases, however, the fresh contact is an event in one individual biography, whereas in the case of generations, **171**

we may speak of "fresh contacts" in the sense of the addition of new psychophysical units who are in the literal sense beginning a "new life." Whereas the adolescent, peasant, emigrant, and social climber can only in a more or less restricted sense be said to begin a "new life," in the case of generations, the "fresh contact" with the social and cultural heritage is determined not by mere social change, but by fundamental biological factors. We can accordingly differentiate between two types of "fresh contact": one based on a shift in social relations, and the other on vital factors (the change from one generation to another). The latter type is *potentially* much more radical, since with the advent of the new participant in the process of culture, the change of attitude takes place in a different individual whose attitude towards the heritage handed down by his predecessors is a novel one.

Were there no change of generation, there would be no "fresh contact" of this biological type. If the cultural process were always carried on and developed by the same individuals, then, to be sure, "fresh contacts" might still result from shifts in social relationships, but the more radical form of "fresh contact" would be missing. Once established, any fundamental social pattern (attitude or intellectual trend) would probably be perpetuated—in itself an advantage, but not if we consider the dangers resulting from one-sidedness. There might be a certain compensation for the loss of fresh generations in such a Utopian society only if the people living in it were possessed, as befits the denizens of a Utopia, of perfectly universal minds—minds capable of experiencing all that there was to experience and of knowing all there was to know, and enjoying an elasticity such as to make it possible at any time to start afresh. "Fresh contacts" resulting from shifts in the historical and social situation could suffice to bring about the changes in thought and practice necessitated by changed conditions only if the individuals experiencing these fresh contacts had such a

perfect "elasticity of mind." Thus the continuous emergence of new human beings in our own society acts as compensation for the restricted and partial nature of the individual consciousness. The continuous emergence of new human beings certainly results in some loss of accumulated cultural possessions; but, on the other hand, it alone makes a fresh selection possible when it becomes necessary; it facilitates re-evaluation of our inventory and teaches us both to forget that which is no longer useful and to covet that which has yet to be won.

(b) The continuous withdrawal of previous participants in the process of culture

The function of this second factor is implied in what has already been said. It serves the necessary social purpose of enabling us to forget. If society is to continue, social remembering is just as important as forgetting and action starting from scratch.

At this point we must make clear in what social form remembering manifests itself and how the cultural heritage is actually accumulated. All psychic and cultural data only really exist insofar as they are produced and reproduced in the present: Hence past experience is only relevant when it exists concretely incorporated in the present. In our present context, we have to consider two ways in which past experience can be incorporated in the present:

(1) As consciously recognized model[5] on which men pattern their behavior (for example, the majority of subsequent revolutions tended to model themselves more or less consciously on the French Revolution); or

(2) As unconsciously "condensed," merely "implicit" or "virtual" patterns; consider, for instance, how past experiences are "virtually" contained in such specific manifestations as that of sentimentality. Every present performance operates a certain selection among handed-down data, for **173**

the most part unconsciously. That is, the traditional material is transformed to fit a prevailing new situation, or hitherto unnoticed or neglected potentialities inherent in that material are discovered in the course of developing new patterns of action.[6]

At the more primitive levels of social life, we mostly encounter unconscious selection. There the past tends to be present in a "condensed," "implicit," and "virtual" form only. Even at the present level of social reality, we see this unconscious selection at work in the deeper regions of our intellectual and spiritual lives, where the tempo of transformation is of less significance. A conscious and reflective selection becomes necessary only when a semi-conscious transformation, such as can be affected by the traditionalist mind, is no longer sufficient. In general, rational elucidation and reflectiveness invade only those realms of experience that become problematic as a result of a change in the historical and social situation; where that is the case, the necessary transformation can no longer be effected without conscious reflection and its technique of destabilization.

We are directly aware primarily of those aspects of our culture that have become subject to reflection; and these contain only those elements, which in the course of development have somehow, at some point, become problematical. This is not to say, however, that once having become conscious and reflective, they cannot again sink back into the unproblematic, untouched region of vegetative life. In any case, that form of memory which contains the past in the form of reflection is much less significant–e.g. it extends over a much more restricted range of experience–than that in which the past is only "implicitly," "virtually" present; and reflective elements are more often dependent on unreflective elements than vice versa.

Here we must make a fundamental distinction between appropriated memories and *personally acquired* memories (a distinction applicable

174

both to reflective and unreflective elements). It makes a great difference whether I acquire memories for myself in the process of personal development, or whether I simply take them over from someone else. I only really possess those "memories" that I have created directly for myself, only that "knowledge" I have personally gained in real situations. This is the only sort of knowledge, which really "sticks," and it alone has real binding power. Hence, although it would appear desirable that man's spiritual and intellectual possessions should consist of nothing but individually acquired memories; this would also involve the danger that the earlier ways of possession and acquisition will inhibit the new acquisition of knowledge. That experience goes with age is in many ways an advantage. That, on the other hand, youth lacks experience means a lightening of the ballast for the young; it facilitates their living on in a changing world: One is old primarily in so far as[7] he comes to live within a specific, individually acquired, framework of useable past experience, so that every new experience has its form and its place largely marked out for it in advance, In youth, on the other hand, where life is new, formative forces are just coming into being, and basic attitudes in the process of development can take advantage of the molding power of new situations. Thus a human race living on forever would have to learn to forget to compensate for the lack of new generations.

(c) Members of any one generation can only participate in a temporally limited section of the historical process.

The implications of this basic fact can also be worked out in the light of what has been said so far. The first two factors, (a) and (b), were only concerned with the aspects of constant "rejuvenation" of society. To be able to start afresh with a new life, to build a new destiny, a new framework of an- **175**

ticipations, upon a new set of experiences, are things that can come into the world only through the fact of new birth. All this is implied by the factor of social rejuvenation. The factor we are dealing with now, however, can be adequately analyzed only in terms of the category of "similarity of location," which we have mentioned but not discussed in detail above.[8]

Members of a generation are "similarly located," first of all, in so far as they all are exposed to the same phase of the collective process. This, however, is a merely mechanical and external criterion of the phenomenon of "similar location." For a deeper understanding, we must turn to the phenomenon of the "stratification" of experience (*Erlebnisschichtung*), just as before we turned to "memory." The fact that people are born at the same time, or that their youth, adulthood, and old age coincide, does not in itself involve similarity of location; what does create a similar location is that they are in a position to experience the same events and data, etc., and especially that these experiences impinge upon a similarly "stratified" consciousness. It is not difficult to see why mere chronological contemporaneity cannot of itself produce a common generation location. No one, for example, would assert that there was community of location between the young people of China and Germany about 1800. Only where contemporaries definitely are in a position to participate as an integrated group in certain common experiences can we rightly speak of community of location of a generation. Mere contemporaneity becomes sociologically significant only when it also involves participation in the same historical and social circumstances. Further, we have to take into consideration at this point the phenomenon of "stratification," mentioned above. Some older generation groups experience certain historical processes together with the young generation and yet we cannot say that they have the same generation location. The fact that their location is a different one, however, can be explained primarily

176

by the different "stratification" of their lives. The human consciousness, structurally speaking, is characterized by a particular inner "dialectic." It is of considerable importance for the formation of the consciousness which experiences happen to make those all-important "first impressions," "childhood experiences"—and which follow to form the second, third, and other "strata." Conversely, in estimating the biographical significance of a particular experience, it is important to know whether it is undergone by an individual as a decisive childhood experience, or later in life, superimposed upon other basic and early impressions. Early impressions tend to coalesce into a *natural view* of the world. All later experiences then tend to receive their meaning from this original set, whether they appear as that set's verification and fulfillment or as its negation and antithesis. Experiences are not accumulated in the course of a lifetime through a process of summation or agglomerations, but are "dialectically" articulated in the way described. We cannot here analyze the specific forms of this dialectical articulation, which is potentially present whenever we act, think, or feel, in more detail (the relationship of "antithesis" is only one way in which new experiences may graft themselves upon old ones). This much, however, is certain, that even if the rest of one's life consisted in one long process of negation and destruction of the natural worldview acquired in youth, the determining influence of these early impressions would still be predominant. For even in negation our orientation is fundamentally centered upon that which is being negated, and we are thus still unwittingly determined by it. If we bear in mind that every concrete experience acquires its particular face and form from its relation to this primary stratum of experiences from which all others receive their meaning, we can appreciate its importance for the further development of the human consciousness. Another fact, closely related to the phenomenon just described, is that any two generations following one another **177**

always fight different opponents, both within and without. While the older people may still be combating something in themselves or in the external world in such fashion that all their feelings and efforts and even their concepts and categories of thought are determined by that adversary, for the younger people this adversary may be simply nonexistent: Their primary orientation is an entirely different one. That historical development does not proceed in a straight line—a feature frequently observed particularly in the cultural sphere—is largely attributed to this shifting of the "polar" components of life, that is, to the fact that internal or external adversaries constantly disappear and are replaced by others. Now this particular dialectic, of changing generations, would be absent from our imaginary society. The only dialectical features of such a society would be those that would arise from social polarities—provided such polarities were present. The primary experiential stratum of the members of this imaginary society would simply consist of the earliest experiences of mankind; all later experience would receive its meaning from that stratum.

(d) The necessity for constant transmission of the cultural heritage

Some structural facts, which follow from this, must at least be indicated here. To mention one problem only: A Utopian, immortal society would not have to face this necessity of cultural transmission, the most important aspect of which is the automatic passing on to the new generations of the traditional ways of life, feelings, and attitudes. The data transmitted by conscious teaching are of more limited importance, both quantitatively and qualitatively. All those attitudes and ideas that go on functioning satisfactorily in the new situation and serve as the basic inventory of group life are unconsciously and unwittingly handed on and transmitted: They seep in without either the teacher or

pupil knowing anything about it. What is consciously learned or inculcated belongs to those things, which in the course of time have somehow, somewhere, become problematic and therefore invited conscious reflection. This is why that inventory of experience which is absorbed by infiltration from the environment in early youth often becomes the historically oldest stratum of consciousness, which tends to stabilize itself as the natural view of the world.[9]

But in early childhood even many reflective elements are assimilated in the same "unproblematic" fashion as those elements of the basic inventory had been. The new germ of an original intellectual and spiritual life which is latent in the new human being has by no means as yet come into its own, The possibility of really questioning and reflecting on things only emerges at the point where personal experimentation with life begins—round about the age of seventeen, sometimes a little earlier and sometimes a little later.[10] It is only then that life's problems begin to be located in a "present" and are experienced as such. That level of data and attitudes which social change has rendered problematical, and which therefore requires reflection, has now been reached; for the first time, one lives "in the present." Combative juvenile groups struggle to clarify these issues, but never realize that, however radical they are, they are merely out to transform the uppermost stratum of consciousness which is open to conscious reflection. For it seems that the deeper strata are not easily stabilized[11] and that when this becomes necessary, the process must start out from the level of reflection and work down to the stratum of habits.[12] The "up-to-dateness" of youth therefore consists in their being closer to the "present" problems (as a result of their "potentially fresh contact" discussed above), and in the fact that they are dramatically aware of a process of destabilization and take sides in it. All this while, the older generation cling to the reorientation that had been the drama of their youth. **179**

From this angle, we can see that an adequate education or instruction of the young (in the sense of the complete transmission of all experiential stimuli which underlie pragmatic knowledge) would encounter a formidable difficulty in the fact that the experiential problems of the young are defined by a different set of adversaries from those of their teachers. Thus (apart from the exact sciences), the teacher-pupil relationship is not as between one representative of "consciousness in general" and another, but as between one possible subjective center of vital orientation and another subsequent one. This tension[13] appears incapable of solution except for one compensating factor: not only does the teacher educate his pupil, but the pupil educates his teacher too. Generations are in a state of constant interaction. This leads us to our next point:

(c) The uninterrupted generation series.

The fact that the transition from one generation to another takes place continuously tends to render this interaction smoother; in the process of this interaction, it is not the oldest who meet the youngest at once; the first contacts are made by other "intermediary" generations, less removed from each other. Fortunately, it is not as most students of the generation problem suggest–the thirty-year interval is not solely decisive. Actually, all intermediary groups play their part; although they cannot wipe out the biological difference between generations, they can at least mitigate its consequences. The extent to which the problems of younger generations are reflected back upon the older one becomes greater in the measure that the dynamism of society increases. Static conditions make for attitudes of piety–the younger generation tends to adapt itself to the older, even to the point of making itself appear older. With the strengthening of the social dynamic, however, the older generation

180

becomes increasingly receptive to influences from the younger.[14] This process can be so intensified that, with an elasticity of mind won in the course of experience, the older generation may even achieve greater adaptability in certain spheres than the intermediary generations, who may not yet be in a position to relinquish their original approach. [15]

Thus, the continuous shift in objective conditions has its counterpart in a continuous shift in the oncoming new generations, which are first to incorporate the changes in their behavior system. As the tempo of change becomes faster, smaller and smaller modifications are experienced by young people as significant ones, and more and more intermediary shades of novel impulses become interpolated between the oldest and newest reorientation systems. The underlying inventory of vital responses, which remains unaffected by the change, acts in itself as a unifying factor; constant interaction, on the other hand, mitigates the differences in the top layer where the change takes place, while the continuous nature of the transition in normal times lessens the frictions involved. To sum up: If the social process involved no change of generations, the new impulses that can originate only in new organisms could not be reflected hack upon the representatives of the tradition; and if the transition between generations were not continuous, this reciprocal action could not take place without friction.

5 *Generation Status, Generation as Actuality, Generation Unit*

This, then, broadly constitutes those aspects of generation phenomena, which can be deduced by formal analysis. They would completely determine the effects resulting from the existence of generations if they could unfold themselves in a purely biological context, or if the generation phenomenon **181**

could be understood as a mere location phenomenon. However, a generation in the sense of a location phenomenon falls short of encompassing the generation phenomenon in its full actuality.[16] The latter is something more than the former, in the same way as the mere fact of class position does not yet involve the existence of a consciously constituted class. The location as such only contains potentialities, which may materialize, or be suppressed, or become embedded in other social forces and manifest themselves in modified form. When we pointed out that mere co-existence in time did not even suffice to bring about community of generation location, we came very near to making the distinction, which is now claiming our attention. In order to share the same generation location, i.e. in order to be able passively to undergo or actively to use the handicaps and privileges inherent in a generation location, one must be born within the same historical and cultural region. Generation as an actuality, however, involves even more than mere co-presence in such a historical and social region. A further concrete nexus is needed to constitute generation as an actuality. This additional nexus may be described as *participation in the common destiny* of this historical and social unit.[17] This is the phenomenon we have to examine next.

We said above that, for example, young people in Prussia about 1800 did not share a common generation location with young people in China at the same period. Membership in the same historical community, then, is the widest criterion of community of generation location. But what is its narrowest criterion? Do we put the peasants, scattered as they are in remote districts and almost untouched by current upheavals, in a common actual generation group with the urban youth of the same period? Certainly not!–and precisely because they remain unaffected by the events which move the youth of the towns. We shall therefore speak of a *generation as an actuality* only where a concrete

182 bond is created between members of a generation by their being

exposed to the social and intellectual symptoms of a process of dynamic desta-bilization. Thus, the young peasants we mentioned above only share the same generation location, without, however, being members of the same generation as an actuality, with the youth of the town. They are similarly located, in so far as they are *potentially* capable of being sucked into the vortex of social change, and, in fact, this is what happened in the wars against Napoleon, which stirred up all German classes. For these peasants' sons, a mere generation location was transformed into membership of a generation as an actuality. Individuals of the same age, they were and are, however, only united as an actual generation in so far as they participate in the characteristic social and intellectual currents of their society and period, and in so far as they have an active or passive experi-ence of the interactions of forces, which made up the new situation. At the time of the wars against Napoleon, nearly all social strata were engaged in such a process of give and take, first in a wave of war enthusiasm, and later in a move-ment of religious revivalism. Here, however, a new question arises. Suppose we disregard all groups, which do *not* actively participate in the process of social transformation—does this mean that all those groups which *do* so participate, constitute one generation? From 1800 on, for instance, we see two contrasting groups—one that became more and more conservative as time went on, as against a youth group tending to become rationalistic and liberal. It cannot be said that these two groups were unified by the *same* modern mentality. Can we then speak, in this case, of the same actual generation? We can, it seems, if we make a further terminological distinction. Both the romantic-conservative and the liberal-rationalist youth belonged to the same actual generation, romantic-conservatism and liberal-rationalism were merely two polar forms of the intellec-tual and social response to an historical stimulus experienced by all in common. Romantic-conservative youth, and liberal-rationalist group **183**

belong to the same actual generation but form separate "generation units" within it. The *generation unit* represents a much more concrete bond than the actual generation as such. *Youth experiencing the same concrete historical problems may be said to be part of the same actual generation; while those groups within the same actual generation which work up the material of their common experiences in different specific ways, constitute separate generation units.*

6 The Origin of Generation Units

The question now arises, What produces a generation unit? In what does the greater intensity of the bond consist in this case? The first thing that strikes one on considering any particular generation unit is the great similarity in the data making up the consciousness of its members. Mental data are of sociological importance not only because of their actual content, but also because they cause the individuals sharing them to form one group—they have a socializing effect. The concept of freedom, for example, was important for the liberal generation unit, not merely because of the material demands implied by it, but also because in and through it was possible to unite individuals scattered spatially and otherwise.[18] The data as such, however, are not the primary factor producing a group—this function belongs to a far greater extent to those formative forces which shape the data and give them character and direction. From the casual slogan to a reasoned system of thought, from the apparently isolated gesture to the finished work of art, the same formative tendency is often at work—the social importance of which lies in its power to bind individuals socially together. The profound emotional significance of a slogan, of an expressive gesture, or of a

work of art lies in the fact that we not merely absorb them as objective

184 data, but also as vehicles of formative tendencies and fundamental

integrative attitudes, thus identifying ourselves with a set of collective strivings. Fundamental integrative attitudes and formative principles are all important also in the handing down of every tradition, firstly because they alone can bind groups together, and, secondly, what is perhaps even more important, they alone are really capable of becoming the basis of continuing practice. A mere statement of fact has a minimum capacity of initiating a continuing practice. Potentialities of a continued thought process, on the other hand, are contained in every thesis that has real group-forming potency; intuitions, feelings, and works of art which create a spiritual community among men also contain in themselves the potentially new manner in which the intuition, feeling, or work of art in question can be re-created, rejuvenated, and re-interpreted in novel situations. That is why unambiguousness, too great clarity is not an unqualified social value; productive misunderstanding is often a condition of continuing life. Fundamental integrative attitudes and formative principles are the primary socializing forces in the history of society, and it is necessary to live them fully in order really to participate in collective life.

Modern psychology provides more and more conclusive evidence in favor of the Gestalt theory of human perception: Even in our most elementary perceptions of objects, we do not behave as the old atomistic psychology would have us believe; that is, we do not proceed towards a global impression by the gradual summation of a number of elementary sense data, but on the contrary, we start off with a global impression of the object as a whole. Now if even sense perception is governed by the Gestalt principle, the same applies, to an even greater extent, to the process of intellectual interpretation. There may be a number of reasons why the functioning of human consciousness should be based on the Gestalt principle, but a likely factor is the relatively limited capacity of the human consciousness when confronted with the

infinity of elementary data which can be dealt with only by means of the simplifying and summarizing Gestalt approach. Seeing things in terms of Gestalt, however, also has its social roots with which we must deal here. Perceptions and their linguistic expressions never exist exclusively for the isolated individual who happens to entertain them, but also for the social group that stands behind the individual. Thus, the way in which seeing in terms of Gestalt modifies the datum as such—partly simplifying and abbreviating it, partly elaborating and filling it out—always corresponds to the meaning which the object in question has for the social groups as a whole. We always see things already formed in a special way; we think concepts defined in terms of a specific context. Form and context depend, in any case, on the group to which we belong. To become really assimilated into a group involves more than the mere acceptance of its characteristic values—it involves the ability to see things from its particular "aspect," to endow concepts with its particular shade of meaning, and to experience psychological and intellectual impulses in the configuration characteristic of the group. It means, further, to absorb those interpretive formative principles that enable the individual to deal with new impressions and events in a fashion broadly predetermined by the group.

The social importance of these formative and interpretive principles is that they form a link between spatially separated individuals who may never come into personal contact at all, Whereas mere common "location" in a generation is of only potential significance, a generation as an actuality is constituted when similarly "located" contemporaries participate in a common destiny and in the ideas and concepts which are in some way bound up with its un folding. Within this community of people with a common destiny there can then arise particular generation units. These are characterized by the fact that they do not merely involve a loose participation by a number of individuals in a

186

pattern of events shared by all alike though interpreted by the different individuals differently, but an identity of responses, a certain affinity in the way in which all move with and are formed by their common experiences.

Thus within any generation there can exist a number of differentiated, antagonistic generation units. Together they constitute an "actual" generation precisely because they are oriented toward each other, even though only in the sense of fighting one another. Those who were young about 1810 in Germany constituted one actual generation whether they adhered to the then current version of liberal or conservative ideas. But in so far as they were conservative or liberal, they belonged to different units of that actual generation.

The generation unit tends to impose a much more concrete and binding tie on its members because of the parallelism of responses it involves. As a matter of fact, such new, overtly created, partisan integrative attitudes characterizing generation units do not come into being spontaneously, without a personal contact among individuals, but within *concrete groups* where mutual stimulation in a close-knit vital unit inflames the participants and enables them to develop integrative attitudes that do justice to the requirements inherent in their common "location." Once developed in this way, however, these attitudes and formative tendencies are capable of being detached from the concrete groups of their origin and of exercising an appeal and binding force over a much wider area.

The generation unit as we have described it is not, as such, a concrete group, although it does have as its nucleus a concrete group that has developed the most essential new conceptions which are subsequently developed by the unit. Thus, for example, the set of basic ideas which became prevalent in the development of modern German Conservatism had its origin in the concrete association "*Christlich-deutsche Tischgesellschaft.*" This association was first to take up and reformulate all the irrational tendencies corresponding to the over-

all situation prevailing at that time, and to the particular "location," in terms of generation, shared by the young Conservatives. Ideas that later were to have recruiting power in far wider circles originated in this particular concrete group.

The reason for the influence exercised beyond the limits of the original concrete group by such integrative attitudes originally evolved within the group is primarily that they provide a more or less adequate expression of the particular "location" of a generation as a whole. Hence, individuals outside the narrow group but nevertheless similarly located find in them the satisfying expression of their location in the prevailing *historical configuration.* Class ideology, for example, originates in more closely knit concrete groups and can gain ground only to the extent that other individuals see in it a more or less adequate expression and interpretation of the experiences peculiar to their particular *social* location. Similarly, the basic integrative attitudes and formative principles represented by a generation unit, which are originally evolved within such a concrete group, are only really effective and capable of expansion into wider spheres when they formulate the typical experiences of the individuals sharing a generation location. Concrete groups can become influential in this sense if they succeed in evolving a "fresh contact" in terms of a "stratification of experience," such as we have described above. There is, in this respect, a further analogy between the phenomenon of class and that of generation. Just as a class ideology may, in epochs favorable to it, exercise an appeal beyond the "location" that is its proper habitat,[19] certain impulses particular to a generation may, if the trend of the times is favorable to them, also attract individual members of earlier or later age groups.

But this is not all; it occurs very frequently that the nucleus of attitudes particular to a new generation is first evolved and practiced by older people who are isolated in their own generation (forerunners),[20] just as it

is often the case that the forerunners in the development of a particular class ideology belong to a quite alien class.

All this, however, does not invalidate our thesis that there are new basic impulses attributable to a particular generation location that, then, may call forth generation units. The main thing in this respect is that the proper vehicle of these new impulses is always a collectivity. The real seat of the class ideology remains the class itself, with its own typical opportunities and handicaps—even when the author of the ideology, as it may happen, belongs to a different class, or when the ideology expands and becomes influential beyond the limits of the class location. Similarly, the real seat of new impulses remains the generation location (which will selectively encourage one form of experience and eliminate others), even when they may have been fostered by other age groups.

The most important point we have to notice is the following: Not every generation location—not even every age group—creates new collective impulses and formative principles original to itself and adequate to its particular situation. Where this does happen, we shall speak of a *realization of potentialities inherent* in the location, and it appears probable that the frequency of such realizations is closely connected with the tempo of social change.[21] When as a result of an acceleration in the tempo of social and cultural transformation basic attitudes must change so quickly that the latent, continuous adaptation and modification of traditional patterns of experience, thought, and expression is no longer possible, then the various new phases of experience are consolidated somewhere, forming a clearly distinguishable new impulse, and a new center of configuration. We speak in such cases of the formation of a new generation style, or of a new *generation entelechy*.

Here too, we may distinguish two possibilities. On the one hand, the generation unit may produce its work and deeds unconsciously **189**

out of the new impulse evolved by itself, having an intuitive awareness of its existence as a group but failing to realize the group's character as a generation unit. On the other hand, groups may consciously experience and emphasize their character as generation units—as is the case with the contemporary German youth movement, or even to a certain extent with its forerunner, the Student's Association (*Burschenschaft*) Movement in the first half of the nineteenth century, which already manifested many of the characteristics of the modern youth movement.

The importance of the acceleration of social change for the realization of the potentialities inherent in a generation location is clearly demonstrated by the fact that largely static or very slowly changing communities like the peasantry display no such phenomenon as new generation units sharply set off from their predecessors by virtue of an individual entelechy proper to them; in such communities, the tempo of change is so gradual that new generations evolve away from their predecessors without any visible break, and all we can see is the purely biological differentiation and affinity based upon difference or identity of age. Such biological factors are effective, of course, in modern society too, youth being attracted to youth and age to age. The generation unit as we have described it, however, could not arise solely on the basis of this simple factor of attraction between members of the same age group.

The quicker the tempo of social and cultural change is, then, the greater are the chances that particular generation location groups will react to changed situations by producing their own entelechy. On the other hand, it is conceivable that too greatly accelerated a tempo might lead to mutual destruction of the embryo entelechies. As contemporaries, we can observe, if we look closely, various finely graded patterns of response of age groups closely following upon each other and living side by side; these age groups, however, are so closely packed together that they do not succeed in achieving a fruitful

new formulation of distinct generation entelechies and formative principles, Such generations, frustrated in the production of an individual entelechy, tend to attach themselves, where possible, to an earlier generation which may have achieved a satisfactory form, or to a younger generation which is capable of evolving a newer form. Crucial group experiences can act in this way as "crystallizing agents," and it is characteristic of cultural life that unattached elements are always attracted to perfected configurations, even when the unformed, groping impulse differs in many respects from the configuration to which it is attracted. In this way the impulses and trends peculiar to a generation may remain concealed because of the existence of the clear-cut form of another generation to which they have become attached.

From all this emerges the fact that each generation need not evolve its own, distinctive pattern of interpreting and influencing the world; the rhythm of successive generation locations, which is largely based upon biological factors, need not necessarily involve a parallel rhythm of successive motivation patterns and formative principles. Most generation theories, however, have this in common, that they try to establish a direct correlation between waves of decisive year classes of birth—set at intervals of thirty years, and conceived in a purely naturalistic, quantifying spirit—on the one hand, and waves of cultural changes on the other. Thus they ignore the important fact that the realization of hidden potentialities inherent in the generation location is governed by extra-biological factors, principally, as we have seen, by the prevailing tempo and impact of social change.

Whether a new *generation style* emerges every year, every thirty, every hundred years, or whether it emerges rhythmically at all, depends entirely on the trigger action of the social and cultural process. One may ask, in this connection, whether the social dynamic operates predominantly through the agency of the economic or of one or the other "ideological" spheres:

But this is a problem which has to be examined separately. It is immaterial in our context how this question is answered; all we have to bear in mind is that it depends on this group of social and cultural factors whether the impulses of a generation shall achieve a distinctive unity of style, or whether they shall remain latent. The biological fact of the existence of generations merely provides the *possibility* that generation entelechies may emerge at all–if there were no different generations succeeding each other, we should never encounter the phenomenon of generation styles. But the question which generation locations will realize the potentialities inherent in them, finds its answer at the level of the social and cultural structure–a level regularly skipped by the usual kind of theory which starts from naturalism and then abruptly lands in the most extreme kind of spiritualism.

A formal sociological clarification of the distinction between the categories "generation location," "generation as actuality," and "generation unit," is important. And indeed indispensable for any deeper analysis, since we can never grasp the dominant factors in this field without making that distinction. If we speak simply of "generations" without any further differentiation, we risk jumbling together purely biological phenomena and others that are the product of social and cultural forces: Thus we arrive at a sort of sociology of chronological tables (*Geschichtstabellensoziologie*), which uses its bird's-eye perspective to "discover" fictitious generation movements to correspond to the crucial turning points in historical chronology.

It must be admitted that biological data constitute the most basic stratum of factors determining generation phenomena; but for this very reason, we cannot observe the effect of biological factors directly; we must, instead, see how they are reflected through the medium of social and cultural forces.

As a matter of fact, the most striking feature of the historical **192** process seems to be that the most basic biological factors operate in

the most latent form, and can only be grasped in the medium of the social and historical phenomena that constitute a secondary sphere above them. In practice this means that the student of the generation problem cannot try to specify the effects attributable to the factor of generations before he has separated all the effects due to the specific dynamism of the historical and social sphere. If this intermediary sphere is skipped, one will be tempted to resort immediately to naturalistic principles, such as generation, race, or geographical situation, in explaining phenomena due to environmental or temporal influences.

The fault of this naturalistic approach lays not so much in the fact that it emphasizes the role of natural factors in human life, as in its attempt to explain *dynamic* phenomena directly by something *constant*, thus ignoring and distorting precisely that intermediate sphere in which dynamism really originates. Dynamic factors operate on the basis of constant factors–on the basis of anthropological, geographical, etc., data–but on each occasion the dynamic factors seize upon different potentialities inherent in the constant factors. If we want to understand the primary, constant factors, we must observe them in the framework of the historical and social system of forces from which they receive their shape. Natural factors, including the succession of generations, provide the basic range of potentialities for the historical and social process. *But precisely because they are constant and therefore always present in any situation, the particular features of a given process of modification cannot be explained by reference to them.*

Their varying relevance (the particular way in which they can manifest themselves in this or that situation) can be clearly seen only if we pay proper attention to the formative layer of social and cultural forces.

From *Essays on the Sociology of Knowledge*, Karl Mannheim,

Copyright © 1998. Reproduced by permission of Taylor & Francis Books UK.

1 In this connection it would be desirable to work out the exact differences between modern youth movements and the age groups of men's societies formed amongst primitive people, carefully described by H. Schurtz.

2 It is a matter for historical and sociological research to discover at what stage in its development, and under what conditions, a class becomes class conscious, and similarly, when individual members of a generation become conscious of their common situation and make this consciousness the basis of their group solidarity. Why have generations become so conscious of their unity today? This is the first question we have to answer in this context.

3 Since actual experiments are precluded by the nature of the social sciences, such a "mental experiment" can often help to isolate the important factors.

4 See Spranger on "being young" and "becoming old," and the intellectual and spiritual significance of these phenomena. (He also gives references to other literature on the psychology of the adolescent–whereon see also Honigsheim). Further, see A. E. Brinckmann (who proceeds by way of interpretive analysis of works of art), Jacob Grimm, F. Ball, Giese. Literature relating to the youth movement constitutes a problem in itself.

5 This is not the place to enumerate all the many forms of social memory. We will therefore deliberately simplify the matter by limiting ourselves to two extreme alternatives. "Consciously recognized models" include, in the wider sense, also the body of global knowledge, stored in libraries. But this sort of knowledge is only effective in so far as it is continually actualized. This can happen in two ways–either intellectually, when it is used as a pattern or guide for action, or spontaneously, when it is "virtually present" as condensed experience. Instinct, as well as repressed and unconscious knowledge, as dealt with in particular by Freud, would need separate treatment.

6 This process of discovery of hidden possibilities inherent in transmitted material alone makes it clear why it is that so many revolutionary and reformist movements are able to graft their new truths on to old ones.

7 That is, if we ignore–as we said we would–the biological factors of physical and psychological aging.

8 It must be emphasized that this "ability to start afresh" of which we are speaking has nothing to do with "conservative" and "progressive" in the usual sense of these terms. Nothing is more false than the usual assumption uncritically shared by most students of generations, that the younger generation is "progressive" and the older generation *eo ipso* conservative. Recent experiences have shown well enough that the old liberal generation tends to be more politically progressive than certain sections of the youth (e.g. the German Students' Associations–*Burschenschaften*–etc.). "Conservative" and "progressive" are categories of historical sociology, designed to deal with the descriptive contents of the dynamism of a historical period of history, whereas "old" and "young" and the concept of the "fresh contact" of a generation are categories belonging to formal sociology. Whether youth will be conservative, reactionary, or progressive, depends (if not entirely, at least primarily) on whether or not the existing social structure and the position they occupy in it provide opportunities for the promotion of their own social and intellectual ends. Their "being young," the "freshness" of their contact with the world, manifest themselves in the fact that they are able to reorient any movement they embrace, to adopt it to the total situation. (Thus, for instance, they must seek within conservatism the particular form of this political and intellectual current best suited to the requirements of the modern situation; or within Socialism, in the same way, an up-to-date formulation.) This lends considerable support to the fundamental thesis of this essay, which will have to be further substantiated later–that biological factors (such as youth and age) do not of themselves involve a definite intellectual or practical orientation (youth cannot be automatically correlated with a progressive attitude and so on); they merely initiate certain formal tendencies, the actual manifestations of which will ultimately depend on the prevailing social and cultural context. Any attempt to establish a direct identity or correlation between biological and cultural data leads to a quid pro quo that can only confuse the issue.

9 It is difficult to decide just at what point this process is complete in an individual–at what point this unconscious vital inventory (which also contains the national and provincial peculiarities out of which national and provincial entelechies can develop) is stabilized. The process seems to stop once the inventory of unproblematic experience has virtually acquired its final form. The child or adolescent is always open to new influences if placed in a new milieu. They readily assimilate new unconscious mental attitudes and habits, and change their language or dialect. The adult, transferred into a new environment, consciously transforms certain aspects of his modes of thought and behavior, but never acclimatizes himself in so radical and thoroughgoing a fashion. His fundamental attitudes, his vital inventory, and, among external manifestations, his language and dialect, remain for the most part on an earlier level. It appears that language and accent offer an indirect indication as to how far the foundations of a person's consciousness are laid, his basic view of the world stabilized. If the point can be determined at which a man's language and dialect cease to change; there is at least an external criterion for the determination also of the point at which his unconscious inventory of experience ceases to accumulate. According to A. Millet, the spoken language and dialect does not change in an individual after the age of twenty-five years. (A. Millet: *Method dams les sciences*, Paris: Alcan, 1911; also his "*Introduction a lettuce comparative des langues indo-europiennes*" 1903, as quoted in Mentré.

10 Spranger also assumes an important turning point about the age of seventeen or so.

11 This throws some light on the way in which "ideas" appear to precede real social transformation. "Ideas" are understood here in the French rather than in the Platonic sense. This "modern

Idea" has a tendency to destabilize and set in motion the social structure. It does not exist in static social units—for example, in self-contained peasant communities—which tend to draw on an unconscious, traditional way of life. In such societies, we do not find the younger generation, associated with ideas of this kind, rising against their elders. "Being young" here is a question of biological differentiation. More on this matter later.

12 The following seems to be the sequence in which this process unfolds: First the "conditions" change. Then concrete behavior begins unconsciously to transform itself in the new situation. The individual seeks to react to the new situation, by instinctive, unconscious adjustment. (Even the most fanatical adherent of an orthodoxy constantly indulges in an adaptive change of his behavior in respects that are not open to conscious observation.) If the dynamic of the situation results in too quick cultural change and the upheaval is too great, if unconscious adjustment proves inadequate and behavior adaptations fail to "function" in the sudden new situation, so that an aspect of reality becomes problematic, then that aspect of reality will be made conscious—on the level of either mythology, philosophy, or science, according to the stage of cultural evolution reached. From this point on, the unraveling of the deeper layers proceeds, as required by the situation.

13 L. von Wiese gives a vivid description of this father-son antagonism. Of considerable importance is the suggestion that the father is more or less forced into the role of representing "Society" to his son.

14 It should be noted, on the other hand, as L. von Wiese points out, that with the modern trend towards individualism, every individual claims more than before the right to "live his own life."

15 This is a further proof that natural biological factors characteristic of old age can be invalidated by social forces, and that biological data can almost be turned into their opposites by social forces.

16 Up till now we have not differentiated between generation location, generation as actuality, etc. These distinctions will now be made.

17 Compare with Heidegger.

18 Mental data can both bind and differentiate socially. The same concept of Freedom, for example, had totally different meanings for the liberal and the conservative generation units. Thus, it is possible to obtain an indication of the extent to which a generation is divided into generation units by analyzing the different meanings given to a current idea. Cf. "Conservative Thought" (to follow in a later volume), where the conservative concept of Freedom is analyzed in contrast to the liberal concept current at the same time.

19 In the '40s in Germany, for example, when oppositional ideas were in vogue, young men of the nobility also shared them. Compare with Karl Marx. "Revolution and Counter-revolution in Germany" (German edition, Stuttgart, 1913).

20 For instance, Nietzsche may be considered the forerunner of the present neo-romanticism. An eminent example of the same thing in France is Taine, who under the influence of the events of 1870–71 turned towards patriotism, and so became the forerunner of a nationalistic generation. (Compare with Platz.) In such cases involving forerunners, it would be advisable to make individual case-analyses and establish in what respect the basic structure of experience in the forerunner differs from that of the new generation that actually starts at the point where the forerunner leaves off. In this connection, the history of German Conservatism contains an interesting example, i.e. that of the jurist Hugo, whom we may consider as the founder of the "historical school." Nevertheless, he never thought in *irrational* terms as did the members of the school (e.g. Savigny) in the next generation, which lived through the Napoleonic wars.

21 The speed of social change, for its part, is never influenced by the speed of the succession of generations, since this remains constant.

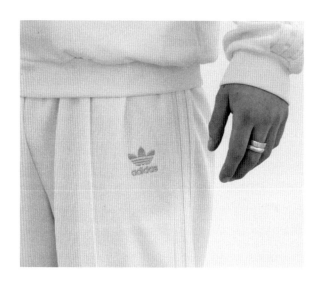

Ryan Gander,
This Consequence, 2005–08.
Track suit with embroidered stains,
worn by gallery attendants, dimensions variable.
Courtesy Tanya Bonakdar Gallery, New York
(Detail)

The Concept of the Generation

José Ortega y Gasset

The most important point about a scientific system is that it should be true. But the explanation of a scientific system involves a further postulate: Besides being true it must be understood. I am not for the moment referring to the difficulties imposed upon the mind by a scheme of abstract thought, especially if unprecedented, but to the comprehension of its fundamental tendency, of its ideological significance, I might almost say, of its physiognomy.

The scheme of thought with which we are now to be concerned claims to be true, in other words to reflect the character of phenomena with fidelity. But it would be Utopian and for that reason false to suppose that in order to make good its claim our system is to be directed exclusively by phenomena and give its undivided attention to its mere context. If the philosopher concentrated simply upon material objects philosophy would never be anything but primitive. Superimposed, however, upon material phenomena, the investigator finds the thoughts of other people, the whole body of human meditation in the past, innumerable traces of previous explorations, the signs of journeys attempted through the eternal jungle of problems, still virgin in spite of repeated violation.

Every philosophical inquiry has therefore to take two data into consideration: the nature of phenomena and the speculations to which phenomena have given rise. Such a collaboration with the theories of the past ensures, at any rate, freedom from errors already committed, and gives a progressive character to the succession of philosophical systems.

Now, the thought of any age can assume two apposite attitudes to what has been thought in other ages. Especially is this the case in regard to the immediate past, which is always the most powerful influence and contains in concentrated form everything anterior to the present. There are in fact some ages in which thought regards itself as growing out of seeds already sown, and others which are conscious of the immediate past as of something in urgent **197**

need of radical reform. The first-named are the ages of pacific, the second those of militant philosophy, the aspiration of which is to destroy and completely supersede the past. Our own age is of the latter type, if we understand by "our own age" not that which has just come to an end but which is just beginning.

When thought found itself compelled to adopt a bellicose attitude to the immediate past the intellectual world was divided into two camps. On the one side stood the great majority, which clung to established ideology; on the other a small minority of spiritual scouts, vigilant souls, who had a glimmering of distant tracts of territory still to be invaded. This minority is doomed never to be properly understood; the gestures which the version of the new dominions calls forth from it cannot be rightly interpreted by the main body advancing behind and not yet in possession of the height from which the "terra incognita" is being examined. Hence the minority in the van is in continual danger, both from the new district it has to conquer and from the rank and file harassing its rear. While it is constructing the new it has to defend itself from the old, and wield at one and the same time, like the renovation of Jerusalem, both the spade and the sword. This division is deeper and more absolute than is generally believed. I will try to show in what sense it subsists.

We attempt, by means of history, to understand the changes which take place in the minds of men. For this purpose we have first to observe that these changes are not all of the same kind. Certain historical phenomena depend on others, more fundamental, and themselves independent of the former. The idea that everything has a bearing on everything else, that everything depends on everything else, is a loose exaggeration of the mystics and ought to be repugnant to anyone determined to see his way clearly. On the contrary, the body of history exhibits a complete hierarchy in its anatomy, an orderly succession of subordinate parts an equally successive interdependence between the various classes of facts.

198

Accordingly, changes of an industrial or political nature are superficial: They depend upon ideas, upon contemporary fashions in morals or aesthetics. But ideology, taste, and morality in their turn are no more than consequences or demonstrations of the root feeling that arises in the presence of life, the sensation of existence in its undifferentiated totality. What we are going to call vital sensibility is the primary phenomenon in history and the first we should have to define in order to understand a particular age. Yet, when a variation in sensibility appears only in a single individual, it has no true historical significance. It has been customary for the field of the philosophy of history to be disputed by two tendencies which are both, in my judgment, and if I may say so without at the moment having any intention of going into the question in detail, equally erroneous. There has been both a collectivist and also an individualist interpretation of historical reality. For the former the process of history is in substance the work of widely diffused masses of mankind; for the latter the makers of history are exclusively individuals. The active, creative nature of personality is, in fact, too evident for the collectivist picture of history to be acceptable. Mankind in the gross is merely receptive: it is content simply to show favor or resistance to men of marked and enterprising vitality. On the other hand, however, the isolated individual is an abstraction. Historical life is social life. The life of the outstanding individual consists precisely in a comprehensive influence on the generality. "Heroes," then, cannot be separated from the rest of the world. There emerges here a duality which is essential to the process of history. Humanity, in all the stages of its evolution, has always been a functioning organism, in which the more energetic members, whatever form their energy may take, have operated upon the remainder and given them a distinct configuration. This circumstance implies a certain basic sympathy between the best type of individual and the generality of mankind. An individual whose nature differed completely from that of the mass would not produce any **199**

effect whatever upon it: His actions would pass over the surface of the society of his age without arousing the least response from it and therefore without entering the general process of history. To one extent or another such occurrences have been fairly frequent; and history has to note in the margin of its main text the biographical details of "extravagant" characters of this kind. Like all other biological sciences history has a department devoted to monstrosities, a teratology, in fact.

The changes in vital sensibility which are decisive in history, appear under the form of the generation. A generation is not a handful of outstanding men, nor simply a mass of men; it resembles a new integration of the social body, with its select minority and its gross multitude, launched upon the orbit of existence with a pre-established vital trajectory. The generation is a dynamic compromise between mass and individual, and is the most important conception in history.

It is, so to speak, the pivot responsible for the movements of historical evolution. A generation is a variety of the human race in the strict sense given that that term by naturalists. Its members come into the world endowed with certain typical characteristics which lend them a common physiognomy, distinguishing them from the previous generation. Beneath this general sign of identity, individuals of so diverse a temper can exist that, being compelled to live in dose contact with one another, inasmuch as they are contemporaries, they often find themselves mutually antipathetic. But under the most violent opposition of "pros" and "antis" it is easy to perceive a real union of interests. Both parties consist of men of their own time; and great as their differences may be their mutual resemblances arc still greater. The reactionary and the revolutionary of the nineteenth century are much nearer to one another than either is to any man of our own age. The fact is, that whether they are black or white the men of that generation belong to one species,

while in our own persons, whether we are black or white, are the
200 beginnings of a further and distinct variety of mankind.

The disputes between "pros" and "antis" are less important in the orbit of a generation than the constant interval separating the elect and the masses. When one is confronted by current theories which ignore or deny this evident difference in historical value between the two classes one feels justifiably tempted to exaggerate it. However, the assumption underlying those very discrepancies in stature is that individuals arise from an identical point of departure, a common plane above which some achieve greater heights than others, and which plays the part of the sea-level in topography. And each generation does in fact represent a certain vital altitude at which existence is conscious, in a certain sense, of being determined. If we consider the evolution of a race in its entirety we find that each of its generations appears as a moment in its vital process or as a pulse-beat in its organic energy. And each pulse-beat has a peculiar, even a unique, physiognomy it is an inconvertible palpitation in the series of pulse-beats, like each note in the development of a melody. We may equally well picture each generation by means of the image of a biological projectile launched into space at a definite moment and with pre-determined force and direction. In such determination all its elements, both the most valuable and the most normal, participate.

Nevertheless, it is clear that we are at present only designing forms or coloring illustrations which serve our purpose of isolating the really significant fact through which the concept of the generation proves its truth. This is simply that the generations are born one of another in such a way that the new generation is immediately faced with the forms which the previous generation gave to existence. Life, then, for each generation, is a task in two dimensions, one of which consists in the reception, through the agency of the previous generation, of what has had life already, e.g., ideas, values, institutions, and so on, while the other is the liberation of the creative genius inherent in the generation concerned. The attitude of the generation cannot be the same towards its own active

agency as towards what it has received from without. What has been done by others, that is, executed and perfected in the sense of being completed, reaches us with a peculiar unction attached to it: it seems consecrated, and in view of the fact that we have not ourselves assisted in its construction, we tend to believe that it is the work of no one in particular, even that it is reality itself. There is a moment at which the concepts of our teachers do not appear to us to be the opinions of particular men, but truth itself come to dwell anonymously upon the earth. On the other hand our spontaneous sensibility of the thoughts and feelings which an are our private possessions, never seem to us properly finished, complete, and fixed, like a definite object: We regard them more as a species of internal flux, composed of less stable elements. This disadvantage is compensated by the greater expansiveness and adaptability to our own nature always characteristic of spontaneity.

The spirit of every generation depends upon the equation established between these two ingredients and on the attitude which the majority of the individuals concerned adopt towards each. Will that majority surrender to its inheritance, ignoring the internal promptings of spontaneity? Or will it obey the latter and defy the authority of the past? There have been generations which felt that there was a perfect similarity between their inheritance and their own private possessions. The consequence, then, is that ages of accumulation arise. Other times have felt a profound dissimilarity between the two factors, and then there ensue ages of elimination and dispute, generations in conflict. In the former case the young men coming to the front coalesce with the old and submit to them: in politics, in science, and in the arts the ancient regime continues. Such periods belong to the old. In the latter case, since there is no attempt at preservation and accumulation, but on the contrary a movement towards relegation and substitution, the old are swept away by youth. Such periods belong to the young and are years

of innovation and creative struggle.

This rhythm of ages of senescence and ages of rejuvenation is a phenomenon so patent in a long view of history that it is surprising not to find it recognized by everyone. The reason for such lack of recognition lies in the fact that there has never been any attempt to found, even formally, a new scientific system which might be called "Metahistory," which would bear the same relation to concrete histories as physiology to the clinic. One of the most interesting of "metahistorical" investigations would consist in the discovery of the great historical rhythms. For there are others no less evident and fundamental than that already referred to, for example, the rhythm of sex. There is in fact a pendulum movement latent in history which swings from ages subjected to the dominant influence of respectability to ages that surrender to the yoke of the female principle. Many institutions, customs, ideas, and myths, hitherto unexplained, are illuminated in an astonishing manner when the fact is taken into account that certain ages have been ruled and modeled by the supremacy of women. The present moment, however, is not a fitting opportunity to enter upon that particular question.

From *The Modern Theme* (New York: Harper Torchbooks, 1961).
Reproduced with the permission of the Fundación José Ortega y Gasset.

Keren Cytter,
Der Spiegel, 2007.
Digital video, color, sound,
4:30 min
Courtesy the artist and Pilar Corrias Gallery, London
(Detail)

The Production of Belief

Pierre Bourdieu

Ways of Growing Old

The opposition between the two economies, that is to say, between two relationships to the "economy," can thus be seen as an opposition between two life cycles of the cultural production business, two different ways in which firms, producers and products *grow old*.[1] The trajectory leading from the avant-garde to consecration and the trajectory leading from the small firm to the "big" firm are mutually exclusive. The small commercial firm has no more chance of becoming a great consecrated firm than the big "commercial" writer (e.g. Guy des Cars or Cécil Saint-Laurent) has of occupying a recognized position in the consecrated avant-garde. In the case of "commercial" firms, whose sole target is the accumulation of "economic" capital and which can only get bigger or disappear (through bankruptcy or takeover), the only pertinent distinction concerns the size of the firm, which tends to grow with time; in the case of firms characterized by a high degree of disavowal of the "economy" and submission to the specific logic of the cultural goods economy, the chronological opposition between the newcomers and the old-established, the challengers and the veterans, the avant-garde and the "classic," tends to merge with the "economic" opposition between the poor and the rich (who are also the big), the "cheap" and the "dear," and aging is almost inevitably accompanied by an "economic" transformation of the relation to the "economy," i.e. a moderating of the denial of the "economy" which is in dialectical relation with the scale of business and the size of the firm. The only defense against "growing old" is a refusal to "get fat" through profits and for profit, a refusal to enter the dialectic of profit which, by increasing the size of the firm and consequently the overheads, imposes a pursuit of profit through larger markets, leading to the devaluation entailed in a "mass appeal."[2]

205

A firm that enters the phase of exploiting accumulated cultural capital runs two different economies simultaneously, one oriented towards production, authors, and innovation (in the case of Gallimard, this is the series edited by Georges Lambrichs), the other towards exploiting its resources and marketing its consecrated products (with series such as the Pléiade editions and especially *Folio* or *Idées*). It is easy to imagine the contradictions that result from the incompatibility of the two economies. The organization appropriate for producing marketing and promoting one category of products is totally unsuited for the other. Moreover, the weight of the constraints that management and marketing bring to bear on the institution and on ways of thinking tends to rule out high-risk investments—when, that is, the authors who might give rise to them are not already turned towards other publishers by the firm's prestige. (They may equally be discouraged by the fact that the "intellectual" series tend to pass unnoticed when they appear in lists in which they are "out of place" or even "incongruous" e.g. as an extreme case, Laffont's *Écarts* and *Change* series.) It goes without saying that though the disappearance of the firm's founder may accelerate the process, it is not sufficient to explain a process which is inscribed in the logic of the development of cultural businesses.

The differences which separate the small avant-garde firms from the "big firms" and "great publishers" have their equivalents in the differences that can be found, among the products, between the "new" product, temporarily without "economic" value, the "old" product, irretrievably devalued, and the "ancient" or "classic" product, which has a constant or constantly growing "economic" value. One also finds similar differences among the producers, between the avant-garde, recruited mainly among the (biologically) young, without being limited to a generation, "finished" or "outdated" authors or artists (who may be biologically young) and the consecrated avant-garde, the "classics."

The Classical and the Old Fashioned

It is clear that the primacy the field of cultural production accords to youth can, once again, be traced back to the disavowal of power and of the "economy" which lies at the field's foundation. The reason why "intellectuals" and artists always tend to align themselves with "youth" in their manner of dress and in their whole bodily *hexis* is that, in representations as in reality, the opposition between the "old" and the "young" is homologous with the opposition between power and "bourgeois" seriousness on the one hand, and indifference to power or money and the "intellectual" refusal of the "spirit of seriousness" on the other hand. The "bourgeois" worldview, which measures age by power or by the corresponding relation to power, endorses this opposition when it identifies the "intellectual" with the young "bourgeois" by virtue of their common status as dominated fractions of the dominant group, from whom money and power are temporarily withheld.[3]

But the priority accorded to "youth" and to the associated values of change and originality cannot be understood solely in terms of the relationships between "artists" and "bourgeois." It also expresses the specific law of change in the field of production, i.e. the dialectic of distinction whereby institutions, schools, artists, and works which are inevitably associated with a moment in the history of art, which have "marked a date" or which "become dated," are condemned to fall into the past and to become *classic* or *outdated*, to drop into the "dustbin" of history or become part of history, in the eternal present of *culture*, where schools and tendencies that were totally incompatible "in their time" can peacefully coexist because they have been canonized, academicized, and neutralized.

Being Different

It is not sufficient to say that the history of the field is the history of the struggle for the monopolistic power to impose the legitimate categories of perception and appreciation. The *struggle itself* creates the history of the field; through the struggle the field is given a temporal dimension. The aging of authors, works, or schools is something quite different from the product of a mechanical slippage into the past. It is the continuous creation of the battle between those who have made their names [*fait date*] and are struggling to stay in view and those who cannot make their own names without relegating to the past the established figures, whose interest lies in freezing the movement of time, fixing the present state of the field forever. On one side are the dominant figures, who want continuity, identity, reproduction; on the other, the newcomers, who seek discontinuity, rupture, difference, revolution. To "make one's name" [*faire date*] means making one's *mark*, achieving recognition (in both senses) of one's *difference* from other producers, especially the most consecrated of them; at the same time, it means *creating a new position* beyond the positions presently occupied, *ahead* of them, in the *avant-garde*. To introduce difference is to produce time. Hence the importance, in this struggle for life and survival, of the distinctive marks which, at best, aim to identify what are often the most superficial and most visible properties of a set of works or producers. Words–the names of schools or groups, proper names–are so important only because they make things. These distinctive signs produce existence in a world in which the only way to be is to be different, to "make one's name," either personally or as a group. The names of the schools or groups which have proliferated in recent painting (Pop art, Minimalist art, Process art, Land art, body art, Conceptual art, Arte Povera, Fluxus, new realism, *nouvelle* figuration, support-surface, *art pauvre*, Op art, kinetic art, etc.) are pseudo concepts,

208

practical classifying tools which create resemblances and differences by naming them; they are produced in the struggle for recognition by the artists themselves or their accredited critics and function as emblems which distinguish galleries, groups and artists and therefore the products they make or sell.[4]

As the newcomers come into existence, i.e. accede to legitimate difference, or even, for a certain time, exclusive legitimacy, they necessarily push back into the past the consecrated producers with whom they are compared, "dating" their products and the taste of those who remain attached to them. Thus the various galleries or publishing houses, like the various artists or writers, are distributed at every moment according to their artistic age, i.e. according to the age of their mode of artistic production and the degree to which this generative scheme, which is also a scheme of perception and appreciation, has been canonized and secularized. The field of the galleries reproduces *in synchrony* the history of artistic movements since the late nineteenth century. Each major gallery was an avant-garde gallery at some time or other, and it is that much more famous and that much more capable of consecrating (or, which amounts to the same thing, sells that much more dearly), the more distant its *floruit*, the more widely known and recognized its "brand" ("geometrical abstract" or "American Pop") but also the more it is encapsulated in that "brand" ("Durand-Ruel, the impressionist dealer"), in a pseudo concept that is also a destiny. At every moment, in whichever field (the field of class struggles, the field of the dominant class, the field of cultural production), the agents and institutions involved in the game are at once contemporaries and out of phase. The field of the present is just another name for the field of struggles (as shown by the fact that an author of the past is present exactly in so far as he or she is at stake) and contemporaneity in the sense of presence in the same present, in the present and presence of others, exists, in practice, only in the struggle that synchronized discordant times (so that, as I hope to show elsewhere, one of the

major effects of great historical crises, of the events which *make history* [*font date*], is that they synchronize the times of fields defined by specific structural durations). But the struggle that *produces* contemporaneity in the form of the confrontation of different times can only take place because the agents and groups it brings together are not present in the same present. One only has to think of a particular field (painting, literature, or the theater) to see that the agents and institutions who clash, objectively at least, through competition and conflict, are separated in time and in terms of time. One group, situated at the vanguard, have no contemporaries with whom they exchange recognition (apart from other avant-garde producers), and therefore no audience, except in the future. The other group, commonly called the "conservatives," only recognize their contemporaries in the past. The temporal movement resulting from the appearance of a group capable of "making history" by establishing an advanced position induces a displacement of the structure of the field of the present, i.e. of the chronological hierarchy of the opposing positions in a given field (e.g. Pop art, kinetic art, and figurative art). Each position is moved down one rung in the chronological hierarchy which is at the same time a social hierarchy. The avant-garde is at every moment separated by an artistic generation (the gap between two modes of artistic production) from the consecrated avant-garde; which is itself separated by another artistic generation from the avant-garde that was already consecrated at the moment it entered the field. This is why, in the space of the artistic field as in social space, distances between styles or lifestyles are never better measured than in terms of time.[5]

The consecrated authors who dominate the field of production also dominate the market; they are not only the most expensive of the most profitable but also the most readable and the most acceptable because they have become part of "general culture" through a process of specific teaching. This means that through them, the strategies directed against their domination always

additionally hit the distinguished consumers of their distinctive products. To bring a new producer, a new product, and a new system of tastes onto the market at a given moments is to push the whole set of producers, products, and systems of tastes into the past. The process whereby the field of production becomes a temporal structure also defines the temporal status of taste. Because the different position in the hierarchical space of the field of production (which can be equally well identified by the names of institutions, galleries, publishers, and theaters, or by the names of artists or schools), are at the same time tastes in a social hierarchy, every transformation of the structure of the field leads to a displacement of the structure of tastes, i.e. of the system of symbolic distinctions between groups. Oppositions homologous with those existing today between the taste of avant-garde artists, the taste of "intellectuals," advanced "bourgeois" taste and provincial "bourgeois" taste, which find their means of expression on markets symbolized by the Sonnabend, Denise René, and Durand-Ruel galleries, would have been able to express themselves equally effectively in 1945, when Denise René represented the avant-garde, or in 1875 when Durand-Ruel was in that position.

This model is particularly relevant nowadays, because owing to the near-perfect unification of the artistic field and its history, each artistic act that "makes history" by introducing a new position into the field "displaces" the whole series of previous artistic acts. Because the whole series of pertinent events is practically present in the latest, in the same way that the six digits already dialed on the telephone are contained in the seventh, an aesthetic act is irreducible to any other act in a different place in the series and the series itself tends towards uniqueness and irreversibility. As Marcel Duchamp points out, this explains why returns to past styles have never been more frequent that in these times of frenetic pursuit of originality: The characteristic of the century now coming to an end is that it is like a double-barreled gun. Kandinsky and Kupka invented abstraction. **211**

Then abstraction died. No one was going to talk about it any more. It came back thirty-five years later with the American Abstract Expressionists. You could say that Cubism reappeared in an impoverished form in the postwar Paris school. Dada came back in the same way. A second shot, second wind. It's a phenomenon typical of this century. You didn't find that in the eighteenth or nineteenth centuries. After the Romantics, came Courbet. And Romanticism never came back. Even the Pre-Raphaelites aren't a rehash of the Romantics.[6]

In fact, these are always *apparent* returns, since they are separated from what they rediscover by a negative reference to something which was itself the negation (of the negation of the negation, etc.) of what they rediscover (when, that is, the intention is not simply of pastiche, a parody that presupposes all the intervening history).[7] In the present stage of the artistic field, there is no room for naïveté, and every act, every gesture, every event, is, as a painter nicely put it, "a sort of nudge or wink between accomplices."[8] In and through the games of distinction, these winks and nudges, silent, hidden references to other artists, past or present, confirm a complicity which excludes the layperson, who is always bound to miss what is essential, namely the interrelations and interactions of which the work is only the silent trace. Never has the very structure of the field been present so practically in every act of production.

Never too has the irreducibility of the work of cultural production to the artist's own labor appeared so clearly. The primary reason is that the new definition of the artist and of artistic work brings the artist's work closer to that of the "intellectual" and makes it more dependent than ever on "intellectual" commentaries. Whether as critics but also the leaders of a school (e.g. Restany and the new realists), or as fellow travellers contributing their reflexive discourse to the production of a work that is always in part its own commentary or to reflection of an art which often itself incorporates a reflection on art, intel-

212

lectuals have never before so directly participated, through their work on art and the artist, in an artistic work that always consists partly of *working on oneself* as an artist. Accompanied by historians writing the chronicles of their discoveries, by philosophers who comment on their "acts" and who interpret and over-interpret their works, artists can constantly invent the distinguishing strategies on which their artistic survival depends, only by putting into their practice the practical mastery of the objective truth of their practice, thanks to the combination of knowingness and naïveté, calculation and innocence, faith and bad faith that is required by *mandarin games*, cultivated games with the inherited culture, whose common feature is that they identify "creation" with the introduction of *deviations* [*écarts*], which only the initiated can perceive, with respect to forms and formulae that are known to all. The emergence of this new definition of the artist and his or her craft cannot be understood independently of the transformations of the artistic field. The constitution of an unprecedented array of institutions for recording, preserving, and analysing works (reproductions, catalogues, art journals, museums acquiring the most modern works, etc.), the growth in the personnel employed, full-time or part-time, in the *celebration* of works of art, the increased circulation of works and artists, with great international exhibitions and the increasing number of chains of galleries with branches in many countries–all combine to favor the establishment of an unprecedented relationship between the body of interpreters and the work of art, analogous to that found in the great esoteric traditions; to such an extent that one has to be blind not to see that discourse about work is not a mere accompaniment, intended to assist its perception and appreciation, but a stage in the production of the work, of its meaning and value.

From *The Field of Cultural Production* by Pierre Bordieu
213

1 The analytical opposition between the two economies implies no value judgement, although in the ordinary struggles of artistic life it is only ever expressed in the form of value judgements and although despite all the efforts to distance and objectify, it is liable to be read in polemical terms. As I have shown elsewhere, the categories of perception and appreciation (e.g. obscure/clear or easy, deep/light, original/banal, etc.) which function in the world of art are oppositions that are almost universally applicable and are based, in the last analysis, through the opposition between rarity and divulgation or vulgarization, uniqueness and multiplicity, quality and quantity, on the social opposition between the "elite" and the "masses," between "elite" (or "quality") products and "mass" products.

2 This effect is perfectly visible in *haute couture* or perfumery, where the consecrated establishments (e.g. Caron, Chanel, and especially Guerlain) are able to keep going for several generations only by means of a policy aimed at artificially perpetuating the rarity of the product (e.g. the "exclusive concessions" that limit sales outlets to a few places that are themselves chosen for their rarity–the great couturiers' own shops, perfume shops in the smartest districts, airports). Since aging is here synonymous with vulgarization, the oldest brands (Coty, Lancôme, Worth, Molyneux, Bourjois, etc.) have a second career, downmarket.

3 We may therefore formulate the hypothesis that acquisition of the social indices of maturity, which is both the condition and the effect of accession to positions of power, and abandonment of the practices associated with adolescent irresponsibility (to which cultural and even political "avant-gardists" belong) have to be more and more precocious as one moves from the artists to the teachers, from the teachers to the members of the professions, and from the professions to the employers; or to put it another way, that the members of the same biological age group, e.g. all the students in the *grandes écoles*, have different social ages, marked by different symbolic attributes and conducts, according to the objective future they are heading for. The Beaux-Arts student has to be *younger* than the *normalien*, and the *normalien* has to be younger than the *Polytechnicien* or the student at the École Nationale d'Administration. One would have to apply the same logic in analyzing the relationship between the sexes within the dominant fraction of the dominant class and more specifically the effects on the division of labor (especially in clature and art) of the dominated-dominant position assigned to women in the "bourgeoisie" that brings them relatively closer to the young "bourgeois" and the "intellectuals," predisposing them to the role of *mediator between the dominant and dominated fractions* (which they have always played, particularly through the "salon").

4 Academic criticism is condemned to interminable arguments about the definition and scope of these pseudo concepts that are generally no more than names that identify practical groupings such as the painters assembled in an outstanding exhibition or a consecrated gallery or the authors on the list of the same publisher (and which are worth neither more nor less than convenient associations such as "Denise René is geometric abstract," "Alexandre Iolas is Max Ernst," or, among the painters, "Arman is dustbins" or "Christo is packages"); and many concepts in literary or artistic criticism are no more than a "learned" designation of similar practical groupings (e.g. *literature objectale* for *nouveau roman*, itself standing for "all the novelists published by Éditions de Minuit").

5 Tastes can be "dated," by reference to what was avant-garde taste in different periods: "Photography is outdated." "Why?" "Because it's gone out of fashion; because it's linked to the Conceptual art of two or three years ago." "Who would say this: 'When I look at a picture, I'm not interested in what it represents.'?" Nowadays, people don't know much about art. It's typical of someone who has no idea about art to say that. *Twenty years ago*, I don't even know if twenty years ago the abstract painters would have said that, I don't think so. It's the sort of person who doesn't know anything and who says "You can't fool me, what counts is whether it's pretty" (avant-garde painter, age thirty-five).

6 Interview published in *VH 101*, 3, autumn 1970, 55–61.

7 That is why it would have been naïve to think that the relationship between the age and the degree of accessibility of works of art disappears when the logic of distinction leads to a (second-degree) return to an old mode of expression (e.g. at present, "neo-Dadaism," "neo-realism," or "hyper-realism").

8 This game of nudges and winks, which has to be played very fast and very "naturally," even more mercilessly excludes the "failure," who makes the same kind of moves as everybody else, but out of phase, usually too late, who falls into all the traps, a clumsy buffoon who ends up serving as a foil for those who make him their unwilling or unwitting accomplice; unless, finally understanding the rules of the game, he turns his status into a choice and makes systematic failure his artistic specialty. (*A propos* of a painter who perfectly illustrates this trajectory, another painter said admirably: "Once he was just a bad painter who wants to succeed. It's excellent."

Shilpa Gupta,
Untitled, 2007.
Archival print on canvas,
40 x 53 in (101.6 x 134.6 cm)
(Detail)

How Long is a Generation?[1]

Bennett M. Berger

All of the recent talk in the United States about the "Beat Generation" and its meaning for our "age" may well prove to have been worthwhile after all if it provokes, among British and American sociologists, serious interest in the study of the problem of generations, a problem which, from Comte down to Mannheim and Ortega y Gasset, has consistently interested serious continental thinkers.[2] For Mannheim and most other European students of the subject, the sociological importance of generations lies in the assumption that they are the agents or "carriers" of major cultural changes; changes in the "spirit of the age" or the formulation of a new *Zeitgeist* are in large part the work (in Ortega's fateful view, the " mission") of rising generations.[3] While British and American sociologists have in general neglected the problem of generations so conceived, survey ·researchers frequently use age-groups as one of the basic variables in terms of which they interpret their data. This essay is an attempt to analyze the peculiar place the generation concept has come to occupy in the vocabulary of American cultural discourse, and by so doing, to render the concept more useful for the purposes of empirical sociological analysis.

Webster, following Herodotus, defines a generation as the period of time it takes for father to be succeeded by son, "usually taken to be about thirty-three years," and Mannheim says that most students of the problem of generations agree that a generation "lasts" about thirty years.[4] Presumably, then, if one begins at some arbitrary point, one would expect there to be roughly three "ages" in a century– but only if a change in the spirit of the age follows the rising of each new generation.[5] Clearly, however, this has not consistently been the case. In England it is commonly held that the last "age" of the nineteenth century (the one we call "Victorian") "lasted" for some sixty years. But regarding the sixty years of our own century in the United States, it is now usual to suggest that there have been at least four distinct cultural "periods" or "ages." Before World War I there

was the "age" of tycoons and moguls. The war was followed by the period known simply but eloquently as "the twenties," or, in its roaring version, as the "jazz age." October 1929 ushered in the "proletarian decade" and the collective cultural experience with Marxism that American intellectuals have still not fully exorcized. The Second World War marked the "transition" (all ages, of course, are "ages of transition") to this "age of conformity" which is said to be characterized by a generation of "organization men" and "suburbanites." And, as some have remarked, the recent summit conferences, US Supreme Court decisions, the passing of Senator McCarthy, and the waning of his ism symbolize yet another turning point, then perhaps the emergence of still another "age" is imminent. From a "Victorian age" spanning about sixty years, we seem to have reached a point where a change in *Zeitgeist* may be expected at approximately ten year intervals.

I say seem. Are generations shrinking? Is the character of our "age" so ephemeral that it is gone almost before it has had time to take shape? Certainly the aplomb with which intellectuals play the game of naming the age and the generation would lead one to think so. Certainly, too, the view has been cogently argued. The apparent tendency for the time period referred to by the term "generation" to shrink, and the corresponding tendency for the duration of an "age" to contract have been explained as the cultural consequences of the increased pace of technological change and the repeated cataclysmic social upheavals to which on century has been witness—upheavals which create sudden discontinuities between the age groups upon which they have had a sharp impact and the age groups to which they are only "history."[6] When C. S. Lewis says that Dr. Johnson is closer to Seneca than he is to us, he is suggesting that the changes wrought by the past 200 years are more profound than the changes in the previous 2,000. Neumann, in a shorter historical view, says that "The cavalcade of thirty years nowadays includes more changes than three centuries before did," and Lionel Trilling has re-

cently called attention to the "enormous acceleration in the rate at which the present is superannuated as the past." If we accept these views for the moment, it may certainly seem sensible to expect the concept of the generation to telescope–as critical events and experiences crystallize at an accelerated pace to create new "generational mentalities" which are subsequently manifested as "the spirit of the age."[7]

But even putting aside the circular logic that usually lies behind this kind of formulation, there is really very little evidence to suggest that recent generations are coming to maturity in quicker succession than in previous centuries. At the same time, however, one cannot avoid being struck by the rapidity with which intellectual "movements" are given generational identities; intellectuals seem to crouch ready and waiting to spring upon each political and cultural event with interpretations suggesting imminent and momentous changes in the temper of the time, and magazines both big and little, stand ready to print them. But to imply, as I have, that this is not a generational phenomenon is not to suggest that it has nothing to do with age groups and conceptions of age; it has: the length of adolescence is increasing in the United States. And along with this "stretching" of youth have come great increases in the numbers of intellectuals, and in the specialization, decentralization, and bureaucratization of intellectual life.

1 Youth in America

Far from generations coming to maturity more rapidly today than in previous centuries, what little evidence there is seems to suggest the opposite. The age at which one "enters" adolescence appears in general to be getting lower, whereas the age at which one "becomes" a "mature" adult appears in general to be getting higher the period of adolescence is thus expanded. Children dance, **219**

drink, date, go steady, become sexually aware and variously delinquent earlier today than thirty years ago.[8] At the other extreme, the increasing educational requirements for occupational mobility upward lengthen the years spent in school, and to that extent postpone the assumption of full adult responsibilities by students. And even when students marry early and take on some responsibilities, there is a sense in which a student, no matter what his age, is not quite completely an adult Mannheim calls attention to the "youthful" functions of student life when he remarks that evidence shows that late exposure of mature persons to a broad, liberal education precipitates an apparent seizure by "adolescent" traits; they pass through stages of tumult, vehemence, exhilaration, doubt, confusion, despair, and so on." [9]

Evidence from novels (that first and last resort of the sociologist in search of data) suggests that for intellectuals especially, the resolution of moral and political perplexities, into a mature and lasting *Weltansckauung* takes a longer time to formulate. If we compare nineteenth century European novels with contemporary American novels which deal with groups of young people struggling to "find themselves," a modern reader is rather startled to discover inadvertently and perhaps rather late in, say, a George Eliot or Dostoevsky novel that some marvellously mature, articulate, and aware character is twenty or twenty-one years old; these nineteenth-century fictional figures in *Middlemarch, The Idiot,* and many others are characteristically between eighteen and twenty-two years old. Their counterparts in contemporary American novels are usually in their late twenties and frequently as "old" as their late thirties.

This extension of "youthfulness" is rife in American culture. "Youth" groups today usually include members in their middle and late thirties; the "junior" chamber of commerce includes thirty-five-year-old business men, and our "young writers"–as Seymour Krim has shown–are as often as not middle-

aged.[10] An English actress, generalizing lightly about American men recently, no doubt exaggerates but makes her point clearly when she says: "I find it difficult to separate the men from the boys. American men always look seven or eight years younger than they really are. When an Englishman is thirty years old, he looks thirty. And he's pretty well settled in his ways. When I meet a young American, I sort of pat him on the hard thinking he's a college lad. Then I find he's married and has four children."

What all this suggests is that Americans are members of the "younger generation" from the time they begin to stay out at night to the time they begin to grow bald and arthritic, and find the stairs steeper, and the co-eds younger looking. The ease with which high school sub bohemians mix with their thirty-five-year-old mentors in the same cool coffee shop milieu symbolizes the extended duration of "youth" in America period prone to cultural pronouncements, movements, "statements," rebellious outbursts, revolutionary flurries, and so on. In a recent public debate, Philip Selznick argued the view that the radical behavior of students is largely a function of their *temporary* alienation–temporary because it is their youth and immaturity which alienate them from participation in the major adult institutions, and not something permanent in their psychological makeup. What I am suggesting is that the extension of cultural definitions of "youth" to a period covering at least twenty years and sometimes longer, extends the period in which "youthful" (i.e. "irresponsible") behavior is positively sanctioned. Understanding this may help explain the apparent proliferation of "new" *Zeitgeist* and "new" generation "movements," which, if not the creations of precisely "young" men, are the creations of youthful men with a longer rime to be young. It may also, for example, help explain the notorious failure of perpetually "promising" American novelists to "fulfil their promise" simply because acceptable *models* of intellectual "maturity" become difficult to find: as the chronological age associated **221**

with "maturity" goes up it becomes only too easy to identify maturity with loss of vigor, idealism, and principle in short, with "compromise."[11] And besides, the generation that students of culture trends are interested in is usually the "younger" generation–which may encourage intellectuals and other creative people to identify themselves with the "rising" group.

It may, of course, be that the extension of "youth" is related on the one hand to the demographic fact of increased life expectancy in industrialized societies, and on the other hand to the political fact that bureaucratization and party control of democratic processes in industrialized parliamentary societies subject young men to long periods of training, that is, waiting, for positions of power and responsibility. Over 100 years ago, Comte believed that increases in life span would slow down the rate of social change because the period of dominance of any single generation would increase with increasing length of life; as the generation grew older its increased conservatism would, according to Comte, dampen the forces making for change inherent in the "rising" generation. What Comte failed to foresee was that the gerontocracies of western Europe and the United States (how many more fatal attacks of the degenerative diseases can our political elite sustain?) would, apparently, not only result in the extension of the definition of youth, but intensify the "youthfulness" and the resentments of the already balding "younger" generation.

2 Intellectuals: Numbers, Decentralization, Specialization

Clearly, if the concept of the generation, which is a *temporal* abstraction, is to have any utility for the empirical analysis of cultural phenomena, it must be kept analytically distinct from *structural* or *locational* (income, occupation, religion, ethnic status, etc.) concepts which also affect "perspective" or "point of

view."[12] Thus, although the extension of the period of time in which youthfulness is culturally defined as appropriate helps explain the apparent proliferation of divergent *Zeitgeist*, there are other social processes bearing upon the structure of intellectual life which also help foster this heterogeneity.

The rapidly increasing *numbers*, both absolute and proportionate, of intellectuals in the United States comes to mind first. S. M. Lipset has recently called attention to this fact in an attempt to explain the relative isolation of American intellectuals (vis-à-vis Europeans and others) from the sources of power.[13] But the fact is relevant to the point under discussion here; for if it is too much to expect American economists to be able to formulate a joint statement of economic policy, it would be even more arrogant to expect American intellectuals, who must number in the hundreds of thousands, to be able to formulate a "spirit" common enough for all or even most to subscribe to. And it is surely more difficult for Americans to do this than English or French or German or Australian intellectuals, whose numbers are so much fewer. And even in countries with relatively few intellectuals, the problem is by no means a simple one. The multiparty political system of the continent represents, perhaps, only the crudest dimension of experience which may fragment a single generation, and Mannheim's labored discussion of "generation units" is testimony to the difficulty in which analysts of generations find themselves the moment they attempt to comprehend not only the "unity" of a generation but its diversity also: The "age" of the tycoons and moguls was also the "age" of the muckrakers; the "roaring twenties" was also the "age" of Harding, Coolidge, Babbit, and the "Booboisie."

In addition to the increase in the numbers of intellectuals, the cultural life of the United States is much more centralized than that of most European nations. French culture means Parisian culture; the revolt of England's "Angry Young Men" has been a revolt against the cultural domination of **223**

England by the London-Cambridge-Oxford "axis" and the classes it represents. New York does not come near to dominating the cultural life of the United States in the sense that London and Paris dominate the cultural life of England and France.

While New York may be said to be the intellectual capital of the United States, there are important groups of intellectuals scattered round the country whose combined number is far greater than those in or adjacent to New York. Important schools of writers and painters exist in various parts of the country... (and) The two leading universities in the country... are located in metropolitan Boston and San Francisco.[14]

One consequence of this, as Lipset himself observes, is to limit the extent to which American intellectuals are acquainted with each other–even when they happen to be in the same "field." Not only size, then, but the geographical dispersion of American intellectual communities, fosters the development of simultaneous multiple "generations" and "ages" based both upon the multiplicity of intellectual cliques and the influence of regionalism: the "proletarian decade" dates also the public emergence of the Southern Agrarian movement, conservative and anti-industrial; and, of course, organization men and "suburbanites" coexist, indeed, even interact with the "Beat Generation."[15]

But perhaps more important than the size and decentralization of American intellectual communities for the heterogeneous cultural character of the "age" and "the generation" is the bearing of occupation upon chronological age. Differences in the meaning of age in terms of occupation are probably most clear in athletics; a prize fighter is an old man at thirty, a baseball player at thirty-five, but a presidential candidate is young at fifty. Factory workers begin losing their hopes for the future (such as they are) at around thirty-five. The thirty-year-old PhD student is indeed an "old" student, but one successful year later, this thirty-one-year-old professor is *a young* professor. These are only the most

224

striking examples, but instances could be multiplied of the difference in average age at which the incumbents of different social and occupational roles are considered "young," "mature," "old," etc., that is, differences in the age range within which they tend to or are expected to produce their best or most representative work. Novelists, for example, often produce their best work in their twenties or early thirties. Musicians and painters on the other hand usually "mature" much later; painters, for example, are still "young" in their forties.[16]

What this means is not only that members of the same age groups may experience their most productive or representative period in different decades, but also that what they produce may be affected by different series of events. For these reasons it is essential, when using the concept of the generation in a cultural sense, to specify generations *of what*, because it is only in a demographic sense that people in the same age group constitute a homogeneous unit, and because the character of any cultural generation depends in part upon the relationship of "youth" to years, and upon the average length of its vital or effective period–which differs according to occupational milieu.[17] There are, in short, literary generations, political generations, musical generations, etc.; the length of each fluctuates, and the age range which constitutes the "younger" generation in one may be considerably older (or younger) than the age range constituting the "younger" generation in another, to say nothing of the internal differentiations which may fragment a single cultural generation however defined.

What I am suggesting, then, is that if the concept of the generation is to be rendered useful for the sociology of culture, the temporal location of a group must first be kept analytically distinct from its structural location; second, when considering them together, we should be aware that the impact of structural (e.g. occupational) factors on the nature of the temporal location may, under some conditions be such as to fragment the cultural "unity" of a **225**

generation beyond recognition just as under other conditions the unity of a generation may be such as to withstand the divisive influence of, say, class factors.

These tendencies toward divisiveness and heterogeneity do not, of course, go on unopposed. The increasing *numbers* of intellectuals is accompanied by their increasing *organization* (for example, into professional associations), which restrains the tendencies toward heterogeneity. The increasing decentralization of intellectuals is accompanied by better *communications* among them, which acts as a brake on the tendency toward ideological fragmentation which geographical dispersion often encourages. (A remarkable feature of Jack Kerouac's novel *On the Road* is its suggestion that a network of bohemian communities exists between San Francisco, Denver, Chicago, and New York, each ready to accept to its bosom the bohemian travelers of the Road.) Finally, the tendency to specialization, which encourages the *ordering* of common bodies or data into increasingly different theoretical frames of concepts and meanings, is countered both by interdisciplinary tendencies (such as those represented in universities by comparative literature departments, integrated social sciences departments, and the new hybrid physical and natural science disciplines) and by the processes of mass culture which act to break down the divisiveness of specialization. But to note that these countertendencies exist is not to attribute to them equal importance; it seems to me that at the present time, for reasons which will be made apparent below, that the divisive influences are stronger than the integrative ones. In any case, it must seem odd that American intellectuals should be so preoccupied with the naming and fixing of "generations" and "ages" in a culture which is apparently so ill suited to being characterized in this way. Mannheim gives us the beginning of an explanation when he writes: "... the mentality of a period does not pervade the whole society at a given time. The mentality which is commonly attributed to an epoch has its proper seat in one (homogeneous of heterogeneous)

social group which acquires special significance at a particular time, and is able to put its intellectual stamp on all other groups...."[18]

I call it only a beginning because Mannheim goes on to explain *Zeitgeist* essentially as a function of the antagonisms *between* generations, and writes off the frequently polar responses of what he calls "units" of the *same* generation as an example of the dialectical principle which is synthesized by a common "generational mentality."[19] Indeed, Mannheim ignores the implications of his own specific insight when he raises (in a footnote) the question of "why have generations become so conscious of their unity today?"–and then drops it. One is tempted to be ill mannered enough to answer the rhetorical question: For the obvious propensity of intellectual groups to identify themselves as "generations" (something that has grown even more pronounced since Mannheim noted it in the twenties) suggests that other modes of identification may have become less viable or, at the very least, less fashionable. Structural identifications such as those of class, party, ideology, race, etc., belong, in industrial societies, to a milieu of *conflict* in which the *function* of the identification is to foster the solidarity of the group so identified *against* other classes, parties, ideologies, etc. Generational identifications, on the other hand, although usually incapable of eliminating the structural sources of conflict, belong to a milieu of *integration*, and foster the structuring of conflict in terms of age groups rather than in terms of other kinds of interest.[20] Such a mode of identification, by implying that age is a more significant source of disagreements among men than party or ideology, suggests that in due course these disagreements may disappear; that, for example, the "radicalism" of youth is more youthful than ideological, and that as the age basis of commitment wanes, so will the commitment itself. This view permits one the luxury of *managing* one's opposition rather than *combating* it; political problems become administrative ones, conflicts over leadership become problems of succession victory and defeat become questions of who co-opts and who is co-opted. **227**

But that generational identifications are apt to be spurious (Harold Rosenberg states tartly that "belonging to a generation is one of the lowest forms of solidarity") in a complex industrialized society is indicated not only by the inherent structural heterogeneities of any age groups in such a society (which I have discussed above), but by the interesting fact that the very *characterization* of "the age" and "the generation" has itself become an object of conflict. The "spirit of the age" is no longer merely something that "emerges" naturally (if indeed it ever did) out of the work of a generation's intellectual elite (as Ortega would have it) or even something that is formulated retrospectively by historians of later generations; the character of the contemporary "generation" and the "spirit" presumably created by it have become *Ideological* questions *for its own members.* The problem of assessing the "spirit of the age" becomes not only a question of analysing the works of its creators; a struggle ensues between different groups of intellectuals of the same generation (each conscious of itself not as a structurally defined group, but as a temporally located "generation") for the right *deliberately to define,* indeed to *name* the spirit of the age. For "naming" the age is not only a diagnostic function, it is an ideological one too; and to belong to a Beat Generation in an age of organization men is, like being a classicist in a romantic age, or an analyst of *Zeitgeist* in an age of logical empiricism, to be fated to live in a historical limbo, that is, to have been born too late (or too early) for "one's time."

Clearly, age groups are important in the analysis of cultural phenomena, but their full significance is likely to remain elusive unless supplemented by the structural variables which not only give a cultural meaning to age but which locate one in a "school of thought," give one a distinct "perspective," and a place within an intellectual tradition which began neither in a North Beach bistro in San Francisco nor in a New York conference room high above Madison Avenue, nor, for that matter in a panelled salon in Bloomsbury. Viewing the mat-

ter this way, one is enabled conceptually to handle multiple continuities of thought between generations, and at the same time to distinguish between structurally defined groups of the contemporary generation who carry on the continuing struggle for the right to "represent" the age.[21]

It should be obvious, however, that all formulations of the nature of "the age" and "the generation" are essentially mythic in character; no "age" is wholly romantic, classic, anxious, or conformist, and no "generation" is wholly lost, found, beat– and certainly not silent. Nevertheless, cultural struggles go on *as if* possession of the myth of the age were at stake; and in a sense it is, for those who win the struggle for the right to be considered "representative" of their age, in Weber's striking phrase, "usurp status,"[22] and their contributions are preserved in the large print of intellectual history, while those who lose are relegated to the always significantly smaller print of footnotes. Yielding, however, to the almost irresistible temptation to find something new and unprecedented in the contemporary situation, Harold Rosenberg has observed that "what is remarkable about the manufacture of myths in the twentieth century is that it takes place under the noses of living witnesses of the actual events and, in fact, cannot dispense with their collaboration.[23] Rosenberg's observation summarizes the apparent belief of intellectuals that their historical sophistication is great enough to permit them to anticipate the historian's function; understanding that the characterization of the past is in large part a function of contemporary documents, intellectuals are tempted to treat the present as history, for by doing so they weight the future's characterization of the present. It is almost as if a contest were being waged to see which of the contending intellectual groups could leave the largest and most convincing body of contemporary documents for the historian of the future to assess. Sometimes they don't even wait: "… to the young people educated in the late forties and early fifties it seemed that a war was being fought in American culture **229**

between two styles of asserting one's seriousness as an intellectual: the old style of "alienation"… and… the new style of "maturity."[24]

Regardless of the merits of the substantive assertion, I would call attention to the historical mood of this writer's prose; he is writing the history of his generation—no more than a few years after they've received their bachelors' degrees. This is anticipatory socialization or other directedness of a peculiarly ghostly sort oriented toward history, intellectuals collapse the historical process in their attempts to find their place in it; and by attempting to write the history of their time before it is actually made, intellectuals create the myth of their time. Attempts like these to structure one's experience so as to make it public, and thus historical, have probably always been with us but David Riesman suggests that "they have been speeded up in recent years by the enormous industry of the mass media which must constantly find new ideas to purvey, and which have short circuited the traditional filtering down of ideas from academic and intellectual centres. We can follow an interpretation of the suburbs from an article in *The American Journal of Sociology* to an article in *Harper's* to a best selling book to an article in *Life* or a TV drama—all in the matter of a couple of years—much in the way in which a… "Beat Generation"… [is] imitated almost before [it] exists."[25]

Surely, this is the cultural dimension of what Weber meant by "rationalization"; the increasing numbers, decentralization, and specialization of intellectuals, the availability of print, the respectability of almost any scheme of values (as long as they are logically articulated), and our predilection to think that by naming something we understand it, all contribute to the helter-skelter rush with which we hasten to confer the status of "trend," "movement," "spirit," etc., on a series of events which, with some historical distance, we might recognize as a minor cultural quiver.

This is not intended as a defence of Olympian detachment or as a recommendation that intellectuals abdicate their responsibility to comment

on and interpret the direction of contemporary culture. We always see the present and immediate past more critically and in more complex detail than we see more distant times, and many of the results of the impulse to record and identify the temper of one's time while it is happening or to make coherent sense of contemporary events perhaps before any coherence or pattern has appeared, may be invaluable as ethnography to future historians and social scientists.[26] At the same time, they may be seriously misleading or puzzling to future researchers who find a five-year period labelled an "age of conformity" (at precisely the time that a "Beat Generation" is flourishing undiscovered by the mass media) or who read of three different "postwar" generations within a period of fifteen years.

This discussion of the relationship of the concept of the generation to the concept of *Zeitgeist* can be extended to the somewhat firmer scientific ground upon which survey research stands. If Lipset *et al.* are correct in saying "there has been no attempt to apply systematically the concept of generation to modern survey research techniques,"[27] then survey research is probably the poorer for it. Shed of its philosophic overtones, the German tradition of generation analysis would simply argue that culturally defined generations may be as important an explanatory variable as class, income, religion, ethnic status, or any other structural variable. This is a simple and reasonable enough assertion, and Lipset *et al.* have cited a few studies of political behavior in which the generation idea illuminated the data quite markedly. More recently, William Evan, in outlining a procedure for studying long-term opinion change, has emphasized the importance of analysing survey data in terms of generation cohorts.[28] Both Evan and Lipset *et al.*, however, suggest that aging, as such, may have less effect upon opinions and attitudes than the impact of certain historical situations. They say, for example: "If, in fact, it is the case that generations tend to vote left or right depending on which group was in the ascendancy during their coming of age, then it may **231**

be necessary to reconsider the popularly held idea that conservatism is associated with increasing age... If a society should move from prolonged instability to stability, it may well be that older people would retain the leftist ideas of their youth, while the younger generation would adopt conservative policies."[29]

Certainly, this observation is readily applicable to the many university teachers (come of age in the thirties) who may be frequently heard remarking in a melancholy vein on the cautiousness, conservatism, and generally restricted horizons of their students. But at the same time, if what I have previously suggested makes sense, one would expect the definition of "coming of age" to vary depending upon the structural factors affecting conceptions of "youth" and "maturity." The possibility that Lipset *et al.* envision does not make a mere stereotype out of the apparent association of conservatism with aging; it suggests only that this is one tendency among others, and Hyman has carefully analyzed some of them; it seems clear enough that differences in "mentalities" due to the differing historical circumstances under which they were formed may frequently persist over time strongly enough to remain only slightly affected by the conservative tendencies of aging. Evan, this time with data (however scanty), suggests, in fact, that the historical situation has a greater effect upon opinion change than aging does. What he and other students of the problem do not take into account, however, is *relative* (or occupational) age; that is, that the forty-year-old painter may be responding to historical circumstances as a young man, whereas the forty-year-old editor of a mass-circulation magazine may respond to the same circumstances as a member of the "older generation." One may not be as old as one feels, but one can be as young as the age norms of one's status and reference groups permit one to be. To be sure, this factor may considerably complicate the practicability of applying the generation variable, but not, it seems to me, to such an extent as to preclude its usefulness–especially where occupation and education are already known.

But the idea of the generation can be effectively used not only in conventional survey work; there seems to be good reason for survey methods to be used to cast light on the larger cultural problems with which the Germans concerned themselves. If survey methods can inquire into political attitudes, sexual behavior, child rearing practices, and such elusive topics as apprehensiveness among professors, then those methods may be used to elicit the attitudes of intellectuals toward questions of style and taste, optimism and pessimism, "responsibility" and alienation, atmosphere and temper–in short, toward components of the *Zeitgeist*. A survey can be no better than the subtlety of the relationships it hypothesizes and the ingenuity of the questions it asks to measure them. Such work will probably show, in empirical terms, that the concept of the generation is a structural variable of major and statistically identifiable significance and not merely a sentimental projection of ageing retrospective philosophers.

From Bennett M. Berger, "How Long is a Generation?"
published in the *British Journal of Sociology*, March 1960, 10–23.

1 I would like to thank Reinhard Bendix, Leonard Cain, Erving Goffman, Robert Merton, and David Riesman for critical readings of an earlier draft of this article.

2 That this interest may in fact be developing is indicated by three recent treatments of the problem which have just come to may attention. See Anselm Strauss's recent discussion in *Mirrors and Masks* (Glencoe: The Free Press, 1959), pp. 132-41; see also Herbert Hyman's comprehensive and disciplined analysis of data on generations in his recent *Political Socialization* (Glencoe: The Free Press, 1959), ch. VI, especially pp. 12g132; see also the paper by Norman Ryder, "The Cohort as a Concept in the Theory of Social Change," delivered at the 1959 meetings of the American Sociological Society in Chicago.

3 Generations, according to Ortega, create changes in "vital sensibility"; he sees generations as a "compromise" between Marxist and Heroic theories of historical change. See ch. I of *The Modern Theme* (London: C.V. Daniel, 1931).

4 See Karl Mannheim, "The Sociological Problem of Generations," in his *Essays on the Sociology of Knowledge* (New York: Oxford, 1952), p. 278 (p. 159 in this volume). Mannheim says that some Europeans have taken a generation to mean a period or about fifteen years. Among these is Ortega. See his overly dogmatic statement in *Man and Crisis* (New York: \V.· W. Norton, 1958), ch. 4.

5 To say even this, of course, assumes that there is *some* utility in abstracting generational age groups for analysis that there is something more than an infinite succession of persons being born and dying at every moment.

6 The clearest expression of this view is in Sigmund Neumann, "The Conflict of Generations in Contemporary Europe," *Vital Speeches* (August I, 1939), which begins, "Modero European politics from Versailles to Munich can be largely explained in terms of a conflict of generations." Neumann conjures up an image of Hitler and Chamberlain at Munich: Hitler, the young warrior of World War I (age 48) and Chamberlain, the "late Victorian gentleman" (age 68).

7 Most students of the generation (in the sense of *Kultur)* agree that the source of the "unity" of its outlook is its common exposure to decisive politically and culturally relevant experiences in the formative stages of its members" development–usually conceived of as late adolescence. See, for example, Rudolph Heberle's chapter on political generations in *Social Movements* (New York: Appleton, Century, Crofts, 1951).

8 Increases in juvenile delinquency in recent years have come more notably in the eleven to fourteen-year-old group than in the fifteen-to-twenty-one group. On the developing group consciousness of teen-agers, see Dwight McDonald's interesting profile of youth pollster Eugene Gilbert, *The New Yorker* (November 22 and 29, 1958).

9 See "The Problem of the Intelligentsia," *Essays on the Sociology of Culture* (New York: Oxford, 1956), p. 164. Certainly there is some evidence to the contrary–especially regarding young people who are not students. Early marriage certainly dampens the irresponsibility and adventurousness of young people, and the whole complex of "organization men" with their ideology of "responsibility" suggests that "maturity" may come early to some. The cultural problem posed by this heterogeneity is discussed below, but it seems to me that the extension of youth is most visible among those intellectuals engaged in the creation and discussion of culture, that is, the formulation of the "spirit of the age."

10 Seymour Krim, "Our Middle-Aged 'Young Writers,'" *Gommentary* (October, 1952).

11 The psychological crisis experienced by many American women who are passing into middle age may be the result of the lack of an ideal model of female middle-agedness. David Riesman has suggested to me that middle-aged men (or at any rate, rich, middle-aged men) are enabled to be vicariously young by surrounding themselves with young women–as one can see in the ads for Cadillacs and other elegant products–although this can have, too, the unanticipated consequence of increasing the poignance of aging.

12 It goes without saying, of course, that the current tendency to identify "my generation" with "my school of thought" obscures this distinction.

13 … In 1929 *all ten* professors of economics in Australia met and told the government they believed it would be disastrous for the country to go off the gold standard. The Labor government of the day was not happy about this but felt it should not move against the "experts." There are far too many such experts in America for them to have such corporate "influence." S. M. Lipset, "American Intellectuals: Their Politics and Status," *Daedalus,* (Summer, 1959), p. 470

14 Lipset, op. cit., pp. 470-I.

15 See Eugene Burdick's discussion of "week-end bohemians" in "Innocent Nihilists Adrift in Squaresville," *The Reporter* (April 3, 1958). See also, "Beatniks in Business," *Mademoiselle* (March, 1959).

16 In a recent book called *Toung Painters 01 Promise* (London and New York: the Studio Publications, 1957), of the 118 "young" artists whose birth dates are listed, forty-five are thirty-five years of age or older, eighteen are over forty, four are over fifty, including one young artist born in 1894.

17 With some sarcasm, Harold Rosenberg observes, "… one may, especially today, call any age-group he chooses a 'generation'–among ensigns or ballet dancers a generation is replaced every three or four years." Harold Rosenberg, *The Tradition of the New* (New York: Horizon Press, 1959), p. 247.

18 Mannheim, "The Sociological Problem of Generations," op. cit., p. 313 (p. 163 in this volume).

19 In this respect, Mannheim comes close to Ortega, who believes that no difference between members of the same generation is as profound as the difference between persons of different generations.

20 Neumann argues that the revolt of the Nazi elite was a revolt by young men against the pre-World War I generation of German

leaders, and cites figures to show that the leaders of political and economic life in Weimar Germany were, in fact, a gerontocracy. Reinhard Bendix and others have argued that the early electoral successes of the Nazis was due in part to their winning the votes of young people.

21 It is really to no one's benefit that the concept of the "generation" and the related concept of "spirit of the age" refer primarily to activity in the arts. The phenomena these concepts attempt to deal with occur in every field of intellectual endeavour–although probably with decreasing sharpness as one moves from the humanities through the social sciences to the natural sciences, the physical sciences and mathematics. Allen Ginsberg and Jack Kerouac on the one hand, and Truman Capote, and William Styron on the other, belong to the same generation but to different intellectual and aesthetic traditions. One could cite similar examples in music, painting and sociology too. The work of C. Wright Mills is clearly an attempt to influence what the "character" of sociology shall be like in the twentieth century; but so is the work of David Riesman–and Paul Lazarsfeld–and Talcott Parsons.

22 That this usurpation may be a precarious one is suggested by Dean Inge's warning that the man who marries the spirit of his own age is likely to be a widower in the next. One need go no

further for an example of Inge's prophecy than the present experience of those who captured "the myth of the thirties."

23 Rosenberg, op cit., p. 221.

24 Quoted from Nonnan Podhoretz by Rosenberg, op. cit., p. 248.

25 David Riesman, in an unpublished manuscript. Riesman also points to the tendency for intellectuals to create myths or themselves by writing autobiographies while still relatively quite young. Presumably, Stephen Spender, Mary McCarthy, Phillip O'Connor, and a number of others still have a good part of their lives ahead of them. Riesman says, "It is as if the principle of buying on credit and living now rather than later was extended into all spheres of intellectual life."

26 Paul Lazarsfeld has commented on the responsibility of today's public opinion pollsters to the future's historians. "The obligations of the 1950 Pollster to the 1984 Historian." *Public Opinion Quarterl:J1* (Winter, 1950-51).

27 S. M. Lipset, *et al.*, "The Psychology of Voting," in G. Lindsey, *Handbook of Social Psychology* (Cambridge: AddisonWesley Press, 1954), vol. II, p. 1148. Hyman's work (op. cit.) is certainly a major effort in this direction.

28 William Evan, "Cohort Analysis of Survey Data," *Public Opinion Quarterly*, spring 1959, p. 68.

29 Lipset *et al.*, op. cit., p. 1148.

Matt Keegan,
You, Me, I, We, 2007.
Silkscreen,
30 x 25 in (76.2 x 63.5 cm)
Courtesy the artist and D'Amelio Terras, New York
(Detail)

A New Generation of Americans

William Strauss and Neil Howe with Pete Markiewicz

According to a recent national survey, barely one adult in three thinks that today's kids, once grown, will make the world a better place. To believe the newspapers, you'd suppose our schools are full of kids who can't read in the classroom, shoot one another in the hallways, spend their loose change on tongue rings, and couldn't care less who runs the country. A few years ago, in an otherwise positive campaign by Apple Computer featuring true-to-life adults, a teenage girl was depicted as stoned, clueless, and scarcely able to put two words together. Not surprisingly, she had twenty- and thirtysomething "fan clubs" talking about her "authenticity"–betraying an underlying cynical contempt for the young.

How depressing. And how wrong.

Current youth indicators reveal attitudes and behaviors among today's teens that represent something very new and unfamiliar.

They're optimists. Nine in ten describe themselves as "happy," "confident," and "positive." Teen suicide rates are declining for the first time in the postwar era. A rapidly decreasing share of teenagers worry about violence, sex, or drugs, and an increasing share say that growing up is easier for them than it was for their parents.

They're rule-followers. Over the past ten years, rates of violent crime among teens has fallen by 70 percent, rates of teen pregnancy and abortion by 40 percent, rates of high school sexual activity by 15 percent, and rates of alcohol and tobacco consumption are reaching all-time lows. As public attention to school shootings has risen, their actual incidence has fallen. Even including such shootings as Columbine, there have been fewer than half as many killings of students by students on school property since 2000 (averaging around ten per year) as there were in the early '90s (over forty killings per year).

237

They're gravitating toward group activity. Twenty years ago, community service was rare in most high schools. Today, it is the norm, having more than tripled since 1984, according to the US Department of Education. A 1999 Roper survey found that more teenagers blamed "selfishness" than anything else when asked about "the major cause of problems in this country."

They trust and accept authority. Most teens say they identify with their parents' values, and more than nine in ten say they "trust" and "feel close to" their parents. A recent survey found 82 percent of teens reporting "no problems" with any family member–versus just 48 percent who said that back in 1974, when parents and teens were far more likely to argue and oppose one another's basic values. Half say they trust government to do what's right all or most of the time–twice the share of older people answering the same question in the same poll. Large majorities of teens favor tougher rules against misbehavior in the classroom and society at large.

They're the most watched-over generation in memory. The typical day of many a child, tween, or teen has become a nonstop round of parents, relatives, teachers, coaches, babysitters, counselors, chaperones, minivans, surveillance cams, and curfews. Whether affluent or not, kids have become more closely managed. Since the mid-'80s, "unstructured activity" has been the most rapidly *declining* use of time among preteens.

They're smart. Since the late '80s, grade school aptitude test scores have been rising or (at least) flat across all subjects and all racial and ethnic groups. The number of high school students who take and pass an Advanced Placement test has more than doubled in the past ten years. Fully 73 percent of high school students today say they want a four-year college degree. A growing share is taking the SAT.

Even so, the average SAT score is the highest in thirty years. Eight in ten teenagers now say it's "cool to be smart."

Not all Millennials reveal these traits, of course. Every generation has all kinds of people, but so too does every generation have core traits that drive new trends and construct a new overall persona.

These Millennial traits reflect the fact that this generation was, from the start, more wanted than the one that came before. Born in an era when Americans showed a more positive attitude toward children, the Millennials are the product of a birthrate reversal. During the Gen Xer childhood, planned parenting meant contraceptives. During the Millennial childhood, it has meant visits to the fertility clinic. In 1998, the number of US children surged past its previous Baby Boom peak. Over the next decade, college freshmen enrollment is due to grow by roughly 40,000 per year.

Once you appreciate how Millennials have been regarded as special since birth and have been more obsessed-over at every age than Gen Xers, recent adult trends come into sharper focus. Falling divorce and abortion rates begin to make sense. You can understand why harms against children (from child abuse and high school gunfire to bloody video games and child kidnappings) are far less tolerable today than twenty years ago. You can clue in to why nearly every political issue of the '90s was recast as what newsweeklies call "kinderpolitics," as in: If it's good for children, do it–and if it isn't, don't. Year by year, for officeholders in both parties and at all levels, America's kids became not just a political trump card, but something like public property.

The Millennial Location in History

One way to define a generation's location in history is to think of a turning point in the national memory that its earliest birth cohorts just missed. Boomers, for example, are the generation whose eldest members have no memory of VJ Day. Gen Xers are the generation whose eldest members have no memory of John **239**

Kennedy's assassination. Millennials are the generation whose eldest members have no memory of sitting in school watching the space shuttle *Challenger* disintegrate.

Let's trace the historical location of each of the generations described earlier.

The Silent (born 1925 to 1942) arrived during the Great Depression and World War II, events they witnessed through the eyes of childhood, tending their Victory Gardens, while the next older GI generation built and sailed in the Victory Ships that won the war.

Boomers (born 1943 to 1960) arrived during the "Great American High" that followed the war, a childhood era of warmth and indulgence that marked them forever as a "postwar" generation, while the next older Silent compliantly entered the suburban and corporate world.

Gen Xers (born 1961 to 1981) arrived during the "Consciousness Revolution," amid the cultural, societal, and familial turbulence of the Boomers' young adulthood.

Millennials (born 1982 and after) arrived during the recent era of the "Culture Wars," while Gen Xers embarked on their young-adult dotcom entrepreneurialism.

America could now be entering a new post-9/11 era. How the "War on Terror" will affect Millennials over time, as they become young adults, is a matter of speculation. So far, the mood is reinforcing several Millennial traits and desires that were already apparent—including their orientation toward personal safety, family closeness, community action, applied high-tech, and long-term planning.

Millennials live in a world that has taken trends Boomers recall from their childhood and turned them upside down. Boomers can recall growing up with a homogenizing popular culture and a wide gender-role gap in an era when community came first and family stability was strong (though starting to weaken). Millennials have grown up with a fragmenting pop culture and a narrow gender-role gap in an era when individuals came first and when family stability was weak (though starting to strengthen).

As a postwar generation, Boomers arrived just when uniting, conforming, and building communities seemed the nation's logical priority. As a post-awakening generation, Millennials began to arrive just when diverging, liberating, and building strong lives as individuals seemed preferable. Such reversals reflect a fundamental difference in the two generations' location in history.

Millennials also represent a sharp break from Generation X. Gen Xers can recall growing up as children during the '60s and '70s, one of the most passionate eras of social dissent and cultural upheaval in American history, an era in which the needs of children were often overlooked or discounted. All this has left a deep impression on most of today's young Gen-X adults.

But Millennials can recall none of it. They have no personal memory of the ordered Cold War world (when only large and powerful governments had weapons of mass destruction). They only know about a post-Cold War era of multilateral confusion and power vacuums (when terrorists and rogue states are seeking these weapons). This generation has been shaped by such formative collective experiences as Waco, Oklahoma City, Columbine, the World Trade Center, and now 9/11 and the War on Terror. In all these instances, the real danger seems to come not from out-of-control institutions, but from out-of-control individuals, or small groups of conspirators, who have become a menace to humanity because national or global institutions are not strong enough to control or even monitor them.

For young Boomers, untethered individuals were the solution. For Millennials, they are more likely to be the problem.

How Boomers and Gen Xers have responded to their own location in history is a story that is mostly written, a story replete with ironies and paradoxes. How Millennials will respond to theirs is a drama waiting to unfold. Yet if you know what to look for and why, certain themes in this drama can be anticipated, and their implications pondered.

How Millennials Will "Rebel"

Over 150 years ago, Alexis de Tocqueville observed that in America "each new generation is a new people." The question arises: Does some pattern or dynamic determine how each generation will be new?

Yes.

Three basic rules apply to any rising generation in nontraditional societies, like America, that allow young people some freedom to redefine what it means to be young, and to prod older people to change social mores—in other words, to "rebel."

· First, each rising generation *breaks with the styles and attitudes* of the young-adult generation, which no longer functions well in the new era.

· Second, each rising generation *corrects for what it perceives as the excesses* of the current midlife generation—their parents and leaders—sometimes as a protest, other times with the implicit support of parents and leaders who seek to correct the deficiencies of the adult world.

· Third, each rising generation *fills the social role* being vacated by the departing elder generation, a role that now feels fresh, functional, desirable, even necessary for a society's wellbeing. Through the living memory of everyone else, this dying generation has filled a social role so firmly as to prevent others from claiming it. Now, with its passing, it's available again to the young.

When you apply these rules to the generational dynamic in America, you can see what's been happening, and will continue to happen even more powerfully, with Millennials.

Millennials will rebel against Gen-X styles and attitudes, correct for Boomer excesses, and fill the role vacated by the GIs.

Stylistically, today's teens are breaking with today's thirtyish Gen Xers and the whole "X" (and "X-treme") attitude. Expect teamwork instead of free agents, political action instead of apathy, technology to elevate the community and not the individual, on-your-side teamwork in place of in-your-face sass.

Gen Xers in their late twenties and thirties often regard themselves as the trend-setters of the teen culture, but often they know little about what actually goes on there. After all, they haven't seen the inside of a high school in many years. So they fall out of touch and, in time, a new batch of teenagers breaks with their culture. This happened in the early '60s, again in the early '80s, and it's starting to happen again.

Meanwhile, Millennials will correct for what teens see as the excesses of today's middle-aged Boomers: narcissism, impatience, iconoclasm, and a constant focus on talk (usually argument) over action. In their "rebellion," Millennials will opt for the good of the group, patience, conformism, and a new focus on deeds over words. When they argue among themselves, they will value finding consensus more than being right. When they argue with older generations, they will try to persuade by showing how more than by explaining why. With adults of all philosophical stripes yearning for "community," the Millennial solution will be to set high standards, get organized, team up, and actually create a community. Unlike Boomers, Millennials won't bother spending three days at a retreat to figure out how to rewrite a mission statement.

The third rule of rebellion may be the key to understanding not just what Millennials are now doing, but where they see their clearest path in the years ahead.

Remember those whom Tom Brokaw christened the "greatest generation"–the ones who pulled America out of Depression, joined unions, conquered half the globe as soldiers, unleashed nuclear power, founded suburbia, and took mankind to the moon. The most important link this "GI Generation" **243**

has to today's teens is in the void they leave behind: No other adult peer group possesses anything close to their upbeat, high-achieving, team-playing, and civic-minded reputation. Sensing this social role unfilled, today's adults have been teaching these (GI) values to Millennials, who now sense the GI "archetype" as the only available script for correcting or complementing the Boomer persona.

In his 2001 *Atlantic Monthly* cover story, David Brooks gave the label "Organization Kids" to these Millennials, a tacit reference to the original GI "Organization Man" and about as far as you can get from the "Bourgeois Bohemians" (or "Bobos") Brooks finds so common among today's middle-aged. Today's Millennial teens often identify the GIs as their grandparents. When asked in surveys to assess the reputations of older generations, Millennials now in college say they have a much higher opinion of GIs and a somewhat lower one of "Generation X" than they do of either generation in-between–Boomers (the children of the postwar American High) or the Silent (the children of World War II). Many speak glowingly about GIs as men and women who "did great things" and "brought us together as a nation."

Today's teens don't rebel against midlife Boomers by being hyper-Xers–not when the oldest Xers are themselves entering their mid-forties. They rebel by being GI redux, a youthful update of the generation against which the Boomers fought thirty years ago. No one under the age of seventy has any direct memory of teens, or twentysomethings, who are GI in spirit. Millennials are, and will be. That's why what's around the cultural corner is so profound that it might better be called a youth revolution. Rebellions peter out–but revolutions produce long-term social change.

Millennial Origins

Recall the last twenty years of American childhood. If you're a Boomer, this era may seem like only yesterday, because you may recall it as a

244

parent. If you're a Gen Xer, in all likelihood, you will know this era through a cloudier prism, since you were neither a child nor were raising children yourself.

The February 22, 1982 issue of *Time* published a cover story about an array of thirtysomething Boomers choosing (finally) to become moms and dads. This same year, bright yellow "Baby on Board" signs began popping up on the windows of minivans, a newfangled "family oriented" vehicle.

In the 1983 holiday season, adult America fell in love with Cabbage Patch Kids— a precious new doll, harvested pure from nature, so wrinkly and cuddly-cute that millions of Boomers wanted to take one home to love. Better yet, why not produce your own genuine, live Millennial?

After twenty years of wanting more distance between themselves and their children, new parents now wanted closeness. From 1974 to 1990, the share of fathers present at the birth of their children rose from 27 to 80 percent—an historic shift helped along by hundreds of Lamaze teachers. By 1990, the "attachment parenting" childrearing style of William and Martha Sears became the vogue.

The *era of the wanted child* had begun.

In September 1982, the first Tylenol scare led to parental panic over trick-or-treating. Halloween suddenly became a night not merely of celebrating silly scary things, but also of hotlines, advisories, and statutes—a fate that soon befell many other once-innocent child pastimes, from bicycle-riding to BB guns.

A few months later came national hysteria over the sexual abuse of toddlers, leading to dozens of adult convictions after what skeptics liken to Salem-style trials.

All the while, several influential new books (*The Disappearance of Childhood, Children without Childhood, Our Endangered Children*) assailed the "anything goes" parental treatment of children since the mid-'60s. Those days were ending. The family, school, and neighborhood wagons were circling.

The *era of the protected child* had begun. **245**

In the early '80s, the national rates for many behaviors damaging to children–divorce, abortion, violent crime, alcohol intake, and drug abuse–reached their post-war high-water mark. The well-being of children began to dominate the national debate over most family issues: welfare, latchkey households, drugs, pornography.

In 1983, the federal *Nation at Risk* report on education blasted America's K–12 students as "a rising tide of mediocrity," prompting editorialists to implore teachers and adults to do better by the next batch of kids.

In 1984, *Children of the Corn* and *Firestarter* bombed at the box office. These were merely the latest installments in a child-horror film genre that had been popular and profitable for well over a decade, ever since *Rosemary's Baby* and *The Exorcist*. But parents suddenly didn't want to see them. Instead, they begin flocking to a new kind of movie (*Baby Boom, Parenthood, Three Men and a Baby*) about adorable babies, wonderful tykes, and adults who would themselves become better people by choosing to look after them.

The *era of the worthy child* had begun.

In 1990, the *Wall Street Journal* headline–"The '60s Generation, Once High on Drugs, Warns Its Children"–was echoed by the *New York Times*: "Do As I Say, Not As I Did." Polls showed that Boomer parents did not want their own children to have the same freedom with drugs, alcohol, and sex that they themselves had once enjoyed.

By the early '90s, elementary-school kids were in the spotlight. During the Gulf War Super Bowl of 1991, children marched onto the field at halftime amid heavy media coverage (unseen during the Vietnam War) of the children of dads serving abroad.

Between 1986 and '91, the number of periodicals offered to young children doubled, and between 1991 and '94, the sale of children's music also doubled. In tot-TV fare, "Barney and Friends" (featuring teamwork and what

kids have in common) stole the limelight from "Sesame Street" (featuring individualism and what makes each kid unique).

During 1996, major-party nominees Dole and Clinton dueled for the presidency amid much talk about "soccer moms" and the safety of young teens (smoking, curfews, limitations on first-time drivers licenses).

During 1997, Millennials began to make an impression on the pop culture. Thanks to the Spice Girls, Hanson, and others, a whole new musical sound appeared—happier, brighter, more innocent. "They like brands with heritage. Contrived, hard-edged fashion is dead. Attitude is over," MTV president Judy McGrath said of her company's new teen interns." They like what's nice and fun in fashion and sports. They like the Baby Gap ads. They're simple and sweet."

The *era of the perfected child* had begun.

Actually, those MTV interns were late Xers, born a little before 1980. But the big change—the revolution in youth—is coming from those 1982–86 birth cohorts. Other key trends await the Millennials' second wave, born later in the '80s. Test scores, though improving gradually for first-wavers, are likely to ramp up steeply once today's heavily homeworked, super-tested tweens enter high school. By the time the preteens of 2001 reach college age, and campuses are a hotbed of Millennial styles, the true Millennial persona will reveal itself in full force.

Boomers started out as the objects of loosening child standards in an era of conformist adults. Millennials have started out as the objects of tightening child standards in an era of nonconformist adults. By the time the last Millennials come of age, they could become the best-educated youths in American history, and the best-behaved young adults in living memory. But they may also have a tendency toward copying, consensus, and conformity that educators will want to challenge, as well as many other new personality traits that will require broad changes in the world of higher education. **247**

Through the late '90s, these same much-watched children passed through high school, accompanied by enormous parental, educational, and media fascination–and headlines, not all of them positive. After the April 1999 Columbine tragedy was replayed again and again on the news, this adult absorption with Millennial safety, achievement, and morality reached a fever pitch. Eighteen months after Columbine, these wanted, protected, worthy, perfected children began entering college.

Twenty years ago, the arrival of Generation X on campus took many institutions of higher learning by surprise. Professors and administrators began noticing that incoming students were less interested in the protest movements that had driven college life throughout the '60s and '70s.

The Gen-X attitude toward knowledge was more instrumental. In history classes, students were less likely to ask about which wars were moral than about how you win one. The most highly motivated students gathered in professional schools, where the object was less to change the world than to enable grads to make a lot of money. A good student was one who could get the best transcript with least possible expenditure of effort–a bottom-line focus which Gen Xers maintained as entry-level workers in the late '80s and '90s, with wondrous consequences for the economy's productivity.

Institutions of higher learning had to adjust to fit this style of student. *In loco parentis*, already under assault during the '60s and '70s, virtually disappeared. Pass/fail grading options became available for many if not most classes, and core curricula requirements relaxed. Widespread use of drug and alcohol forced colleges and universities to build new relationships with local police. Speech codes were enacted to counter uncivil discourse. Large, school-wide events became less common as cynicism about school spirit and campus community spread. Students took longer to earn their degrees.

College clientele changed as well. More foreign, older, and "continuing education" students were enrolled. To meet shifting demand driven by changing economic conditions, business and law schools expanded, while science and engineering departments were increasingly the province of international students.

Now, with the arrival of the Millennials, campus life is undergoing another transformation. Policies needed to accommodate or manage college students in the '80s and '90s have become inappropriate. Instead, in the current decade, college administrators have been adjusting their institutions to a new crop of students who are:

- Close to their parents
- Focused on grades and performance
- Busy with extracurricular activities
- Eager to volunteer for community service
- Talented in technology
- More interested in math and science, relative to the humanities
- Insistent on a secure, regulated environment
- Respectful of norms and institutions
- Ethnically diverse, but less interested in questions of racial identity
- Majority female, but less interested in questions of gender identity

They also are very numerous and very intent on going to college, which are making these trends all the more consequential.

In the fall of 2004, the first Millennials entered law schools, medical schools, and others postgraduate programs. As they flood into the highest student reaches of academe, every aspect of university life is revealing a new young-adult mindset.

From *Millennials and the Pop Culture:*
Strategies for a New Generation of Consumers in Music, Movies, Television, the Internet,
and Video Games (Great Falls, VA: LifeCourse Associates, 2006).

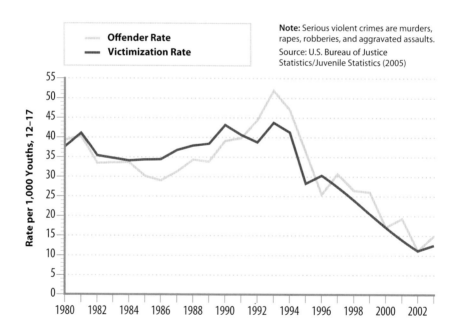

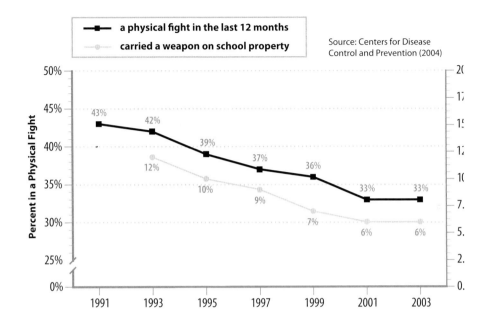

Source: Centers for Disease
Control and Prevention (2004)

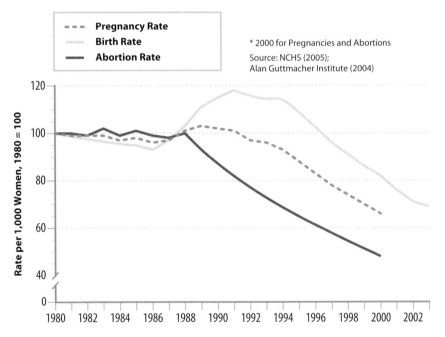

* 2000 for Pregnancies and Abortions

Source: NCHS (2005);
Alan Guttmacher Institute (2004)

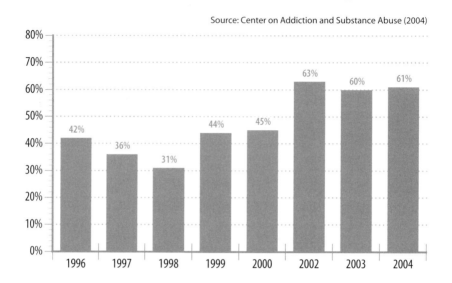

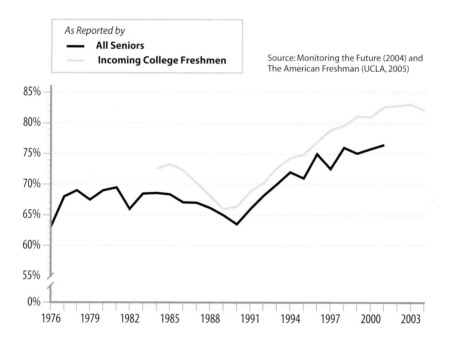

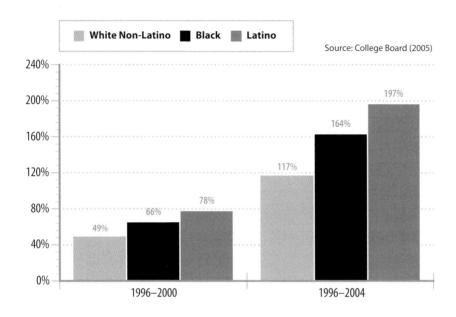

White Non-Latino Black Latino

Source: College Board (2005)

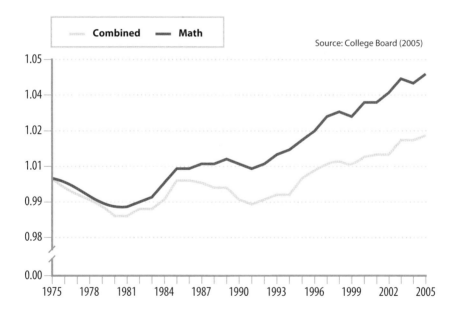

Combined Math

Source: College Board (2005)

LaToya Ruby Frazier,
Gramps in his bedroom, 2003.
Gelatin silver print, 16 x 20 in (40.6 x 50.8 cm).
Collection Harvard University Fogg Art Museum
(Detail)

How to Bottle a Generation

Eric Wilson

In 1994, Calvin Klein designed a fragrance that embodied, in its flat little screw-top bottle, the disaffected, sexually ambivalent grunge youth of the moment. CK One, with its unconventional black-and-white advertisements filled with moping, androgynous models, was arguably the most perfectly tailored fragrance ever pitched to one market, breaking industry rules and records, selling twenty bottles per minute at its peak. A unisex brand that became the olfactory talisman of Generation X, CK One was so authentically grunge it was carried in record stores alongside albums by Nirvana.

Next month, Calvin Klein Inc. and Coty, its fragrance licensee, will introduce a sequel to CK One for a new generation, the so-called Millennials, and in doing so, they will attempt to capture lightning in a bottle for a second time. Calvin Klein, now without its namesake designer, hopes to rejuvenate a fragrance embodying the essence of hip twenty-somethings–even at the risk that such a notion is as outdated as a Prince song about partying like it's 1999.

There are reasons to ask whether the Calvin Klein company can repeat its CK One success. The beauty industry has been in a slump for several years, facing a decline that is in part the result of young consumers spending more money on electronics than on fashion and fragrances. CK One offshoots–CK Be, introduced in 1996; several limited-edition bottle designs since 2000; and a fruitier CK One remix from the summer of 2004–served as little more than stopgaps in the decline of a brand that, to today's young adults, is as antiquated as shopping for music in a record store.

CK One, which had annual sales of about $90 million in the mid-1990s, now sells about $30 million in the United States, its reign having ended around the time Klein sold his company to Phillips-Van Heusen in 2002 and stepped back from daily involvement. Added to its other challenges, the Calvin Klein company is trying to develop a hit fragrance without the

era-defining instincts Klein displayed in the days when he hired Brooke Shields to sell blue jeans. The only major figure to carry over from the creation of the original scent is Ann Gottlieb, a fragrance consultant and the nose of Calvin Klein since the designer started making scents in 1985. She described the concepts of CK One and its sequel "as different as red and yellow."

Last month, in a minimal white conference room at the Calvin Klein offices on West 39th Street in the garment district, Tom Murry, the president of the company, reviewed a series of outtakes filmed for a commercial for the new fragrance. They depict the actor Kevin Zegers (who played the son of a pre-operative transsexual in "Transamerica") in romantic pursuit of a model, Freja Beha Erichsen.

A companion ad to appear in magazines, photographed by the artsy duo Inez van Lamsweerde and Vinoodh Matadin (replacing Steven Meisel, who created the iconic CK One campaign), shows Erichsen leaning against a wall, tugging off Zegers's belt as he twists a strand of her hair.

The page is layered with watery graffiti images of the words "sex" and "today," and on top of that, as large as the models, two glass bottles shaped like rocket silos topped in white plastic casing and the name of the new scent: CK in2u.

Embedded in these images, as described by a half-dozen Calvin Klein and Coty executives gathered around a table, is a portrait of a generation they describe as physically bold but emotionally guarded, having grown up using computers as a primary means of interaction. Now young adults, they are post-Abercrombie, post-Juicy Couture and over any number of scents derived from the essences of Jennifer Lopez, Britney Spears, and Paris Hilton.

The CK in2u bottle, designed by Stephen Burks, is made from the same materials—white plastic and glass—recognizable in an iPod. (Fabien Baron designed the original bottle.) The name is written in the shorthand of

an instant message, a casual invitation to sex so immediate as to imply there was no time to spell it out: "in to you."

"We have envisioned this as the first fragrance for the technosexual generation," said Murry, using a term the company made up to describe its intended audience of thumb-texting young people whose romantic lives are defined in part by the casual hookup.

Last year, the company went so far as to trademark "technosexual," anticipating it could become a buzzword for marketing to Millennials, the roughly 80 million Americans born from 1982 to 1995. A typical line from the press materials for CK in2u goes like this: "She likes how he blogs, her texts turn him on. It's intense. For right now."

Which may turn off its intended audience by the tens of thousands.

Few consumers like being marketed to less than twenty-somethings, and Calvin Klein and Coty know this because, as part of their development of CK in2u, they interviewed young consumers thought to be typical of their generation, including ones in the Dumbo and Williamsburg sections of Brooklyn.

"They have less brand loyalty," said Lori Singer, a vice president for global marketing for Coty, referring to twenty-somethings. "They don't want to feel that they are being marketed to or spoken at. They are much more empowered, but they are unshockable. They have seen everything from 9/11 to Paris Hilton and Britney Spears without underwear. They see everything instantaneously that goes on in the world."

Youngna Park, twenty-four, a freelance photographer, would seem to be just this kind of individual and consumer. She has been interviewed by companies looking to tap into the Millennial mindset (though not by the researchers for CK in2u). Park moved to New York two and a half years ago and began taking pictures in restaurants and writing an online food column for **257**

Gothamist, a blog for urban markets. Her network of friends and professional contacts was forged partly through the Internet, and she has occasionally dated people she met online.

She would seem an ideal candidate to illustrate the term "technosexual," if the idea did not immediately turn her off. "That's such a weird phrase," she said. "I just imagine kids putting on cologne to sit behind their computers. That's really weird."

A friend of Park's, Zach Klein, twenty-four, has also participated in market surveys attempting to distill his demographic, though he was skeptical of the idea of companies adapting to the language of the target audience.

"What's most interesting about our generation is that it is very obvious when brands are attempting to market down to us when they use our own vernacular or types of personal technology," Klein said. "It's very transparent, and I tend to shy away."

Klein (no relation to Calvin) was a partner in the Website CollegeHumor.com when it was sold to Barry Diller's IAC/Interactive and is now developing a music site. He said he admired the Calvin Klein brand and its marketing, but "abbreviating in2u like that is lame," he said, "to put it simply."

To seem more authentic, Calvin Klein is trying to reach consumers on their own turf by creating an online community, whatareyouin2.com, patterned after sites like MySpace and Facebook. The company has invited students at film schools around the country to submit shorts addressing the theme of "what are you into?" and their clips can be found on the site.

The response to CK in2u among fragrance retailers at trade shows was so strong, the company says, that it delayed its introduction by a month, to April 1, to increase production to close to two million units, nearly twice the

initial volume of its Euphoria women's fragrance in 2005.

The timing of the introduction may be fortunate, as statistics released last month by the NPD Group, the market research concern, indicate that the consumer appeal of celebrity fragrances, most of them targeted to Millennials, has waned considerably. Sales of celebrity scents in department stores in the United States dropped last year by 17 percent to $140 million from 2005, despite a significant increase in the number of new celebrity scents. This drop, Calvin Klein executives believe, leaves room in the overall $2.8 billion prestige fragrance business for new ideas like CK in2u.

"We've been seeing a trend among younger consumers toward more fragrances from designer brands than from celebrities," said Karen Grant, a senior beauty analyst for NPD Group. "The new Millennial Generation didn't have a CK fragrance for them. So this really is a good opportunity to launch this."

Gottlieb, the Calvin Klein nose, has an instinct for what sells. "If I know enough about the target audience, I can develop a scent for anyone," she said. "The way I work is less about ingredients than the feelings they evoke."

The fizzy, fruity flavor of CK One was an intentionally unexpected counterpoint to the prevailing gloomy image of the generation. CK in2u is more direct, she said, "spontaneous and seductive."

The women's scent includes notes of pink grapefruit, bergamot, and red currant with a core of neon amber, the common denominator of all Calvin Klein scents. The men's version of CK in2u is more beachy, with a salty mix of lime, cocoa, and musk.

Because Millennials are used to fast-moving information and images, Gottlieb said, the fragrance is meant to be quick-acting and immediately recognizable on the skin. Their food and drinks, like Smartwater and coffee-flavored colas, and gum charged with flavor crystals, all come in high-definition, intensified varieties. So their fragrance should also seem busy.

"More than anyone, Americans smell with their eyes and their brains before they smell with their noses," she said.

Park and her friend Klein do not discount entirely the likelihood of CK in2u becoming a blockbuster for their generation. Trends spread fast among their peers because they are so networked, accustomed to taking cues from what they see online. The Web can give anything–clothing, sneakers, fragrance–a viral aspect. But the Web can also leave anything open to ridicule, exposing marketing ploys, not to mention "technosexuals," for what they really are.

Adriana Lara,
Art Film 1: Ever present yet ignored, 2006.
16mm black-and-white film transferred to DVD,
7:30 min
(Detail)

They Play Games

for Ten Hours and Earn $4 in a "Virtual Sweatshop"

Tony Thompson

Bogdan Ghirda is paid $105 a month to do what most bosses would fire him for. From the moment he arrives at work, he plays computer games on the Internet. With only a few short breaks Ghirda, twenty, goes on playing furiously for ten hours in the backroom of a rundown apartment block in Caracal, Romania. The moment he leaves his desk a member of an evening shift takes over the computer and continues the same game with equal determination.

Between them, the company's eleven employees keep a dozen or so computers running twenty-four hours a day, seven days a week.

Although Ghirda works in Romania, the computers and the Internet connection he uses are paid for by a company in northern California. Gamersloot.net is one of a growing number of firms taking advantage of a boom in online computer games by opening "virtual sweatshops," using the low pay in poor countries to provide services for wealthy Western players.

Older computer games pit a single player against computerized opponents, but the new ones allow players to join forces with others anywhere in the world. There are now an estimated 350 such games, the most popular of which have more than 300,000 subscribers, each paying a monthly fee to keep his or her place.

"Depending on how you define 'sweatshop,' I guess we qualify," says Patrick Bernard, head of Gamersloot.net. "If you mean exploiting helpless people and making them work fifteen plus hours a day at repetitive tasks that they hate in appalling work conditions, that's not us.

"If you mean employing people that don't mind 'playing' a computer game for eight to ten hours a day at a wage that would starve a UK resident but is a decent salary for an employed university graduate in their country then yeah, that's us.

263

"One of the things that gets me up in the morning is knowing that the people in Romania are making a decent living out of what I'm doing, and that without it some of them might have turned bad. I feel very good about that. It's a decent job, not a career perhaps, but there are far worse things they could be doing."

When the *Observer* arrived in Caracal, a bleak-looking town of 33,000 inhabitants three hours from the capital, Bucharest, the local Internet connection had failed and the staff were sitting around with nothing to do. For Ghirda, who joined the company a year ago, the job compares favorably with his previous one in a local club.

"I'd never played any kind of computer game before I started here," he said. "I was working as a barman when I saw a commercial on television asking for people who spoke a little English and liked to play games to apply for a job.

"The money I make here [equal to just 42 cents an hour] is around the same that I made in the bar but this is much better."

The television commercial was placed by his twenty-six-year-old boss, Adrian, whose apartment is the base for the operation. "Caracal is a dead town, a ghost city," Adrian said. "There is no industry and many of the factories are closed. People are desperate for work.

"When I bought the advertisement I got a huge response. Lots of women in their forties and fifties were so desperate for work that they applied for the job too."

The games are highly addictive—the average player spends twenty-two hours per week online—and Adrian acknowledges that this can work to his advantage. "Quite often at the end of the shift I have to tell people to go because they want to carry on playing. Sometimes they come in on their days off and play the game some more."

An hour later the Internet connection is back and the day's work begins. Ten computers are switched on and Ghirda and two young col-

264

leagues on the day shift assume the parts of numerous characters, and begin fighting huge groups of virtual "bad guys."

Their skills are so finely honed that they easily win every battle, earning valuable experience points which can then be passed on to other players.

The most valuable commodity in all such games is time, and this has spawned the rise of the virtual sweatshops. Every new player starts at the bottom with little virtual money and few skills. Moving up to the next level of the game involves carrying out dull, repetitive tasks such as killing thousands of virtual monsters.

But thanks to companies such as Gamersloot.net, new players now have an alternative. They simply pay someone else to do the dull repetitive work, and buy a readymade character at a more advanced level.

Getting to the highest level in some games takes months and for players working alone is almost impossible to achieve. Gamersloot.net offers to promote your character in a matter of days for a fee of around $370.

Other companies–most of them based in Russia and Asia–concentrate on "farming" virtual currency that is then exchanged over the Internet for the real thing. Last week 10 million Adena, the currency from a game called Lineage, was retailing for around $80. Up to 200 gold pieces, the currency from Everquest, could be bought for around $70.

The virtual sweatshops represent only a small part of the overall market in virtual goods. The auction Web site eBay is selling everything from virtual daggers and magic potions to high-level Elves and Jedi Knights for up to $1,100, in a market worth more than 700 million.

The Top Games

Everquest

Players meet in a medieval virtual world called Norrath. There they pick a character to play, such as a warrior, a blacksmith, or a healer, and then band together to slay magical beasts. Completing such quests earns the players virtual currency that can be used to buy better weapons or other equipment. It can also be used to purchase houses. Everquest is said to be so addictive it is often referred to as Evercrack.

World of Warcraft

Warcraft has proved so popular with more than 400,000 subscribers in its first six months that the manufacturers have stopped providing new copies. Revolving around a battle between Orcs and humans, players create characters which they take through a fantasy world, learning magic and mastering weapons to vanquish foes. Players can fight against computer-generated characters or against other players.

Eve Online

This game takes place in space. A player starts off as the captain of a small mining vessel but can progress to become the head of a mighty corporation, a trader, or a mercenary. Some players decide to become pirates and spend their time flying around attacking other players. Unlike normal computer games that stop when you switch off, these continue in your absence. One reason they are so addictive is that players are afraid of what they might miss if they leave the game.

From guardian.co.uk, Sunday Mar. 13, 2005. © Guardian News & Media Ltd 2005.

Anna Molska,
Jesus Loves Me, 2005.
Digital video, black and white, sound,
2:43 min
Courtesy Foksal Gallery Foundation, Warsaw
(Detail)

Private, Public, and the Collapse of the Personal

Clay Shirky

The big change in privacy in our current social environment isn't a simple decay, from more to less. It is instead a change from privacy as part of that environment to privacy as an affirmative right, one that must be negotiated with every merchant and every government agency and even every friend whose life touches ours. How that haggling gets resolved—with businesses, with the government, and within our social network—is in many ways less momentous than the emergence of privacy as something that has to be haggled over at all.

It was not always this way. Back in the technological dark ages (circa 1980, say) the public and private sphere were separated by a wide gulf, enabling one to engage in behavior that was observable in principle but unobserved in practice, a gulf we might call "personal" (a word that has fallen into recent disuse, except as a label for certain electronic gadgets).

In those days, there were microphones and cameras and computers, all of which provided a mechanism for fixing evanescent thoughts or actions into a storable form, but its potential remained untapped for most citizens.

Then as now, we had a notion that our love letters or medical data were rightly defended from casual view, but unlike now, we could also assume that our behavior wasn't being recorded when we confided in our friends or joked with our colleagues or even walked down the street. Technological possibility had not yet become technological reality—our personal behaviors weren't private, in the sense of being actively hidden, but nor were they public, in the sense of being readily and cheaply available to all. In that era, most of our unobserved behavior wasn't concealed—it was just ignored; the principal guarantor of privacy wasn't rights or privileges, it was the sheer inconvenience of trying to capture every bit of information about everybody.

And now it is pretty easy to do that, and getting easier every day. In the generation between then and now, several major shifts have occurred. The first was what always happens to technology: It got cheaper and more effective at the same time. The cost of absolutely every form of information capture has plummeted. Cameras are so cheap they are added to phones as a freebie. Video surveillance is no longer found only in banks but is now a common feature of nearly every store, small or large. The most trivial utterances around the water cooler are sent through the ether and stored, almost by accident, alongside the wisdom of the ages.

As the cost of capture and storage has fallen, the ease of retransmission has increased and spread. Your ability to recount verbally what a friend told you over dinner is unreliable–you could be misremembering or dramatizing your friend's utterances in the retelling. However, your ability to republish exactly what a friend told you in an e-mail is effortless and the result is perfectly accurate; it would be accepted as evidence in a court of law.

It used to take considerable effort just to try to make something public. The old phrase "Shout it from the rooftops" conjures up some of the ad-hoc and impractical nature of an individual citizen emulating a media outlet. Now, everyone with a computer or a phone has been given both a rooftop and a megaphone. The costs to an individual citizen to make something public, measured not just in expense but in time and risk, have fallen so far that the key question of publishing information has been reversed. When doing so was expensive and relatively rare, the question was simple: "Why publish this?" As almost anyone can now become an accidental publisher, the question is now the opposite: "Why not publish this?" Photo sharing is the canonical example, depending as it does on the billions of cheap cameras and camera phones in the hands of the public. With the resulting high volume of photos sent and

received each day, it is easier to share all of them than to edit out the boring or disclosing shots in advance. Just upload it all and sort it out someday, or never; why not?

As making things public has become cheaper and easier, keeping things private has become harder and more expensive. If you had a paper document you wanted to keep out of the public eye, simple inaction was usually enough: Just put it on a shelf instead of handing it around. There were always places where more security was needed (trade secrets and spies' identities and the location of buried treasure have always required heightened vigilance), but for most people, keeping our private information private required no heroic effort. Now, however, our most reflexive actions—which used to remain unequivocally in our personal sphere—increasingly fall into either the easily public or the expensively private sphere. Consider, as a thought experiment, trying to walk without being photographed from, say, the Empire State Building to the Lower East Side, or to drive from Buckingham Palace to Brick Lane without a surveillance camera recording your car's license plate. It's impossible even to imagine such a thing without the aid of some form of intentional cloaking.

In the same way we have all become accidental publishers, we have all become accidental archivists. Just as social networks and Web blogs flip the question of publishing from "Why publish this?" to "Why not?", the availability of cheap storage flips the question of whether to save information from "Why keep this?" to "Why throw this away?" Consider the problem of sending e-mail to a friend when you want its contents not to spread any further than that friend. You can no longer rely on simple inconvenience to aid you in keeping the information confidential; it all falls to your friend's discretion over what you've shared, and the ease and accuracy of sending digital information weakens this defense. Friendships can fade or even dissolve over the **271**

years (with deeper secrets and more intense reversals applying *a fortiori* to lover-s' confidences), but a perfect record often remains of every word you said. This record may outlast the relationship, ready to be copied a million times at no cost and in the blink of an eye, should the rest of the world come to care about what you said.

The most recent growth in accidental archives is occurring via the tele-phone. McLuhan's dictum that the contents of the new medium are the old media is coming true, again, as the Internet carries more and more of our phone calls. When our voices are digitized, those digital recordings of what we have said can also be stored, often for the best of reasons. This form of transmitting messages is as reproducible as e-mail while preserving the more emotional con-tent of human speech, and puts the technology for making, saving, and/or send-ing those voice recordings in the hands of ordinary people. Calls used to be recorded only by institutions–by businesses, "for quality purposes," or by the police, for other purposes–but phone calls transmitted over the Internet are now being recorded by individuals, for later reference, for pure sentiment, or merely because they don't know what might matter to them in the future. Given the continued fall in the cost of digital storage and the continual rise in the cost of human time, it is now cheaper to keep things by accident than to delete them on purpose. Having a conversation that isn't being archived, whether deliber-ately or not, is becoming as rare as passing through town without being pho-tographed.

Making things public has gone from difficult to easy and from expensive to cheap. Keeping things private has gone in the opposite direction. And the per-sonal sphere–which used to be the envelope that contained most of our speech and action–is slowly disappearing. In many of the current arguments

around privacy, and especially privacy in the market, much of the

discussion is around informed consent by the users, and the question of opt in vs. opt out. Should your doctor share your medical records? Should Facebook tell the world you just bought a new pair of shoes? Yes or no? But beyond yes or no, there is, or was, a third option: Don't ask. By the time the conversation has rolled around to opting in vs. opting out, the collapse of the personal sphere has already taken place.

The stories we hear about the loss of privacy are usually about a particular loss–identity theft, say, or unwanted disclosure. Much harder to quantify is the general loss, not of the right to privacy but rather of the right not to have to think about our privacy, the right to take for granted some large sphere of observable but unobserved speech and action. That era is already a dim memory for those of us who live in cities geared for high-tech communication, and it is fading everywhere, if only because the public access to satellite photography brings even the least digital among us into the world of recorded action.

This change is not limited to any narrow definition of privacy; when showing information is cheap and hiding it is expensive, it transforms all kinds of ancillary relationships. One example of this collateral change is the way our conception of the whistle-blower has altered in the last several years. In 2001, an Enron accountant Sherron Watkins sent e-mail to a handful of executives at Enron entitled, "Smoking guns you can't extinguish," detailing the suspect practices that Enron was using to hide the company's liabilities. As she put it, presciently: "I am incredibly nervous that we will implode in a wave of accounting scandals," which is exactly what happened the following year. Watkins was widely described as a whistle-blower, even though her e-mail was addressed to only a few insiders. Unlike any previous whistle-blower, all she did was write a particularly forceful interoffice memo. Watkins didn't in fact take anything private and make it public; the act of her e-mail becoming **273**

public took place months after the fact, when lawyers were searching Enron's e-mail archives.

The application of the whistle-blower label to Watkins signals that in an age where copying information can be done infinitely and exactly, the very act of documenting and sharing something can be a threat to privacy: Once data is shared, it is almost impossible to destroy all the copies, and anyone who has a copy can effortlessly broadcast it to the world at will. One may presume that from now on, the act of creating and circulating evidence of wrongdoing, even among a small group, will be regarded as a public act.

This is the kind of transformation that makes privacy impossible to frame as a single concept that persists across historical ages. For anyone contemplating the aesthetic, social, or historical dimensions of privacy, what may be toughest to grasp isn't the technological transformation of the current era (which has already been documented in tedious detail), but rather the emotional and social transformations that it creates. It is becoming harder to remember what it felt like to live at a time when privacy was easy to get and difficult to violate, and when we could expect that most of our behavior would be kept from public awareness. (For a teenager today, that world is already as distant as the Watergate scandal or the fall of the Berlin Wall.)

This coarsening of the world into public or private, and the collapse of the barriers between them, has led to a much-discussed generation gap. People under thirty or so, for whom digital tools are matter of fact, even boring, are often described as caring less about their own privacy than their elders do, and as being less inhibited and more exhibitionistic. Most of the discussion about this is being done by those very elders, and their descriptions tend toward the value-laden: "When I was young, we didn't tell the world about our

most recent trip to the mall! We didn't put party pictures of ourselves

out where our bosses could see!" The behavior of the world's callow youth is framed as a personal failing, a shift in behavior from the good old Right Way (our way) to a bad new Wrong Way (theirs).

But what if the change in behavior is an effect, not a cause? While it's tempting for those of us who are Of A Certain Age (a label that is now closer to thirty-five than fifty) to attribute novel and upsetting behaviors to a lack of common sense among our juniors, the truth is more banal: It wasn't forbearance that kept us from making our lives public when we were in our twenties—we didn't share our party pictures or random thoughts with the world because we never had the opportunity. These twentysomethings are the same kind of people we were, but responding to a different kind of incentive.

They are also responding to a different kind of threat. Much of the what has been described as self-disclosure is in fact disclosure by others. When every one of your friends has a camera phone, having your image transmitted to the public at large, or not, isn't necessarily your own personal decision to make. When the act of texting messages to your friends (and vice versa) creates a permanent and easily publishable record, you give up the option to defend your privacy unilaterally; perhaps the only way to restore this control to you would be to drop out of society.

Because we usually change our actions when we are being observed, the re-creation of privacy as a rare and expensive commodity produces behavior modification on a societal scale. We have built the panopticon, and it is us. If people today are acting out more, it is in part because they understand, correctly, that they are onstage more. This is a form of governance, as depicted in George Orwell's canonical novel 1984; but what Orwell didn't predict was that governance does not require Government. It turns out that ubiquitous observation is best achieved through ubiquitous observing, and social and market forces are better at driving that sort of change. **275**

Pascal Boyer, in his brilliant book *Religion Explained*, notes that one of the commonalities of religious belief, whether mono- or polytheistic, is that supernatural agents have access to strategic information (thus confirming H.L. Mencken's observation "Conscience is the inner voice that warns us somebody may be looking"). All religions, with or without an omniscient god, imagine spirits of some sort who can see what we are doing, even when we are alone. The gods are not real, of course, so this inner voice used to be wrong most of the time, but not anymore. One might describe as "godlike" the access that almost anyone has nowadays to strategic information about others; the number of people who may be looking, and the number of times they look, are growing by the day, often as much a side effect of us digitizing our lives as of other people setting out to observe us.

Thus, it falls to those of us wrestling with the current changes to deal with the metamorphosis of privacy from something we took for granted to something each individual has to consider almost daily. The hardest part of documenting and describing this change will be figuring out how to convey, to our peers and our descendants, just how weird things have gotten.

Ryan Trecartin,
I-BE AREA, 2007.
Digital video, color, sound,
108 min
Courtesy Elizabeth Dee, New York
(Detail)

Mirror, Mirror, on the Web

Lakshmi Chaudhry

"Everyone, in the back of his mind, wants to be a star," says YouTube co-founder Chad Hurley, explaining the dizzying success of the online mecca of amateur video in *Wired* magazine. And thanks to MySpace, YouTube, Facebook, LiveJournal, and other bastions of the retooled Web 2.0, every Jane, Joe, or Jamila can indeed be a star, be it as wannabe comics, citizen journalists, lip-syncing geeks, military bloggers, aspiring porn stars, or even rodent-eating freaks.

We now live in the era of micro-celebrity, which offers endless opportunities to celebrate that most special person in your life, i.e., you—who not coincidentally is also *Time* magazine's widely derided Person of the Year for 2006. An honor once reserved for world leaders, pop icons, and high-profile CEOs now belongs to "you," the ordinary Netizen with the time, energy and passion to "make a movie starring my pet iguana…mash up 50 Cent's vocals with Queen's instrumentals…blog about my state of mind or the state of the nation or the *steak-frites* at the new bistro down the street."

The editors at *Time* tout this "revolution" in the headiest prose: "It's a story about community and collaboration on a scale never seen before. It's about the cosmic compendium of knowledge Wikipedia and the million-channel people's network YouTube and the online metropolis MySpace. It's about the many wresting power from the few and helping one another for nothing and how that will not only change the world, but also change the way the world changes."

This is the stuff of progressive fantasy: change, community, collaboration. And it echoes our cherished hope that a medium by, of, and for the people will create a more democratic world. So it's easy to miss the editorial sleight of hand that slips from the "I" to the "we," substitutes individual self-expression for collective action, and conflates popular attention with social consciousness.

For all the talk about coming together, Web 2.0's greatest successes have capitalized on our need to feel significant and admired and,

above all, to be seen. The latest iteration of digital democracy has indeed brought with it a new democracy of fame, but in doing so it has left us ever more in the thrall of celebrity, except now we have a better shot at being worshiped ourselves. As MySpace luminary Christine Dolce told the *New York Post*, "My favorite comment is when people say that I'm their idol. That girls look up to me."

So we upload our wackiest videos to YouTube, blog every sordid detail of our personal lives so as to insure at least fifty inbound links, add 200 new "friends" a day to our MySpace page with the help of friendflood.com, all the time hoping that one day all our efforts at self-promotion will merit–at the very least–our very own Wikipedia entry.

In *The Frenzy of Renown*, written in 1986, Leo Braudy documented the long and intimate relationship between mass media and fame. The more plentiful, accessible and immediate the ways of gathering and distributing information have become, he wrote, the more ways there are to be known: "In the past that medium was usually literature, theater, or public monuments. With the Renaissance came painting and engraved portraits, and the modern age has added photography, radio, movies, and television. As each new medium of fame appears, the human image it conveys is intensified and the number of individuals celebrated expands." It's no surprise then that the Internet, which offers vastly greater immediacy and accessibility than its top-down predecessors, should further flatten the landscape of celebrity.

The democratization of fame, however, comes at a significant price. "Through the technology of image reproduction and information reproduction, our relation to the increasing number of faces we see every day becomes more and more transitory, and 'famous' seems as devalued a term as 'tragic,'" Braudy wrote. And the easier it is to become known, the less we have to do to earn that

280 honor. In ancient Greece, when fame was inextricably linked to pos-

terity, an Alexander had to make his mark on history to insure that his praises would be sung by generations to come. The invention of the camera in the nineteenth century introduced the modern notion of fame linked inextricably to a new type of professional: the journalist. Aspiring celebrities turned increasingly to achievements that would bring them immediate acclaim, preferably in the next day's newspaper, and with the rise of television, on the evening news.

The broadcast media's voracious appetite for spectacle insured that notoriety and fame soon became subsumed by an all-encompassing notion of celebrity, where simply being on TV became the ultimate stamp of recognition. At the same time, advertisers sought to redefine fame in terms of buying rather than doing, fusing the American Dream of material success with the public's hunger for stars in programs such as *Lifestyles of the Rich and Famous.*

But the advent of cyber-fame is remarkable in that it is divorced from any significant achievement—farting to the tune of "Jingle Bells," for example, can get you on VH1. While a number of online celebrities are rightly known for doing something (a blogger like Markos Moulitsas, say), and still others have leveraged their virtual success to build lucrative careers (as with the punk-rock group Fall Out Boy), it is no longer necessary to do either in order to be "famous."

Fame is now reduced to its most basic ingredient: public attention. And the attention doesn't have to be positive either, as in the case of the man in Belfast who bit the head off a mouse for a YouTube video. "In our own time merely being looked at carries all the necessary ennoblement," Braudy wrote twenty years ago, words that ring truer than ever today.

Celebrity has become a commodity in itself, detached from and more valuable than wealth or achievement. Even rich New York socialites feel the need for their own blog, socialiterank.com, to get in on the action. The advice for aspiring celebutantes may be tongue-in-cheek—"To become **281**

a relevant socialite, you are virtually required to have your name in the press"– but no less true in this age of Paris Hilton wannabes.

Fame is no longer a perk of success but a necessary ingredient, whether as a socialite, chef, scholar, or skateboarder. "For a great many people it is no longer enough to be very good at what you do. One also has to be a public figure, noticed and celebrated, and preferably televised," writes Hal Niedzviecki in his book *Hello, I'm Special.* When it is more important to be seen than to be talented, it is hardly surprising that the less gifted among us are willing to fart our way into the spotlight.

The fantasy of fame is not new, but what is unprecedented is the primacy of the desire, especially among young people. "I wanna be famous because I would love it more than anything… Sometimes I'll cry at night wishing and praying for a better life to be famous… To be like the others someday too! Because i know that I can do it!" declares Britney Jo, writing on iWannaBeFamous.com.

She is hardly unusual. A 2000 Interprise poll revealed that 50 percent of kids under twelve believe that becoming famous is part of the American Dream. It's a dream increasingly shared by the rest of the world, as revealed in a recent survey of British children between five and ten, who most frequently picked being famous as the "very best thing in the world." The views of these young children are no different from American college freshmen, who, according to a 2004 survey, most want to be an "actor or entertainer."

Our preoccupation with fame is at least partly explained by our immersion in a media-saturated world that constantly tells us, as Braudy described it, "we should [be famous] if we possibly can, because it is the best, perhaps the only, way to be." Less obvious, however, is how our celebrity culture has fueled, and been fueled by, a significant generational shift in levels of narcissism in the United States.

In the 1950s, only 12 percent of teenagers between twelve and fourteen agreed with the statement, "I am an important person." By the late 1980s, the number had reached an astounding 80 percent, an upward trajectory that shows no sign of reversing. Preliminary findings from a joint study conducted by Jean Twenge, Keith Campbell, and three other researchers revealed that an average college student in 2006 scored higher than 65 percent of the students in 1987 on the standard Narcissism Personality Inventory test, which includes statements such as "I am a special person," "I find it easy to manipulate people," and "If I were on the *Titanic*, I would deserve to be on the *first* lifeboat." In her recent book *Generation Me*, Twenge applies that overarching label to everyone born between 1970 and 2000.

According to Twenge and her colleagues, the spike in narcissism is linked to an overall increase in individualism, which has been fostered by a number of factors, including greater geographical mobility, breakdown of traditional communities, and, more important, "the self-focus that blossomed in the 1970s [and] became mundane and commonplace over the next two decades." In schools, at home, and in popular culture, children over the past thirty-odd years have been inculcated with the same set of messages: You're special; love yourself; follow your dreams; you can be anything you want to be.

These mantras, in turn, have been woven into an all-pervasive commercial narrative used to hawk everything from movie tickets to sneakers. Just do it, baby, but make sure you buy that pair of Nikes first. The idea that every self is important has been redefined to suit the needs of a cultural marketplace that devalues genuine community and selfhood in favor of "success." In this context, "feeling good about myself" becomes the best possible reason to staple one's stomach, buy that shiny new car, or strip for a *Girls Gone Wild* video. The corollary of individualism becomes narcissism, an inflated evaluation of self-worth devoid of any real sense of "self" or "worth." **283**

Since a key component of narcissism is the need to be admired and to be the center of attention, Generation Me's attraction to fame is inevitable. "You teach kids they're special. And then they watch TV, the impression they get is that everyone should be rich and famous. Then they hear, 'You can be anything you want.' So they're like, 'Well, I want to be rich and famous,'" says Twenge. Or if not rich and famous, at least to be "seen"—something the rest of us plebeians can now aspire to in the brave new media world. "To be noticed, to be wanted, to be loved, to walk into a place and have others care about what you're doing, even what you had for lunch that day: That's what people want, in my opinion," *Big Brother* contestant Kaysar Ridha told the *New York Times*, thus affirming a recent finding by Drew Pinsky and Mark Young that reality TV stars are far more narcissistic than actors, comedians, or musicians—perhaps because they reflect more closely the reason the rest of us are obsessed more than ever with "making it."

Not only do Americans increasingly want to be famous, but they also believe they *will* be famous, more so than any previous generation. A Harris poll conducted in 2000 found that 44 percent of those between the ages of eighteen and twenty-four believed it was at least somewhat likely that they would be famous for a short period. Those in their late twenties were even more optimistic: Six in ten expected that they would be well-known, if only briefly, sometime in their lives. The rosy predictions of our destiny, however, contain within them the darker conviction that a life led outside the spotlight would be without value. "People want the kind of attention that celebrities receive more than anything else," says Niedzviecki. "People want the recognition, the validation, the sense of having a place in the culture [because] we no longer know where we belong, what we're about, or what we should be about."

Without any meaningful standard by which to measure our worth, we

turn to the public eye for affirmation. "It's really the sense that Hey, I

exist in this world, and that is important. That I matter," Niedzviecki says. Our "normal" lives therefore seem impoverished and less significant compared with the media world, which increasingly represents all that is grand and worthwhile, and therefore more "real."

No wonder then that sixteen-year-old Rachel, Britney Jo's fellow aspirant to fame on iWannaBeFamous.com, rambles in desperation, "I figured out that I am tired of just dreaming about doing something, I am sick of looking for a 'regular' job… I feel life slipping by, and that 'something is missing' feeling begins to dominate me all day and night, I can't even watch the Academy Awards ceremony without crying…that is how I know…that is me…. I have to be…in the movies!!!"

The evolution of the Internet has both mirrored and shaped the intense focus on self that is the hallmark of the post-Boomer generation. "If you aren't posting, you don't exist. People say, 'I post, therefore I am,'" Rishad Tobaccowala, CEO of Denuo, a new media consultancy, told *Wired*, inadvertently capturing the essence of Web 2.0, which is driven by our hunger for self-expression. Blogs, amateur videos, personal profiles, even interactive features such as Amazon.com's reviews offer ways to satisfy our need to be in the public eye.

But the virtual persona we project online is a carefully edited version of ourselves, as "authentic" as a character on reality TV. People on reality TV "are ultra-self-aware versions of the ordinary, über-facsimiles of themselves in the same way that online personals are *re-creations* of self constantly tweaked for maximum response and effect," writes Niedzviecki in his book.

Self-expression glides effortlessly into self-promotion as we shape our online selves–be it on a MySpace profile, LiveJournal blog, or a YouTube video–to insure the greatest attention. Nothing beats good old-fashioned publicity even in the brave new world of digital media. So it should come as

no shock that the oh-so-authentic LonelyGirl15 should turn out to be a PR stunt or that the most popular person on MySpace is the mostly naked Tila Tequila, the proud purveyor of "skank-pop" who can boast of 1,626,097 friends, a clothing line, a record deal, and making the cover of *Maxim UK* and *Stuff* magazines. YouTube has become the virtual equivalent of Los Angeles, the destination de rigueur for millions of celebrity aspirants, all hoping they will be the next Amanda Congdon, the videoblogger now with a gig on ABCNews.com, or the Spiridellis brothers, who landed venture capital funding because of their wildly popular video "This Land."

Beginning with the dot-com boom in the 1990s through to its present iteration as Web 2.0, the cultural power of the Internet has been fueled by the modern-day Cinderella fantasy of "making it." With their obsessive focus on A-list bloggers, upstart twentysomething CEOs, and an assortment of weirdos and creeps, the media continually reframe the Internet as yet another shot at the glittering prize of celebrity. "We see the same slow channeling of the idea that your main goal in life is to reach as many people as possible all over the world with your product. And your product is you," says Niedzviecki. "As long as that's true, it's very hard to see how the Internet is going to change that." As long as more democratic media merely signify a greater democracy of fame—e.g., look how that indie musician landed a contract with that major label—we will remain enslaved by the same narrative of success that sustains corporate America.

In our eagerness to embrace the Web as a panacea for various political ills, progressives often forget that the Internet is merely a medium like any other, and the social impact of its various features—interactivity, real-time publishing, easy access, cheap mass distribution—will be determined by the people who use them. There is no doubt that these technologies have facilitated **286** greater activism, and new forms of it, both on- and offline. But we

confuse the Web's promise of increased visibility with real change. Political actions often enter the ether of the media world only to be incorporated into narratives of individual achievement. And the more successful among us end up as bold-faced names, leached dry of the ideas and values they represent—yet another face in the cluttered landscape of celebrity, with fortunes that follow the usual trajectory of media attention: First you're hot, and then you're not.

"It's all about you. Me. And all the various forms of the First Person Singular," writes cranky media veteran Brian Williams in his contribution to *Time*'s year-end package. "Americans have decided the most important person in their lives is…them, and our culture is now built upon that idea." So, have we turned into a nation of egoists, uninterested in anything that falls outside our narrow frame of self-reference?

As Jean Twenge points out, individualism doesn't necessarily preclude a social conscience or desire to do good. "But [Generation Me] articulates it as 'I want to make a difference,'" she says. "The outcome is still good, but it does put the self in the center." Stephen Duncombe, on the other hand, author of the new book *Dream: Re-imagining Progressive Politics in an Age of Fantasy*, argues that rather than dismiss our yearning for individual recognition, progressives need to create real-world alternatives that offer such validation. For example, in place of vast anonymous rallies that aim to declare strength in numbers, he suggests that liberal activism should be built around small groups. "The size of these groups is critical. They are intimate affairs, small enough for each participant to have an active role in shaping the group's direction and voice," he writes. "In these 'affinity groups,' as they are called, every person is recognized: in short, they exist."

Such efforts, however, would have to contend with GenMe's aversion to collective action. "The Baby Boomers were self-focused in a different way. Whether it was self-examination like EST or social protest, they

did everything in groups. This new generation is allergic to groups," Twenge says. And as Duncombe admits, activism is a tough sell for a nation weaned on the I-driven fantasy of celebrity that serves as "an escape from democracy with its attendant demands for responsibility and participation."

There is a happier alternative. If these corporate technologies of self-promotion work as well as promised, they may finally render fame meaningless. If everyone is onstage, there will be no one left in the audience. And maybe then we rock stars can finally turn our attention to life down here on earth. Or it may be life on earth that finally jolts us out of our admiring reverie in the mirrored hall of fame. We forget that this growing self-involvement is a luxury afforded to a generation that has not experienced a wide-scale war or economic depression. If and when the good times come to an end, so may our obsession with fame. "There are a lot of things on the horizon that could shake us out of the way we are now. And some of them are pretty ugly," Niedzviecki says. "You won't be able to say that my MySpace page is more important than my real life.... When you're a corpse, it doesn't matter how many virtual friends you have." Think global war, widespread unemployment, climate change. But then again, how cool would it be to blog your life in the new Ice Age–kind of like starring in your very own *Day After Tomorrow*. LOL.

From the *Nation*, Jan. 29, 2007.

Josh Smith,
Untitled (JSC07346), 2007.
Mixed mediums on panel,
48 x 36 in (122 x 91.4 cm).
Courtesy the artist and Luhring Augustine, New York
(Detail)

All-Stars of the Clever Riposte

Allen Salkin

DaShiv is in town, and the celebration has not ceased.

Strange women are opening their apartments to him. Three parties have been given in his honor. His beer mug has been constantly refilled.

All hail DaShiv.

Who in the world is DaShiv?

Well, in one sense he is Bob Hsiao, a twenty-eight-year-old part-time wedding photographer from Berkeley, CA, who does not have a girlfriend and lives with a roommate.

But thanks to a particular wrinkle of Internet culture, DaShiv is a star, an internationally famous portrait photographer, feted and fawned over during his ten-day visit to New York. This fame is not thanks to his own blog. He doesn't have one. Nor has he scored big by creating a clever YouTube video or a flashy MySpace page.

DaShiv's notoriety stems from the popularity of the comments and photos he posts on blogs run by other people.

There are those who have blogs. Then there are those who leave comments on other people's blogs, sometimes lots and lots of comments, sometimes nasty, clever, brilliant, monumentally stupid, or filthy comments.

DaShiv posts mostly to MetaFilter, a Web site that allows anyone to submit items of interest or questions inviting comment by other people. Another user there, Chad Okere, a twenty-seven-year-old computer programmer in Ames, IA, who uses the screen name Delmoi, has posted more than 13,000 comments. On the conservative politics blog Little Green Footballs, nearly 4.3 million comments have been left by tens of thousands of users since its creation in 2001.

"People are doing it for the same reason another generation of people called in on talk radio," said Shel Israel, a social media consultant and a columnist for *Blogger & Podcaster* magazine. "They are passionate; they live in a world where nobody listens to them; and they suddenly have a way to speak."

291

Since many blogs have a readership of one—or, at best, the writer, his mother, and some guy he sat next to in seventh grade who found him on Google—piggy-backing on a more popular site offers a wider audience for a keyboard jockey's gripes and quips. Not everyone is up to the task of creating a blog with the kind of consistent tone and provocative topics that attract visitors.

"There are people who react rather than act," Israel said. "As much as we talk about joining the conversation on the Internet, the most popular bloggers start a conversation."

And some folks react a lot.

Seth Chadwick has posted his reviews of 207 restaurants in Phoenix on Chowhound, the online bulletin board where all things food are discussed with fathomless detail. Far more readers see his reviews on Chowhound than on Chadwick's own Web site, Feasting in Phoenix. In two years, the Google ads on his site have yielded him a grand total of $110, he said.

That's more than the zilch his Chowhound posts have earned him, but Chadwick, a project coordinator at a retirement investment fund, spends about six hours a week writing about food because he has adopted the mission of using Chowhound's bulletin boards to lift his desert city's culinary reputation.

"There are some small, wonderful places here that people don't know about because they are hidden behind huge neon signs for Applebee's, Cheesecake Factory, and the like," he said by telephone.

Like the narrator of the Elton John song "Rocket Man," frequent commenters can spend a little time every day inhabiting the identity of their wished-for selves—Hsiao becomes DaShiv, or Georgia Logothetis, a second-year lawyer in Chicago, metamorphoses into the respected liberal commenter georgia10 on Daily Kos. Online they indulge the sweet fantasy that "I'm not the man they think I am at home."

"You are one of the millions of people who sit at a computer all day," said Marshall Poe, a professor of history and new media at the University of Iowa, who has studied Internet communities. "Every hour you have ten minutes where you're not doing anything productive at work, and you can't look at porn. So you make a comment and fulfill this desire to show yourself off as a smarty-pants."

What point there might be to someone putting all his creative sweat into a 1,700-word exegesis on the cultural status of Bonobo apes, which a few hundred strangers might read, can be partially explained by a writer's desire to be recognized within an online community, Poe said. On MetaFilter, readers can mark other users' comments as a favorite, and commenters derive pride from how many times they have been "favorited," he said.

On Gawker, the media gossip Web site, editors select the best comments of the week and conduct commenter executions, in which users judged to be unclever are stripped of their commenting privileges.

Sometimes, would-be Rocket Men pop up in strange places. The real-life identity of one of Gawker's most frequent contributors, and a best of the week honoree, LolCait, was a mystery to the editorial staff until a few weeks ago. That's when Richard Lawson, a twenty-four-year-old sales coordinator in the Gawker Media ad department, who was worried his insider status could be discovered and ethically embarrass the company, confessed that he was LolCait.

His success shows how good commenting has become social currency online. Lawson, who studied playwriting in college, said he started leaving comments after he was hired five months ago, just to see if he could survive the audition as a Gawker-approved commenter. He made it, and was later singled out for a comment that was in the form of a fake entry from the socialite Tinsley Mortimer's diary.

"That was when some of the other commenters started saying, 'Hey, I like your stuff,'" Lawson said in a telephone interview.　　**293**

His basic style is "easy jokes, puns, random celebrity jabs," he explained. In response to a news item about the rapper Foxy Brown slapping a neighbor with her Blackberry, LolCait commented, "This is like the time Spinderella stabbed me with her Treo."

Since he confessed, Lawson's job responsibilities have grown, although he has not received a raise. He was put in charge of choosing the best comments of the week.

Not every commenter is a frustrated office worker yearning for pinprick shafts of fame. Some already have the real thing. The restaurateur Jeffrey Chodorow commented on an item that Eater, the restaurant business blog, wrote about an advertisement Chodorow had placed in the *New York Times* criticizing a restaurant review by Frank Bruni. (Is this meta enough for you?)

After explaining why he'd focused on the topic of salmon in the ad, Chodorow referred to the title of the Eater item, "Chodorow Edging Closer to Insanity, Places 'Dear Frank' Ad," and wrote, "If you worked in this business, you'd be crazy too."

David Sifry, the founder of Technorati, the site that tracks 107.4 million blogs, said that when he learned of a blog post in which he or Technorati was mentioned, he went to that site to leave a comment, a practice that let people know they were being heard. "If you can do this," he said. "People who are often your harshest critics become your evangelists."

Commenting has become such a widely played sport that new tools are being deployed to separate the "trolls"—unwelcome commenters—from the favorites. Eater plans to offer readers the option of custom-filtering comments to exclude certain writers. Little Green Footballs started a rating system that lets users vote a comment up or down on a page, "to help the better ones be noticed," the site creator, Charles Johnson, wrote in an e-mail message.

DaShiv's posts on MetaFilter, which has about 30,000 active users, have been "favorited" 297 times. In addition to dispensing dating advice online ("Mathematically speaking, being good friends after a breakup makes it 258.1 percent harder to move on than a no-contact breakup"), DaShiv began snapping photos at San Francisco Bay Area real-world get-togethers, or meetups as they are called, of MetaFilter users. He posted them on Flickr, the photo-sharing site, which shares content with MetaFilter.

"He's a MetaFilter star," said ThePinkSuperhero, the screen name of a woman who helped organize a meetup in Astoria, Queens, on Wednesday in DaShiv's honor. "He came to be known as a great portrait photographer. Wherever he goes, people flock to him to have their picture taken." (The woman, a twenty-four-year-old director of operations at a financial operations firm, asked that her real name not be printed because "I don't want my MetaFilter comment history tied to my Google index forever and evermore.")

Soon, those organizing meetups in other cities started asking DaShiv if he would show up to take photos. This summer, Matthew Haughey, the founder of MetaFilter, flew DaShiv to Portland, OR, for the site's eighth-anniversary party.

When Hsiao announced he was coming to New York for ten days, at least five people he'd never met in person offered couch space, and three meetups were organized.

He said he chose the mean-sounding online moniker DaShiv when he was younger and posting to dial-up computer bulletin boards in Los Angeles. "I chose it mostly because I was a sarcastic little brat growing up," he said.

Despite his growing fame, he doesn't see himself creating his own blog soon. "It's easier to join in on a conversation than to start one," he said matter of factly.

Some have parlayed commenting into a profession, even if only part time. Matt Diggs was a college student so obsessed with high

school football in the Dallas/Fort Worth area that he began filing reports for the message boards at the Web site that is now called Texas Prep Insider in exchange for free entry to high school games.

He has since graduated and is now paid $20,000 annually to make 30 to 50 entries a week on the site, a nice addition to what he earns teaching psychology at a community college. Recognized as the area's foremost expert on his subject, Diggs, 29, also leaves comments, gratis, on the *Dallas Morning News* high school sports blogs.

His obsession with high school football started when he was a freshman at Plano East Senior High School. "I played tight end," he said. "But I never made it to varsity."

Robin Epstein contributed reporting.

Kateřina Šedá,
It Doesn't Matter, 2005–07.
Social action with drawings, photographs,
and digital video, duration and dimensions variable.
Courtesy the artist and Franco Soffiantino Gallery, Turin
(Detail)

Twilight of the Books:
What Will Life Be Like if People Stop Reading?

Caleb Crain

In 1937, 29 percent of American adults told the pollster George Gallup that they were reading a book. In 1955, only 17 percent said they were. Pollsters began asking the question with more latitude. In 1978, a survey found that 55 percent of respondents had read a book in the previous six months. The question was even looser in 1998 and 2002, when the General Social Survey found that roughly 70 percent of Americans had read a novel, a short story, a poem, or a play in the preceding twelve months. And, this August, 73 percent of respondents to another poll said that they had read a book of some kind, not excluding those read for work or school, in the past year. If you didn't read the fine print, you might think that reading was on the rise.

You wouldn't think so, however, if you consulted the Census Bureau and the National Endowment for the Arts, who, since 1982, have asked thousands of Americans questions about reading that are not only detailed but consistent. The results, first reported by the NEA in 2004, are dispiriting. In 1982, 56.9 percent of Americans had read a work of creative literature in the previous twelve months. The proportion fell to 54 percent in 1992 and to 46.7 percent in 2002. Last month, the NEA released a follow-up report, "To Read or Not to Read," which showed correlations between the decline of reading and social phenomena as diverse as income disparity, exercise, and voting. In his introduction, the NEA chairman, Dana Gioia, wrote, "Poor reading skills correlate heavily with lack of employment, lower wages, and fewer opportunities for advancement."

This decline is not news to those who depend on print for a living. In 1970, according to *Editor & Publisher International Year Book*, there were 62.1 million weekday newspapers in circulation–about 0.3 papers per person. Since 1990, circulation has declined steadily, and in 2006 there were just 52.3 mil-lion weekday papers–about 0.17 per person. In January 1994, **299**

49 percent of respondents told the Pew Research Center for the People and the Press that they had read a newspaper the day before. In 2006, only 43 percent said so, including those who read online. Book sales, meanwhile, have stagnated. The Book Industry Study Group estimates that sales fell from 8.27 books per person in 2001 to 7.93 in 2006. According to the Department of Labor, American households spent an average of $163 on reading in 1995 and $126 in 2005. In "To Read or Not to Read," the NEA reports that American households' spending on books, adjusted for inflation, is "near its twenty-year low," even as the average price of a new book has increased.

More alarming are indications that Americans are losing not just the will to read but even the ability. According to the Department of Education, between 1992 and 2003 the average adult's skill in reading prose slipped one point on a five-hundred-point scale, and the proportion who were proficient—capable of such tasks as "comparing viewpoints in two editorials"—declined from 15 percent to 13. The Department of Education found that reading skills have improved moderately among fourth and eighth graders in the past decade and a half, with the largest jump occurring just before the No Child Left Behind Act took effect, but twelfth graders seem to be taking after their elders. Their reading scores fell an average of six points between 1992 and 2005, and the share of proficient twelfth-grade readers dropped from 40 percent to 35 percent. The steepest declines were in "reading for literary experience"—the kind that involves "exploring themes, events, characters, settings, and the language of literary works," in the words of the department's test-makers. In 1992, 54 percent of twelfth graders told the Department of Education that they talked about their reading with friends at least once a week. By 2005, only 37 percent said they did.

The erosion isn't unique to America. Some of the best data come from the Netherlands, where in 1955 researchers began to ask people

to keep diaries of how they spent every fifteen minutes of their leisure time. Time-budget diaries yield richer data than surveys, and people are thought to be less likely to lie about their accomplishments if they have to do it four times an hour. Between 1955 and 1975, the decades when television was being introduced into the Netherlands, reading on weekday evenings and weekends fell from five hours a week to 3.6, while television watching rose from about ten minutes a week to more than ten hours. During the next two decades, reading continued to fall and television watching to rise, though more slowly. By 1995, reading, which had occupied 21 percent of people's spare time in 1955, accounted for just 9 percent.

The most striking results were generational. In general, older Dutch people read more. It would be natural to infer from this that each generation reads more as it ages, and, indeed, the researchers found something like this to be the case for earlier generations. But, with later ones, the age-related growth in reading dwindled. The turning point seems to have come with the generation born in the 1940s. By 1995, a Dutch college graduate born after 1969 was likely to spend fewer hours reading each week than a little-educated person born before 1950. As far as reading habits were concerned, academic credentials mattered less than whether a person had been raised in the era of television. The NEA, in its twenty years of data, has found a similar pattern. Between 1982 and 2002, the percentage of Americans who read literature declined not only in every age group but in every generation—even in those moving from youth into middle age, which is often considered the most fertile time of life for reading. We are reading less as we age, and we are reading less than people who were our age ten or twenty years ago.

There's no reason to think that reading and writing are about to become extinct, but some sociologists speculate that reading books **301**

for pleasure will one day be the province of a special "reading class," much as it was before the arrival of mass literacy, in the second half of the nineteenth century. They warn that it probably won't regain the prestige of exclusivity; it may just become "an increasingly arcane hobby." Such a shift would change the texture of society. If one person decides to watch *The Sopranos* rather than to read Leonardo Sciascia's novella *To Each His Own*, the culture goes on largely as before—both viewer and reader are entertaining themselves while learning something about the Mafia in the bargain. But if, over time, many people choose television over books, then a nation's conversation with itself is likely to change. A reader learns about the world and imagines it differently from the way a viewer does; according to some experimental psychologists, a reader and a viewer even think differently. If the eclipse of reading continues, the alteration is likely to matter in ways that aren't foreseeable.

Taking the long view, it's not the neglect of reading that has to be explained but the fact that we read at all. "The act of reading is not natural," Maryanne Wolf writes in *Proust and the Squid* (Harper; $25.95), an account of the history and biology of reading. Humans started reading far too recently for any of our genes to code for it specifically. We can do it only because the brain's plasticity enables the repurposing of circuitry that originally evolved for other tasks—distinguishing at a glance a garter snake from a haricot vert, say.

The squid of Wolf's title represents the neurobiological approach to the study of reading. Bigger cells are easier for scientists to experiment on, and some species of squid have optic-nerve cells a hundred times as thick as mammal neurons, and up to four inches long, making them a favorite with biologists. (Two decades ago, I had a summer job washing glassware in Cape Cod's Marine Biological Laboratory. Whenever researchers extracted an optic nerve, they threw the rest of the squid into a freezer, and about once a

month we took a cooler-full to the beach for grilling.) To symbolize the humanistic approach to reading, Wolf has chosen Proust, who described reading as "that fruitful miracle of a communication in the midst of solitude." Perhaps inspired by Proust's example, Wolf, a dyslexia researcher at Tufts, reminisces about the nuns who taught her to read in a two-room brick schoolhouse in Illinois. But she's more of a squid person than a Proust person and seems most at home when dissecting Proust's fruitful miracle into such brain parts as the occipital "visual association area" and "area 37's *fusiform gyrus*." Given the panic that takes hold of humanists when the decline of reading is discussed, her cold-blooded perspective is opportune.

Wolf recounts the early history of reading, speculating about developments in brain wiring as she goes. For example, from the eighth to the fifth millennia BC, clay tokens were used in Mesopotamia for tallying livestock and other goods. Wolf suggests that once the simple markings on the tokens were understood not merely as squiggles but as representations of, say, ten sheep, they would have put more of the brain to work. She draws on recent research with functional magnetic resonance imaging (fMRI), a technique that maps blood flow in the brain during a given task, to show that meaningful squiggles activate not only the occipital regions responsible for vision but also temporal and parietal regions associated with language and computation. If a particular squiggle was repeated on a number of tokens, a group of nerves might start to specialize in recognizing it, and other nerves to specialize in connecting to language centers that handled its meaning.

In the fourth millennium BC, the Sumerians developed cuneiform, and the Egyptians hieroglyphs. Both scripts began with pictures of things, such as a beetle or a hand, and then some of these symbols developed more abstract meanings, representing ideas in some cases and sounds in others. **303**

Readers had to recognize hundreds of symbols, some of which could stand for either a word or a sound, an ambiguity that probably slowed down decoding. Under this heavy cognitive burden, Wolf imagines, the Sumerian reader's brain would have behaved the way modern brains do when reading Chinese, which also mixes phonetic and ideographic elements and seems to stimulate brain activity in a pattern distinct from that of people reading the Roman alphabet. Frontal regions associated with muscle memory would probably also have gone to work, because the Sumerians learned their characters by writing them over and over, as the Chinese do today.

Complex scripts like Sumerian and Egyptian were written only by scribal elites. A major breakthrough occurred around 750 BC, when the Greeks, borrowing characters from a Semitic language, perhaps Phoenician, developed a writing system that had just twenty-four letters. There had been scripts with a limited number of characters before, as there had been consonants and even occasionally vowels, but the Greek alphabet was the first whose letters recorded every significant sound element in a spoken language in a one-to-one correspondence, give or take a few diphthongs. In ancient Greek, if you knew how to pronounce a word, you knew how to spell it, and you could sound out almost any word you saw, even if you'd never heard it before. Children learned to read and write Greek in about three years, somewhat faster than modern children learn English, whose alphabet is more ambiguous. The ease democratized literacy; the ability to read and write spread to citizens who didn't specialize in it. The classicist Eric A. Havelock believed that the alphabet changed "the character of the Greek consciousness."

Wolf doesn't quite second that claim. She points out that it is possible to read efficiently a script that combines ideograms and phonetic elements, something that many Chinese do daily. The alphabet, she suggests,

entailed not a qualitative difference but an accumulation of small quantitative ones by helping more readers reach efficiency sooner. "The efficient reading brain," she writes, "quite literally has more time to think." Whether that development sparked Greece's flowering she leaves to classicists to debate, but she agrees with Havelock that writing was probably a contributive factor because it freed the Greeks from the necessity of keeping their whole culture, including the *Iliad* and the *Odyssey,* memorized.

The scholar Walter J. Ong once speculated that television and similar media are taking us into an era of "secondary orality," akin to the primary orality that existed before the emergence of text. If so, it is worth trying to understand how different primary orality must have been from our own mindset. Havelock theorized that in ancient Greece the effort required to preserve knowledge colored everything. In Plato's day, the word *mimesis* referred to an actor's performance of his role, an audience's identification with a performance, a pupil's recitation of his lesson, and an apprentice's emulation of his master. Plato, who was literate, worried about the kind of trance or emotional enthrallment that came over people in all these situations, and Havelock inferred from this that the idea of distinguishing the knower from the known was then still a novelty. In a society that had only recently learned to take notes, learning something still meant abandoning yourself to it. "Enormous powers of poetic memorization could be purchased only at the cost of total loss of objectivity," he wrote.

It's difficult to prove that oral and literate people think differently; orality, Havelock observed, doesn't "fossilize" except through its nemesis, writing. But some supporting evidence came to hand in 1974 when Aleksandr R. Luria, a Soviet psychologist, published a study based on interviews conducted in the 1930s with illiterate and newly literate peasants in Uzbekistan and Kyrgyzstan. Luria found that illiterates had a "graphic-functional" way **305**

of thinking that seemed to vanish as they were schooled. In naming colors, for example, literate people said "dark blue" or "light yellow," but illiterates used metaphorical names like "liver," "peach," "decayed teeth," and "cotton in bloom." Literates saw optical illusions; illiterates sometimes didn't. Experimenters showed peasants drawings of a hammer, a saw, an axe, and a log and then asked them to choose the three items that were similar. Illiterates resisted, saying that all the items were useful. If pressed, they considered throwing out the hammer; the situation of chopping wood seemed more cogent to them than any conceptual category. One peasant, informed that someone had grouped the three tools together, discarding the log, replied, "Whoever told you that must have been crazy," and another suggested, "Probably he's got a lot of firewood." One frustrated experimenter showed a picture of three adults and a child and declared, "Now, clearly the child doesn't belong in this group," only to have a peasant answer, "Oh, but the boy must stay with the others! All three of them are working, you see, and if they have to keep running out to fetch things, they'll never get the job done, but the boy can do the running for them." Illiterates also resisted giving definitions of words and refused to make logical inferences about hypothetical situations. Asked by Luria's staff about polar bears, a peasant grew testy. "What the cock knows how to do, he does. What I know, I say, and nothing beyond that!" The illiterates did not talk about themselves except in terms of their tangible possessions. "What can I say about my own heart?" one asked.

In the 1970s, the psychologists Sylvia Scribner and Michael Cole tried to replicate Luria's findings among the Vai, a rural people in Liberia. Since some Vai were illiterate, some were schooled in English, and others were literate in the Vai's own script, the researchers hoped to be able to distinguish

cognitive changes caused by schooling from those caused specifically

by literacy. They found that English schooling and English literacy improved the ability to talk about language and solve logic puzzles, as literacy had done with Luria's peasants. But literacy in Vai script improved performance on only a few language-related tasks. Scribner and Cole's modest conclusion–"Literacy makes some difference to some skills in some contexts"–convinced some people that the literate mind was not so different from the oral one after all. But others have objected that it was misguided to separate literacy from schooling, suggesting that cognitive changes came with the culture of literacy rather than with the mere fact of it. Also, the Vai script, a syllabary with more than 200 characters, offered nothing like the cognitive efficiency that Havelock ascribed to Greek. Reading Vai, Scribner and Cole admitted, was "a complex problem-solving process," usually performed slowly.

Soon after this study, Ong synthesized existing research into a vivid picture of the oral mindset. Whereas literates can rotate concepts in their minds abstractly, orals embed their thoughts in stories. According to Ong, the best way to preserve ideas in the absence of writing is to "think memorable thoughts" whose zing insures their transmission. In an oral culture, cliché and stereotype are valued, as accumulations of wisdom, and analysis is frowned upon, for putting those accumulations at risk. There's no such concept as plagiarism, and redundancy is an asset that helps an audience follow a complex argument. Opponents in struggle are more memorable than calm and abstract investigations, so bards revel in name-calling and in "enthusiastic description of physical violence." Since there's no way to erase a mistake invisibly, as one may in writing, speakers tend not to correct themselves at all. Words have their present meanings but no older ones, and if the past seems to tell a story with values different from current ones, it is either forgotten or silently adjusted. As the scholars Jack Goody and Ian Watt observed, it is only in a literate **307**

culture that the past's inconsistencies have to be accounted for, a process that encourages skepticism and forces history to diverge from myth.

Upon reaching classical Greece, Wolf abandons history, because the Greeks' alphabet-reading brains probably resembled ours, which can be readily put into scanners. Drawing on recent imaging studies, she explains in detail how a modern child's brain wires itself for literacy. The ground is laid in preschool, when parents read to a child, talk with her, and encourage awareness of sound elements like rhyme and alliteration, perhaps with "Mother Goose" poems. Scans show that when a child first starts to read she has to use more of her brain than adults do. Broad regions light up in both hemispheres. As a child's neurons specialize in recognizing letters and become more efficient, the regions activated become smaller.

At some point, as a child progresses from decoding to fluent reading, the route of signals through her brain shifts. Instead of passing along a "dorsal route" through occipital, temporal, and parietal regions in both hemispheres, reading starts to move along a faster and more efficient "ventral route," which is confined to the left hemisphere. With the gain in time and the freed-up brain-power, Wolf suggests, a fluent reader is able to integrate more of her own thoughts and feelings into her experience. "The secret at the heart of reading," Wolf writes, is "the time it frees for the brain to have thoughts deeper than those that came before." Imaging studies suggest that in many cases of dyslexia the right hemisphere never disengages, and reading remains effortful.

In a recent book claiming that television and video games were "making our minds sharper," the journalist Steven Johnson argued that since we value reading for "exercising the mind," we should value electronic media for offering a superior "cognitive workout." But, if Wolf's evidence is right, Johnson's metaphor of exercise is misguided. When reading goes well,

Wolf suggests, it feels effortless, like drifting down a river rather than rowing up it. It makes you smarter because it leaves more of your brain alone. Ruskin once compared reading to a conversation with the wise and noble, and Proust corrected him. It's much better than that, Proust wrote. To read is "to receive a communication with another way of thinking, all the while remaining alone, that is, while continuing to enjoy the intellectual power that one has in solitude and that conversation dissipates immediately."

Wolf has little to say about the general decline of reading, and she doesn't much speculate about the function of the brain under the influence of television and newer media. But there is research suggesting that secondary orality and literacy don't mix. In a study published this year, experimenters varied the way that people took in a PowerPoint presentation about the country of Mali. Those who were allowed to read silently were more likely to agree with the statement "The presentation was interesting," and those who read along with an audiovisual commentary were more likely to agree with the statement "I did not learn anything from this presentation." The silent readers remembered more, too, a finding in line with a series of British studies in which people who read transcripts of television newscasts, political programs, advertisements, and science shows recalled more information than those who had watched the shows themselves.

The antagonism between words and moving images seems to start early. In August, scientists at the University of Washington revealed that babies aged between eight and sixteen months know on average six to eight fewer words for every hour of baby DVDs and videos they watch daily. A 2005 study in Northern California found that a television in the bedroom lowered the standardized-test scores of third graders. And the conflict continues throughout a child's development. In 2001, after analyzing data on more than a million **309**

students around the world, the researcher Micha Razel found "little room for doubt" that television worsened performance in reading, science, and math. The relationship wasn't a straight line but "an inverted check mark": a small amount of television seemed to benefit children; more hurt. For nine-year-olds, the optimum was two hours a day; for seventeen-year-olds, half an hour. Razel guessed that the younger children were watching educational shows, and, indeed, researchers have shown that a five-year-old boy who watches *Sesame Street* is likely to have higher grades even in high school. Razel noted, however, that 55 percent of students were exceeding their optimal viewing time by three hours a day, thereby lowering their academic achievement by roughly one grade level.

The Internet, happily, does not so far seem to be antagonistic to literacy. Researchers recently gave Michigan children and teenagers home computers in exchange for permission to monitor their Internet use. The study found that grades and reading scores rose with the amount of time spent online. Even visits to pornography Web sites improved academic performance. Of course, such synergies may disappear if the Internet continues its YouTube-fueled evolution away from print and toward television.

No effort of will is likely to make reading popular again. Children may be browbeaten, but adults resist interference with their pleasures. It may simply be the case that many Americans prefer to learn about the world and to entertain themselves with television and other streaming media rather than with the printed word, and that it is taking a few generations for them to shed old habits like newspapers and novels. The alternative is that we are nearing the end of a pendulum swing, and that reading will return, driven back by forces as complicated as those now driving it away.

But if the change is permanent, and especially if the slide continues, the world will feel different, even to those who still read. Because

the change has been happening slowly for decades, everyone has a sense of what is at stake, though it is rarely put into words. There is something to gain, of course, or no one would ever put down a book and pick up a remote. Streaming media give actual pictures and sounds instead of mere descriptions of them. "Television completes the cycle of the human sensorium," Marshall McLuhan proclaimed in 1967. Moving and talking images are much richer in information about a performer's appearance, manner, and tone of voice, and they give us the impression that we know more about her health and mood, too. The viewer may not catch all the details of a candidate's healthcare plan, but he has a much more definite sense of her as a personality, and his response to her is therefore likely to be more full of emotion. There is nothing like this connection in print. A feeling for a writer never touches the fact of the writer herself, unless reader and writer happen to meet. In fact, from Shakespeare to Pynchon, the personalities of many writers have been mysterious.

Emotional responsiveness to streaming media harks back to the world of primary orality, and, as in Plato's day, the solidarity amounts almost to a mutual possession. "Electronic technology fosters and encourages unification and involvement," in McLuhan's words. The viewer feels at home with his show, or else he changes the channel. The closeness makes it hard to negotiate differences of opinion. It can be amusing to read a magazine whose principles you despise, but it is almost unbearable to watch such a television show. And so, in a culture of secondary orality, we may be less likely to spend time with ideas we disagree with.

Self-doubt, therefore, becomes less likely. In fact, doubt of any kind is rarer. It is easy to notice inconsistencies in two written accounts placed side by side. With text, it is even easy to keep track of differing levels of authority behind different pieces of information. The trust that a reader grants **311**

to the *New York Times*, for example, may vary sentence by sentence. A comparison of two video reports, on the other hand, is cumbersome. Forced to choose between conflicting stories on television, the viewer falls back on hunches, or on what he believed before he started watching. Like the peasants studied by Luria, he thinks in terms of situations and story lines rather than abstractions.

And he may have even more trouble than Luria's peasants in seeing himself as others do. After all, there is no one looking back at the television viewer. He is alone, though he, and his brain, may be too distracted to notice it. The reader is also alone, but the NEA reports that readers are more likely than non-readers to play sports, exercise, visit art museums, attend theater, paint, go to music events, take photographs, and volunteer. Proficient readers are also more likely to vote. Perhaps readers venture so readily outside because what they experience in solitude gives them confidence. Perhaps reading is a prototype of independence. No matter how much one worships an author, Proust wrote, "all he can do is give us desires." Reading somehow gives us the boldness to act on them. Such a habit might be quite dangerous for a democracy to lose.

First published in the *New Yorker*, December 24, 2007. © 2007 by Caleb Crain, reprinted with the permission of The Wylie Agency LLC.

Carolina Caycedo,
Israel-Lebanon, 2006.
Sewn nylon flag.
24 x 36 in (61 x 91.4 cm).
Berezdivin Collection, San Juan
(Detail)

A Nation at War:

The Troops; Military Mirrors a Working-Class America

David M. Halbfinger and Steven A. Holmes

They left small towns and inner cities, looking for a way out and up, or fled the anonymity of the suburbs, hoping to find themselves. They joined the all-volunteer military, gaining a free education or a marketable skill or just the discipline they knew they would need to get through life.

As the United States engages in its first major land war in a decade, the soldiers, sailors, pilots and others who are risking, and now giving, their lives in Iraq represent a slice of a broad swath of American society—but by no means all of it.

Of the twenty-eight servicemen killed who have been identified so far, twenty were white, five black, three Hispanic—proportions that neatly mirror those of the military as a whole. But just one was from a well-to-do family, and with the exception of a Naval Academy alumnus, just one had graduated from an elite college or university.

A survey of the American military's endlessly compiled and analyzed demographics paints a picture of a fighting force that is anything but a cross-section of America. With minorities overrepresented and the wealthy and the underclass essentially absent, with political conservatism ascendant in the officer corps and Northeasterners fading from the ranks, America's 1.4 million-strong military seems to resemble the makeup of a two-year commuter or trade school outside Birmingham or Biloxi far more than that of a ghetto or barrio or four-year university in Boston.

Today's servicemen and women may not be Ivy Leaguers, but in fact they are better educated than the population at large: reading scores are a full grade higher for enlisted personnel than for their civilian counterparts of the same age. While whites account for three of five soldiers, the military has become a powerful magnet for blacks, and black women in particular, who now outnumber white women in the Army.

315

But if the military has become the most successfully integrated institution in society, there is also a kind of voluntary segregation: While whites and blacks seek out careers in communications, intelligence, the medical corps and other specialties in roughly equal numbers, blacks are two and a half times as likely to fill support or administrative roles, while whites are 50 percent more likely to serve in the infantry, gun crews or their naval equivalent.

Sgt. Annette Acevedo, twenty-two, a radio operator from Atlanta, could have gone to college but chose the Army because of all the benefits it offered: travel, health coverage, work experience, and independence from her parents. The Army seemed a better opportunity to get started with her life and be a more independent person, she said.

Specialist Markita Scott, twenty-seven, a reservist from Columbus, GA, called up as a personnel clerk in an Army deployment center, says she is now planning to make a career of the Army. "Oh, yes, I am learning a skill," said Specialist Scott, who is black. "I get a lot of papers that are not correct, and so I know I'm helping the person. It could be making sure the right person is notified in case of an emergency, or maybe I tell them, "You know, if you do your insurance this way, the money will not go directly to the child, but the child's guardian,' and they say, 'Oh, I don't want it going to my ex.'"

Lt. James Baker, twenty-seven, of Shelbyville, TN, who is white, enlisted in the National Guard. The Tennessee Guard had no infantry units, so he chose artillery instead. "Artillery is exciting," he said. "I get to blow a lot of stuff up and play in the woods. The Army is the biggest team sport in the world."

Confronted by images of the hardships of overseas deployment and by the stark reality of casualties in Iraq, some have raised questions about the composition of the fighting force and about requiring what is, in essence, a working-class military to fight and die for an affluent America.

"It's just not fair that the people that we ask to fight our wars are people who join the military because of economic conditions, because they have fewer options," said Representative Charles B. Rangel, a Democrat from Manhattan and a Korean War veteran who is calling for restoring the draft.

Some scholars have noted that since the draft was abolished in 1973, the country has begun developing what could be called a warrior class or caste, often perpetuating itself from father or uncle to son or niece, whose political and cultural attitudes do not reflect the diversity found in civilian society—potentially foreshadowing a social schism between those who fight and those who ask them to.

It is an issue that today's soldiers grapple with increasingly as they watch their comrades, even their spouses, deploy to the combat zone. "As it stands right now, the country is riding on the soldiers who volunteer," said Sgt. Barry Perkins, thirty-nine, a career military policeman at Fort Benning, GA. "Everybody else is taking a free ride."

The Way It Was The Vietnam War And the Draft's End

The Vietnam War looms large as the defining epoch in the creation of what has become today's professional, blue-collar military.

It led to the creation of an all-volunteer force, when the Nixon administration, in an attempt to reduce opposition to the war, abolished the draft in 1973.

Because the draft provided deferment to college students, the burden of being sent to Vietnam fell heavily on the less well-educated and less affluent. And because of the unpopularity of the war, military service was disdained by many members of the nation's elite, leading their children to lose the propensity to serve that had characterized earlier generations of America's privileged.

As a result, the Americans who fought in the Vietnam War looked very different from the professional corps now fighting in Iraq and stationed around the globe.

The 2,594,000 troops who served in Vietnam between 1965 and 1972 were younger, much less likely to be married, and almost entirely male, according to a study of Defense Department data by Richard K. Kolb, the editor and publisher of *VFW* magazine.

The average soldier in a combat unit in Vietnam was nineteen or twenty years old and unmarried, Kolb said. Of the 58,000 Americans killed in Vietnam, 61 percent were twenty-one or younger; of the enlisted men killed, only about 25 percent were married.

"I can only recall one guy I served with who was married, and he was about thirty and a lifer," said Kolb, who was a nineteen-year-old radio operator in Vietnam in 1970.

By contrast, the average age of the twenty-eight men killed in the war with Iraq so far is twenty-six, and eight of the twenty-two enlisted men who died, or 36 percent, were married.

In the Army, about 25 percent of enlisted men were married in 1973. Today that figure has almost doubled.

Another major difference, of course, is that few women served in Vietnam, and women were not allowed in combat units. Only 7,494 women served in Vietnam, of whom 6,250 were nurses, according to the Defense Department. Of the 58,000 Americans who died in Vietnam, only eight were women, all of them nurses, and only one is officially listed as killed in action.

There were no female prisoners of war in Vietnam. By contrast, one female soldier has already been captured in Iraq and two others are listed as missing in action. Women are enlisting in far greater numbers today, especially since the Pentagon lifted many of the restrictions on women

serving in combat. Fifteen percent of all officers and enlisted personnel are women.

The existence of the draft during the Vietnam War, and the War's growing unpopularity as the years passed without victory, also created fundamental differences in the makeup of the armed forces. Soldiers tended to enlist for single tours of duty and then go back quickly to civilian life, making for a higher turnover rate and less professionalism than the Pentagon boasts of now. Today, the average enlistee stays about seven years, up from less than two years in 1973.

But Kolb and other experts say the widespread idea that the Army in Vietnam was made up mostly of draftees is incorrect. In fact, only 25 percent of all American forces in Vietnam were draftees, compared with 66 percent in World War II.

"With me, it was not a question of whether I would enlist, but when," Kolb said. "I grew up in a small town, and my father and uncles had all served in World War II. Enlisting was what we did in my family."

Among the many myths of Vietnam that persist today, experts say, is that it was a war fought by poor and black Americans, who died in greater proportions than whites.

Although that was true in the early stages of the American ground war, in 1965 and 1966, when there were large numbers of blacks in front-line combat units, Army and Marine Corps commanders later took steps to reassign black servicemen to other jobs to equalize deaths, according to Col. Harry G. Summers Jr. in "Vietnam War Almanac."

By the end of the war, African Americans had suffered 12.5 percent of the total deaths in Vietnam, 1 percentage point less than their proportion in the overall population, Colonel Summers wrote.

Servicemen from states in the South had the highest rate of battlefield deaths, thirty-one per 100,000 of the region's population, Kolb

found. Soldiers from states in the Northeast had the lowest rates, 23.5 deaths per 100,000.

Since the end of the draft, that geographic skew on the battlefield has extended to the services as a whole. The percentages of people from the Northeast and Midwest have dropped, while the proportion from the West has climbed and from the South has skyrocketed—even after accounting for southward and westward population shifts in society at large. For the year ending Sept. 30, 2000, 42 percent of all recruits came from the South.

Over all, Kolb said, 76 percent of the soldiers in Vietnam were from working-class or lower-income families, while only 23 percent had fathers in professional, managerial, or technical occupations.

The disparity created by the Vietnam draft can be seen on the walls of Memorial Hall and Memorial Church at Harvard University, where the names of Harvard students and alumni who died for their country are inscribed. There were 200 Harvard students killed in the Civil War and 697 in World War II, but only twenty-two in Vietnam.

For Stanley Karnow, the journalist and author of *Vietnam: A History,* who began reporting from Vietnam in 1959, the contrast with World War II was personal. When he turned eighteen in 1943, he dropped out of Harvard and enlisted in the Army. In 1970, when his son turned eighteen and became eligible for the draft, he was also a Harvard student. "We did everything we could to keep him out of the draft," Karnow said.

Signing Up Recruiting Office as Melting Pot

If the nation's wealthy and more well-educated youth have shunned the military, others less privileged have gravitated toward it.

Compared to their contemporaries in civilian life, the armed forces have a greater percentage of minorities, a higher proportion of high school graduates and better reading levels. As a group, about 60 percent of enlisted men and women are white; they tend to be married and upwardly mobile, but to come from families without the resources to send them to college.

While blacks make up about 12.7 percent of the same-age civilian population, they constitute about 22 percent of enlisted personnel. Perhaps most striking is the number of enlisted women who are black: more than 35 percent, according to Pentagon figures, indicating not only that black women enlist at higher rates, but that they stay in the military longer. In the Army, in fact, half of all enlisted women are black, outnumbering whites, who account for 38 percent.

In Chicago Heights, IL, the Marine Corps recruiting office was filled on Wednesday with the huffs and puffs of more than a dozen fresh young recruits, mostly wearing buzz cuts, doing crunches and chin-ups.

The afternoon workout is a ritual for these newest marines, a gregarious group made up mainly of seventeen and eighteen year olds who still have to get fitted for prom tuxes and graduate from high school before shipping out in just a few months. They resemble the American melting pot: Hispanics, blacks, whites, young men, and one young woman.

Patriotism and the prospect of getting a chance to go to Iraq, where the action is, played a role in their decisions to enlist, the recruits said. But Lori Luckey, twenty-four, a single mother of three girls, said the main reasons she signed up for the Marines were to get a chance at a career and the opportunity for advancement, to see the world, and to obtain a dental plan and other benefits.

Others, like Myles Tweedy, eighteen, a high school senior whose baby face is adorned with a goatee, said joining the military was a family tradition. Tweedy's father was an infantryman in Vietnam, and his

grandfather was in the Army as well. "Now it's my turn," Tweedy said. "It's something I knew I was always going to do."

Jonathan Lewis, eighteen, who said he enlisted for the benefits, and out of a sense of patriotism, said he figured he had less to fear as a marine in Baghdad than in the streets of Chicago, where he lived for twelve years until his family moved to the south suburbs.

"Being over in Baghdad, you've got a thousand people 100 percent behind you," he said. "Around here, who says you can't be going to McDonald's and that's it? Over there, you're part of everybody, you're with your friends and family, you're still safe."

Luckey has already made plans for her two oldest daughters, six and four, to stay with their paternal grandmother when she leaves in May for sixteen weeks of basic training. Her youngest daughter, not yet two, will stay with Luckey's mother.

A corrections officer for six years, she says her job "was just so dead-end." She decided to resign in November and enlisted in the Marines, eyeing not just the benefits but also a fairer chance of advancement.

The Race Issue Equal Opportunity on the Battlefield

Though Hispanics are underrepresented in the military, their numbers are growing rapidly. Even as the total number of military personnel dropped 23 percent over the last decade, the number of Hispanics in uniform grew to 118,000 from 90,600, a jump of about 30 percent.

While blacks tend to be more heavily represented in administrative and support functions, a new study shows that Hispanics, like whites, are

322 much more likely to serve in combat operations. But those Hispanics

in combat jobs tend to be infantry grunts, particularly in the Marine Corps, rather than fighter or bomber pilots.

"The Air Force is substantially more white, and the officer corps is substantially more white than Latino," said Roberto Suro, director of the Pew Hispanic Center, which issued a report last week on Hispanics in the military. "So you won't see Latinos flying airplanes over Iraq."

There are as many explanations for why Hispanics are flocking to the armed forces as there are individuals—but the explanations are not that different.

Specialist Joel Flores joined the Army five years ago on an impulse. Already in his late twenties, married and the father of two daughters, he was fed up with his sales clerk job at a crafts store in San Antonio, where he had worked for nine years. "They kept passing me up for management," Specialist Flores, thirty-four, said. "I got tired of it."

So one Friday after work he walked into a recruitment office to ask about his options in the military. Two hours later he was signing papers to enlist. "When I saw that first paycheck, it was 'Oh my God,'" said Specialist Flores, now an Army cook. His take-home pay was half what he had made at the store.

But he says he does not regret his decision even now, when he is among more than 12,000 troops waiting to depart Fort Hood, TX, for the war in the Persian Gulf.

Specialist Flores, who was born in Texas to Mexican-American parents and was the first person in his family to join the military, has since re-enlisted. He says he has found a more level playing field in the Army than in the outside world.

He has moved up a few notches, from private to a specialist supervising other cooks, and says he wants to retire after reaching sergeant major. In the Army, he said, "It doesn't matter who you are if you can do the job." **323**

For many soldiers like Specialist Flores, the military has not disappointed. Some complain about the low pay compared to what they could be making in the private sector, as well as the long hours and the time they spend away from their families.

But they say they have found a more egalitarian and racially harmonious society, one in which prejudice is trumped by meritocracy, discipline and the need to get along to survive.

Sgt. Nathalie Williams, twenty-nine, said that in her hometown, Tuskegee, AL, her closest friends would probably be black, like her. At Fort Hood, they are black, Puerto Rican, and white. "You can't judge somebody by their skin color," she said. "That one person who you don't like could be the person who saves your life."

Sergeant Williams's father served in the military, and an older sister is also in the Army. She said she joined the Army in 1992, after graduating from high school, to seek exposure to different kinds of people and travel. A dream came true when she was posted in Hawaii for three years.

But Sergeant Williams, the wife of a nursing assistant and the mother of three children, now faces going to war. Her sister, a staff sergeant, is already in Kuwait.

What Lies Ahead A New Draft or a Warrior Caste?

For those who support a return to the military draft, the question is whether the wealthy and elite of America–the sons and daughters of members of Congress, among others–were meant to serve as well.

Charles C. Moskos, a professor of sociology at Northwestern Uni-

versity who has written extensively in support of a national draft for

the armed services, domestic security and civilian service, argues that the military must represent every stratum of society.

"In World Wars I and II, the British nobility had a higher killed-in-action rate than the working class," he said. "Our enlisted ranks resemble the British: they're lower- to middle-class, working-class, intelligent people, who are joining for both the adventure and economic opportunity. But the officer corps today does not represent American nobility. These are not people who are going to be future congressmen or senators. The number of veterans in the Senate and the House is dropping every year. It shows you that our upper class no longer serves."

Dr. Moskos said the pitfalls of having leaders who do not share in the casualties of war were common knowledge in Homeric times: "Agamemnon was willing to sacrifice his daughter Iphigenia," he said. Today's military recruiters, he said, grasp what the ancient Greeks understood–"that nobody'll accept casualties unless the elite are willing to put their own children's lives on the line."

"I once addressed a group of recruiters and asked them, would you prefer to have your advertising budget tripled or see Chelsea Clinton joining the Army– and they all said Chelsea Clinton joining the Army," he said. "That would be the signal that America was serious about joining the military. Imagine Jenna Bush joining the military–that would be the signal thing saying, this is a cause worth dying for."

Dr. Moskos says support for the Vietnam War ended when it became possible for the elite to win draft deferments. Other experts on military demographics dispute this.

James Burk, a professor of sociology at Texas A&M University, acknowledged that few wealthy citizens today choose military service. "But if you say, is the all-volunteer force not representative of the country as a whole, I'd say it's more representative than the upper class," he said. **325**

Dr. Moskos and others also suggest that the citizen soldier who serves out his term and then returns to civilian life is being replaced by a class, or caste, of career soldiers–even in frontline combat positions that do not require the expertise and experience of years of service. On top of that, experts say, members of the military are far more likely to have parents who served in the armed forces, suggesting that such a caste is self-perpetuating.

"To carry the logic further, why don't you hire a foreign legion and be done with it?" Dr. Moskos said. "Go out, hire foreigners, say they can join the American military and get a decent salary. Oh, no–maybe Americans should fight for America?"

Those who warn of a warrior class cite a study by the Triangle Institute for Security Studies in North Carolina showing that between 1976 and 1996 the percentage of military officers who saw themselves as nonpartisan or politically independent fell from more than 50 percent to less than 20 percent. The main beneficiary of this shift has been the Republican Party.

"The officer corps has always been more conservative," said Richard H. Kohn, a professor of military history at the University of North Carolina. "But even so, the change there is dramatic."

Dr. Kohn and other scholars worry that with fewer families having sons or daughters in the military, especially among the affluent, and with a high percentage of enlistees coming from military families, a potential cultural and political gap could open up between civilian and martial societies.

"One of my concerns is effective civilian control of the military," he said. "The decline in the number of members of Congress who are veterans is dramatic. Up until 1995 Congress had a larger percentage of veterans than there was in the general population. After 1995 it was less–and that's after the Republican takeover.

That means there is potentially a less knowledgeable, less effective over-

sight from Congress."

Even among academics, to be sure, those concerns are narrowly felt. "When the troops come back, many of them will get out; they'll have some memories," said John Allen Williams, a retired Navy captain who is a political science professor at Loyola University Chicago. "A military that self-identified as different from, and possibly superior to, the civilian society it served, with a distinct set of values, and that might be willing to act on them opposed to civilian leaders? The thought that we could have that in this country is just inconceivable."

Both Burk and Williams say they support the idea of a draft, though they suggest it could never be enacted in today's political environment.

Ask a squad of today's volunteer soldiers whether they like the idea of a draft, and you'll get a platoon's worth of answers.

Pfc. Michael Philbert, eighteen, had just finished basic training on Thursday and was browsing at Ranger Joe's, a uniform and equipment store outside Fort Benning, with his father and thirteen-year-old brother. He said a draft was a bad idea.

"It sounds kind of fair," Private Philbert said. "It's not fair that some poor kids don't have much of a choice but to join if they want to be productive because they didn't go to a good school, or they had family problems that kept them from doing well, so they join up and they're the ones that die for our country while the rich kids can avoid it.

"From the other side, it's not someone's fault that they're born rich or poor. Just because someone is rich doesn't mean you have to yank them out of the comfort of their life just to get even. And most poor people are glad they had this kind of opportunity. They're glad they got in."

But Sgt. Barry Perkins, the military policeman at Fort Benning, who has been around the block a few more times than a buck private, said America's military—and its youth—would benefit from a draft that included both **327**

men and women. "If you look at today's society, teenagers are staying at home, not doing a thing," he said. "They need a productive life. It should be straight across the board. As long as you don't allow power, money, and wealth to influence it, it will be straight across the board–it will be fairer."

Specialist Markita Scott, the reservist from Columbus, GA, said she thought a draft was unnecessary. "Already with callbacks you can see the morale is down lower," she said. "They're like, 'I had a job.' Just think if you had a whole draft of people who didn't want to be there. I think of that guy who threw the grenade–you wonder if there would be a lot more like that."

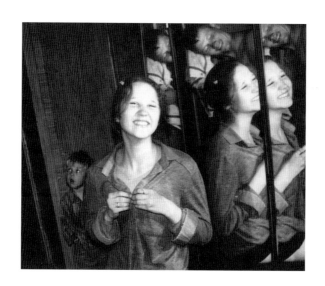

Alexander Ugay,
Untitled from the "We are from Texas" series, 2002–05.
Artist-printed gelatin silver prints,
19 3/4 x 23 1/2 in (50 x 60 cm)
(Detail)

Generation Faithful:
Youthful Voice Stirs Challenge to Secular Turks
Sabrina Tavernise

ISTANBUL–High school hurt for Havva Yilmaz. She tried out several selves. She ran away. Nothing felt right.

"There was no sincerity," she said. "It was shallow."

So at sixteen, she did something none of her friends had done: She put on an Islamic head scarf.

In most Muslim countries that would be a nonevent. In Turkey, it was a rebellion. Turkey has built its modern identity on secularism. Women on billboards do not wear scarves. The scarves are banned in schools and universities. So Yilmaz dropped out of school. Her parents were angry. Her classmates stopped calling her.

Like many young people at a time of religious revival across the Muslim world, Yilmaz, now twenty-one, is more observant than her parents. Her mother wears a scarf, but cannot read the Koran in Arabic. They do not pray five times a day. The habits were typical for their generation–Turks who moved from the countryside during industrialization.

"Before I decided to cover, I knew who I was not," Yilmaz said, sitting in a leafy Ottoman-era courtyard. "After I covered, I finally knew who I was."

While her decision was in some ways a recognizable act of youthful rebellion, in Turkey her personal choices are part of a paradox at the heart of the country's modern identity.

Turkey is now run by a party of observant Muslims, but its reigning ideology and law are strictly secular, dating from the authoritarian rule in the 1920s of Mustafa Kemal Ataturk, a former army general who pushed Turkey toward the West and cut its roots with the Ottoman East. For some young people today, freedom means the right to practice Islam, and self-expression means covering their hair.

331

They are redrawing lines between freedom and devotion, modernization and tradition, and blurring some prevailing distinctions between East and West.

Yilmaz's embrace of her religious identity has thrust her into politics. She campaigned to allow women to wear scarves on college campuses, a movement that prompted emotional, often agonized, debates across Turkey about where Islam fit into an open society. That question has paralyzed politics twice in the past year and a half, and has drawn hundreds of thousands into the streets to protest what they call a growing religiosity in society and in government.

By dropping out of the education system, she found her way into Turkey's growing, lively culture of young activists.

She attended a political philosophy reading group, studying Hegel, St. Augustine, and Machiavelli. She took sociology classes from a free learning center. She met other activists, many of them students trying to redefine words like "modern," which has meant secular and Western-looking for decades. She made new friends, like Hilal Kaplan, whose scarf sometimes had a map of the world on it.

Their fight is not solely about Islam. Turkey is in ferment, and Yilmaz and her young peers are demanding equal rights for all groups in Turkey. They are far less bothered by the religious and ethnic differences that divide older generations. "Turkey is not just secular people versus religious people," Kaplan said. "We were a very segregated society, but that segregation is breaking up."

In a slushy week in the middle of January, the head scarf became the focus of a heated national outpouring, and Yilmaz one of its most eloquent defenders.

The government of Prime Minister Recep Tayyip Erdogan pledged to pass a law letting women who wear them into college. Staunchly secular Turks opposed broader freedoms for Islam, in part because they did not trust Mr. Erdogan, a popular politician who began his career championing a greater role for Islam in politics and who has since moderated his stance.

Turkey remains a democratic experiment unique in the Muslim world. The Ottomans dabbled in democracy as early as 1876, creating a Constitution and a Parliament. The country was never colonized by Western powers, as Arabs were. It gradually developed into a vibrant democracy. The fact that young people like Yilmaz are protesting at all is one of its distinguishing features.

In many ways, Yilmaz's scarf freed her, but for many other women, it is the opposite. In poor, religiously conservative areas in rural Turkey, girls wear scarves from young ages, and many Turks feel strongly that without state regulation, young women would come under more pressure to cover up.

The head scarf bill, in that respect, could lead to less freedom for women, they argued. But for Yilmaz, the anger against the bill was hard to understand.

So one day, armed with a microphone and a strong sense of justice, Yilmaz marched into a hotel in central Istanbul and, with two friends, both in scarves, made her best case.

"The pain that we've been through as university doors were harshly shut in our faces taught us one thing," she said, speaking to reporters. "Our real problem is with the mentality of prohibition that thinks it has the right to interfere with people's lives."

Yilmaz's heartfelt speech, written with her friends, drew national attention. They were invited on television talk shows. They gave radio and newspaper interviews. Part of their appeal came from their attempt to go beyond religion to include all groups in Turkish society, like ethnic and sectarian minorities.

After Yilmaz left high school, she joined a group called the Young Civilians, a diverse band of young people who used dark humor and occasional references to the philosopher Michel Foucault to criticize everything from the state's repression of Kurds, the biggest ethnic minority, to its day of "Youth and Sport," a series of Soviet-style rallies of students in stadiums every spring. **333**

Their symbol was a Converse sneaker. Their members were funny and irreverent. One once joked that if you mentioned the name Marx, young women without head scarves assumed you were talking about the British department store Marks & Spencer, while ones in scarves understood the reference to the philosopher.

In a tongue-in-cheek effort to change perceptions of Kurds, the group ran a discussion program called "Let's Get a Little Kurdish," which featured sessions on Kurdish music, history and—in a particularly rebellious twist—even language.

By March, the month after Parliament passed the final version of the head scarf proposal, the debate had reached a frenzied pitch. Yilmaz and some friends—some in scarves, some not—agreed to go on a popular television talk show. The audience's questions were angry.

One young woman stood up and, looking directly at another in a scarf, said that she did not want her on campus, said Neslihan Akbulut, a friend of Yilmaz, who had helped to compose the head scarf statement. Another said she felt sorry for them because they were oppressed by men. A third fretted that allowing them into universities would lead to further demands about jobs, resulting in an "invasion."

Yilmaz said later: "I thought, Are we living in the same country? No, it's impossible."

They did not give up. They spent the day in a drafty cafe in central Istanbul, wearing boots and coats and going over their position with journalists, one by one.

"If women are ever forced to wear head scarves, we should be equally sensitive and stand against it," Akbulut said.

One of the journalists said, "You don't support gays."

Kaplan countered: "Islam tells us to fight this urge," but she said

that did not affect a homosexual's rights as a citizen. "I am against

police oppression of homosexuals. I am against a worldview that diminishes us to our scarves and homosexuals to the bedroom."

Yilmaz agreed. "When you wear a scarf," she said, "you are expected to act and think in a certain way, and support a certain political party. You're stripped of your personality."

The young women say that the scarf, contrary to popular belief, was not forced on them by their families. Some women wear it because their mothers did. For others, like Yilmaz, it was a carefully considered choice.

Though it is not among the five pillars of Islam—the duties required for every Muslim, including daily prayer—Yilmaz sees it as a command in the Koran.

"Physical contact is something special, something private," she said, describing the thinking behind her covering. "Constant contact takes away from the specialness, the privacy of the thing you share."

Still, in Turkey, traditional rules are often bent to accommodate modern life. Handshaking, for example, is a widespread Turkish custom, and most women follow it. Turkey is culturally very different from Arab societies, and for that reason interprets Islam differently. Islam here is heavily influenced by Sufism, an introspective strain that tends to be more flexible.

"You can't reject an extended hand," Kaplan said. "You don't want to break a person's heart."

Young activists like Yilmaz are driving change in Turkish society against a backdrop of growing materialism and consumerism. Most young Turks care little for politics and are instead occupied with the daily task of paying the bills.

That is an easier task in Turkey than in a number of Middle Eastern countries, because Turkey is relatively affluent. After three decades of intense development, its economy is five times bigger than Egypt's—a country with roughly the same population. **335**

The wealth has profoundly shaped young lives. In cities, young people no longer have to live with their parents after marriage. They take mortgages. They buy furniture on credit. They compete for jobs in new fields like marketing, finance and public relations.

In past generations, women lived with their husband's families, doubling their work.

"When you don't have time to do anything for yourself, you don't have time to question anything, even religion," Kaplan said.

The economic changes that have swept Turkish society, bringing cellphones, iPods, and the Internet, are transforming the younger generation. Young people are more connected to the Western world than ever before. A quick visit to a bookstore or a movie theater offers proof.

Observant Turks are grappling with questions like: Where does praying fit in a busy life of e-mail messages and sixty-hour weeks? How do you hold on to Eastern tradition in a rising tide of Western culture?

The head scarf debate ended abruptly in June, when Turkey's Constitutional Court ruled that the new law allowing women attending universities to wear scarves was unconstitutional, because it violated the nation's principles of secularism.

Yilmaz got the news in a text message from her friend. In her bitter disappointment, she realized how much hope she had held out. "How can I be a part of a country that does not accept me?" she said.

Still, she has no regrets and is not giving up. "What we did was worth something," she said. "People heard our voices. One day the prohibition is imposed on us. The next day, it could be someone else. If we work together, we can fight it."

336 *Sebnem Arsu contributed reporting.*

Ahmet Öğüt,
Light Armoured, 2006.
Video animation,
1 min
(Detail)

Generation Faithful:

Violence Leaves Young Iraqis Doubting Clerics

Sabrina Tavernise

Correction Appended

BAGHDAD—After almost five years of war, many young people in Iraq, exhausted by constant firsthand exposure to the violence of religious extremism, say they have grown disillusioned with religious leaders and skeptical of the faith that they preach.

In two months of interviews with forty young people in five Iraqi cities, a pattern of disenchantment emerged, in which young Iraqis, both poor and middle class, blamed clerics for the violence and the restrictions that have narrowed their lives.

"I hate Islam and all the clerics because they limit our freedom every day and their instruction became heavy over us," said Sara, a high school student in Basra. "Most of the girls in my high school hate that Islamic people control the authority because they don't deserve to be rulers."

Atheer, a nineteen-year-old from a poor, heavily Shiite neighborhood in southern Baghdad, said: "The religion men are liars. Young people don't believe them. Guys my age are not interested in religion anymore."

The shift in Iraq runs counter to trends of rising religious practice among young people across much of the Middle East, where religion has replaced nationalism as a unifying ideology.

While religious extremists are admired by a number of young people in other parts of the Arab world, Iraq offers a test case of what could happen when extremist theories are applied. Fingers caught in the act of smoking were broken. Long hair was cut and force-fed to its wearer. In that laboratory, disillusionment with Islamic leaders took hold.

It is far from clear whether the shift means a wholesale turn away from religion. A tremendous piety still predominates in the private lives of young Iraqis, and religious leaders, despite the increased skepticism, still wield tremendous power. Measuring religious adherence, furthermore, is a tricky business in Iraq, where access to cities and towns far from Baghdad is limited.

But a shift seems to be registering, at least anecdotally, in the choices some young Iraqis are making.

Professors reported difficulty in recruiting graduate students for religion classes. Attendance at weekly prayers appears to be down, even in areas where the violence has largely subsided, according to worshipers and imams in Baghdad and Falluja. In two visits to the weekly prayer session in Baghdad of the followers of the militant Shiite cleric Moktada al-Sadr this fall, vastly smaller crowds attended than had in 2004 or 2005.

Such patterns, if lasting, could lead to a weakening of the political power of religious leaders in Iraq. In a nod to those changing tastes, political parties are dropping overt references to religion.

You Cost Us This

"In the beginning, they gave their eyes and minds to the clerics; they trusted them," said Abu Mahmoud, a moderate Sunni cleric in Baghdad, who now works deprogramming religious extremists in American detention. "It's painful to admit, but it's changed. People have lost too much. They say to the clerics and the parties, You cost us this."

"When they behead someone, they say 'Allahu akbar,' they read Koranic verse," said a moderate Shiite sheik from Baghdad, using the phrase **340** for "God is great."

"The young people, they think that is Islam," he said. "So Islam is a failure, not only in the students' minds, but also in the community."

A professor at Baghdad University's School of Law, who identified herself only as Bushra, said of her students: "They have changed their views about religion. They started to hate religious men. They make jokes about them because they feel disgusted by them."

That was not always the case. Saddam Hussein encouraged religion in Iraqi society in his later years, building Sunni mosques and injecting more religion into the public school curriculum, but always made sure it served his authoritarian needs.

Shiites, considered to be an opposing political force and a threat to Hussein's power, were kept under close watch. Young Shiites who worshiped were seen as political subversives and risked attracting the attention of the police.

For that reason, the American liberation tasted sweetest to the Shiites, who for the first time were able to worship freely. They soon became a potent political force, as religious political leaders appealed to their shared and painful past and their respect for the Shiite religious hierarchy.

"After 2003, you couldn't put your foot into the *husseiniya,* it was so crowded with worshipers," said Sayeed Sabah, a Shiite religious leader from Baghdad, referring to a Shiite place of prayer.

Religion had moved abruptly into the Shiite public space, but often in ways that made educated, religious Iraqis uncomfortable. Militias were offering Koran courses. Titles came cheaply. In Mahmoud's neighborhood, a butcher with no knowledge of Islam became the leader of a mosque.

A moderate Shiite cleric, Sheik Qasim, recalled watching in amazement as a former student, who never earned more than mediocre marks, whizzed by stalled traffic in a long convoy of sport utility vehicles in central Baghdad. He had become a religious leader.

"I thought I would get out of the car, grab him, and slap him!" said the sheik. "These people don't deserve their positions."

An official for the Ministry of Education in Baghdad, a secular Shiite, described the newfound faith like this: "It was like they wanted to put on a new, stylish outfit."

Religious Sunnis, for their part, also experienced a heady swell in mosque attendance, but soon became the hosts for groups of religious extremists, foreign and Iraqi, who were preparing to fight the United States.

Zane Mohammed, a gangly nineteen-year-old with an earnest face, watched with curiosity as the first Islamists in his Baghdad neighborhood came to barbershops, tea parlors, and carpentry stores before taking over the mosques. They were neither uneducated nor poor, he said, though they focused on those who were.

Then, one morning while waiting for a bus to school, he watched a man walk up to a neighbor, a college professor whose sect Mohammed did not know, shoot the neighbor at point blank range three times, and walk back to his car as calmly "as if he was leaving a grocery store."

"Nobody is thinking," Mohammed said in an interview in October. "We use our minds just to know what to eat. This is something I am very sad about. We hear things and just believe them."

Weary of Bloodshed

By 2006, even those who had initially taken part in the violence were growing weary. Haidar, a grade-school dropout, was proud to tell his family he was following a Shiite cleric in a fight against American soldiers in the summer of 2004. Two years later, however, he found himself in the company of gangsters.

Young militia members were abusing drugs. Gift mopeds had become gift guns. In three years, Haidar saw five killings, mostly of Sunnis, including that of a Sunni cab driver shot for his car.

It was just as bad, if not worse, for young Sunnis. Rubbed raw by Al Qaeda in Mesopotamia, a homegrown Sunni insurgent group that American intelligence says is led by foreigners, they found themselves stranded in neighborhoods that were governed by seventh-century rules. During an interview with a dozen Sunni teenage boys in a Baghdad detention facility on several sticky days in September, several of them expressed relief at being in jail, so they could wear shorts, a form of dress they would have been punished for in their neighborhoods.

Some Iraqis argue that the religious-based politics was much more about identity than faith. When Shiites voted for religious parties in large numbers in an election in 2005, it was more an effort to show their numbers, than a victory of the religious over the secular.

"It was a fight to prove our existence," said a young Shiite journalist from Sadr City. "We were embracing our existence, not religion."

The war dragged on, and young people from both the Shiite and Sunni sects became more broadly involved. Criminals had begun using teenagers and younger boys to carry out killings. The number of Iraqi juveniles in American detention was up more than sevenfold in November from April last year, and Iraq's main prison for youth, situated in Baghdad, has triple the prewar population.

Different Motivations

But while younger people were taking a more active role in the violence, their motivation was less likely than that of the adults to be **343**

religion-driven. Of the 900 juvenile detainees in American custody in November, fewer than 10 percent claimed to be fighting a holy war, according to the American military. About one-third of adults said they were.

A worker in the American detention system said that by her estimate, only about a third of the adult detainee population, which is overwhelmingly Sunni, prayed.

"As a group, they are not religious," said Maj. Gen. Douglas Stone, the head of detainee operations for the American military. "When we ask if they are doing it for jihad, the answer is no."

Muath, a slender, nineteen-year-old Sunni with distant eyes and hollow cheeks, is typical. He was selling cellphone credits and plastic flowers, struggling to keep his mother and five young siblings afloat, when an insurgent recruiter in western Baghdad, a man in his thirties who is a regular customer, offered him cash last spring to be part of an insurgent group whose motivations were a mix of money and sect.

Muath, the only wage earner in his family, agreed. Suddenly his family could afford to eat meat again, he said in an interview last September.

Indeed, at least part of the religious violence in Baghdad had money at its heart. An officer at the Kadhimiya detention center, where Muath was being held last fall, said recordings of beheadings fetched much higher prices than those of shooting executions in the CD markets, which explains why even non-religious kidnappers will behead hostages.

"The terrorist loves the money," said Capt. Omar, a prison worker who did not want to be identified by his full name. "The money has big magic. I give him $10,000 to do small thing. You think he refuse?"

When Muath was arrested last year, the police found two hostages, Shiite brothers, in a safe house that Muath told them about. Photo-

graphs showed the men looking wide-eyed into the camera; dark welts covered their bodies.

Violent struggle against the United States was easy to romanticize at a distance.

"I used to love Osama bin Laden," proclaimed a twenty-four-year-old Iraqi college student. She was referring to how she felt before the war took hold in her native Baghdad. The Sept. 11, 2001, strike at American supremacy was satisfying, and the deaths abstract.

Now, the student recites the familiar complaints: Her college has segregated the security checks; guards told her to stop wearing a revealing skirt; she covers her head for safety.

"Now I hate Islam," she said, sitting in her family's unadorned living room in central Baghdad. "Al Qaeda and the Mahdi Army are spreading hatred. People are being killed for nothing."

Worried Parents

Parents have taken new precautions to keep their children out of trouble. Abu Tahsin, a Shiite from northern Baghdad, said that when his extended family had built a Shiite mosque, they did not register it with the religious authorities, even though it would have brought privileges, because they did not want to become entangled with any of the main religious Shiite groups that control Baghdad.

In Falluja, a Sunni city west of Baghdad that had been overrun by Al Qaeda, Sheik Khalid al-Mahamedie, a moderate cleric, said fathers now came with their sons to mosques to meet the instructors of Koran courses. Families used to worry most about their daughters in adolescence, but now, the sheik said, they worry more about their sons.

"Before, parents warned their sons not to smoke or drink," said Mohammed Ali al-Jumaili, a Falluja father with a twenty-year-old son. "Now all their energy is concentrated on not letting them be involved with terrorism."

Recruiters are relentless, and, as it turns out, clever, peddling things their young targets need. General Stone compares it to as a sales pitch a pimp gives to a prospective prostitute. American military officers at the American detention center said it was the Qaeda detainees who were best prepared for group sessions and asked the most questions.

A Qaeda recruiter approached Mohammed, the nineteen-year-old, on a college campus with the offer of English lessons. Though lessons had been a personal ambition of Mohammed's for months, once he knew what the man was after, he politely avoided him.

"When you talk with them, you find them very modern, very smart," said Mohammed, a non-religious Shiite, who recalled feigning disdain for his own sect to avoid suspicion.

The population they focused on, however, was poor and uneducated. About 60 percent of the American adult detainee population is illiterate, and is unable to even read the Koran that religious recruiters are preaching.

That leads to strange twists. One young detainee, a client of Abu Mahmoud, the moderate Sunni cleric, was convinced that he had to kill his parents when he was released, because they were married in an insufficiently Islamic way. General Stone is trying to rectify the problem by offering religion classes taught by moderates.

There is a new favorite game in the lively household of the young Baghdad journalist. When they see a man with a turban on television, they yell and crack jokes. In one joke, people are warned not to give their cellphone numbers to a religious man.

"If he knows the number, he'll steal the phone's credit," the journalist said. "The sheiks are making a society of nonbelievers."

Kareem Hilmi, Ahmad Fadam, and Qais Mizher contributed reporting from Baghdad, and Iraqi employees of the New York Times *contributed reporting from Basra, Falluja, Baquba, and Mosul.*

This article has been revised to reflect the following correction:

Correction: Mar. 6, 2008
A front-page article on Tuesday about the religious disillusionment among young people in Iraq carried an incomplete list of reporting credits. In addition to three Iraqi reporters who contributed from Baghdad, where the article was written, Iraqi employees of the *Times* interviewed residents in Basra, Falluja, Baquba, and Mosul.

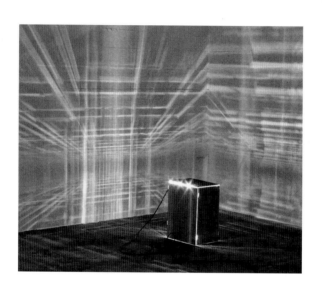

Kitty Kraus,
Untitled, 2008.
Mirror and light, dimensions variable.
Installation view,
Boros Collection, Berlin
Courtesy Galerie Neu, Berlin
(Detail)

Letter from China

Angry Youth: The New Generation's Neocon Nationalists.

Evan Osnos

On the morning of April 15th, a short video entitled *2008 China Stand Up!* appeared on Sina, a Chinese Web site. The video's origin was a mystery: Unlike the usual YouTube-style clips, it had no host, no narrator, and no signature except the initials "CTGZ."

It was a homespun documentary, and it opened with a Technicolor portrait of Chairman Mao, sunbeams radiating from his head. Out of silence came an orchestral piece, thundering with drums, as a black screen flashed, in both Chinese and English, one of Mao's mantras: "Imperialism will never abandon its intention to destroy us." Then a cut to present-day photographs and news footage, and a fevered sprint through conspiracies and betrayals–the "farces, schemes, and disasters" confronting China today. The sinking Chinese stock market (the work of foreign speculators who "wildly manipulated" Chinese stock prices and lured rookie investors to lose their fortunes). Shoppers beset by inflation, a butcher counter where "even pork has become a luxury." And a warning: this is the dawn of a global "currency war," and the West intends to "make Chinese people foot the bill" for America's financial woes.

A cut, then, to another front: rioters looting stores and brawling in Lhasa, the Tibetan capital. The music crescendos as words flash across the scenes: "So-called peaceful protest!" A montage of foreign press clippings critical of China–nothing but "rumors, all speaking with one distorted voice." The screen fills with the logos of CNN, the BBC, and other news organizations, which give way to a portrait of Joseph Goebbels. The orchestra and the rhetoric climb toward a final sequence: "Obviously, there is a scheme behind the scenes to encircle China. A new Cold War!" The music turns triumphant with images of China's Olympic hurdler Liu Xiang standing in Tiananmen Square, raising the Olympic torch, "a symbol of Peace and Friendship!" But,

349

first, one final act of treachery: In Paris, protesters attempt to wrest the Olympic torch from its official carrier, forcing guards to fend them off—a "long march" for a new era. The film ends with the image of a Chinese flag, aglow in the sunlight, and a solemn promise: "We will stand up and hold together always as one family in harmony!"

The video, which was just over six minutes long and is now on YouTube, captured the mood of nationalism that surged through China after the Tibetan uprising, in March, sparked foreign criticism of China's hosting of the 2008 Summer Olympics. Citizens were greeting the criticism with rare fury. Thousands demonstrated in front of Chinese outlets of Carrefour, a French supermarket chain, in retaliation for what they considered France's sympathy for pro-Tibetan activists. Charles Zhang, who holds a PhD from MIT and is the founder and CEO of Sohu, a leading Chinese Web portal along the lines of Yahoo, called online for a boycott of French products "to make the thoroughly biased French media and public feel losses and pain." When Speaker of the House Nancy Pelosi denounced China's handling of Tibet, Xinhua, China's official news service, called her "disgusting." State-run media revived language from another age: The magazine *Outlook Weekly* warned that "domestic and foreign hostile forces have made the Beijing Olympics a focus for infiltration and sabotage." In the anonymity of the Web, decorum deteriorated. "People who fart through the mouth will get shit stuffed down their throats by me!" one commentator wrote, in a forum hosted by a semi-official newspaper. "Someone give me a gun! Don't show mercy to the enemy!" wrote another. The comments were an embarrassment to many Chinese, but they were difficult to ignore among foreign journalists who had begun receiving threats. (An anonymous letter to my fax machine in Beijing warned, "Clarify the facts on China . . . or you and your loved ones will wish you were dead.")

In its first week and a half, the video by CTGZ drew more than a million hits and tens of thousands of favorable comments. It rose to the site's fourth-most-popular rating. (A television blooper clip of a yawning news anchor was No. 1.) On average, the film attracted nearly two clicks per second. It became a manifesto for a self-styled vanguard in defense of China's honor, a patriotic swath of society that the Chinese call the *fen qing*, the angry youth.

Nineteen years after the crackdown on student-led protests in Tiananmen Square, China's young elite rose again this spring—not in pursuit of liberal democracy but in defense of sovereignty and prosperity. Nicholas Negroponte, the founder of MIT's Media Laboratory and one of the early ideologists of the Internet, once predicted that the global reach of the Web would transform the way we think about ourselves as countries. The state, he predicted, will evaporate "like a mothball, which goes from solid to gas directly," and "there will be no more room for nationalism than there is for smallpox." In China, things have gone differently.

A young Chinese friend of mine, who spends most of his time online, traced the screen name CTGZ to an e-mail address. It belonged to a twenty-eight-year-old graduate student in Shanghai named Tang Jie, and it was his first video. A couple of weeks later, I met Tang Jie at the gate of Fudan University, a top Chinese school, situated on a modern campus that radiates from a pair of thirty-story steel-and-glass towers that could pass for a corporate headquarters. He wore a crisp powder-blue oxford shirt, khakis, and black dress shoes. He had bright hazel eyes and rounded features—a baby face, everyone tells him—and a dusting of goatee and mustache on his chin and upper lip. He bounded over to welcome me as I stepped out of a cab, and he tried to pay my fare.

Tang spends most of his time working on his dissertation, which is on Western philosophy. He specializes in phenomenology; specifically, **351**

in the concept of "intersubjectivity," as theorized by Edmund Husserl, the German philosopher who influenced Sartre, among others. In addition to Chinese, Tang reads English and German easily, but he speaks them infrequently, so at times he swerves, apologetically, among languages. He is working on his Latin and Ancient Greek. He is so self-effacing and soft-spoken that his voice may drop to a whisper. He laughs sparingly, as if he were conserving energy. For fun, he listens to classical Chinese music, though he also enjoys screwball comedies by the Hong Kong star Stephen Chow. He is proudly unhip. The screen name CTGZ is an adaptation of two obscure terms from classical poetry: *changting* and *gongzi*, which together translate as "the noble son of the pavilion." Unlike some elite Chinese students, Tang has never joined the Communist Party, for fear that it would impugn his objectivity as a scholar.

Tang had invited some friends to join us for lunch, at Fat Brothers Sichuan Restaurant, and afterward we all climbed the stairs to his room. He lives alone in a sixth-floor walkup, a studio of less than seventy-five square feet, which could be mistaken for a library storage room occupied by a fastidious squatter. Books cover every surface, and great mounds list from the shelves above his desk. His collections encompass, more or less, the span of human thought: Plato leans against Lao-tzu, Wittgenstein, Bacon, Fustel de Coulanges, Heidegger, the Koran. When Tang wanted to widen his bed by a few inches, he laid plywood across the frame and propped up the edges with piles of books. Eventually, volumes overflowed the room, and they now stand outside his front door in a wall of cardboard boxes.

Tang slumped into his desk chair. We talked for a while, and I asked if he had any idea that his video would be so popular. He smiled. "It appears I have expressed a common feeling, a shared view," he said.

Next to him sat Liu Chengguang, a cheerful, broad-faced PhD student in political science who recently translated into Chinese a

lecture on the subject of "Manliness" by the conservative Harvard professor Harvey Mansfield. Sprawled on the bed, wearing a gray sweatshirt, was Xiong Wenchi, who earned a PhD in political science before taking a teaching job last year. And to Tang's left sat Zeng Kewei, a lean and stylish banker, who picked up a master's degree in Western philosophy before going into finance. Like Tang, each of his friends was in his twenties, was the first in his family to go to college, and had been drawn to the study of Western thought.

"China was backward throughout its modern history, so we were always seeking the reasons for why the West grew strong," Liu said. "We learned from the West. All of us who are educated have this dream: Grow strong by learning from the West."

Tang and his friends were so gracious, so thankful that I'd come to listen to them, that I began to wonder if China's anger of last spring should be viewed as an aberration. They implored me not to make that mistake.

"We've been studying Western history for so long, we understand it well," Zeng said. "We think our love for China, our support for the government and the benefits of this country, is not a spontaneous reaction. It has developed after giving the matter much thought."

In fact, their view of China's direction, if not their vitriol, is consistent with the Chinese mainstream. Almost nine out of ten Chinese approve of the way things are going in the country—the highest share of any of the twenty-four countries surveyed this spring by the Pew Research Center. (In the United States, by comparison, just two out of ten voiced approval.) As for the more assertive strain of patriotism, scholars point to a Chinese petition against Japan's membership in the UN Security Council. At last count, it had attracted more than forty million signatures, roughly the population of Spain. I asked Tang to show me how he made his film. He turned to face the screen of his Lenovo desktop **353**

PC, which has a Pentium 4 Processor and one gigabyte of memory. "Do you know Movie Maker?" he said, referring to a video-editing program. I pleaded ignorance and asked if he'd learned from a book. He glanced at me pityingly. He'd learned it on the fly from the help menu. "We must thank Bill Gates," he said.

When people began rioting in Lhasa in March, Tang followed the news closely. As usual, he was receiving his information from American and European news sites, in addition to China's official media. Like others his age, he has no hesitation about tunneling under the government firewall, a vast infrastructure of digital filters and human censors which blocks politically objectionable content from reaching computers in China. Younger Chinese friends of mine regard the firewall as they would an officious lifeguard at a swimming pool—an occasional, largely irrelevant, intrusion.

To get around it, Tang detours through a proxy server—a digital way station overseas that connects a user with a blocked Web site. He watches television exclusively online, because he doesn't have a TV in his room. Tang also receives foreign news clips from Chinese students abroad. (According to the Institute of International Education, the number of Chinese students in the United States—some sixty-seven thousand—has grown by nearly two-thirds in the past decade.) He's baffled that foreigners might imagine that people of his generation are somehow unwise to the distortions of censorship.

"Because we are in such a system, we are always asking ourselves whether we are brainwashed," he said. "We are always eager to get other information from different channels." Then he added, "But when you are in a so-called free system you never think about whether you are brainwashed."

At the time, news and opinion about Tibet was swirling on Fudan's electronic bulletin board, or BBS. The board was alive with criticism of foreign coverage of Tibet. Tang had seen a range of foreign press clippings

deemed by Chinese Web users to be misleading or unfair. A photograph on CNN.com, for instance, had been cropped around military trucks bearing down on unarmed protesters. But an uncropped version showed a crowd of demonstrators lurking nearby, including someone with an arm cocked, hurling something at the trucks. To Tang, the cropping looked like a deliberate distortion. (CNN disputed this and said that the caption fairly describes the scene.)

"It was a joke," he said bitterly. That photograph and others crisscrossed China by e-mail, scrawled with criticism, while people added more examples from the *Times* of London, Fox News, German television, and French radio. It was a range of news organizations, and, to those inclined to see it as such, it smacked of a conspiracy. It shocked people like Tang, who put faith in the Western press, but, more important, it offended them: Tang thought that he was living in the moment of greatest prosperity and openness in his country's modern history, and yet the world still seemed to view China with suspicion. As if he needed confirmation, Jack Cafferty, a CNN commentator, called China "the same bunch of goons and thugs they've been for the last fifty years," a quote that rippled across the front pages in China and for which CNN later apologized. Like many of his peers, Tang couldn't figure out why foreigners were so agitated about Tibet—an impoverished backwater, as he saw it, that China had tried for decades to civilize. Boycotting the Beijing Games in the name of Tibet seemed as logical to him as shunning the Salt Lake City Olympics to protest America's treatment of the Cherokee.

He scoured YouTube in search of a rebuttal, a clarification of the Chinese perspective, but he found nothing in English except pro-Tibet videos. He was already busy—under contract from a publisher for a Chinese translation of Leibniz's *Discourse on Metaphysics* and other essays—but he couldn't shake the idea of speaking up on China's behalf.

"I thought, OK, I'll make something," he said. **355**

Before Tang could start, however, he was obligated to go home for a few days. His mother had told him to be back for the harvest season. She needed his help in the fields, digging up bamboo shoots.

Tang is the youngest of four siblings from a farming family near the eastern city of Hangzhou. For breaking China's one-child policy, his parents paid fines measured in grain. Tang's birth cost them two hundred kilos of unmilled rice. ("I'm not very expensive," he says.)

Neither his mother nor his father could read or write. Until the fourth grade, Tang had no name. He went by Little Four, after his place in the family order. When that became impractical, his father began calling him Tang Jie, an abbreviated homage to his favorite comedian, Tang Jiezhong, half of a popular act in the style of Abbott and Costello.

Tang was bookish and, in a large, boisterous household, he said little. He took to science fiction. "I can tell you everything about all those movies, like *Star Wars*," he told me. He was a good, though not a spectacular, student, but he showed a precocious interest in ideas. "He wasn't like other kids, who spent their pocket money on food—he saved all his money to buy books," said his sister Tang Xiaoling, who is seven years older. None of his siblings had studied past the eighth grade, and they regarded him as an admirable oddity. "If he had questions that he couldn't figure out, then he couldn't sleep," his sister said. "For us, if we didn't get it we just gave up."

In high school, Tang improved his grades and had some success at science fairs as an inventor. But he was frustrated. "I discovered that science can't help your life," he said. He happened upon a Chinese translation of a fanciful Norwegian novel, *Sophie's World*, by the philosophy teacher Jostein Gaarder, in which a teen-age girl encounters the history of great thinkers. "It was then that I discovered philosophy," Tang said.

Patriotism was not a particularly strong presence in his house, but landmarks of national progress became the backdrop of his adolescence. When Tang was in junior high, the Chinese were still celebrating the country's first major freeway, completed a few years before. "It was famous. We were proud of this. At last we had a highway!" he recalled one day, with a laugh, as we whizzed down an expressway in Shanghai. "Now we have highways everywhere, even in Tibet."

Supermarkets opened in his home town, and, eventually, so did an Internet café. (Tang, who was eighteen at the time, was particularly fond of the Web sites for the White House and NASA, because they had kids' sections that used simpler English sentences.) Tang enrolled at Hangzhou Normal University. He came to credit his country and his family for opportunities that his siblings had never had. By the time he reached Fudan, in 2003, he lived in a world of ideas. "He had a pure passion for philosophy," Ma Jun, a fellow philosophy student who met him early on, said. "A kind of religious passion."

The Internet had barely taken root in China before it became a vessel for nationalism. At the Atlanta Olympics, in 1996, as the Chinese delegation marched into the stadium, the NBC announcer Bob Costas riffed on China's "problems with human rights, property right disputes, the threat posed to Taiwan." Then he mentioned "suspicions" that Chinese athletes used performance-enhancing drugs. Even though the Web in China was in its infancy (there were just five telephone lines for every hundred people), comments spread instantly among Chinese living abroad. The timing couldn't have been more opportune: After more than fifteen years of reform and Westernization, Chinese writers were pushing back against Hollywood, McDonald's, and American values. An impassioned book titled *China Can Say No* came out that spring and sold more than a hundred thousand copies in its first month. Written by a group of young intellectuals, it decried China's "infatuation with America," **357**

which had suppressed the national imagination with a diet of visas, foreign aid, and advertising. If China didn't resist this "cultural strangulation," it would become "a slave," extending a history of humiliating foreign incursions that stretched back to China's defeat in the first Opium War and the British acquisition of Hong Kong, in 1842. The Chinese government, which is wary of fast-spreading new ideas, eventually pulled the book off the shelves, but not before a raft of knockoffs sought to exploit the same mood (*Why China Can Say No, China Still Can Say No,* and *China Always Say No*).

Xu Wu, a former journalist in China who is now a professor at Arizona State University, says in his 2007 book *Chinese Cyber Nationalism* that groups claiming to represent more than 70,000 overseas Chinese wrote to NBC asking for an apology for the Costas remarks. They collected donations online and bought an ad in the *Washington Post*, accusing Costas and the network of "ignominious prejudice and inhospitality." NBC apologized, and Chinese online activism was born.

Each day, some 3,500 Chinese citizens were going online for the first time. In 1998, Charles Zhang's Sohu launched China's first major search engine. The following spring, when a NATO aircraft, using American intelligence, mistakenly dropped three bombs on the Chinese Embassy in Belgrade, the Chinese Web found its voice. The United States apologized, blaming outdated maps and inaccurate databases, but Chinese patriotic hackers—calling themselves "honkers," to capture the sound of *hong*, which is Chinese for the color red—attacked. As Peter Hays Gries, a China scholar at the University of Oklahoma, details in *China's New Nationalism*, they plastered the home page of the US Embassy in Beijing with the slogan "Down with the Barbarians!," and they caused the White House Web site to crash under a deluge of angry e-mail. "The Internet is Western," one commentator wrote, "but . . . we Chinese can use

358 it to tell the people of the world that China cannot be insulted!"

The government treated online patriots warily. They placed their pride in the Chinese nation, not necessarily in the Party, and leaders rightly sensed that the passion could swerve against them. After a nationalist Web site was shut down by censors in 2004, one commentator wrote, "Our government is as weak as sheep!" The government permitted nationalism to grow at some moments but strained to control it at others. The following spring, when Japan approved a new textbook that critics claimed glossed over wartime atrocities, patriots in Beijing drafted protest plans and broadcast them via chat rooms, bulletin boards, and text messages. As many as 10,000 demonstrators took to the streets, hurling paint and bottles at the Japanese Embassy. Despite government warnings to cease these activities, thousands more marched in Shanghai the following week—one of China's largest demonstrations in years—and vandalized the Japanese consulate. At one point, Shanghai police cut off cell-phone service in downtown Shanghai.

"Up to now, the Chinese government has been able to keep a grip on it," Xu Wu told me. "But I call it the 'virtual Tiananmen Square.' They don't need to go there. They can do the same thing online and sometimes be even more damaging."

Tang was at dinner with friends one night in 2004 when he met Wan Manlu, an elegantly reserved PhD student in Chinese literature and linguistics. Her delicate features suited her name, which includes the character for the finest jade. They sat side by side, but barely spoke. Later, Tang hunted down her screen name—gracelittle—and sent her a private message on Fudan's bulletin board. They worked up to a first date: an experimental opera based on *Regret for the Past*, a Chinese story.

They discovered that they shared a frustration with China's unbridled Westernization. "Chinese tradition has many good things, but we've ditched them," Wan told me. "I feel there have to be people to carry them on."

She came from a middle-class home, and Tang's humble roots and **359**

old-fashioned values impressed her. "Most of my generation has a smooth, happy life, including me," she said. "I feel like our character lacks something. For example, love for the country or the perseverance you get from conquering hardships. Those virtues, I don't see them in myself and many people my age."

She added, "For him, from that kind of background, with nobody educated in his family, nobody helping him with schoolwork, with great family pressure, it's not easy to get where he is today."

They were engaged this spring. In their years together, Wan watched Tang fall in with a group of students devoted to a charismatic thirty-nine-year-old Fudan philosophy professor named Ding Yun. He is a translator of Leo Strauss, the political philosopher whose admirers include Harvey Mansfield and other neoconservatives. A Strauss student, Abram Shulsky, who co-authored a 1999 essay titled "Leo Strauss and the World of Intelligence (By Which We Do Not Mean *Nous*)," ran the Pentagon's Office of Special Plans before the invasion of Iraq. Since then, other Strauss disciples have vigorously ridiculed suggestions of a connection between Strauss's thought and Bush-era foreign policy.

I saw Mansfield in Shanghai in May, during his first visit to China, at a dinner with a small group of conservative scholars. He was wearing a honey-colored panama and was in good spirits, though he seemed a bit puzzled by all the fuss they were making about him. His first question to the table: "Why would Chinese scholars be interested in Leo Strauss?"

Professor Ding teaches a Straussian regard for the universality of the classics and encourages his students to revive ancient Chinese thought. "During the 1980s and '90s, most intellectuals had a negative opinion of China's traditional culture," he told me recently. He has close-cropped hair and stylish rectangular glasses, and favors the conspicuously retro loose-fitting shirts

of a Tang-dynasty scholar. When Ding grew up, in the early years of

reform, "conservative" was a derogatory term, just like "reactionary," he said.

But Ding and others have thrived in recent years amid a new vein of conservatism which runs counter to China's drive for integration with the world. Just as America's conservative movement in the 1960s capitalized on the yearning for a post-liberal retreat to morality and nobility, China's classical revival draws on a nostalgic image of what it means to be Chinese. The biggest surprise best-seller of recent years is, arguably, *Yu Dan's Reflections on the Analects*, a collection of Confucian lectures delivered by Yu, a telegenic Beijing professor of media studies. She writes, "To assess a country's true strength and prosperity, you can't simply look at GNP growth and not look at the inner experience of each ordinary person: Does he feel safe? Is he happy?" (Skeptics argue that it's simply *Chicken Soup for the Confucian Soul.*)

Professor Ding met Tang in 2003, at the entrance interview for graduate students. "I was the person in charge of the exam," Ding recalled. "I sensed that this kid is very smart and diligent." He admitted Tang to the program, and watched with satisfaction as Tang and other students pushed back against the onslaught of Westernization. Tang developed an appetite for the classics. "The fact is we are very Westernized," he said. "Now we started reading ancient Chinese books and we rediscovered the ancient China."

This renewed pride has also affected the way Tang and his peers view the economy. They took to a theory that the world profits from China but blocks its attempts to invest abroad. Tang's friend Zeng smiled disdainfully as he ticked off examples of Chinese companies that have tried to invest in America.

"Huawei's bid to buy 3Com was rejected," he said. "CNOOC's bid to buy into Unocal and Lenovo's purchase of part of IBM caused political repercussions. If it's not a market argument, it's a political argument. We think the world is a free market–"

Before he could finish, Tang jumped in. "This is what you–America–taught us," he said. "We opened our market, but when we try to buy your companies we hit political obstacles. It's not fair."

Their view, which is popular in China across ideological lines, has validity: American politicians have invoked national-security concerns, with varying degrees of credibility, to oppose Chinese direct investment. But Tang's view, infused with a sense of victimhood, also obscures some evidence to the contrary: China has succeeded in other deals abroad (its sovereign-wealth fund has stakes in the Blackstone Group and in Morgan Stanley), and though China has taken steps to open its markets to foreigners, it remains equally inclined to reject an American attempt to buy an asset as sensitive as a Chinese oil company.

Tang's belief that the United States will seek to obstruct China's rise–"a new Cold War"– extends beyond economics to broader American policy. Disparate issues of relatively minor importance to Americans, such as support for Taiwan and Washington's calls to raise the value of the yuan, have metastasized in China into a feeling of strategic containment. In polls, the Chinese public has not demonstrated a significant preference for either Barack Obama or John McCain, though Obama has attracted negative attention for saying that, were he President, he might boycott the opening ceremony of the Olympics. Tang and his friends have watched some debates online, but the young patriots tend to see the race in broader terms. "No matter who is elected, China is still China and will go the way it goes," one recent posting in a discussion about Obama said. "Who can stand in the way of the march of history?"

This spring, Tang stayed at his family's farm for five days before he could return to Shanghai and finish his movie. He scoured the Web for photographs on the subjects that bother him and his friends, everything from inflation to Taiwan's threats of independence. He selected some of the

362

pictures because they were evocative—a man raising his arm in a sea of Chinese flags reminded him of Delacroix's *Liberty Leading the People*—and chose others because they embodied the political moment: a wheelchair-bound Chinese amputee carrying the Olympic flame in Paris, for instance, fending off a protester who was trying to snatch it away.

For a soundtrack, he typed "solemn music" into Baidu, a Chinese search engine, and scanned the results. He landed on a piece by Vangelis, a Yanni-style pop composer from Greece who is best known for his score for the movie *Chariots of Fire*. Tang's favorite Vangelis track was from a Gérard Depardieu film about Christopher Columbus called *1492: Conquest of Paradise*. He watched a few seconds of Depardieu standing manfully on the deck of a tall ship, coursing across the Atlantic. Perfect, Tang thought: "It was a time of globalization."

Tang added scenes of Chairman Mao and the Olympic track star Liu Xiang, both icons of their eras. The film was six minutes and sixteen seconds long. Some title screens in English were full of mistakes, because he was hurrying, but he was anxious to release it. He posted the film to Sina and sent a note to the Fudan bulletin board. As the film climbed in popularity, Professor Ding rejoiced. "We used to think they were just a postmodern, Occidentalized generation," Ding said. "Of course, I thought the students I knew were very good, but the wider generation? I was not very pleased. To see the content of Tang Jie's video, and the scale of its popularity among the youth, made me very happy. Very happy."

Not everyone was pleased. Young patriots are so polarizing in China that some people, by changing the intonation in Chinese, pronounce "angry youth" as "shit youth."

"How can our national self-respect be so fragile and shallow?" Han Han, one of China's most popular young writers, wrote on his blog, in **363**

an essay about nationalism. "Somebody says you're a mob, so you curse him, even want to beat him, and then you say, We're not a mob. This is as if someone said you were a fool, so you held up a big sign in front of his girlfriend's brother's dog, saying 'I Am Not a Fool.' The message will get to him, but he'll still think you're a fool."

If the activists thought that they were defending China's image abroad, there was little sign of success. After weeks of patriotic rhetoric emanating from China, a poll sponsored by the *Financial Times* showed that Europeans now ranked China as the greatest threat to global stability, surpassing America.

But the eruption of the angry youth has been even more disconcerting to those interested in furthering democracy. By age and education, Tang and his peers inherit a long legacy of activism that stretches from 1919, when nationalist demonstrators demanded "Mr. Democracy" and "Mr. Science," to 1989, when students flooded Tiananmen Square, challenging the government and erecting a sculpture inspired by the Statue of Liberty. Next year will mark the twentieth anniversary of that movement, but the events of this spring suggest that prosperity, computers, and Westernization have not driven China's young elite toward tolerance but, rather, persuaded more than a few of them to postpone idealism as long as life keeps improving. The students in 1989 were rebelling against corruption and abuses of power. "Nowadays, these issues haven't disappeared but have worsened," Li Datong, an outspoken newspaper editor and reform advocate, told me. "However, the current young generation turns a blind eye to it. I've never seen them respond to those major domestic issues. Rather, they take a utilitarian, opportunistic approach."

One caricature of young Chinese holds that they know virtually nothing about the crackdown at Tiananmen Square–known in Chinese as "the June 4 incident"–because the authorities have purged it from the na-

364

tion's official history. It's not that simple, however. Anyone who can click on a proxy server can discover as much about Tiananmen as he chooses to learn. And yet many Chinese have concluded that the movement was misguided and naïve.

"We accept all the values of human rights, of democracy," Tang told me. "We accept that. The issue is how to realize it."

I met dozens of urbane students and young professionals this spring, and we often got to talking about Tiananmen Square. In a typical conversation, one college senior asked whether she should interpret the killing of protesters at Kent State in 1970 as a fair measure of American freedom. Liu Yang, a graduate student in environmental engineering, said, "June 4 could not and should not succeed at that time. If June 4 had succeeded, China would be worse and worse, not better."

Liu, who is twenty-six, once considered himself a liberal. As a teenager, he and his friends happily criticized the Communist Party. "In the 1990s, I thought that the Chinese government is not good enough. Maybe we need to set up a better government," he told me. "The problem is that we didn't know what a good government would be. So we let the Chinese Communist Party stay in place. The other problem is we didn't have the power to get them out. They have the Army!"

When Liu got out of college, he found a good job as an engineer at an oil-services company. He was earning more money in a month than his parents–retired laborers living on a pension–earned in a year. Eventually, he saved enough money that, with scholarships, he was able to enroll in a PhD program at Stanford. He had little interest in the patriotic pageantry of the Olympics until he saw the fracas around the torch in Paris. "We were furious," he said, and when the torch came to San Francisco he and other Chinese students surged toward the relay route to support it. I was in San Francisco not long ago, and we arranged to meet at a Starbucks near his dorm, in Palo Alto. He arrived on his mountain bike, wearing a Nautica fleece pullover and jeans.

The date, we both knew, was June 4th, nineteen years since soldiers put down the Tiananmen uprising. The overseas Chinese students' bulletin board had been alive all afternoon with discussions of the anniversary. Liu mentioned the famous photograph of an unknown man standing in front of a tank—perhaps the most provocative image in modern Chinese history.

"We really acknowledge him. We really think he was brave," Liu told me. But, of that generation, he said, "They fought for China, to make the country better. And there were some faults of the government. But, finally, we must admit that the Chinese government had to use any way it could to put down that event."

Sitting in the cool quiet of a California night, sipping his coffee, Liu said that he is not willing to risk all that his generation enjoys at home in order to hasten the liberties he has come to know in America. "Do you live on democracy?" he asked me. "You eat bread, you drink coffee. All of these are not brought by democracy. Indian guys have democracy, and some African countries have democracy, but they can't feed their own people.

"Chinese people have begun to think, One part is the good life, another part is democracy," Liu went on. "If democracy can really give you the good life, that's good. But, without democracy, if we can still have the good life why should we choose democracy?"

When the Olympic torch returned to China, in May, for the final journey to Beijing, the Chinese seemed determined to make up for its woes abroad. Crowds overflowed along the torch's route. One afternoon, Tang and I set off to watch the torch traverse a suburb of Shanghai.

At the time, the country was still in a state of shock following the May 12 earthquake in the mountains of Sichuan Province, which killed more than sixty-nine thousand people and left millions homeless. It was the worst disaster in three decades, but it also produced a rare moment of national

unity. Donations poured in, revealing the positive side of the patriotism that had erupted weeks earlier.

The initial rhetoric of that nationalist outcry contained a spirit of violence that anyone old enough to remember the Red Guards—or the rise of skinheads in Europe—could not casually dismiss. And that spirit had materialized, in ugly episodes: When the Olympic torch reached South Korea, Chinese and rival protesters fought in the streets. The Korean government said it would deport Chinese agitators, though a Chinese Foreign Ministry spokeswoman stood by the demonstrators' original intent to "safeguard the dignity of the torch." Chinese students overseas emerged as some of the most vocal patriots. According to the *Times*, at the University of Southern California they marshalled statistics and photographs to challenge a visiting Tibetan monk during a lecture. Then someone threw a plastic water bottle in the monk's direction, and campus security removed the man who tossed it. At Cornell, an anthropology professor who arranged for the screening of a film on Tibet informed the crowd that, on a Web forum for Chinese students, she was "told to 'go die.'" At Duke University, Grace Wang, a Chinese freshman, tried to mediate between pro-Tibet and pro-China protesters on campus. But online she was branded a "race traitor." People ferreted out her mother's address, in the seaside city of Qingdao, and vandalized their home. Her mother, an accountant, remains in hiding. Of her mother, Grace Wang said, "I really don't know where she is, and I think it's better for me not to know."

Now in summer school at Duke, Grace Wang does not regret speaking up, but she says that she misjudged how others her age, online but frustrated in China, would resent her. "When people can't express themselves in real life, what can they do? They definitely have to express their anger toward someone. I'm far away. They don't know me, so they don't feel sorry

367

about it. They say whatever they want." She doesn't know when she'll return home (she becomes uneasy when she is recognized in Chinese restaurants near campus), but she takes comfort in the fact that history is filled with names once vilified, later rehabilitated. "This is just like what happened in the Cultural Revolution," she said. "Think about how Deng Xiaoping was treated at that time, and then, in just ten years, things had changed completely."

In the end, nothing came of the threats to foreign journalists. No blood was shed. After the chaos around the torch in Paris, the Chinese efforts to boycott Carrefour fizzled. China's leaders, awakening to their deteriorating image abroad, ultimately reined in the students with a call for only "rational patriotism."

"We do not want any violence," Tang told me. He and his peers had merely been desperate for someone to hear them. They felt no connection to Tiananmen Square, but, in sending their voices out onto the Web, they, too, had spoken for their moment in time. Their fury, Li Datong, the newspaper editor, told me, arose from "the accumulated desire for expression—just like when a flood suddenly races into a breach." Because a flood moves in whatever direction it chooses, the young conservatives are, to China's ruling class, an unnerving new force. They "are acutely aware that their country, whose resurgence they feel and admire, has no principle to guide it," Harvey Mansfield wrote in an e-mail to me, after his visit. "Some of them see . . . that liberalism in the West has lost its belief in itself, and they turn to Leo Strauss for conservatism that is based on principle, on 'natural right.' This conservatism is distinct from a status-quo conservatism, because they are not satisfied with a country that has only a status quo and not a principle."

In the weeks after Tang's video went viral, he made a series of others, about youth, the earthquake, China's leaders. None of his follow-ups generated more than a flicker of the attention of the original. The Web had moved on—to newer nationalist films and other distractions.

As Tang and I approached the torch-relay route, he said, "Look at the people. Everyone thinks this is their own Olympics."

Vendors were selling T-shirts, big Chinese flags, headbands, and mini-flags. Tang told me to wait until the torch passed, because hawkers would then cut prices by up to 50 per cent. He was carrying a plastic bag and fished around in it for a bright-red scarf of the kind that Chinese children wear to signal membership in the Young Pioneers, a kind of Socialist Boy Scouts. He tied it around his neck and grinned. He offered one to a passing teenager, who politely declined.

The air was stagnant and thick beneath a canopy of haze, but the mood was exuberant. Time was ticking down to the torch's arrival, and the town was coming out for a look: a man in a dark suit, sweating and smoothing his hair; a construction worker in an orange helmet and farmer's galoshes; a bellboy in a vaguely nautical getup.

Some younger spectators were wearing T-shirts inspired by China's recent troubles: "Love China, Oppose Divisions, Oppose Tibetan Independence," read a popular one. All around us, people strained for a better perch. A woman hung off a lamppost. A young man in a red headband climbed a tree.

The crowd's enthusiasm seemed to brighten Tang's view of things, reminding him that China's future belongs to him and to those around him. "When I stand here, I can feel, deeply, the common emotion of Chinese youth," he said. "We are self-confident."

Police blocked the road. A frisson swept through the crowd. People surged toward the curb, straining to see over one another's heads. But Tang hung back. He is a patient man.

Loris Gréaud,
"Cellar Door," 2008.
Exhibition view,
Palais de Tokyo, Paris
(Detail)

Generation *Ku*:

Individualism and China's Millennial Youth

Robert L. Moore

It is all but impossible to discuss China today without acknowledging the significance of its increasingly rapid pace of change. Change is evident in economic development, especially in major urban centers like Shanghai and Beijing, and in the new official attitude toward private enterprise that is, to say the least, supportive. These overt trappings of change are part of a global process that has made marketing by major corporations a force whose power and immediacy may exceed those of the various religious or political philosophies the world has seen so far. Corresponding to this economically driven change are other transformations that are particularly apparent in the educated youth of China's Millennial Generation.[1] Of course young Chinese respond to the forces of globalization in a variety of ways, many of which are mutually contradictory. Some may pointedly speak out against commercial forces while others readily accept them or embrace the commodities that are their agents in the popular media of films, music, television, and the Internet.

The Millennials are the children of the Cultural Revolution generation. Largely because of globalization, their viewpoints and attitudes are profoundly different from those of their parents. A central feature of these attitudes is a kind of individualism that stands emphatically opposed to the collectivist spirit promoted during the Cultural Revolution, an individualism that is influenced by Western pop culture and is linked to the new Chinese slang term "*ku*," derived from the English slang term "cool." The *ku* of China's Millennials is not a carbon copy of Western styles. There are different ways to be *ku* in contemporary China, but all reflect Western kinds of modernity and individualism.

The adoption of the word *ku* as a basic slang term symbolizing the values of a current generation of Chinese youth is similar to what occurred in the US twice during the twentieth century, first in the 1920s with the

term "swell," and again in the 1960s when swell was replaced by "cool."[2] In each case a fundamental transformation in values, driven by adolescents and young adults, was accompanied by the emergence and widespread acceptance of a new slang term of approval. China today is experiencing a similar transformation in values among its youth. The acceptance of new values by young people in the face of resistance by their elders is a pattern commonly found in modern societies where popular culture flourishes via mass media. It is also common for the younger generation to emphasize its association with their new values via a pervasively used slang term.

In the case of *ku*, the newly adopted term is revealing in that it comes from a basic slang lexeme originating in Western popular culture, but is semantically linked to features not associated with the meaning of the Western term. In fact, the semantic modification of this slang term highlights what is most prominent in the way young Chinese identify themselves as distinct from their forebears.

Ku is written with a classical Chinese character (also pronounced *kù*) whose original meaning was "cruel." This written character is now more commonly employed to represent the new slang term in current popular culture contexts rather than the classical word *ku*. Most users of the word *ku* in the late 1990s reported being exposed to it mainly via Internet connections or through exposure to Western popular culture, sometimes via Hong Kong Chinese mediators. Most respondents view the term as being derived from the American slang "cool," and when a young Chinese is asked about the meaning of *ku*, she will often simply say, "It means cool."

The issue of identity has drawn increasing attention in social science research in recent decades, and a number of cultural icons and complexes have been highlighted as markers of identity, including religion, food, sexuality, genealogy, and, of course, language.[3] However, the use of a

slang term as a generational identifier is different from the more general function of a dialect or other linguistic register as a key bearer of identity. This is partly because of the affective element inherent in slang. Slang lexemes function differently from most standard words and phrases in that they are part of what Biber refers to as relatively "involved" rather than "informational" speech.[4] The former kind of speech is most typical of conversation and personal letters and not typical of the more "informational" registers such as scientific prose or official documents. What Biber labels as "involved" is one's self as an evaluating and emotional entity. Slang, as a speech form that strongly implies a measure of emotional or evaluative attitude, serves as a marker for those wishing to signal identity within a social milieu, particularly one associated with a distinct value complex. Basic slang emerges when members of a rising generation wish to signal their commitment to a set of values and attitudes that are clearly different from those of their parents' generation. For China's Millennial youth, the value in question is a positive disposition toward a new kind of individualism represented by *ku*.

Collectivism in China

The broad characterization of traditional China as a "collective" culture is misleading in its essentialism, yet does contain a grain of truth.[5] It is accurate to say that there are some groups to which individual Chinese typically belong, and to which they defer in their daily activities and decision making. Chinese and others concur that the demands made on individual Chinese by these groups are more pervasive and powerful than those made on most Westerners. The family and, in some parts of China, the extended family or lineage are such groups.[6] The People's Republic of China in 1949 brought in the **373**

values of Marxism, Leninism, and Mao Zedong thought. Maoist China was the formative context for the parents of the Millennial Generation. It was deeply hostile to individualistic impulses, which were enounced as contrary to the new socialist society. For the youth of the 1960s and 1970s, everything revolved around the state and Chairman Mao. Anyone interested in reading American literature, for example, or in improving her economic situation, was reviled as a bourgeois individualist. The intolerance was expressed in the traditional forms of gossip, ostracism, and in beatings and incarceration.[7] During this Maoist phase, the traditional kin-focused collectivism of old China became state-focused.

Reform, Pop Culture, and the New Individualism

With the post-Mao reforms, individualistic tendencies emerged. The economic reforms of the 1980s encouraged individuals to sell their goods in the market. New clothing styles appeared in the 1980s, replacing the virtually universal, solid blue, grey, or brown loose-fitting shirt and pants combination of the Mao years. For the first time in decades, young women in colorful dresses and men in Western-influenced sport shirts and pants appeared in urban China.

More significantly, starting in 1978, young people were told that education for self-improvement was not selfish and immoral after all, and a dedication to promoting one's career through education became widespread. At the same time, consumer goods from Japan and the West began to appear, although the modest incomes of Chinese consumers limited their accessibility.[8]

Throughout the 1980s and early 1990s Chinese cities were rapidly transformed. Some of this dramatic change was expressed in a popular youth culture that took most of its cues from America and the West. By the late

374 1980s rock bands and stars had become famous among China's youth,

including Tang Dynasty, Black Panther, and Cui Jian.[9] In the mid-1990s came the Internet café, soon followed by an explosion of Western films available on DVDs. When China's Millennial Generation was coming of age in the late 1990s, the People's Republic was utterly transformed from what it had been in 1980.

The individualistic tendencies of this generation are often linked to influences from the West, Japan, and South Korea. The emergence of hundreds of local rock bands was accompanied by the use of marijuana and other drugs by band members, apparently because these habits were thought to be typical of famous Western rockers. It seemed almost as though a cultural complex from the American 1960s was incorporated as a whole to the rock music scene of urban China in the 1990s.

American Beat authors like Jack Kerouac and Allen Ginsberg became popular with the Millennial Generation, as did socially conscious 1960s American music like that of Bob Dylan and John Lennon, as evidenced in Zhang Yang's 2001 film *Quitting*, and Wei Hui's 1999 novel *Shanghai Baobei*. The so-called Sixth Generation produced a panoply of individualistic films, such as *East Palace, West Palace* (1998, dir. Zhang Yuan) and *Suzhou River* (2000, dir. Lou Ye).

The birth of a new kind of individualism among young millennial Chinese is occurring against a longstanding backdrop of entrenched collectivism, although individualist attitudes were not completely absent in Chinese society in all its varied contexts.[10] Traditional individualism was embodied in the legendary "knights-errant" (*youxia*) of past dynasties, whose heroic style resembled such modern western figures as Zorro and Spiderman.[11] The newly emerged business elite in contemporary China might also be called individualistic.[12] The current form of individualism of the Millennial youth is remarkable in having become mainstream rather than being restricted to obscure or specialized corners of society. Those youths are in a position to model behavior **375**

for others less well educated and further from the centers of urban influence, and this is certain to reverberate throughout China in the coming decades despite official opposition to its bourgeois association.[13] Given the nature of some of the individualistic practices of the Millennials, it is no wonder that their parents deplore the behaviors and ideals that their adolescent children embrace. Common parental complaints focus on the adolescents' dyed hair and pursuit of fashion, calling them utterly foolish wastes of time. Another parental complaint is that their adolescent children do not study enough. But overriding all of these areas of conflict is the tendency for young Chinese to establish boyfriend-girl-friend relations.[14]

Dating and forming romantic relationships have long been prohibited in China, by Confucian-influenced families and, more recently, by dictate of the state. Teachers and university professors have traditionally helped maintain these prohibitions, but today professors generally do not interfere in the romantic attachments that are widespread on campuses throughout China. The pursuit of romantic relationships is a profoundly individualistic undertaking; in countenancing such relationships through the passivity of its educational personnel, the state has condoned this aspect of individualism.

Yan describes a similar effect in Xiajia Village of Heilongjiang Province.[15] In that rural community the state, in the 1950s and 1960s, ruthlessly undermined family and local authority systems. In so doing it inadvertently laid the groundwork for individualistic tendencies to emerge later, during the reform era when state authorities abandoned their role as arbiters of the lives of ordinary Chinese. With the kin groups weakened or destroyed, the young Heilongjiang villagers of the 1990s were able to explore individualistic pursuits to the extent that their economic resources would allow, and the rapidly expanding free market economy of this era encouraged exploration.

In contemporary urban China, university students choose majors that promise high incomes in the future, often in response to their parents' urging; but some students choose majors against their parents' wishes. This is a more dramatic gesture than it may appear to non-Chinese since it has long been common for Chinese parents to determine the secondary school studies and the post-secondary educational and career plans of their children. Most of the students I taught at Qingdao University in the early 1990s had applied to universities and selected their majors on the basis of their parents' advice. Parents, with an eye on economics, most often encouraged their children to major in such pragmatic subjects as international business, English, or Japanese. These patterns reveal a post-Mao acceptance of individual striving on behalf of the family and, in those cases where the students went against parental advice or pressure, the pursuit of personal interests.

Several forces act simultaneously on young urban Chinese, the most obvious being the retreat of the state from the private lives of Chinese, the encouragement of profitable economic activity, the rapid rise in urban household incomes, the availability of consumer goods, and the accessibility of Western popular culture through film, music, television, and the Internet.

Before 1995, university student life offered few opportunities for entertainment. In Qingdao in 1994, a single, rather dreary discotheque drew the occasional university student visitor (as most lacked the money to attend regularly). Today there are numerous clubs in cities the size of Qingdao, and they have the appearance of similar clubs in the US and Europe. Now, many university students have the means to visit them occasionally, despite the considerable expense of cover charges and drinks. The changes in university student life that include this new world of entertainment and self-indulgence have engendered mixed reactions from parents and official authorities.[16] **377**

Though the promotion of seeking wealth has spurred individualistic tendencies, so has the imitation of Western, especially American, styles as these have been portrayed in popular culture. One of the most prominent aspects is American "cool." Young Chinese not only accept this ideal in its broadest sense, they emphasize those of its features that speak most directly to their new sense of individualism. Thus, Chinese *ku*, though not identical to American cool, is linked to it historically and in terms of the values it references.

The Semantics of *Ku*

Ku was not widely used among Chinese university students in the early 1990s. By the late 1990s, it had become ubiquitous on university campuses all over mainland China. Two factors promoting its rapid rise as a widely used term of approval were the emergence of Internet cafés and the increasing number of Chinese students on American campuses.

A comment that indicates the connection of the *ku* concept with the new individualism was made to me in 1998 by a Beijing native in her thirties. After emphasizing the newness of *ku*, she concluded: "The *ku* person is someone we might have called *qiguai* (merely strange) ten years ago, [when] China was not so open, so it would not accept someone who is so special."

Other respondents described *ku* as referring to surprise about a person who is brave enough to do something different, or as describing a girl who does her hair in the "Korean style," which none of her friends has yet dared to do, or "someone fashionable, handsome, or even quite different or strange." An office worker who succeeded in getting a complex computer program to work, announced his success by loudly saying, "*ku!*"

378 This slang term, in wide use among university students by 1998, was

still a mystery to the older generation. During visits to Beijing in 1998 and 2000, fewer than five adults with whom I came in contact were familiar with this term. A questionnaire I distributed to a class of history students at Beiwai in 1998 asked the respondent to indicate if he knew anyone who could be considered *ku* and, if so, what qualities made this person *ku*? Most students indicated they did know someone *ku* and, of those who provided examples of a *ku* individual, the majority named famous Chinese or American film, sports, or music stars. A minority identified classmates and friends as ones who could be called *ku*. Some did not specify anyone but simply listed the features a *ku* person would have. The qualities making a person *ku* can be categorized into five groups.

The most salient attribute of the *ku* individual, according to the student responses, is a manner or pose in which inner feelings are kept concealed. Feelings of warmth in particular are thought to be kept concealed, though there is the implication that the *ku* person has a warm heart that appears in special circumstances. Of course, given that *ku* is a term of approval, a person who is genuinely cold-hearted would not likely be described as *ku*.

The second most common category of responses designates fashionable or unusual clothing and grooming styles. This feature is often linked to rock stars and other popular music performers. Some young Chinese listed "appearance" as a key feature of *ku*, others thought that *ku* was merely a certain look.

Willful individualism constitutes the third most commonly identified attribute. This category includes references to people of strong will who do what they want despite the opposition of others or society.

The fourth category is competence, which includes references to outstanding singers and movie characters who can do amazing things. The fifth category refers to a friendly and easy-going personality. This attribute contradicts the first category and seems to signal an expanded meaning **379**

for *ku*, but this referent is best explained as a consequence of *ku* having become a generalized term of approval.

The categories elicited from the Beiwai questionnaire describe two different kinds of *ku* people. The first is the heroic figure who is tough and emotionally controlled, though implicitly having a heart of gold. The prototype is the action hero along the lines of the characters played by Chow Yun-fat, a model of the stoic hero. The other image of *ku* comes from the stylish young person, and is prototypically represented by flamboyantly dressed rock stars and those who imitate them. Unlike the stoic hero ideal, the rock star ideal can be male or female, though in general Chinese *ku* is more closely associated with masculine rather than feminine qualities. Individualism is the key feature connecting these two ideals or cultural models.

A significant minority of university students, when asked to identify people they thought of as *ku*, indicated their friends and classmates. The features of these *ku* acquaintances included the same qualities identified in the film and rock stars: emotionally controlled, knowing, sometimes fashionably dressed, and strongly individualistic. Sunglasses, associated in the West with urban cool, are also associated with Chinese *ku*, and sunglasses may well be the *ku* symbol par excellence, in that they can express both flamboyance and emotional distance.

In the questionnaire, Chinese students were asked to identify what makes a person *ku*; some of the students answered that "*ku*" simply means "good" or "worthy of approval." The fifth category includes such varied responses as being friendly, easygoing, and full of energy. Some responses suggest that *ku* has a broad range of meanings. One female student said that Chow Yun-fat is *ku* because he is "dashing"; another said *ku* people are "refined in words and behavior."

The most telling answer came from the student who said, "[*ku*] has a

very large range of meanings in Chinese. Everything could be *ku*."

Another item on the 1998 Beiwai questionnaire elicited Chinese words that are the opposite of *ku* in meaning. This was to supplement other sources of information on the semantics of *ku*, and to circumvent the tendency of some respondents to make broad statements along the lines of "anything can be *ku*." The thirty-five students responding to this question generated sixteen Mandarin terms, as well as the English term "warm-hearted" (though the question specifically asked for Mandarin words).

A remarkable feature of this sample is the large number of respondents who offered the word *mian* as the opposite of *ku*. *Mian*, like *ku*, is a slang (*liyu*) term and, as such, offers an appropriate contrast with *ku*. *Mian*, most commonly used in northern China, is semantically linked to the standard Mandarin word *mian* (noodle), and is written with the Mandarin character for noodle, thereby suggesting a soft or weak disposition. The implication of weakness and timidity in *mian* contrasts with the latter's reference to a bold, individualistic style or personality.

Conclusion

For young Chinese, the term *ku* is still closely tied to the images of action-movie heroes and rock stars, but it also has been accepted as a generalized term of approval. If it continues to fulfill its role as the basic slang term of the Millennial Generation, *ku* is likely to be held by successive generations as a pervasively used and mildly rebellious term of general approval—until, perhaps, a new youth rebellion against parental values results in the appropriation of a new basic slang term. Some other widely used slang terms of approval include *shuang* and *niubi*. *Shuang* refers to something that is refreshing and relaxing, like a glass of beer. *Niubi* is a vulgar term that is most delicately translated as cow vagina. **381**

Neither of these is associated with young people or with a newly emerging value complex, and the latter term's vulgarity makes it more than mildly rebellious, thereby limiting the contexts in which it can be used. Neither of these terms is a plausible candidate as a basic slang term for the current generation.

The values linked to the term *ku* are individualism and, in some ways, self-indulgence. Such values have not been prominent in mainstream Chinese society in the past. Individualism did not spring fully armed from among the Millennial Generation, but emerged gradually with the increasing freedoms of the 1980s. According to Farquhar, the popular 1979 Zhang Jie short story, *Love Must Not Be Forgotten*, "opened up a domain in which people could explore the possibilities of a personal life within the broader social transformation that was just beginning."[17] But what the Millennial Generation offers that sets it apart from their predecessors in the early reform era is an openly and enthusiastically individualistic approach to life that values the bold and the innovative.

The self-indulgence of the young, educated urbanites of China does not have the same negative implications that Yan portrays for the young, individualistic peasants of Xiajia village where, in his view, the rise of individualism has had a decidedly negative effect.[18] Yan sees the pressure put on parents by young newlyweds for the early inheritance of property as an indication of blatant selfishness. Yan portrays the economic leverage and demands of the youthful generation as all too often accompanied by a lack of civility or sense of responsibility for the wellbeing of their elders.[19]

The individualism of Chinese university students is not as troubling as that which Yan described for his rural community. The relations between students and their parents have few points of conflict, and the conflicts that did occur seemed to be amicably resolved. The difference between Yan's villagers and the city dwellers may be that the urban parents are more ac-

cepting of the individualistic striving of their offspring because it does not threaten the parents' economic wellbeing. In Xiajia village, the members of the younger generation often put pressure on their parents to turn over much of their property as a kind of pre-mortal inheritance. Some parents have actually been left destitute by such property transfers. The urban parents are not likely to have such pressures because the wellbeing of their children will depend not on inherited property, but on their success at finding remunerative employment given the skills they acquire through schooling. The forces of individualism in China today have different effects in different contexts.

Though China's young people glorify individualism, it cannot be said that their parents, children of the Cultural Revolution, consider individualism to be utterly wrongheaded. They themselves were obligated by political and social forces to reject individualism in their youth, but few of these adults would want to bring back the coercive collectivism of that age. So, though the young may seem provocatively ostentatious in their promotion of the unique, the odd, or the extravagantly expressive, their parents can appreciate the move away from the ideals of Maoist collectivism. This is why a mildly rebellious term is the appropriate form for such a generational shift. A shift in values marked by a slang term signals youthful rebellion, but it also is a way of saying "We're going this far, but no farther." A more profound and thorough rejection of adult values might attach itself to a more shocking verbal expression, and would be viewed as grossly inappropriate. As the Millennial Generation grows up, it will likely find itself carrying these individualistic values forward, while subtly signaling its adherence to them through the long-term, pervasive use of the now entrenched slang term *ku*.

1 See Beverly Hooper, "Chinese Youth: The Nineties Gener-
ation," *Current History* 90 (1991): 264–69; and David Marr and
Stanley Rosen, "Chinese and Vietnamese Youth in the 1990s,"
The China Journal 40 (1998): 145–72.

2 Robert Moore, "We're Cool, Mom and Dad Are Swell: Basic
Slang and Generational Shifts in Values," *American Speech* 79, no.
1 (2004): 59–86.

3 See Fredrik Barth, *Ethnic Groups and Boundaries* (Boston: Lit-
tle, Brown & Co., 1969); Robert Levy, *Tahitians: Mind and Expe-
rience in the Society Islands* (Chicago: Univ. of Chicago Press,
1973); E.N. Anderson, *The Food of China* (New Haven: Yale
Univ. Press, 1973); Charles Lindholm, *Culture and Identity: The
History, Theory, and Practice of Psychological Anthropology* (New
York: McGraw Hill, 2001); and James L. Watson and Melissa L.
Caldwell, eds. *The Cultural Politics of Food and Eating* (Oxford:
Blackwell, 2005).

4 Douglas Biber, *Variation across Speech and Writing* (Cam-
bridge: Cambridge Univ. Press, 1988).

5 See, for example, C.H. Hui, "Measurement of Individualism-
Collectivism," *Journal of Research in Personality* 22 (1988): 17–36;
and Harry C. Triandis, *Individualism and Collectivism: New Direc-
tions in Social Psychology* (Boulder: Westview Press, 1995).

6 See Maurice Freedman, *Lineage Organization in Southeastern
China,* London School of Economics Monographs on Social An-
thropology, no. 18 (London: Athlone Press, 1958); James L. Wat-
son, *Emigration and the Chinese Lineage: The "Mans" in Hong Kong
and London* (Berkeley: Univ. of California Press, 1975); Myron
Cohen, *House United, House Divided: The Chinese Family in Taiwan*
(New York: Columbia Univ. Press, 1976).

7 See Nien Cheng, *Life and Death in Shanghai* (London:
Grafton, 1986); and Yuan Gao, *Born Red: A Chronicle of the Cultur-
al Revolution* (Stanford: Stanford Univ. Press, 1987).

8 Deborah Davis, ed., *The Consumer Revolution in Urban China,*
Studies on China, no. 22 (Berkeley: Univ. of California Press,
1999).

9 Andrew Jones, *Like a Knife: Ideology and Genre in Contemporary
Chinese Popular Music,* Cornell East Asia Series, vol. 57 (Ithaca:
Cornell Univ. Press, 1992).

10 See, for example, Gail Hershatter, *Dangerous Pleasures: Prosti-
tution and Modernity in Twentieth-Century. Shanghai* (Berkeley:
Univ. of California Press, 1997).

11 James J.Y. Liu, *The Chinese Knight-Errant* (Chicago: Univ. of
Chicago Press, 1967).

12 Xin Liu, *The Otherness of Self: A Genealogy of Self in Contempo-
rary China* (Ann Arbor: Univ. of Michigan Press, 2002).

13 X. Wang, "The Post-Communist Personality: The Spectre
of China's Capitalist Market Reforms," *The China Journal* 47
(2002): 1–17.

14 Robert Moore, "Parent-Adolescent Disputes in China
(PRC) and America: Images and Outcomes" (paper presented at
the 96th AAA Annual Meeting, Washington, DC, 1997).

15 See Yunxiang Yan, "The Triumph of Conjugality: Structural
Transformation of Family Relations in a Chinese Village," *Eth-
nology* 36, no. 3 (1997): 191–212; and *Private Life under Socialism:
Love, Intimacy, and Family Change in a Chinese Village 1949–1999*
(Stanford: Stanford Univ. Press, 2003).

16 See also Thomas Shaw, "'We Like to Have Fun': Leisure and
the Discovery of the Self in Taiwan's 'New' Middle Class," *Mod-
ern China* 20, no. 4 (1994): 416–45.

17 Judith Farquhar, *Appetites: Food and Sex in Post-Socialist China*
(Durham: Duke Univ. Press, 2002), 178.

18 See Yan, "Triumph of Conjugality" and *Private Life under So-
cialism.*

19 Ibid.

Liz Glynn,
The 24 Hour Roman Reconstruction Project, or,
Building Rome in a Day, 2008.
Installation view, Machine Project,
Los Angeles

Adult in 2008: Future Citizens

Seventeen, going on eighteen. The world is their oyster but India has a special place in their hearts. *Tehelka* talks to ten Indians on the cusp of innocence and the grown-up challenges of life

Daughter of a domestic servant, of agricultural laborers, of a doctor, of a businessman. The son of a handicraft dealer, of a caretaker. From Shillong and Siliguri to Srinagar and Kochi. Voices as gloriously diverse as India, who have their age in common, and the fact that they have dreams of shaping their destiny–and that of the nation and the planet they inhabit–when they take the first tentative steps towards adulthood in 2008. The year when they can cast a vote and, in case of girls, marry. Their hopes, frustrations, ambitions, likes and dislikes are varied but there is a harmony in their collective vision of tomorrow.

Krishna Balu Naidu

June 7, 1990 • Mumbai, Maharashtra

Perhaps it was Krishna Balu Naidu's good fortune that he was born inside the precincts of Kamla Raheja College of Architecture (under a staircase to be precise). His father was a caretaker there and he says that he spent the first fourteen years of his childhood surrounded by architects, playing with keyboards in the computer lab and sleeping in different studios in the college.

Krishna was not so fortunate in that his father was an alcoholic. He says that he was forced to assist him from an early age. His mother is Krishna's "hero." He completed his primary education at Vidyanidhi school and his secondary education from Gandhi Shiksha Bhavan high school and is now studying at Mithibhai College in Mumbai.

Like most people his age, Krishna wants to become "something" when he grows up. Unlike most of them, he doesn't have any idea what. Understandable perhaps given that his concerns are more immediate. "I just hope to complete my graduation," he says. "Right now I don't know if I will be in college the next year because my father thinks I should start earning and not waste money on studies."

No wonder then that the one thing he is looking forward to when he grows up is the freedom to make his own decisions. At this point, his ambitions are pretty basic: As an adult, he wants to earn enough to take care of his family and still have money in hand to spend on personal needs. What would those be? "Going to McDonald's, watching films, and buying new clothes," he replies.

For now, he saves what little pocket money he gets. These days Krishna's spare time is taken up by the Mithibhai College drama team. On Sundays, he likes to read newspapers. His loves cricket, worships cricketers, likes SRK and Rajnikanth, and doesn't read books.

In college he spends time with a small group of boys and girls. When does he think he will get married? Only after he becomes financially independent, he says. His views on marriage couldn't be more conventional–he wants a life partner "who is understanding and has a good personality." Talking about sex makes him uncomfortable on a personal level but Krishna is quick to add that sex education is necessary today. He makes it a point to go to the Kali temple on two days every week and on those days refrains from eating non-vegetarian food.

Is there anything that he would risk his personal security for? "Yes," says Krishna. "My mother needs to repay a massive loan for our rented home. Perhaps for that."

Krishna feels that India's bane is population explosion; it is at the root of poverty, illiteracy, and increasing crime rates. Two recent events that saddened and angered him were the killing of a schoolboy in Gur-

388

gaon by his classmates and the suicide by a Mumbai boy who felt that he hadn't scored enough in his exams.

If there is one thing that he could change about India, it would be the lack of jobs. Despite the ills that he enumerates, Krishna has a lot of feeling for India. He says he likes "the environment in Mumbai" and wouldn't want to live abroad. What about India gives him hope? Krishna ponders over the question and comes up with an answer that is disarming in its candidness. He can't think of anything. And yet, you know that this is not an articulation of hopelessness. Despite having seen a lot of life already for his years, Krishna is upbeat about the future.

Samir Lukka

Geetha Kadappa Gudgapur

June 1, 1990 • Bangalore, Karnataka

"It feels like we are in a foreign land!" Geetha squeals, as she walks jauntily down Bangalore's posh shopping centre, Brigade Road. On her first visit to Bangalore's central business district, she spends five hesitant minutes clutching her bag and dodging passersby. From then on, it is a confident step that takes Geetha, the daughter of a domestic servant and a weaver, closer to the huge shop windows decorated with mannequins dressed in fancy clothes.

"What kind of design is that? Who would wear a belt around their thigh on a pair of jeans?" asks Geetha. She nods disapprovingly and moves on. An hour later, Geetha's voice is level as she reflects on the bright neon lights, the expensively dressed people, the number of cars and the price tags.

Geetha Kadappa Gudgapur is going to be a fashion designer and a full-time activist with Samanatha Mahila Vedike (SMV), a women's

389

rights organization. If these appear naturally dichotomous, Geetha has no such confusions. A fashion designer is someone who can work independently, she states matter- of-factly. "If I work for someone, I won't have the time. They will make me work hard, I will be tired and working with SMV will be reduced to a part-time occupation."

Geetha is sure that she will run a shop of her own one day—paint on clothes that she can sell and embroider saris that women will be proud of. For now though, she is finishing a vocational course in fashion designing at Vani Vilas College for Women. It is a government-aided college and the facilities leave much to be desired. Geetha opens up a box with carefully preserved pieces of embroidered cloth, excitedly pointing out various stitches and patterns. Square white pieces of cloth, with patterns that speak alternately of perfection and a learning hand.

Says Geetha about her college, "Most of the teachers in my college finish their own work while they are supposed to be teaching us. Even the tailoring machines haven't been repaired." Amid peals of laughter, she talks of the mischief they have planned for their teachers once the final exams are done.

A minute later, she is serious again. "Why should our juniors and other students after us waste their lives? We want to shake the teachers up a bit." Did she always want to be a fashion designer? She laughs. "I was around thirteen years old when I was sent to work in the weaving looms. I had no dreams then of anything beyond that. It was only after I joined this course that I learned that my love for painting and embroidery was called fashion designing!"

There is a remarkable clarity about Geetha's plans for her life, extending to the society she inhabits as well. Joining a women's rights organization has always been part of the plan. In Ramdurga (Belgaum district), where she

390 lived with her mother and three siblings, Geetha volunteered to work

when she was barely ten years old. She had watched her mother starve to make sure they ate. "My younger sister, who was eight years old, and I worked as domestic help in a house nearby and then scampered off to school. We were paid $1.20 a month." She quickly compares that amount to the prices of the clothes she's just been looking at. Worse was to follow, due largely to an alcoholic father who resorted frequently to violence on his rare visits home. Work was difficult to come by and wages dangerously low.

Under the circumstances, it was Geetha's constant preoccupation with books, and determination to study and speak English that made an impression on a women's rights activist in the area. At her suggestion, Geetha rejoined school in Belgaum and then traveled to Bangalore to stay at a hostel run by the same organization.

Today, Geetha's progression to becoming a member of Samanatha Mahila Vedike is a natural one. "I hear my classmates saying that they won't be allowed to study further. I think of my mother being beaten up. I see the acid attacks on women taking place. The dowry deaths. The amount of violence that women have to face everyday. I was lucky to have traveled this far. What about the others? There are so many others…" Geetha's voice trails off, there are tears as the past crowds in.

Asked about icons, she smiles. "Prathibha Patil became the president and they said women had gained better status in India. But nothing has changed for a lot of us. For some people, like on Brigade Road, life may be different, that's all."

In quieter moments, there are more questions. "Will things really change? How long do we have to fight? If I grow up and continue fighting for women's rights, will everything really change?" For someone who is happy that she moved out of Ramdurga ("I would have been married now if I had

stayed there"), for a girl with dreams of becoming a fashion designer so she can gain her independence, for a member of a women's rights organization—there can be no easy answers to these questions.

Sanjana

Suhaib Mahajan

July 17, 1990 • Srinagar, Kashmir

For Suhaib Mahajan, music is what the soul is to the body. Brought up in conservative Kashmiri society, the son of a handicraft dealer and a housewife, Mahajan dreams of becoming a pop star, something quite unheard of in Kashmir. He has formed, along with his friends, a rock band, Blood Rockz. In the next five years, he looks forward to his band performing for Western audiences. "My parents are supporting me in my decision to be a pop star. I am a lucky fellow that way," says he.

Mahajan's wish is to soothe hearts blighted by years of violence in Kashmir with music. "People here have suffered a lot, their souls are bruised and for that I think music is the cure. I want people to heave a sigh of relief, and feel relaxed with the melodious tones of the guitar, drums, and keyboards," says Mahajan in a philosophical tone.

Mahajan, who lives in a posh colony of Srinagar, works hard on his physique at the gym, has strutted on the fashion ramp and even won the prestigious Gladrags competition. In the years to come he plans to make Western music popular with the youth in Kashmir, perhaps by setting up a school to teach guitar and violin. "Now our performances and efforts will be taken more seriously by people. I was really waiting for this stage of life to come,"

392

Mahajan says. He doesn't want to change much about himself, except let his hair grow long so it can be plaited.

Humorous, full of the hopeful ebullience of youth, Mahajan believes that being an adult means being mature and handling difficult situations without losing his cool. However, he will miss carefree days spent bunking classes, singing, and dancing. The coming year portends to be more hectic, as he will be preparing for his Class 12 exam. At school, Mahajan gets enough time to mix with friends, both girls and boys, and have a good time. "Once out of school, girls can't hang out with boys. Such a culture has not prevailed here as yet," he says.

The unity of his band is Mahajan's prime concern. "Junoon was a known band but broke up and then vanished into thin air. I would risk my life to prevent any such division in my band," says an emotional Mahajan. Exactly ten years from now, he wants to get married in a lavish style but he rejects the custom of dowry. "I think the young have a role in rooting out the evil of dowry from society," he says.

Growing communalism worries this young Kashmiri and he advocates the growth of a liberal society. "Religion is a prime thing for a human being. Everything rests with God." But he also believes that people should protest against the forces that foment communal feelings. Like any other singer, Mahajan talks of peace and harmony.

One thing that pinches Mahajan about India is its poverty but he'd rather live here in his homeland, than in "any alien land." "I am proud of living in scenic Srinagar city," he says. He sees civic infrastructure, poverty, and illiteracy as India's key worries but is hopeful with India's pace of development.

Mahajan is haunted by the Gujarat pogrom of 2002, the sentencing of Saddam Hussein to the gallows, and the brutal use of police force

in Kashmir and Nandigram. Global warming and growing unrest are two things that also worry him. "Why can't we be environmental friendly? Why can't nations like America behave in a civilized way?" he wonders.

<div align="right">Peerzada Arshad Hamid</div>

Adhira Ce

January 5, 1990 • New Delhi

Adhira Ce is currently attending medical School in Prague, in the Czech Republic. Her father is a doctor with the WHO, and her mother works with an Israeli company. Five years from now she hopes to still be in medical school. She lives between her old home in Panchsheel Park in South Delhi and Gurgaon. She enjoys Panchsheel because it's green and peaceful, "and there are not too many people."

Is there anything she looks forward to about becoming an adult? "Making my own decisions but I'm pretty much doing whatever I want to do now," she says. "I guess it will be harder when I'm eighteen, being more responsible and not having someone behind you; you have a lot more independence but you miss being treated like a child sometimes."

"Now that I've gone abroad I don't miss Hindi music," Adhira laughs. In her free time, she plays sports or goes to the gym. She hangs out with her friends, both boys and girls. "We go for a meal, to a café–it mostly revolves around food," she jokes. Her idol is Lance Armstrong, the cyclist. "Because of his cancer and how he still won the Tour de France. Apart from that, no one."

When asked what she would change about India, "Public hy-
giene," she says, "I wish people were more aware of how much differ-

ence they could make if they didn't litter the streets. Littering and pissing and spitting on the road needs to change." The biggest threat to the world is global warming and scarcity of water. Is there anything to be hopeful about? "India is growing as a nation and an economy, so its views will be considered more internationally. We'll have more power to change stuff."

Adhira is an atheist. "I'm fine with others believing in God, but personally I don't think there is anything known as God. I guess I need proof, and there is no real proof and everyone's belief is different."

With regard to marriage, Adhira thinks "earlier than twenty-two, twenty-three would be too early." But she wouldn't give a dowry. "Actually that's something I'd probably be enraged by," she admits.

Are there are any political or social problems she has been following? "Not really," she shrugs. One thing that does upset her though is "cruelty towards animals." Apart from that, "people complaining about India, especially abroad. You would expect them to be more patriotic." Otherwise, "it takes a lot to get me enraged. I'm not really an angry or aggressive person; I'm pretty patient that way."

Morgan Harrington

Christopher Noel Marbaniang

December 22, 1990 • Shilong, Meghalaya

Christopher Noel Marbaniang is shocked at the idea of being interviewed and laughs when asked about public figures he admires. But he is aware that his existence in Shillong is near idyllic.

He walks to college every day with his friends. His family sold their car because neither his father nor his older siblings had any inter- **395**

est in driving it. He plays the guitar and sings for a band that plays metal and alternative music. In the evenings he plays basketball and football and hangs out with friends. Right now he only hangs out with boys. "In Shillong boys hang out with boys and girls hang out with girls." Someday he thinks he will have a girlfriend ("My father will be happy if I have one"), perhaps even a wife. He thinks that girls in Shillong are cool and good looking but thinks he could marry a "cute, non-fashion-obsessed girl from any community and any religion." Does he go to church? "I believe in God but I can't wake up on Sunday mornings. I go for the service at night."

He can't remember the last time he was angry with any macro concern. "I am a little upset that my friend is not talking to me right now and I don't know why," he admits. The idea of adulthood is vaguely worrying to Christopher, who sees his bank officer father and two older siblings working hard. "It seems like a lot of responsibility," he says. Someday, he thinks, he will have to become an adult, get a job, and miss hanging out with his friends. But before that, he wants to go to one of the IIMs, get an MBA and travel to Jamaica and Spain. Christopher does not even have a grouse about his upbringing. His mother died when he was very young. He and his elder siblings were brought up with "freedom and some limitations." "He would not like it if I turned up drunk but he lets me serve beer at my birthday party," he says of his father. He thinks a lot of teenagers demand too many expensive things from their parents. "Why do they want all these new mobiles? Just to show off?" But Christopher does not judge them too harshly.

Christopher laughs a lot at the idea of dying for his country or a cause. So does anything make him angry? He approves of Shillong for keeping its green cover and does not like people littering. Less corruption would be good too, he thinks. In a while, Christopher knows he will have to

leave Shillong for higher education but as of now the state of the nation is not on his mind. "I don't know what I like about India but I like Shillong."

Nisha Susan

Ratanapriya

October 9, 1990 • Siliguri, West Bengal

"Where do you see yourself in five years?" I ask the girl. Her answer is prompt, almost premeditated, as if she's been answering this question for years: "Cruising in the air." When Ratnapriya says this, you might think of her as another teenager taking recourse to a "cool" metaphor. But she means this literally. She wants to be a commercial pilot, she says, then explains her answer. "I love speed," and then moves on, speedily, to another subject.

It's not her attention span but something else that typifies her as part of this generation–the Gotta-Do-Everything club. "What can you not do now that you look forward to doing when you're an adult?" I ask, indulging what I perceive as a sense of rebelliousness. "I'm not allowed to speak when certain elders are speaking," she ventures. Then keeps quiet.

Siliguri is a small town; Ratnapriya and I live only a couple of kilometers from each other. And yet she insists on answering most of my queries by e-mail: The keyboard is her tongue. And her baton in this relay race called Life. She loves being seventeen, she says, but just as much as she loved being sixteen or thirteen. Or one? No, she couldn't have been happy at that age, her parents didn't own a PC then. She'll miss being seventeen, she admits, and then adds half-philosophically, "What I do today, I can't do tomorrow."

Adulthood is a class-lecture she'd rather give the slip. "Loads of **397**

responsibilities on your shoulder, no?" she asks. Adulthood doesn't begin at eighteen anymore, she implies; it's almost a choice. She'll decide when she wants to be an adult. Like she's decided not to have a boyfriend. She doesn't miss having one; she doesn't miss being an adult. "Simple logic, no?" She does miss something very much though: being a few sizes smaller.

Is there any issue that makes you want to step out and protest? She doesn't wait for me to complete the question. "The education system." But "I'm still a student. How can I fight the system while I'm a part of it?" Suddenly, she volunteers some personal information, "I've been wearing contact lenses for the last three years." As if that was a totem for adulthood.

I ask her if it's better to live in India, or move abroad. She answers with a familiar teenage adjective—awesome. "India is an awesome place to live, no?" Three worries about the country? Her answer on Google-talk is tinted with a poetaster's naughtiness: "Pollution, Population, Politicians." I note the alliteration, and call her Priya. She replies with a smiley. I then ask her, have you been angry recently? She types a long answer, long for her attention span—"Reality shows, Guwahati riots, Nandigram, rapid hike in fees of educational institutions, Ekta Kapoor's soaps." The coexistence of such different anger-nodes makes me want to laugh. What public figures mean the most you? "Angelina Jolie, John Abraham, Raakhi Sawant." She provides the comic relief, the names performing the role of smileys.

"What is the best thing about Siliguri?" I ask. "Me!" Back to teenage mode. She's an electronics gadget freak, she confirms, almost with a hint of pride. She loves sports like "racing"– in the virtual world of course. She loves watching movies too: "Sci-fi, racing, horror, mythical." And music? "Hard rock, trance, hip-hop, psychedelic." When I ask about favorite books: "School books are enough!"

She "hangs out" with her brother's friends, and "masti" is how she describes their activities. "When do you think you should get married?"

Another single word answer: "Never." I try to get her into girlish mode. "What do you imagine in a life partner?" She mumbles, "I don't want one." A little later she says, "Donkey!" I'm not sure who this is thrown at, the life-partner or the interviewer.

Just as she wears "everything," she prays "everywhere." What about inter-caste and inter-religious marriage? "Stupid!" Again, that teenage default mode which I find difficult to crack. I'm not sure where she wants this adjective tagged, to the question or the implied opposition, or perhaps even the questioner!

Sumana Roy

Richa Priyadarshini

August 11, 1990 • Patna, Bihar

One of the reasons Richa is looking forward to adulthood is love marriage. "I cannot do it now because I haven't stood on my own feet yet," she says. "After getting a job, I can fall in love and marry the one I love."

Richa Priyadarshini is a first-year student at Patna's AN College. The eldest of four sisters, she is doing her bachelor's degree in Biotechnology. She hails from a village in Madhubani district and happens to be a Bhumihar–the dominant upper caste in Bihar. She also works part-time as an announcer and anchor for public events in the city. "I get only $6.80 for four hours, but I like to put my voice to meaningful and creative work," she says.

Richa is optimistic about her home state on the economic front. Five years from now, she sees herself working in a pharmaceutical company. "By then, Bihar should have attracted one or two big companies producing drugs or doing research and development," she says. "A salary of $800 per month would be good enough."

399

There is another reason she is looking forward to adulthood: "In Bihar, there is so much societal pressure on girls that it's stifling. When I become an adult, I would no longer be ordered, 'Don't do this or don't do that.'"

Clearly, Richa finds being a girl in Bihar limiting in many ways. "I used to play cricket and badminton as a child," she says. "All sports ended as I grew up. In Bihar, it's impossible for girls to engage in sports seriously for many reasons." Are there any possible situations in which she sees herself willing to put herself in danger? "A family member getting kidnapped or receiving threats," she says. "Such fears are still alive in many places in Bihar."

Richa would also like to control her temper. As she elaborates, you get the sense that there are things about Patna she is not happy with. "When I am walking on the road and someone passes a comment at me, I fly into a rage and react without fearing the consequences," she says. "But I have gradually come to realize it is better to be more tolerant of harmless mischief."

Clearly, being a girl here can have its drawbacks. Going out in the evenings to relax or socialize is just not possible for girls. "No hangout even though I would love one," she says. "Patna is still not a suitable place for hangouts for girls."

But the gentler pace of life here, she points out, has its rewards. "People here are more cooperative and reliable than in other places I know," she says. "In Delhi, where I lived for two years, I found people not bothered even if there is a road accident. Life elsewhere is maddeningly fast."

When she has kids of her own, Richa will place fewer restrictions on them. "I hated the way my mother wanted me to return by 5 p.m. and kept asking me to stop talking with this or that person," she says. "I would be friendlier with my kids. That would encourage them to share their complex thoughts with me. I would allow them to take their own decisions."

400 Like most of her peers, Richa feels politics and politicians are holding

India back. "Left-wing terrorism and separatism spreading to new areas, and the youth experimenting with new forms of intoxicants, the derailing of the Indo-US nuclear deal at a time when we need energy so badly–all these are signs of India's politics losing direction," she says. One of the things that made her very angry last year was "MLAs like Anant Singh in Bihar exploiting a girl and raping her before getting her killed." So it comes as a surprise that politicians figure prominently in her list of role models. There is former president APJ Abdul Kalam, Sonia Gandhi, and even the current occupant of Rashtrapati Bhawan, Pratibha Patil. Her all-time idol and role model is Indira Gandhi. Why? "For her confidence," she replies.

Richa is convinced that India's star is ascendant. She gives three examples why: "The booming markets of India, the cheapest medical care available here, and India's youth who can go to any level to achieve anything."

Richa would like to stay and work here. "Earlier there was brain-drain from India, but now the brains are coming back. India is booming, money from all across the globe is flowing into India," she says. And above all, there is something else, something intangible. "Life in India is full of meaning," says Richa.

Anand St Das

Neelam Shah

July 11, 1990 • Lansdowne, Uttarakhand

"I want my face to become more attractive," says Neelam when asked what she wishes to change about her physical appearance in 2008, the year she turns eighteen. **401**

The coming year is significant for the seventeen-year-old, a class 12 student of the Government Girls Inter-College in Lansdowne and the eldest child of the local hospital's caretaker. She is eager and edgy to embrace adulthood. But what is it that she will miss about being seventeen? "When I was younger, I could go everywhere with my friends. When I turn eighteen," says she, "there will be a lot of new restrictions." But it will also move her a step closer to her ambition of becoming a teacher.

"I see myself teaching economics in the same school that I study in five years from now. It will be a great to come back and serve the place which has taught me so much," she says. Independence is also important to her. "I want to be able to stand on my feet when I turn eighteen. I don't want to depend on anyone else. I hope I will be able to think freely."

She also hopes to end discrimination against women in education. "The sons in the family are given more importance while the girls are told to help in the kitchen. There are many girls who are married off even before they have turned eighteen. Some of my own friends are engaged to be married," she informs. Neelam is also concerned about old people being deserted by their family members. "Once an old lady fell in the market. No one came forward to help her. Then my friend and I took her to the hospital. She told us how her sons had left her to live by herself."

Terrorism is another concern for Neelam. "I don't want to blame a particular religion or a community, but feel the perpetrators of violence are the ones who dislike Hindus and Muslims living peacefully."

She probably would not risk personal security for anything she feels strongly about, but clarifies, almost as if asserting her tough persona: "There have been times when I've contested something wrong said about me."

Over the brief chat, she gives you enough reason to believe she is an

aware and opinionated citizen of the country. "The July 11 serial

blasts in Mumbai, and the Hyderabad Mecca masjid and Ajmer dargah blasts left me fuming because hundreds of innocents were killed." At home, another incident that angered her was the rape of a schoolgirl in Lansdowne a few years ago. "She was attacked and raped when she was returning from school. The rapist cut her body into small parts and hid it in the bushes. He is now in jail. I hope he will be punished soon."

But mention marriage, and you see the otherwise extroverted girl reveal her bashful side. "I don't want to get married," she says. "I want to wait till I am independent and then decide whether I want to get married," she says. "I would like to spend a lot on my wedding." So does that mean a love, or an arranged, marriage? "I would marry a person of my parents' choice," she says, almost trying to avoid the question. "There is no harm in inter-caste and inter-religious marriages. But unfortunately society doesn't accept it in most cases. I would like to marry within my caste and be a part of society," she says.

If given a choice Neelam would like to continue living in Lansdowne, a "safe and an unpolluted place" where she can wander freely without any fear.

Shobhita Naithani

TC Rejitha
———

April 18, 1990 • Kochi, Kerala

"I want to be a biotechnologist as I'll be able to contribute to the betterment of society," says TC Rejitha, the daughter of agricultural workers. Her aim is to get a PhD and then engage in research. "Various epidemics have surfaced even in hygienic Kerala, making a mockery of its public health **403**

credentials. I hope research in biotechnology will find solutions." Rejitha is now at the end of her pre-university course and is also undergoing a course set up by the SC/ST department of the Kerala government and IIM-Kozhikode to boost the potential of young talent.

Why are you so concerned about society, I ask. "From childhood, I've been watching how the meek in our society struggle to survive. I can say proudly that I belong to a segment that has faced discrimination because of caste and class. But I have always dreamt of an egalitarian society where everyone would have their share," she says.

Rejitha is a close observer of the political system in India and is adamant about the need to change the course of students' politics. "It must be free from the influence of self seeking and corrupt political leaders. Patronage must not be a criterion to choose student leaders." She also wants an end to the commercialization of education where only the children of the rich can study and prosper.

"The relationship between parents and children must be friendly and free from all kinds of force. Gone are the days when parents commanded and children just obeyed," she opined.

Rejitha is ready to take any risk to help anyone with a genuine problem. "I hate inequality. In today's India, the gap between the rich and poor is widening. Caste and income considerations are not allowing people with real potential to succeed. Caste is the number-one enemy of our country."

Rejitha is worried about the fate of India. She is concerned about growing violence against women and the attack by upper castes on SCs and STs. She is also anxious about the growing clout of the US. "Imperialist hegemony, like in the case of Iraq, must not be repeated," she says. In the meantime, she finds pleasure in witnessing India's emergence as a world power. Another matter of pride is

that India is still united despite sharp divisions of caste and community.

While upholding her strong leftist convictions, Rejitha is unhappy about the developments in Nandigram. "This is not the way to ensure industrialization. Agriculture must be the foundation of any economy. Otherwise we would all starve," she says. The carnage in Gujarat and the inability of the country to punish perpetrators like Modi is shocking. She's also concerned about the number of sex scandals in Kerala and the delay on the part of authorities in arresting those responsible. "Our political system must be free from vested interests and corrupt elements," she says.

Rejitha has extreme regard for Medha Patkar and Arundhati Roy. The positive thing about her home city of Kochi is its readiness to accept different cultures and ways of life. "There is not much discrimination," says she.

In the case of marriage, she feels it would be better if there is a consensus between the person and his or her parents. "Imposition of parental decisions is not right. The boy or girl must have a say." In the case of inter-religious marriages, she wants protection for the right of the concerned individuals. She is against dowry and lavish weddings and maintains that girls ought be self-reliant. "A decent job is necessary." Rejitha goes to both temples and churches. She has fear of God but no faith in rituals.

Ka Shaji

Preity Sachdev

———————

August 12, 1990 • Bhopal, Madhya Pradesh

"People call me Hitler because I follow rules. I can't see injustice," says Preity Sachdev. This is no idle boast. Once she spotted some boys harassing girls. "You won't believe me when I tell you this but I beat up those **405**

boys," she says. "I have grown up with my cousin brothers so I have the guts to fight for my rights. Now those boys go hiding when they see me coming."

Preity would call this just another advantage of growing up in a joint family. She lives with "one real brother," a housewife mother, a businessman father, and many cousins and elders. She loves the arrangement. "I hate nuclear families. People who live in them face a lot of problems. Here my brothers are my best friends. There is no downside to joint families. My chachis are working women."

She is happy to have grown up where she did. "Everyone is kind hearted in Bhopal," she says. "People actually have time to share and solve each other's problems. Best example is Marine Drive, everyone sits there in the evening and talks things through."

Preity has some of the usual gripes about India and her citizens—negative attitude, superstition, poor infrastructure, lack of good jobs which lead to brain-drain. (Asked about her career plans, she says she would like to stay in India unless, of course, a better opportunity presents itself outside the country.) But she is full of hope about the future.

"Our education system is improving. Industries are developing. Even the political system has improved," she says, smiling. Among her role models is the lady cop Kiran Bedi. "She has worked unselfishly and she never worked against the rules," says Preity.

During her free time, Preity surfs the Net or hangs out at "CCD [Café Coffee Day] or Barista or VIP Road" with her "gang of six boys and four girls." "If we want to just enjoy and relax, only the girls go out. If we want to make fun, make masti, we take the boys along 'cause they make noise." Then Preity says something that will reassure those who don't want the winds of change to blow away everything: "We also hang out at temples."

406

Preity considers herself religious. "Going to a temple is my routine," she says. "I go there for the calm it offers." The talk veers towards marriage. "Ask any girl and she'll say, 'I want a boy who is trustworthy, flexible and conservative.' I don't see any boys like that though."

Just by the way, does Preity have er … um… a naughty side? Yes she does, she admits, full of glee, and proceeds to spell it out. "I am such a spendthrift! I spend my pocket money on chocolates for my cousins and friends."

<div align="right">Arshad Said Kahn</div>

From *Tehelka*, January 12, 2008, vol. 5:1.

Wojciech Bąkowski,
Kundelku ujadaj perelko rób pieklo
(Bark, you mongrel, Raise hell my pearl!), 2006.
Animation,
3:53 min
Courtesy Leto Gallery, Warsaw
(Detail)

The New Generation
Of Tibetan Activists Speaks Out

PEOPLE CAN'T CARRY THEIR PAIN EVERYDAY

Fosbang Yeshi, 41 and Sherab Woeser, 27

Tibetan Youth Congress

Sherab Woeser's grandfather was a Tantric who once read that iron birds in the sky were a bad omen. In 1959, in those days of remarkably slow communication, he had heard nothing of what had befallen his country. But when he saw Chinese airplanes he was worried enough by the omen to take his family out of Tibet. He fell ill and died soon after the family arrived in India. Sherab's grandmother was one among thousands of Tibetan refugees whom the Indian government had deployed to work on roads in the Himalayas. Though poor, Sherab's father and uncles grew up within the embryonic Tibetan school system. They became the first generation of leaders of the Tibetan Youth Congress (TYC), a group which was formed in 1970 and sets Tibet's independence, even at the cost of one's life, as one of its goals.

"When my family told me about the grass, the water, the beautiful land they have left behind, I dreamt of going to Tibet. But I grew up in a Tibetan community and never actually felt the pinch. It was when I went to Chandigarh to college that I realized that not even people with the best intentions in the world could pronounce my name. All my childhood memories of my father being away for months on TYC work finally made sense."

As the International Relations secretary of the 13,000-strong TYC Sherab was a natural choice to be one of two coordinators of the March to Tibet. He and other youth organizers have seen over and over again that even the most apolitical seeming young Tibetans respond to a call to action. "I would see these young Tibetans who I thought were useless party-goers. But **409**

then we called for a protest when the Chinese ambassador came to Chandigarh and every one of them turned up. We hear similar stories from across the border. A friend of ours was telling us how he was in Lhasa in an upmarket club. And he was very depressed to think that young Tibetans had been fooled by all this new affluence. He brought up the Dalai Lama. And these drunk young men turned to him and said, 'We may not talk of him aloud but he is in our hearts. He gives us strength.' That was a small incident but it makes me believe. People can't carry pain all the time. The wounds are there and when the time comes the people will rise and they will rise strong."

Sherab's older colleague Lobsang Yeshi is the embodiment of the relaxed watchfulness Sherab talks of. A lifelong activist and the father of three young children, Yeshi's two favored sources of amusement are his own guilt at not contributing to the family income, and non-Tibetans who insist that Tibetans ought to be too soft-spoken to even shout a slogan.

"Not only are the Chinese oppressing us, so is the rest of the world," he laughs. The geniality is present even when he, an obsessive follower of Chinese propaganda, says that very soon after the Olympics the Chinese will move millions of people into Tibet and wipe out their country.

Sherab has been organizing workshops for the marchers to stay non-violent even if they are arrested or assaulted. But he shrugs, "As a child when you burst patakhas you pretended you were killing the Chinese. Even now I don't think that killing the Chinese is the worst thing a Tibetan can do. It's just that you think a little more about why you are doing things. We have bent down, knelt down before China for a very long time. But now we need Tibetans everywhere to know that China is not impregnable."

WE DON'T HAVE MUCH TIME LEFT

Tenzin Palkyi, 26

Tibetan Women's Association

Tenzin Palkyi, a media officer for the Tibetan People's Uprising Movement, says she respects activists who are measured in their speech. But beneath her calmness is a thread of urgency, a need to take the current events at the flood. When Palkyi went to a US university on a scholarship, there was never any doubt of her coming back to join the movement. "The fact that we had lost our homeland was something we thought of everyday in school. But the big catalyst was seeing Thupten Ngodup's martyrdom on television. In 1998 I had just finished my Class X exams.

A group of Tibetans had started a hunger strike in Jantar Mantar. After forty-five days, when the Indian police came Thupten Ngodup immolated himself. That day, there was a full-day rally in Dharamsala. People were shouting, fainting, writing on their chests with sharp things. The police dispersed us because we were too active. I knew the responsibility for Tibet's independence lay with each one of us."

Palkyi dreams of working for the emancipation of women and children in Tibet. In this her desires coincide with those of the Tibetan Women's Association (TWA), an organization first formed in Lhasa in 1959 to protest the Chinese occupation. Of the five groups now part of the Uprising, the TWA is the only one who chose autonomy within China. "A decade ago when our referendum took place, the TWA did not pick the four options available–middle path, independence, self determination and Satyagraha–but decided to follow the Dalai Lama's choices."

411

This is where Palkyi differs sharply. "Everybody knows the Dalai Lama is holding it all together. But when His Holiness is no longer with us, shall we wait for him to be reincarnated? For the next Dalai Lama to grow up and lead a movement? We don't have that much time. Even the Buddha asked us to follow his teachings only after thinking them through. So we can revere the Dalai Lama but we can respectfully disagree on political issues." This, she says, is too radical an idea for many Tibetans. "I cannot discuss this with my parents or anyone from their generation. Even for some younger people this is a difficult idea."

"The Chinese government is dying to call us a terrorist group and crack down on us. They only need the smallest excuse. We cannot afford violence. But neither can we afford to let this year go while the spotlight is on China."

Nisha Susan

WE NEED TO SHOW OUR FIST NOW

Tenzin Choeying, 27

President, Students for Free Tibet, India

Tenzin Choeying, like other Tibetan activists, thinks that this generation of Tibetan exiles may be the only one able to make Independence possible. The first generation of refugees had more immediate concerns of survival. The next generation may not find a Tibet intact to fight for.

"We have a long struggle ahead of us but we also know that the Chinese are moving more and more of their people into Tibet. We need to move now and show our fist." As a student of law and history, Tenzin

Choeying places the predicament of the Tibetan community squarely within the discourse of colonization. But as the member of an organization that has 600 chapters in universities around the world, his stance on the Dalai Lama's role in the movement has to be expressed with tact and respect.

He says carefully, "There are two ways of looking at it. We are unified under one government, under one leader and yes there will be problems if His Holiness passes away. But at the same time, because of His presence, there is a reluctance among our people to establish a movement of the common people. If other nations have done it, why not us? So I tell the young people I meet education is really about making decisions on the basis of your own thinking. But it is difficult. My father calls me a communist."

Choeying and Tsering Choedup, coordinator of the International Tibet Support Network, both say that they draw inspiration and strength from the examples of Gandhi and Mandela. But they add that they have learned the creative use of media and technology from lobbying groups such as Greenpeace. With a sudden sardonic note Choeying adds, "The Dalai Lama's establishment is 600 years old, but Tibetans have been around for 5,000 years. We have the ability to continue beyond the Dalai Lama's establishment."

Nisha Susan

WE MUST END THE STATUS QUO

Ngawang Woeber

Gu-Chu-Sum (A former political prisoners group)

A politically active monk, Ngawang Woeber was jailed thrice inside Lhasa. The torture, he says, is not something you can describe to an-

other human being. Dogs set loose on naked bodies, beatings with electric batons. Physical humiliation is not enough, the Chinese police want to colonize the mind.

In April 1991, he crossed over to India and, with thirty-five others, started the Gu-Chu-Sum, the former political prisoners' association. Today, there are 450 members, resolutely committed to winning independence for Tibet, even if that is at odds with the Dalai Lama's goal. "Our people are still languishing in jail. I cannot sleep sometimes thinking of them. They were all fighting for independence, not autonomy. As a Tibetan, as a monk, I have complete reverence for His Holiness," says Ngawang. "But in a democracy it is fine to disagree. If every young Tibetan starts demanding freedom, His Holiness will change his stand."

Ngawang is consumed by a sense of urgency. "This is a very significant moment in our history. There is a new awakening. We cannot let it pass by. We have to break the status quo. This year a big change must happen because China has a specific plan to resettle two million Chinese in Lhasa in 2009. This population transfer will have a huge impact on Asia."

Shoma Chaudhury

From *Tehelka*, April 26, 2008, vol. 5:16.

Stephen G. Rhodes,
Vacant Portraits (Red & Blue), 2008.
Oil and collage on canvas, 45 x 40 in
(114.3 x 101.6 cm) each (framed diptych).
Courtesy Overduin and Kite, Los Angeles
(Detail)

Musings on Africa,

International Development and Hacking the Media: Draft Paper on Mobile Phones and Activism

Ethan Zuckerman

Filed under: Blogs and bloggers, Developing world, Geekery, Human Rights/ Free Speech, Media – Ethan 5:11 p.m.

I'm giving a talk on activist uses of mobile phones in the developing world later this month. Prior to the talk, the organizers have asked me to submit a short paper on the topic–here's a draft of what I'm planning on turning in, with the hope that you guys can offer some comments and make it better.

(This paper revised 4/26/07, thanks to the comments offered here and on Worldchanging. Thanks, everyone, for great examples and for helping me improve this paper. It is, of course, CC-attribution licensed, so if it's useful at all in your work, please pass it around....)

If you ask a US-based activist the most important technical development of the past five years, they'll likely tell you about the rise of citizen media, the use of blogs and Web community sites to disseminate information, organize events, and raise money. Bloggers helped make Howard Dean a contender for the Democratic nomination for president in 2004, and many of the people involved with his online campaign have gone on to develop increasingly complicated software, helping support efforts towards Congressional transparency as well as political organizing. Because blogs were such a visible manifestation of political discourse, they've been extensively studied and reported on, which leads to a sense of the importance of these media for the campaign's impact.

Ask an activist from the developing world the same question and you'll get a different answer: The most important activist technology of the last five years is the mobile phone. The reasons for this are simple–for

most of the world, mobile phone penetration vastly exceeds Internet usage. (In China in 2005, there were 350 million mobile phone users, and 100 million Internet users. In sub-Saharan Africa in 2004, there were 52 million mobile phone users and approximately 5-8 million Internet users.) While analysts in the North talk about users receiving information on three screens—the computer, the television, and the mobile—users in the South are usually looking at two screens, and users in rural areas of the South are looking at one: a mobile phone that might be shared by all the residents of a village.

Market estimates suggest that there are over 2 billion mobile phone users in the world today, heading towards 3.3 billion in 2010. The parts of the world where mobile use is growing the most quickly—the Middle East, sub-Saharan Africa, and South and Southeast Asia are markets where the mobile isn't a replacement for existing landline technology, but is allowing people to have a personal communications channel for the first time. 97 percent of people in Tanzania reported that they could have access to a mobile phone—their own, a friend's, or one they could rent—as compared to 28 percent who could access a landline. (A map of mobile phone coverage in Uganda from MTN gives you a sense for how thoroughly some nations have become connected via wireless technology.)

The only technology that compares to the mobile phone in terms of pervasiveness and accessibility in the developing world is the radio. Indeed, considered together, radios and mobile phones can serve as a broad-distribution, participatory media network with some of the same citizen-media dynamics of the Internet, but accessible to a much wider, and non-literate audience. Interactive Radio for Justice, a participatory radio show in the Ituri region of the DR Congo uses SMS to let listeners ask questions about justice and human rights to a panel of Congolese and UN officials, who answer the questions over the air.

The questioners to Interactive Radio for Justice are anonymous. The producers ask callers not to identify themselves for fear that some pointed questions—"Are soldiers allowed to stay at my house and eat my food without paying for it?"—may lead to retribution. In general, the anonymity of mobile phones is one of the key reasons they've been so useful to activists. In the US, we consider most mobiles to be highly traceable—generally, mobile users have a phone number associated with a permanent address and a credit card. But mobile phones in most developing nations are sold on a pay-as-you-go basis. Some countries require registration of a phone's SIM card using a validated ID, but most don't, either for the SIM or for "top-up" cards. As a result, it's not difficult for an activist to have a single phone with multiple SIMs, one which is closely correlated with her identity and one which might be used to send messages to organize a protest or promote a cause.

Anonymity makes these protests unusually difficult for police or other authorities to block. "Smart mobs" of activists, brought to demonstrations by text messages, have led to political change in the Phillipines and the Ukraine. In 2001, SMS messages about political corruption helped turn the tide against Joseph Estrada, and led to SMS-organized street protests and Estrada's eventual ouster. (Filipino activists have organized subsequent text-based protests, many focused on lobbying for mobile phone user's rights. The organization TXTPower started as a consumer rights' organization and has now become active in broader political protest.) SMS messages in Ukraine helped mobilize tens of thousands of young demonstrators in the streets of Kiev in late 2004 to protest election fraud and demand a revote.

In both cases, calls to take to the streets spread organically—virally—with recipients forwarding the messages to multiple friends. Blocking the ability of a single phone to send messages would likely do little to stop **419**

the spread of the message. (Activists have discussed the wisdom of using SMS gateways, Web-based services which can send SMS messages to hundreds or thousands of phones. An argument against using gateways is the fact that they are single points of failure that could be blocked by a government anxious to stop the spread of a smart mob message.)

To stop virally spreading messages, concerned governments might order SMS networks shut down. Some Belarussian activists reported shutdowns of the SMS network in March 2006 to prevent activists in Minsk from making contact outside the capital and encouraging Belarussians in the countryside to come into the city. Similar accusations come from Ethiopian activists, who report that SMS was blocked during election protests in June 2005. Concerned about political text messages, the government of Cambodia declared a two-day "tranquility" period before governing council elections, shutting off SMS messaging and prompting accusations that the blockage was an unconstitutional limitation of speech. Observers from the National Democratic Institute report that the Albanian government attempted to block SMS throughout their network for a week before recent elections. Iran may have blocked SMSs sent from Internet gateways as a way of preventing "defamation" of candidates prior to elections in late 2006.

The Shanghai police have tried another technique for controlling SMS-spread demonstrations–they used SMS messages to warn potential protesters away from anti-Japan street protests. (The technique was a mixed success–the message from Shangai police was so ambiguously worded that some recipients took it as encouragement to protest.) Belarussian authorities attempted something similar during the October Square protests, sending SMS messages warning potential march

participants about their health and safety if they appeared at marches,

stating that "provocateurs are planning bloodshed."

In smart-mob scenarios, mobile phones function as an impromptu broadcast network–if activists had access to radio stations with sufficient footprint, they could achieve similar goals by broadcasting information about rallies over the airwaves. Other activist uses of mobiles take advantage of the ability of mobile owners to create content as well as forwarding it. Activists with the pro-democracy Kefaya movement use mobile phones and their cameras to document demonstrations and other news events, including a government crackdown on Sudanese protesters in Cairo–they call, text, or use MMS to send messages to the administrator of the Kefaya blog, which compiles reports into blog posts much as a newroom turns field reports into finished articles.

A dispersed group with mobile phones–especially mobile phones equipped with cameras–becomes a powerful force for "sousveillance." Coined by Dr. Steve Mann, "sousveillance" refers to the monitoring of authority figures by grassroots groups, using the technologies and techniques of surveillance. The use of mobile phones to monitor the 2000 presidential election in Ghana is a good example of sousveillance–voters who were prevented from voting used mobile phones to report their experience to call-in shows on local radio stations. The stations broadcast the reports, prompting police to respond to the accusations of voter intimidation. Had voters called the police directly, it's possible that authorities might not have responded–by making reports public through the radio, voters eliminated the possibility of police announcing that there had been no reports of voter intimidation. Similar techniques have been used in Sierra Leone, Senegal, and even in the US–American voters used mobile phone cameras and Web sites to record reports of voting irregularities during the 2006 congressional elections.

Sousveillance has a way of trapping authority figures, even when they're the ones holding the cameras. Egyptian blogger and activist **421**

Mohammed Sharkawy was beaten and sodomized while in police custody–his tormentors filmed the incident and threatened to humiliate him by posting the video on the Internet. The video, posted at sites like YouTube, has now become a document demonstrating the brutality of Egyptian police, leading to criticism by the US State Department of Egypt's human rights record. In a future where most citizens carry cameras with them at all times and have the ability to spread them phone to phone, or by posting them to a Web site, there's tremendous potential for sousveillance to serve as a check to people in power. (Needless to say, there are hundreds of more worrisome scenarios made possible by the same technology, including noxious phenomena like "happy slapping.")

Mobiles are powerful because they're pervasive, personal, and capable of authoring content. An intriguing new dimension emerges as they become systems of payment as well. Kenyan mobile company Safaricom has introduced a new system allowing mobile phone users to send money to other users of the network–it's called M-PESA and has moved from pilot to full-scale implementation rapidly. Once Vodaphone, Safaricom's international partner in the project, makes it possible for people outside of Kenya to deposit money into the network, it's likely that M-PESA will become a major tool for remittance as well as for cashless payment. Activists armed with M-PESA-type phones could do more than organize a dispered protest–they could fundraise, making it possible for groups of activists to fund the travel of an activist to a protest or the cost of leaflets. Similar projects, like Wizzit in South Africa, suggest that mobile banking is likely to become widespread in countries with a large "unbanked" population.

These mobile payment systems have a high degree of centralization and identification–M-PESA users have to register with Safaricom with a government ID. But other emerging payment via mobile systems look more

422 like hawala, the informal money transfer system used through much of

the Middle East and South Asia. Nokia anthropologist Jan Chipchase tells a story about Ugandan mobile phone users and a system called "sente": A caller purchases mobile phone airtime cards in a major cities, then calls his home village—he reads the recharge codes to the person in town who owns a mobile phone, giving her the credits to use. She enters the credits into her phone (validating the transaction), then gives a large percentage of the value of the credits to the person of the caller's choice, usually a member of his family. Systems like this allow for virtually untraceable money transfer, unless phone card vendors are forced to check identification before selling phone cards.

Finally, it's worth remembering that the powers unleashed by the mobile phone can affect all sides of a political situation. Protests organized by SMS helped unseat Joseph Estrada in the Philippines and bring President Gloria Arroyo to power. When Arroyo found herself embroiled in a corruption scandal involving tape recordings of phonecalls to voting commissioner Virgilio Garcillano, one of the tools activists used to spread information was a ringtone. The ringtone featured a snippet of dialogue between Arroyo and Garcillano and rapidly became one of the world's most downloaded ringtones and spawning over a dozen remixed versions. The personal nature of mobile phones makes them the perfect venue for protest, even if the protest is as innocuous as having your phone chirp "Hello Garcia?" in the President's voice every time you get an SMS. What the mobile giveth, it can taketh away.

Kerstin Brätsch,
Untitled from the "Psychic" series, 2007.
Oil on paper,
98 x 69 1/2 in (249 x 176.5 cm).
Courtesy BaliceHertling, Paris
(Detail)

The Aughties

Grigory Okhotin

Sorrowful, I gaze upon my generation...

 — Mikhail Lermontov

Don't trust anyone over thirty.

 — Popular saying in 1968

The first epigraph above is something I could never sign my own name to–my fellow twenty-somethings are a source of curiosity and hope for me, not of sorrow. But the second–and here I won't presume to speak on behalf of my entire generation–holds a grain of truth. Assuming that most readers of this journal[1] are over thirty, I'd like to briefly explain my position in general terms.

I am not inclined to trust the thirty-something generation. Its members are more active in all sectors of the economy than are members of my generation; they are the bosses and partners of what I'll call the "aughties." Yet the relationship between the two generations is not precisely that of teacher to student. While the "students" respect the knowledge and experience of the "teachers," in this case there is also a genuine interest in the reverse direction.

This mutual interest is, of course, complicated by competitiveness–to use a coarse metaphor, thirty-somethings see twenty-somethings as younger brothers trying to sleep with their wives–and some contemptuousness: The younger generation thinks that the thirty-somethings' level of competence cannot compete with their own knowledge and skills. (Of course, the latter perception isn't quite true–no one can hold a job today without mastering some contemporary technologies and methods.) Reality seems to matter less than perceptions, and the attitude of twenty-somethings–the aughties–is patronizing. They expect their "big brothers" to have similar beliefs and aptitudes, to **425**

understand their problems, and are disappointed when that mutual understanding does not materialize. Perhaps in other, more stable societies such expectations are at least partially met. In the post-Soviet world, however, intergenerational relationships often yield real conflicts.

The Soviet empire collapsed just as today's thirty-somethings were completing their education, which means that they studied in Soviet universities. Their personalities began to take shape in the Soviet Union, and matured in the chaotic days of the early 1990s. "Anything goes," "grab what you can," "pull a fast one on grandma"—such was the dominant ideology of business at the birth of the new era. The dubious morality of this position is perhaps less important than its inefficacy, its shortsightedness; such a strategy, it seems fair to say, cannot lie at the foundation of a serious business vision.

The ideological divide between twenty-somethings and thirty-somethings can be traced to the drastically different situations in which their outlooks took shape. The aughties barely remember the Soviet Union. They were able to receive an education adapted to their new environment. And in both in Russia and Ukraine, the aughties matured and entered the workforce during a period of economic growth, whereas the thirty-somethings entered the workforce in a recession and then suffered through the 1998 economic crisis.

Contradictory as it may seem, because of the trial by fire the thirty-somethings endured, I would call their generation the fearful generation. Unable to receive a normal education, because of either Soviet teaching methods or the lackadaisical attitude toward learning characteristic of the 1990s, today's thirty-somethings have little confidence in their abilities. Those who managed to survive capitalism's difficult early phase were hit hard by the crisis of 1998. Uncertainty about the future grew, and fear of another crisis remains with them to this day. Salaries have risen back to pre-crisis levels, but they

are twice as hard to earn. After barely recovering from economic shake ups and encountering yet another shift in ideology (Putin's rise to power in Russia, the victory of the Orange Revolution in Ukraine), thirty-somethings became mobile–they learned how to adapt to any conditions. This has benefits. Mobility mixed with fear numbs the sensation of losing one's country. But while mobility smoothes the adaptation to new homelands, it is not necessarily a trait compatible with long-term strategic thinking and development. The attitudes of the 1990s still dominate the outlook of thirty-somethings in this decade.

Drawing generalizations is a dangerous, thankless task. I cannot dismiss the older generation's talent, for it is thanks to its outstanding representatives that the economy of the former Soviet republics emerged from stagnation and embarked on a course of gradual expansion. If not for Mikhail Khodorkovsky, a man of rare strategic thinking, the Russian economy would not be what it is today. The same can justifiably said of Viktor Pinchuk; although he exploited the market situation in the interests of his business, he possessed sufficient strategic understanding to sustain a major business empire in Ukraine. Khodorkovsky and Pinchuk set goals of developing not only their businesses, but also their countries. There are other, less-prominent businessmen who deftly manipulated their surroundings to build their companies. While twenty-somethings were studying theories of politics and business, the thirty-somethings were already deploying them in practice.

Fear can yield positive results. Thirty-somethings are not only mobile; they are also extremely hardworking. The fear of losing work and a regular income initiated a huge number of projects and businesses, which undoubtedly guarantees their positions of leadership in business, media, and culture. But often their attempts to achieve everything at once are to the detriment of strategic growth in the future, a course that leads to crisis and subsequent **427**

bankruptcy. While I have expressed my idea in economic terms, it can also be applied to culture, politics, and other spheres of activity. A thirty-something journalist can write thirty articles a month only to discover one day that publications have stopped commissioning his texts.

To better describe what sets the aughties apart, I should expand upon my definition of the thirty-somethings as the fearful generation. The parameter of fear is extremely useful in the description of any generation, since the fears people have or don't have at a given time can highlight much about the period in which they come of age. That the aughties do not fear a return to totalitarianism, for example, helps explain their uncritical attitude toward the regime [in Russia]. Likewise, they began their careers in a period of economic growth and therefore do not fear a financial downturn; they came of age in a new country with a new ideology and therefore do not know what it means for a country to collapse and vanish. The aughties are the first "free" generation, a fact that bolsters their ambition and confidence. This is their country; for better or for worse, they will decide what happens to it. Their awareness of this gives the aughties noticeable self-confidence.

The term "fearless generation" may better fit Ukrainian twenty-somethings than their Russian counterparts, because the Orange Revolution in late 2004 and early 2005 removed the Ukrainians' lingering Soviet inhibitions and fear of authority. It needs to be acknowledged that the Orange Revolution was not the doing of Viktor Yushchenko,[2] or of George Soros and George Bush, or even of Yulia Tymoshenko.[3] The revolution belongs to the aughties. None of what has been said about the role of political tactics and media manipulation of the electorate has relevance. The revolution was not about politics, and not about Yushchenko and Yanukovich[4]; the revolution was about Pora,[5] and about the thousands of young people who stood on the Maidan.[6]

428

Ukraine's power structures released the genie from the bottle when they involved twenty-somethings in the political process, and now there's no way that they can put it back in. The country already belongs to the aughties.

In Russia, unfortunately, the experiment failed. At this point Russia has no fearless generation. The economy is growing, and self-assurance is, too. But the Russian regime is doing all it can to curb the impertinence and spontaneity typical of twenty-somethings, through travel restrictions, conscription, a ban on drinking beer outdoors, and, last but not least, the war in Chechnya and the war on terror. However the situation develops in Russia, the taste of fear—the nearly palpable smell of blood and flesh mixed with the military explosive Hexogen—will hold fast in the minds of Russia's aughties forever; it cannot be erased by revolutions or therapy. The only hope is that Russia's twenty-somethings will be wise enough to turn the negative energy directed at them against those who devised such awful ways of suppressing their generation's rebellious spirit. Then, perhaps, despite the lingering taste of blood, they will feel that they did not suffer in vain. Then they and Russia will have a future. But we'll have to wait for their children to see a fearless generation.

From *Ji*, July 2005, issue 38. Translation by Brian Droitcour.

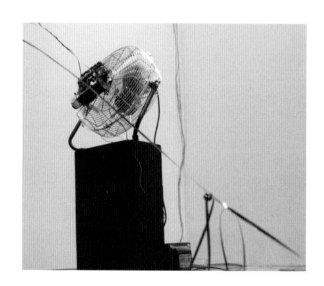

Icaro Zorbar,
ventila dor, 2007.
Speaker, ventilator, tape player, and audio cassette,
47 x 24 x 60 in (119.3 x 61 x 152.4 cm)
(Detail)

Brave New World of Digital Intimacy

Clive Thompson

On Sept. 5, 2006, Mark Zuckerberg changed the way that Facebook worked, and in the process he inspired a revolt.

Zuckerberg, a doe-eyed twenty-four-year-old CEO, founded Facebook in his dorm room at Harvard two years earlier, and the site quickly amassed nine million users. By 2006, students were posting heaps of personal details onto their Facebook pages, including lists of their favorite TV shows, whether they were dating (and whom), what music they had in rotation and the various ad hoc "groups" they had joined (like "Sex and the City" lovers). All day long, they'd post "status" notes explaining their moods–"hating Monday," "skipping class b/c i'm hung over." After each party, they'd stagger home to the dorm and upload pictures of the soused revelry, and spend the morning after commenting on how wasted everybody looked. Facebook became the de facto public commons–the way students found out what everyone around them was like and what he or she was doing.

But Zuckerberg knew Facebook had one major problem: It required a lot of active surfing on the part of its users. Sure, every day your Facebook friends would update their profiles with some new tidbits; it might even be something particularly juicy, like changing their relationship status to "single" when they got dumped. But unless you visited each friend's page every day, it might be days or weeks before you noticed the news, or you might miss it entirely. Browsing Facebook was like constantly poking your head into someone's room to see how she was doing. It took work and forethought. In a sense, this gave Facebook an inherent, built-in level of privacy, simply because if you had 200 friends on the site–a fairly typical number–there weren't enough hours in the day to keep tabs on every friend all the time.

"It was very primitive," Zuckerberg told me when I asked him about it last month. And so he decided to modernize. He developed something he called News Feed, a built-in service that would actively broadcast changes in a user's page to every one of his or her friends. Students would no **431**

longer need to spend their time zipping around to examine each friend's page, checking to see if there was any new information. Instead, they would just log into Facebook, and News Feed would appear: a single page that–like a social gazette from the eighteenth century–delivered a long list of up-to-the-minute gossip about their friends, around the clock, all in one place. "A stream of everything that's going on in their lives," as Zuckerberg put it.

When students woke up that September morning and saw News Feed, the first reaction, generally, was one of panic. Just about every little thing you changed on your page was now instantly blasted out to hundreds of friends, including potentially mortifying bits of news–Tim and Lisa broke up; Persaud is no longer friends with Matthew–and drunken photos someone snapped, then uploaded and tagged with names. Facebook had lost its vestigial bit of privacy. For students, it was now like being at a giant, open party filled with everyone you know, able to eavesdrop on what everyone else was saying, all the time.

"Everyone was freaking out," Ben Parr, then a junior at Northwestern University, told me recently. What particularly enraged Parr was that there wasn't any way to opt out of News Feed, to "go private" and have all your information kept quiet. He created a Facebook group demanding Zuckerberg either scrap News Feed or provide privacy options. "Facebook users really think Facebook is becoming the Big Brother of the Internet, recording every single move," a California student told *The Star-Ledger* of Newark. Another chimed in, "Frankly, I don't need to know or care that Billy broke up with Sally, and Ted has become friends with Steve." By lunchtime of the first day, 10,000 people had joined Parr's group, and by the next day it had 284,000.

Zuckerberg, surprised by the outcry, quickly made two decisions. The first was to add a privacy feature to News Feed, letting users decide what **432** kind of information went out. But the second decision was to leave

News Feed otherwise intact. He suspected that once people tried it and got over their shock, they'd like it.

He was right. Within days, the tide reversed. Students began e-mailing Zuckerberg to say that via News Feed they'd learned things they would never have otherwise discovered through random surfing around Facebook. The bits of trivia that News Feed delivered gave them more things to talk about—Why do you hate Kiefer Sutherland?—when they met friends face to face in class or at a party. Trends spread more quickly. When one student joined a group—proclaiming her love of Coldplay or a desire to volunteer for Greenpeace—all her friends instantly knew, and many would sign up themselves. Users' worries about their privacy seemed to vanish within days, boiled away by their excitement at being so much more connected to their friends. (Very few people stopped using Facebook, and most people kept on publishing most of their information through News Feed.) Pundits predicted that News Feed would kill Facebook, but the opposite happened. It catalyzed a massive boom in the site's growth. A few weeks after the News Feed imbroglio, Zuckerberg opened the site to the general public (previously, only students could join), and it grew quickly; today, it has 100 million users.

When I spoke to him, Zuckerberg argued that News Feed is central to Facebook's success. "Facebook has always tried to push the envelope," he said. "And at times that means stretching people and getting them to be comfortable with things they aren't yet comfortable with. A lot of this is just social norms catching up with what technology is capable of."

In essence, Facebook users didn't think they wanted constant, up-to-the-minute updates on what other people are doing. Yet when they experienced this sort of omnipresent knowledge, they found it intriguing and addictive. Why? **433**

Social scientists have a name for this sort of incessant online contact. They call it "ambient awareness." It is, they say, very much like being physically near someone and picking up on his mood through the little things he does–body language, sighs, stray comments–out of the corner of your eye. Facebook is no longer alone in offering this sort of interaction online. In the last year, there has been a boom in tools for "microblogging": posting frequent tiny updates on what you're doing. The phenomenon is quite different from what we normally think of as blogging, because a blog post is usually a written piece, sometimes quite long: a statement of opinion, a story, an analysis. But these new updates are something different. They're far shorter, far more frequent and less carefully considered. One of the most popular new tools is Twitter, a Web site and messaging service that allows its two-million-plus users to broadcast to their friends haiku-length updates–limited to 140 characters, as brief as a mobile-phone text message–on what they're doing. There are other services for reporting where you're traveling (Dopplr) or for quickly tossing online a stream of the pictures, videos, or Web sites you're looking at (Tumblr). And there are even tools that give your location. When the new iPhone, with built-in tracking, was introduced in July, one million people began using Loopt, a piece of software that automatically tells all your friends exactly where you are.

For many people–particularly anyone over the age of thirty–the idea of describing your blow-by-blow activities in such detail is absurd. Why would you subject your friends to your daily minutiae? And conversely, how much of their trivia can you absorb? The growth of ambient intimacy can seem like modern narcissism taken to a new, supermetabolic extreme–the ultimate expression of a generation of celebrity-addled youths who believe their every utterance is fascinating and ought to be shared with the world. Twitter, in particular, has been the subject of nearly relentless scorn since it went online.

"Who really cares what I am doing, every hour of the day?" wondered Alex Beam, a *Boston Globe* columnist, in an essay about Twitter last month. "Even I don't care."

Indeed, many of the people I interviewed, who are among the most avid users of these "awareness" tools, admit that at first they couldn't figure out why anybody would want to do this. Ben Haley, a thirty-nine-year-old documentation specialist for a software firm who lives in Seattle, told me that when he first heard about Twitter last year from an early-adopter friend who used it, his first reaction was that it seemed silly. But a few of his friends decided to give it a try, and they urged him to sign up, too.

Each day, Haley logged on to his account, and his friends' updates would appear as a long page of one- or two-line notes. He would check and recheck the account several times a day, or even several times an hour. The updates were indeed pretty banal. One friend would post about starting to feel sick; one posted random thoughts like "I really hate it when people clip their nails on the bus"; another Twittered whenever she made a sandwich—and she made a sandwich every day. Each so-called tweet was so brief as to be virtually meaningless.

But as the days went by, something changed. Haley discovered that he was beginning to sense the rhythms of his friends' lives in a way he never had before. When one friend got sick with a virulent fever, he could tell by her Twitter updates when she was getting worse and the instant she finally turned the corner. He could see when friends were heading into hellish days at work or when they'd scored a big success. Even the daily catalog of sandwiches became oddly mesmerizing, a sort of metronomic click that he grew accustomed to seeing pop up in the middle of each day.

This is the paradox of ambient awareness. Each little update—each individual bit of social information—is insignificant on its own, even

435

supremely mundane. But taken together, over time, the little snippets coalesce into a surprisingly sophisticated portrait of your friends' and family members' lives, like thousands of dots making a pointillist painting. This was never before possible, because in the real world, no friend would bother to call you up and detail the sandwiches she was eating. The ambient information becomes like "a type of ESP," as Haley described it to me, an invisible dimension floating over everyday life.

"It's like I can distantly read everyone's mind," Haley went on to say. "I love that. I feel like I'm getting to something raw about my friends. It's like I've got this heads-up display for them." It can also lead to more real-life contact, because when one member of Haley's group decides to go out to a bar or see a band and Twitters about his plans, the others see it, and some decide to drop by—ad hoc, self-organizing socializing. And when they do socialize face to face, it feels oddly as if they've never actually been apart. They don't need to ask, "So, what have you been up to?" because they already know. Instead, they'll begin discussing something that one of the friends Twittered that afternoon, as if picking up a conversation in the middle.

Facebook and Twitter may have pushed things into overdrive, but the idea of using communication tools as a form of "co-presence" has been around for a while. The Japanese sociologist Mizuko Ito first noticed it with mobile phones: Lovers who were working in different cities would send text messages back and forth all night—tiny updates like "enjoying a glass of wine now" or "watching TV while lying on the couch." They were doing it partly because talking for hours on mobile phones isn't very comfortable (or affordable). But they also discovered that the little Ping-Ponging messages felt even more intimate than a phone call.

"It's an aggregate phenomenon," Marc Davis, a chief scientist at Yahoo **436** and former professor of information science at the University of Cali-

fornia at Berkeley, told me. "No message is the single-most-important message. It's sort of like when you're sitting with someone and you look over and they smile at you. You're sitting here reading the paper, and you're doing your side-by-side thing, and you just sort of let people know you're aware of them." Yet it is also why it can be extremely hard to understand the phenomenon until you've experienced it. Merely looking at a stranger's Twitter or Facebook feed isn't interesting, because it seems like blather. Follow it for a day, though, and it begins to feel like a short story; follow it for a month, and it's a novel.

You could also regard the growing popularity of online awareness as a reaction to social isolation, the modern American disconnectedness that Robert Putnam explored in his book *Bowling Alone.* The mobile workforce requires people to travel more frequently for work, leaving friends and family behind, and members of the growing army of the self-employed often spend their days in solitude. Ambient intimacy becomes a way to "feel less alone," as more than one Facebook and Twitter user told me.

When I decided to try out Twitter last year, at first I didn't have anyone to follow. None of my friends were yet using the service. But while doing some Googling one day I stumbled upon the blog of Shannon Seery, a thirty-two-year-old recruiting consultant in Florida, and I noticed that she Twittered. Her Twitter updates were pretty charming—she would often post links to camera-phone pictures of her two children or videos of herself cooking Mexican food, or broadcast her agonized cries when a flight was delayed on a business trip. So on a whim I started "following" her – as easy on Twitter as a click of the mouse – and never took her off my account. (A Twitter account can be "private," so that only invited friends can read one's tweets, or it can be public, so anyone can; Seery's was public.) When I checked in last month, I noticed that she had built up a huge number of online connections: She was now **437**

following 677 people on Twitter and another 442 on Facebook. How in God's name, I wondered, could she follow so many people? Who precisely are they? I called Seery to find out.

"I have a rule," she told me. "I either have to know who you are, or I have to know of you." That means she monitors the lives of friends, family, anyone she works with, and she'll also follow interesting people she discovers via her friends' online lives. Like many people who live online, she has wound up following a few strangers–though after a few months they no longer feel like strangers, despite the fact that she has never physically met them.

I asked Seery how she finds the time to follow so many people online. The math seemed daunting. After all, if her 1,000 online contacts each post just a couple of notes each a day, that's several thousand little social pings to sift through daily. What would it be like to get thousands of e-mail messages a day? But Seery made a point I heard from many others: Awareness tools aren't as cognitively demanding as an e-mail message. E-mail is something you have to stop to open and assess. It's personal; someone is asking for 100 percent of your attention. In contrast, ambient updates are all visible on one single page in a big row, and they're not really directed at you. This makes them skimmable, like newspaper headlines; maybe you'll read them all, maybe you'll skip some. Seery estimated that she needs to spend only a small part of each hour actively reading her Twitter stream.

Yet she has, she said, become far more gregarious online. "What's really funny is that before this 'social media' stuff, I always said that I'm not the type of person who had a ton of friends," she told me. "It's so hard to make plans and have an active social life, having the type of job I have where I travel all the time and have two small kids. But it's easy to tweet all the time, to post pictures of what I'm doing, to keep social relations up." She paused for a

438

second, before continuing: "Things like Twitter have actually given me a much bigger social circle. I know more about more people than ever before."

I realized that this is becoming true of me, too. After following Seery's Twitter stream for a year, I'm more knowledgeable about the details of her life than the lives of my two sisters in Canada, whom I talk to only once every month or so. When I called Seery, I knew that she had been struggling with a three-day migraine headache; I began the conversation by asking her how she was feeling.

Online awareness inevitably leads to a curious question: What sort of relationships are these? What does it mean to have hundreds of "friends" on Facebook? What kind of friends are they, anyway?

In 1998, the anthropologist Robin Dunbar argued that each human has a hard-wired upper limit on the number of people he or she can personally know at one time. Dunbar noticed that humans and apes both develop social bonds by engaging in some sort of grooming; apes do it by picking at and smoothing one another's fur, and humans do it with conversation. He theorized that ape and human brains could manage only a finite number of grooming relationships: Unless we spend enough time doing social grooming–chitchatting, trading gossip or, for apes, picking lice–we won't really feel that we "know" someone well enough to call him a friend. Dunbar noticed that ape groups tended to top out at fifty-five members. Since human brains were proportionally bigger, Dunbar figured that our maximum number of social connections would be similarly larger: about 150 on average. Sure enough, psychological studies have confirmed that human groupings naturally tail off at around 150 people: the "Dunbar number," as it is known. Are people who use Facebook and Twitter increasing their Dunbar number, because they can so easily keep track of so many more people?

As I interviewed some of the most aggressively social people online–people who follow hundreds or even thousands of others–it **439**

became clear that the picture was a little more complex than this question would suggest. Many maintained that their circle of true intimates, their very close friends and family, had not become bigger. Constant online contact had made those ties immeasurably richer, but it hadn't actually increased the number of them; deep relationships are still predicated on face time, and there are only so many hours in the day for that.

But where their sociality had truly exploded was in their "weak ties"–loose acquaintances, people they knew less well. It might be someone they met at a conference, or someone from high school who recently "friended" them on Facebook, or somebody from last year's holiday party. In their pre-Internet lives, these sorts of acquaintances would have quickly faded from their attention. But when one of these far-flung people suddenly posts a personal note to your feed, it is essentially a reminder that they exist. I have noticed this effect myself. In the last few months, dozens of old work colleagues I knew from ten years ago in Toronto have friended me on Facebook, such that I'm now suddenly reading their stray comments and updates and falling into oblique, funny conversations with them. My overall Dunbar number is thus 301: Facebook (254) + Twitter (47), double what it would be without technology. Yet only twenty are family or people I'd consider close friends. The rest are weak ties–maintained via technology.

This rapid growth of weak ties can be a very good thing. Sociologists have long found that "weak ties" greatly expand your ability to solve problems. For example, if you're looking for a job and ask your friends, they won't be much help; they're too similar to you, and thus probably won't have any leads that you don't already have yourself. Remote acquaintances will be much more useful, because they're farther afield, yet still socially intimate enough to want to help you out. Many avid Twitter users–the ones who fire off witty posts hourly **440** and wind up with thousands of intrigued followers–explicitly milk this

dynamic for all it's worth, using their large online followings as a way to quickly answer almost any question. Laura Fitton, a social-media consultant who has become a minor celebrity on Twitter—she has more than 5,300 followers—recently discovered to her horror that her accountant had made an error in filing last year's taxes. She went to Twitter, wrote a tiny note explaining her problem, and within ten minutes her online audience had provided leads to lawyers and better accountants. Fritton joked to me that she no longer buys anything worth more than $50 without quickly checking it with her Twitter network.

"I outsource my entire life," she said. "I can solve any problem on Twitter in six minutes." (She also keeps a secondary Twitter account that is private and only for a much smaller circle of close friends and family—"My little secret," she said. It is a strategy many people told me they used: one account for their weak ties, one for their deeper relationships.)

It is also possible, though, that this profusion of weak ties can become a problem. If you're reading daily updates from hundreds of people about whom they're dating and whether they're happy, it might, some critics worry, spread your emotional energy too thin, leaving less for true intimate relationships. Psychologists have long known that people can engage in "parasocial" relationships with fictional characters, like those on TV shows or in books, or with remote celebrities we read about in magazines. Parasocial relationships can use up some of the emotional space in our Dunbar number, crowding out real-life people. Danah Boyd, a fellow at Harvard's Berkman Center for Internet and Society who has studied social media for ten years, published a paper this spring arguing that awareness tools like News Feed might be creating a whole new class of relationships that are nearly parasocial—peripheral people in our network whose intimate details we follow closely online, even while they, like Angelina Jolie, are basically unaware we exist.

441

"The information we subscribe to on a feed is not the same as in a deep social relationship," Boyd told me. She has seen this herself; she has many virtual admirers that have, in essence, a parasocial relationship with her. "I've been very, very sick, lately, and I write about it on Twitter and my blog, and I get all these people who are writing to me telling me ways to work around the health-care system, or they're writing saying, 'Hey, I broke my neck!' And I'm like, 'You're being very nice and trying to help me, but though you feel like you know me, you don't.'" Boyd sighed. "They can observe you, but it's not the same as knowing you."

When I spoke to Caterina Fake, a founder of Flickr (a popular photo-sharing site), she suggested an even more subtle danger: that the sheer ease of following her friends' updates online has made her occasionally lazy about actually taking the time to visit them in person. "At one point I realized I had a friend whose child I had seen, via photos on Flickr, grow from birth to 1 year old," she said. "I thought, I really should go meet her in person. But it was weird; I also felt that Flickr had satisfied that getting-to-know you satisfaction, so I didn't feel the urgency. But then I was like, Oh, that's not sufficient! I should go in person!" She has about 400 people she follows online but suspects many of those relationships are tissue-fragile. "These technologies allow you to be much more broadly friendly, but you just spread yourself much more thinly over many more people."

What is it like to never lose touch with anyone? One morning this summer at my local café, I overheard a young woman complaining to her friend about a recent Facebook drama. Her name is Andrea Ahan, a twenty-seven-year-old restaurant entrepreneur, and she told me that she had discovered that high-school friends were uploading old photos of her to Facebook and tagging them with her name, so they automatically appeared in searches for her.

She was aghast. "I'm like, my God, these pictures are completely hideous!" Ahan complained, while her friend looked on sympathetically and sipped her coffee. "I'm wearing all these totally awful '90s clothes. I look like crap. And I'm like, Why are you people in my life, anyway? I haven't seen you in ten years. I don't know you anymore!" She began furiously detagging the pictures–removing her name, so they wouldn't show up in a search anymore.

Worse, Ahan was also confronting a common plague of Facebook: the recent ex. She had broken up with her boyfriend not long ago, but she hadn't "unfriended" him, because that felt too extreme. But soon he paired up with another young woman, and the new couple began having public conversations on Ahan's ex-boyfriend's page. One day, she noticed with alarm that the new girlfriend was quoting material Ahan had e-mailed privately to her boyfriend; she suspected he had been sharing the e-mail with his new girlfriend. It is the sort of weirdly subtle mind game that becomes possible via Facebook, and it drove Ahan nuts.

"Sometimes I think this stuff is just crazy, and everybody has got to get a life and stop obsessing over everyone's trivia and gossiping," she said.

Yet Ahan knows that she cannot simply walk away from her online life, because the people she knows online won't stop talking about her, or posting unflattering photos. She needs to stay on Facebook just to monitor what's being said about her. This is a common complaint I heard, particularly from people in their twenties who were in college when Facebook appeared and have never lived as adults without online awareness. For them, participation isn't optional. If you don't dive in, other people will define who you are. So you constantly stream your pictures, your thoughts, your relationship status and what you're doing–right now!–if only to ensure the virtual version of you is accurate, or at least the one you want to present to the world. **443**

This is the ultimate effect of the new awareness: It brings back the dynamics of small-town life, where everybody knows your business. Young people at college are the ones to experience this most viscerally, because, with more than 90 percent of their peers using Facebook, it is especially difficult for them to opt out. Zeynep Tufekci, a sociologist at the University of Maryland, Baltimore County, who has closely studied how college-age users are reacting to the world of awareness, told me that athletes used to sneak off to parties illicitly, breaking the no-drinking rule for team members. But then camera phones and Facebook came along, with students posting photos of the drunken carousing during the party; savvy coaches could see which athletes were breaking the rules. First the athletes tried to fight back by waking up early the morning after the party in a hungover daze to detag photos of themselves so they wouldn't be searchable. But that didn't work, because the coaches sometimes viewed the pictures live, as they went online at 2 a.m. So parties simply began banning all camera phones in a last-ditch attempt to preserve privacy.

"It's just like living in a village, where it's actually hard to lie because everybody knows the truth already," Tufekci said. "The current generation is never unconnected. They're never losing touch with their friends. So we're going back to a more normal place, historically. If you look at human history, the idea that you would drift through life, going from new relation to new relation, that's very new. It's just the twentieth century."

Psychologists and sociologists spent years wondering how humanity would adjust to the anonymity of life in the city, the wrenching upheavals of mobile immigrant labor—a world of lonely people ripped from their social ties. We now have precisely the opposite problem. Indeed, our modern awareness

444

tools reverse the original conceit of the Internet. When cyberspace

came along in the early '90s, it was celebrated as a place where you could rein-vent your identity—become someone new.

"If anything, it's identity-constraining now," Tufekci told me. "You can't play with your identity if your audience is always checking up on you. I had a student who posted that she was downloading some Pearl Jam, and someone wrote on her wall, 'Oh, right, ha-ha—I know you, and you're not into that.'" She laughed. "You know that old cartoon? 'On the Internet, nobody knows you're a dog'? On the Internet today, everybody knows you're a dog! If you don't want people to know you're a dog, you'd better stay away from a keyboard."

Or, as Leisa Reichelt, a consultant in London who writes regularly about ambient tools, put it to me: "Can you imagine a Facebook for children in kinder-garten, and they never lose touch with those kids for the rest of their lives? What's that going to do to them?" Young people today are already developing an attitude toward their privacy that is simultaneously vigilant and laissez-faire. They curate their online personas as carefully as possible, knowing that every-one is watching—but they have also learned to shrug and accept the limits of what they can control.

It is easy to become unsettled by privacy-eroding aspects of awareness tools. But there is another—quite different—result of all this incessant updating: a culture of people who know much more about themselves. Many of the avid Twitterers, Flickrers, and Facebook users I interviewed described an unexpected side effect of constant self-disclosure. The act of stopping several times a day to observe what you're feeling or thinking can become, after weeks and weeks, a sort of philosophical act. It's like the Greek dictum to "know thyself," or the therapeutic concept of mindfulness. (Indeed, the question that floats eternally at the top of Twitter's Web site—"What are you doing?"—can come to seem existen-tially freighted. What are you doing?) Having an audience can make the **445**

self-reflection even more acute, since, as my interviewees noted, they're trying to describe their activities in a way that is not only accurate but also interesting to others: the status update as a literary form.

Laura Fitton, the social-media consultant, argues that her constant status updating has made her "a happier person, a calmer person" because the process of, say, describing a horrid morning at work forces her to look at it objectively. "It drags you out of your own head," she added. In an age of awareness, perhaps the person you see most clearly is yourself.

Tris Vonna-Michell,
The Trades of Others, 2008.
Performance, duration variable.
Installation view T293, Naples, 2008
(Detail)

The Generation

Facing its First Recession. How Will They Cope?

Tracy McVeigh

They grew up in an era of never-ending house price rises and fully expected to shop until they dropped. But the members of Generation Y will soon be forced to face the realities of a harsher economic climate. Tracy McVeigh asks them what they expect of the future and how they plan to adapt to it.

They are young, confident, affluent, and have no memory of tougher times. But Generation Y now faces its first recession and a future very different from the one it expected. Aged from eighteen to twenty-seven, and mostly middle-class, these young people have grown up in owner-occupied homes with total acceptance of technology, global warming, and homeland terrorism—and their love of shopping has made them dream consumers. But sooner or later their lives are going to change.

The average Generation Yer does not know the difference between a credit card and a debit card, according to a Bank of Scotland survey, and while two-thirds know the price of an Apple iPod Mini ($260), three-quarters have no idea what a pint of milk costs. One in eight thinks that "in the red" means being embarrassed. They each have 800 illegally downloaded songs, and one in twenty spends more than $145 a month on mobile phone bills. Many never read newspapers and two-thirds do not vote.

They like to shop, and whether it's Topshop, Primark, or TJ Maxx designer labels, they are used to getting what they want in a high-street catering to almost every income level.

If the credit crunch becomes a full-scale recession, no one will get a bigger shock to their aspirations than this pampered, techno-savvy generation.

"They will be at the sharp end because that age is always at the sharp end of social change. They are trying to enter the adult world

anyway, struggling with expectations and views that aren't theirs," said Jon Savage, a music writer and author of *Teenage: The Creation of Youth*. "But my question is, "What are they going to do if they can't shop? Our society has been based on consumerism for the past fifteen years, and these kids have racks of CDs, and plasma TVs, and comparatively unparalleled riches."

At Birmingham University this weekend, the *Observer* gathered a group of first-year students—at the heart of Generation Y—to ask what the credit crunch meant to them. For many, the answer was "not much."

"The credit crunch doesn't really affect me," said Lauren Ludlow, a twenty-year-old studying art history, one of the non-career-based subjects that traditionally slip in popularity in economic downturns. "I'm more concerned for my parents, and I'm just hoping it'll all have sorted itself out in three or four years' time."

Law student Jess Darley, nineteen, from Ipswich, added, "I don't think it's been too over-hyped or anything, but young people don't really understand economics because we're not taught about it. I guess it probably does affect us, but it sort of feels irrelevant."

Some are cushioned by "helicopter" parents—hovering protectively over their offspring. Amy Perry, eighteen, from Telford, said, "My mum does most of my food shopping for me. I guess it will get more expensive for her for a while, though."

Few are fearful. They're just not that bothered. "It doesn't mean much to me at all," admitted Joe Griffiths, nineteen, from Southampton.

Perhaps they are right not to worry. According to Dr David Twigg, a business lecturer at the University of Sussex, today's group of students are far more prepared for a difficult job market.

"Anyone born after 1983 is not really used to considering anything

other than wealth, but students are much more determined to build up

a broad skill base; they'll work hard to get it and demand we provide the teaching," he said. "They will be successful no matter what; they are independent self-learners who are better equipped than any previous generation."

And while recessions inevitably bring financial strain, they are also known to inspire creativity. "The last big recession produced punk, which was great," said Savage, but he added that it was not all positive. "You had to have a lot of bravery to be part of that, and the '70s also produced political polarization and extremism, perhaps an easier option.

"In the '30s, the Great Depression brought that kind of increased regimentation by the state. When you're of Generation Y age, you are fairly open to becoming extremely obsessed with an idea, and you feel invulnerable and you don't have much idea of the consequences of your actions. It can be a dangerous mix."

Few organizations in education and the arts were prepared to talk about the future other than to fret that funding drops in a recession. One west London art gallery owner told the *Observer*, "This stuff about kids getting creative in a recession is rot. It's not the '70s; they have seen Damien Hirst and Banksy make millions and that's what Generation Y wants, the same as Generation X—money. If they can't get it in art, they'll go and be eco-bankers."

Back in Birmingham, Paula, nineteen, (who didn't want to give her full name) said she was concerned about the impact of the credit crunch on her and her friends. "The recession is having an influence that many of us fail to recognize. Food prices are increasing, while loans remain at the same rate. Student expenditure is on a constant rise, and if the recession continues, paying bank loans may mean a huge increase in interest. Many students have not even considered this; it needs to be more widely publicized."

The Consumer Credit Counseling Service has long had concerns over students being unable to manage their finances. In the past two **451**

years, it has seen a ten-fold increase in calls from eighteen- to twenty-one-year-olds to its helpline.

Others point to housing and warn that Generation Y will be one of the hardest hit. Adam Sampson, chief executive of the homeless charity Shelter, said lower prices wouldn't help because there would be fewer mortgages. "These young people don't trust pensions any more and believe as much in house-as-security as their parents, who got us into this situation. But these kids have far less chance of getting on the ladder," he said.

"We have 240,000 new households forming every year and no one is building houses for them. They haven't been building enough for twenty years and that's some backlog. The recession will make that worse, as builders won't get money from the banks to build. I'm afraid Generation Y will be at home with mum and dad and we'll see the hidden homeless issue–overcrowding–get worse."

Charlotte Paul has two boys–Marcus, fourteen, and Charlie, sixteen–and lives with her husband and his twenty-two-year-old daughter in Yorkshire. "My stepdaughter was hoping to move into her own flat this year, but the mortgages weren't there, so she's squashed in here. It's been a shock to her because it's the first time in her life she has not been able to get something she wanted. She's just that age group; they've never been told, 'No, you can't have,'" said Paul. "Now she wants to give up her job and go volunteering abroad for a year, and she has no fear of coming back to no job. I envy her confidence."

For her boys, Paul is thinking the previously unthinkable. "We've an endowment policy we kept to pay out in time for Charlie's second year at university, and for Marcus we'd downsize the house and get Charlie on to the housing ladder at the same time. That's gone to pot. Charlie doesn't like the idea

452 of university. I went to university to duck out of the last recession–

there were grants and it kept me off the dole. Maybe not going will help him duck the debt and get experience." Then, Paul stopped herself. "I can't believe I'm thinking like this."

At business consultants talentsmoothie, Simon Walker has spent a lot of time explaining the confident behavior of Generation Y to perplexed employers. "Will Generation Y behave differently now things aren't so rosy? Well, of course they will," he said.

"They are very different from other generations and have only known very buoyant times. They demand things like flexible working and expect to get it. Past generations turned up on their first day in a suit and tie and did what they were told, but that's changed and you cannot reverse that. We were approached by a company that had 50 percent of the workforce who were Generation Y, and they were worried that their inexperience with a downturn would lead to absenteeism and extra stress. But we haven't found that yet at all—they adapt. But then, at the moment, people are not losing their jobs."

When that happens, few believe things won't change, particularly on the high street.

Robert Clarke, of business analysts Retail Knowledge Bank, argued that the high-profile reporting of the crisis would soon have an impact. "We're getting it hour by hour, and that brings problems in itself," he said. "Consumer confidence is hugely important and people who are getting ahead of themselves to preach doom and gloom are deeply irresponsible. A mindset will take us into recession faster than any bank collapse. Retail sales figures have not started falling yet. The likelihood is that the high street next year will look different for young people; there will be a few empty shops."

However, according to Clarke, it is not all bad news. "The optimism of Generation Y is correct because the likelihood is that most **453**

people will continue to be employed and will continue to be able to clothe and feed themselves.

"Yes, there will be fewer Saturday jobs and part-time jobs in retailing, which will affect the 75 percent of university students who have part-time jobs, but they won't have mortgages, rents will be cheaper, and I think they will still have money in their pockets."

From the *Guardian*, Sunday Oct. 12, 2008.
Copyright © Guardian News & Media Ltd 2008

Checklist of the Exhibition

AIDS-3D
OMG Obelisk, 2007
MDF, electroluminescent wire,
steel, hot glue,
acrylic paint, and fire
118 x 1/2 x 23 5/8 in
(300 x 1.5 x 60 cm)

Ziad Antar
WA, 2004
Digital video featuring Nathalie
and Mohamed Bsat
3 min
Courtesy the artist

Ziad Antar
La Marche Turque, 2006
Digital video featuring
Matea Marras
3 min
Courtesy the artist

Cory Arcangel
Panasonic TH-42PWD8UK
Plasma Screen Burn, 2007
Plasma screen monitor and
DVD player
26 x 41 x 12 in
(66 x 103 x 30 cm)
Collection Stacey Fabrikant

Cory Arcangel
Photoshop CS: 72 by 110 inches,
300 DPI, RGB, square pixels,
default gradient "Spectrum",
mousedown y=1416 x=1000,
mouse up y=208 x=42, 2009
Unique chromogenic print
72 x 110 in
(182.9 x 279.4 cm)
Courtesy the artist and
Team Gallery, New York

Tauba Auerbach
Crease II, 2009
Acrylic and inkjet on canvas
80 x 60 in (203 x 152.4 cm)
Courtesy Deitch Projects,
New York

Tauba Auerbach
Shatter III, 2009
Acrylic and glass on panel
64 x 48 in (162.6 x 122 cm)
Courtesy Deitch Projects,
New York

Tauba Auerbach
Static VIII, 2009
Chromogenic print
60 x 42 in (152.4 x 106.7 cm)
Courtesy Deitch Projects,
New York

Tauba Auerbach
Static IX, 2009
Chromogenic print
60 x 42 in (152.4 x 106.7 cm)

Courtesy Deitch Projects,
New York

Wojciech Bąkowski
Film Mówiony 1 (Spoken
Movie 1), 2007
Animation
5:22 min
Courtesy Leto Gallery, Warsaw

Dineo Seshee Bopape
thwebula/ukuthwebula (the process
of making someone into a zombie,
which is also the same word for
photographing someone), 2009
Mixed mediums
Dimensions variable
Courtesy the artist and
Marthouse Gallery,
Amsterdam

Mohamed Bourouissa
Le hall, 2007
Lambda print mounted on
aluminum
47 1/4 x 63 in (120 x 160 cm)
Musée national
de l'histoire et des cultures de
l'immigration, CNHI;
Courtesy Galerie les filles du
calvaire, Paris

Mohamed Bourouissa
Périphérique, 2007

Lambda print mounted on
aluminum
31 1/2 x 47 1/4 in (80 x 120 cm)
Musée national de l'histoire et
des cultures de l'immigration,
CNHI; Courtesy Galerie les filles
du calvaire, Paris

Mohamed Bourouissa
La fenêtre, 2005
Lambda print mounted on
aluminum
35 1/2 x 47 1/4 in (90 x 120 cm)
Musée national de l'histoire et
des cultures de l'immigration,
CNHI; Courtesy Galerie les filles
du calvaire, Paris

DAS INSTITUT (Kerstin
Brätsch and Adele Roeder)
Untitled, 2008
Poster rack with title posters
and mannequin
50 x 8 x 70 in
(147 x 20.3 x 177.8 cm)
Courtesy the artist and
BaliceHertling, Paris

Kerstin Brätsch for
DAS INSTITUT (Kerstin
Brätsch and Adele Roeder)
Machine of Light, from the
"New Images Unisex" series,
2008
Oil on paper
72 x 110 in (183 x 280 cm)
Courtesy the artist and
BaliceHertling, Paris

Kerstin Brätsch
Untitled 1, from the "Psychic"
series, 2007
Oil on paper
72 x 105 in (183 x 267 cm)
Hort Family Collection,
New York

Kerstin Brätsch
Untitled 2, from the "Psychic"
series, 2006
Oil on paper
72 x 100 in (183 x 254 cm)
Courtesy the artist and
Balice Hertling, Paris

Kerstin Brätsch
Untitled 8, from the "Psychic"
series, 2007
Oil and spray paint on paper
80 x 110 in (203 x 271 cm)
Courtesy the artist
and BaliceHertling, Paris

Cao Fei
Deep Breathing from the
"COSPlayers" series, 2004
Chromogenic print
30 x 40 in (76 x 102 cm)
Courtesy Lombard-Freid
Projects, New York

Cao Fei
Silent Curse from the
"COSPlayers" series, 2004
Chromogenic print
30 x 40 in (76 x 102 cm)
Courtesy Lombard-Freid
Projects, New York

Cao Fei
Game Over from the
"COSPlayers" series, 2004
Chromogenic print
30 x 40 in
(76 x 102 cm)
Courtesy Lombard-Freid
Projects, New York

Cao Fei
Murderess from the "COSPlayers"
series, 2004
Chromogenic print
30 x 40 in
(76 x 102 cm)
Courtesy Lombard-Freid
Projects, New York

Cao Fei
Nada at Home from the
"COSPlayers" series, 2004
Chromogenic print
30 x 40 in (76 x 102 cm)
Courtesy Lombard-Freid
Projects, New York

Cao Fei
Yanmy at Home from the
"COSPlayers" series, 2004
Chromogenic print
30 x 40 in (76 x 102 cm)
Courtesy Lombard-Freid
Projects, New York

Carolina Caycedo
Ni Dios, Ni Patrón, Ni Marido,
2009
Nylon banner
3 x 13 ft (91 x 396 cm)

Carolina Caycedo
Trust Each Other, 2009
Nylon banner
3 x 13 ft
(91 x 396 cm)
Courtesy Black and White
Gallery, New York

Carolina Caycedo
Don't Pay Taxes, 2009
Nylon banner
3 x 13 ft
(91 x 396 cm)
Courtesy Black and White
Gallery, New York

Chu Yun
This is XX, 2006
Female participant, sleeping
pill, and bed
Dimensions variable
La Gaia Collection, Busca,
Italy

Keren Cytter
Der Spiegel, 2007
Digital video, color, sound
4:30 min
Courtesy the artist and Pilar
Corrias Gallery,
London

Mariechen Danz
*Fossilizing the Body Border
Disorder*, 2008
Mannequins, Plexiglas,
digital print, and MDF
Dimensions variable
Courtesy the artist

Mariechen Danz
Complain the Explanation,
2008
Video, 16 min
Courtesy the artist

Faye Driscoll
Loneliness, 2006
Video, 2:10 min

Ida Ekblad
Untitled (M), 2008
Ink, dye, and chlorine on paper
stamped with ink and
chlorine with a stolen
McDonalds sign
84 x 124 in (213 x 315 cm)
Courtesy the artist and Gaudel
de Stampa, Paris

Ida Ekblad
On Otherness (No Tolerance), 2008
Posca marker on
chromogenic print
28 x 19 in (71 x 48 cm)
Courtesy the artist and Gaudel
de Stampa, Paris

Ida Ekblad
On Otherness (Rainbow Children),
2008
Posca marker on
chromogenic print
28 x 19 in (71 x 48 cm)
Courtesy the artist and Gaudel
de Stampa, Paris

Ida Ekblad
On Otherness (No Prejudice), 2008,

Posca marker on
chromogenic print
28 x 19 in (71 x 48 cm)
Courtesy the artist and Gaudel
de Stampa, Paris

Haris Epaminonda
Untitled 04, 2005–06
Collage
12 5/8 x 9 7/8 in
(32 x 25 cm)
Courtesy The Dakis Joannou
Collection, Athens

Haris Epaminonda
Untitled 10, 2005–06
Collage
8 5/8 x 9 1/2 in (22 x 24 cm)
Courtesy The Dakis Joannou
Collection, Athens

Haris Epaminonda
Untitled 11, 2005–06
Collage
12 5/8 x 9 7/8 in (32 x 25 cm)
Courtesy The Dakis Joannou
Collection, Athens

Haris Epaminonda
Untitled 12, 2005–06
Collage
5 1/8 x 6 1/4 in
(13 x 16 cm)
Courtesy The Dakis Joannou
Collection, Athens

Haris Epaminonda
Untitled 32, 2007
Collage

10 5/8 x 8 1/8 in
(26.9 x 20.7 cm)
Courtesy The Dakis Joannou
Collection, Athens

Haris Epaminonda
Untitled 35, 2007
Collage
9 5/8 x 6 3/8 in (24.6 x 17.1 cm)
Courtesy The Dakis Joannou
Collection, Athens

Haris Epaminonda
Untitled 008c/g, 2007
Collage
6 3/4 x 6 3/4 in (17.2 x 17 cm)
Courtesy Rodeo Gallery,
Istanbul

Haris Epaminonda
Untitled *0010c/g*, 2007
Collage
6 3/4 x 6 3/4 in (17.2 x 17 cm)
Courtesy Rodeo Gallery,
Istanbul

Haris Epaminonda
Untitled 0012c/g, 2007
Collage
6 3/4 x 6 3/4 in (17.2 x 17 cm)
Courtesy Rodeo Gallery,
Istanbul

Haris Epaminonda
Untitled 0014 c/g, 2007
Collage
11 x 8 in (28 x 20.2cm)
Courtesy Rodeo Gallery,
Istanbul

Haris Epaminonda
Untitled 0011c/g, 2007
Collage
6 7/8 x 6 3/4 in (17.5 x 17 cm)
Courtesy Rodeo Gallery,
Istanbul

Patricia Esquivias
"The future was when?," 2009
Video projection
19:47 min
Courtesy the artist and Murray
Guy, New York

Mark Essen
Flywrench, 2008
Video game
Courtesy the artist

Ruth Ewan
*A Jukebox of People Trying to
Change the World*, 2009
Jukebox
60 x 41 x 26 in (152 x 104 x 66 cm)
Courtesy Ancient and Modern,
London

Brendan Fowler
*Poster for Dialog With
The Band AIDS Wolf,*
2009
Silkscreen ink and acrylic on
acid-free paper and frames
25 x 37 in (63.5 x 94 cm) each;
37 x 30 x 74 in
(94 x 76.2 x 188 cm) overall
Collection Jon Miller and
Shirley Marales; Courtesy
Mesler&Hug, Los Angeles

Brendan Fowler
*UNTITLED
(Spring 2007-Fall 2008)*, 2009
Archival inkjet print, enamel,
lightjet photo print, acylic,
and frames
51 x 32 (129.5 x 813 cm)
Collection John Morace and
Tom Kennedy; Courtesy
Mesler&Hug, Los Angeles

Luke Fowler
*What You See Is Where
You're At*, 2001
Video
24:40 min
Courtesy the artist and
The Modern Institute,
Glasgow

LaToya Ruby Frazier
*Me and Mom's Boyfriend
Mr. Art*, 2005,
Gelatin silver print
20 x 24 in (51 x 61 cm)
Courtesy the artist

LaToya Ruby Frazier
Mom and her Boyfriend Mr. Art,
2005
Gelatin silver print
20 x 24 in (51 x 61 cm)
Courtesy the artist

LaToya Ruby Frazier
Gramps on his bed, 2003
Gelatin silver print
20 x 24 in (51 x 61 cm)
Courtesy the artist

LaToya Ruby Frazier
Grandma Ruby's Porcelain Dolls,
2004
Gelatin silver print
20 x 24 in (51 x 61 cm)
Courtesy the artist

LaToya Ruby Frazier .
Mom and Mr. Yerby, 2005
Gelatin silver print
20 x 24 (51 x 61 cm)
Courtesy the artist

LaToya Ruby Frazier
Self-Portrait (October 7th, 9:30am),
2008
Gelatin silver print
24 x 20 (61 x 51 cm)
Courtesy the artist

LaToya Ruby Frazier
Grandma Ruby Smoking Pall Malls,
2002
Gelatin silver print
20 x 24 cm (51 x 61 cm)
Courtesy the artist

Cyprien Gaillard
Desniansky Raion, 2007
Digital video, color, sound
30 min
Courtesy Cosmic Galerie, Paris
and Laura Bartlett Gallery,
London

Ryan Gander
This Consequence, 2005–08
Track suit with embroidered
stains, worn by gallery attendants

Dimensions variable
Courtesy Tanya Bonakdar
Gallery, New York

Liz Glynn
*The 24 Hour Roman
Reconstruction Project, or,
Building Rome in a Day*, 2008–09
24-hour performance and
installation with wood, paper,
cardboard, and other materials
21 x 21 ft (640 x 640 cm)
(approx)

Loris Gréaud
*Nothing Is True Everything Is
Permitted, Stairway Edit*, 2007
(Developed with Vincent Nevot)
Modified motor, modified
stairway, and black mirror
48 x 157 1/2 in (122 x 400 cm)
Fondation Louis Vuitton pour
la Création, Paris

Shilpa Gupta
Untitled, 2006
Photograph printed on Flex
72 x 120 in (183 x 305 cm)

Emre Hüner
Panoptikon, 2005
Animation
11:18 min
Courtesy Rodeo Gallery,
Istanbul

Matt Keegan
1986/2008 New Museum Edit,
2009
Installation including

AMERICAMERICA
(2008) excerpts,
23 Portraits of 22 year-olds (2008),
Barbara Kruger (2008),
and *Hands Almost Across
America* (2008)
Sheetrock, inkjet prints,
23 framed digital chromogenic
prints, HydroCal, latex paint,
and acrylic
Dimensions variable
Courtesy D'Amelio Terras,
New York

Tigran Khachatryan
Nachalo, 2007
Video
12:19 min

Kitty Kraus
Untitled, 2008
Mirrors and light bulbs
Dimensions variable
Courtesy Galerie Neu, Berlin

Adriana Lara
Installation (Banana peel), 2008
Banana peel
Dimensions variable

Adriana Lara
Opening Hours, 2008
504 hours

Adriana Lara
U.A.O. /wa /, 2009
Performance
Duration variable

Elad Lassry
Portrait, Amarant Red, 2008
Chromogenic print
10 x 8 1/2 in (25.4 x 21.6 cm)
Courtesy David Kordansky
Gallery, Los Angeles

Elad Lassry
Felicia, 2008
Chromogenic print
14 x 11 in (35.6 x 27.9 cm)
Courtesy David Kordansky
Gallery, Los Angeles

Elad Lassry
Drinks, Cheese, 2008
Foil on magazine paper
14 1/2 x 10 1/2 in (36.7 x 26.7 cm)
Collection Martin and
Rebecca Eisenberg

Elad Lassry
Untitled (Red Cabbage 1), 2008
Chromogenic print
14.5 x 11.5 in (36.8 x 29.2 cm)
Courtesy David Kordansky
Gallery, Los Angeles

Elad Lassry
Baguette, Croissant, 2008
Chromogenic print
14.5 x 11.5 in (36.8 x 29.2 cm)
Courtesy David Kordansky
Gallery, Los Angeles

Elad Lassry
Wolf (Blue), 2008
Chromogenic print
11 1/2 x 14 1/2 in (29.2 x 36.8 cm)
Collection David Kordansky

Elad Lassry
Untitled (Cheetah), 2008
Chromogenic print
11 1/2 x 14 1/2 in (29.2 x 36.8 cm)
Courtesy David Kordansky
Gallery, Los Angeles

Elad Lassry
Burmese Mother, Kittens, 2008
Chromogenic print
11 1/2 x 14 1/2 in (29.2 x 36.8 cm)
Courtesy David Kordansky
Gallery, Los Angeles

Liu Chuang
Buying Everything On You,
2006/08
Mixed mediums
94 1/2 x 47 1/4 in (240 x 120 cm)
Courtesy the artist

Guthrie Lonergan
Myspace Intro Playlist, 2006
Two-channel video,
color, sound
8 min; 13 min

Tala Madani
Bright Eyes, 2007
Oil on linen
91/2 x 11 7/8 in (24 x 30 cm)
Collection Sara Kier

Tala Madani
Hug, 2008
Oil on canvas
11 3/4 x 11 3/4 in
(29.8 x 29.8 cm)
Collection Marcia Eitelberg

Tala Madani
Lesson Two, 2008
Oil on linen, 14 x 10 in
(35.6 x 25.4 cm)
Courtesy the artist and
Lombard-Freid Projects,
New York

Tala Madani
Original Sin, 2008
Oil on linen
12 x 9 1/2 in (30.5 x 24.1 cm)
Susan D. Goodman
Collection

Tala Madani
Panties, 2008
Oil on wood
15 3/4 x 12 in (40 x 30.5 cm)
Collection Gilbert and
Doreen Bassin

Tala Madani
Hangman Lesson, 2008
Oil on wood
15 3/4 x 15 3/4 in (40 x 40 cm)
Courtesy the artist and
Lombard-Freid Projects,
New York

Tala Madani
Hand Burn on Back, 2006
Oil on canvas
16 x 16 in (40.6 x 40.6 cm)
Courtesy the artist and
Lombard-Freid Projects,
New York

Tala Madani
Cake Silence, 2006

Oil on canvas
12 x 14 in (30.5 x 35.6 cm)
Courtesy the artist and
Lombard-Freid Projects,
New York

Tala Madani
Rip Image, 2006
Oil on canvas
10 x 8 in (25.4 x 20.3 cm)
Courtesy the artist and
Lombard-Freid Projects,
New York

Anna Molska
Tanagram, 2006–07
Digital video, black and white,
sound
5:10 min
Courtesy Foksal Gallery
Foundation, Warsaw

Ciprian Muresan
Choose...., 2005
Video
0:45 min
Courtesy Plan B, Cluj,
and Nicodim Gallery,
Los Angeles

Ciprian Muresan
Stanca, 2006
Video
0:17 min
Courtesy Plan B, Cluj

Ciprian Muresan
Untitled (Shoe Laces), 2006

Video
3 min
Courtesy Nicodim Gallery,
Los Angeles

Ciprian Muresan
Untitled (Garbage Bin), 2007
Video
0:51 min
Courtesy Nicodim Gallery,
Los Angeles

Ahmet Öğüt
Death Kit Train, 2005
Video, color, sound
2:57 min

Ahmet Öğüt
Mutual issues, Invented Acts, 2008
3 chromogenic prints
mounted on aluminium
55 1/8 x 39 3/8 in
(140 x 100 cm) each

Adam Pendleton
Black Dada, 2009
Silkscreen on canvas
96 x 75 in (244 x 191 cm)
Courtesy Haunch of
Courtesy the artist and Haunch
of Venison, New York,

Adam Pendleton
Black Dada, 2009
Silkscreen on canvas
96 x 75 in
(244 x 191 cm)
Courtesy the artist and Haunch
of Venison, New York,

Stephen G. Rhodes
*Interregnum Repetition
Restoration*, 2008
Chair, speakers, electrical
components, fabric, resin,
Presidential Seal carpet, wooden
flagpoles, rubber flagpoles, flags,
green-screen board, and video
9 x 6.5 x 7.5 ft (274 x 198 x 228 cm)
2 min
Private collection; Courtesy
Overduin and Kite,
Los Angeles

Stephen G. Rhodes
Vacant Portraits 35-36, 2008
Oil and collage on canvas
52 3/4 x 48 in
(134 x 122 cm) (diptych)
Private collection

James Richards
Active Negative Programme,
2008
Video installation
with stage, chairs,
standing plasma screen,
and speakers
Dimensions variable

Emily Roysdon
*Four Screens as Dialogue
(pioneering, devotional, familiar,
invasive)*, 2008
Airbrushed mesh, wood frames,
and wheels
10 x 6 ft (305 x 183 cm)
or 10 x 10 ft (305 x 305 cm) (each)

Support provided by Big Image
Systems

Kateřina Šedá
Her Mistress's Everything, 2008
Video, 18:05 min
Courtesy the artist and
Franco Soffiantino Gallery,
Turin

Kateřina Šedá
Copying Mother, 2004
Video documentation of
24-hour social action, 1:08 min
Courtesy the artist and
Franco Soffiantino Gallery,
Turin

Kateřina Šedá
Copying Father, 2004
Video documentation of
24-hour social action, 3:05 min
Courtesy the artist and
Franco Soffiantino Gallery,
Turin

Kateřina Šedá
It Doesn't Matter, 2005–07
160 photocopied drawings
Dimensions variable
Courtesy the artist and
Franco Soffiantino Gallery, Turin

Josh Smith
Untitled, 2008
Collage on 9 panels
60 x 48 in (152.4 x 122 cm) (each)
Courtesy the artist and Luhring
Augustine, New York

Ryan Trecartin
Not Yet Titled, 2009
3-channel video and installation
approx. 45 min
Courtesy the artist and
Elizabeth Dee, New York;
The Fabric Workshop and
Museum, Philadelphia;
Goetz Collection, Munich;
The Moore Space - Craig
Robins, Rosa de la Cruz and
Silvia Cubiña, Miami

Alexander Ugay
Untitled from the "We are from
Texas" series, 2002–05
Artist-printed gelatin
silver prints
19 3/4 x 23 1/2 in (50 x 60 cm)

Tris Vonna-Michell
*No more racing in circles – just pacing
within lines of a rectangle*, 2009
Installation with sound
Dimensions variable
Courtesy the artist

Jakub Julian Ziolkowski
The Great Battle Under the Table,
2006
Oil on canvas
74 3/4 x 65 in (190 x 165 cm)
Zabludowicz Collection

Jakub Julian Ziolkowski
Untitled, 2007
Oil on canvas
15 3/4 x 12 5/8 in (40 x 32 cm)

Collection Dianne Wallace,
New York

Jakub Julian Ziolkowski
Untitled, 2007
Oil on canvas
39 3/8 x 31 7/8 in (100 x 80 cm)
Hort Family Collection,
New York

Jakub Julian Ziolkowski
Untitled, 2007
Oil on canvas
23 5/8 x 27 1/2 in (70 x 60 cm)
Hort Family Collection,
New York

Jakub Julian Ziolkowski
U-Boot Wachoffizier, 2007
Oil on canvas
21 5/8 x 18 1/8 in (55 x 46 cm)
Hort Family Collection,
New York

Jakub Julian Ziolkowski
Untitled, 2007
Oil on canvas
22 1/2 x 18 7/8 in (57 x 48 cm)
Collection Dianne Wallace,
New York

Icaro Zorbar
*Little by Little or Golden
Triangle*, 2006
3 turntables, disc, and
amplifiers
43 x 27 x 17 in
(109.2 x 68.6 x 43.2 cm)
Courtesy the artist

Artist Biographies

AIDS-3D (Daniel Keller and Nik Kosmas)
Daniel Keller Born 1986, Detroit / Lives and works in Berlin
Nik Kosmas Born 1985, Minneapolis / Lives and works in Berlin
Education Städelschule Frankfurt, 2007 / Universitaet der Kuenste Berlin, 2007 / School of the Art Institute of Chicago, 2006
Selected Solo Exhibitions
2008 "Digital Awakening," Kr44, Athens
2007 "Honeybee Population Collapse," Galerie Air Garten, Berlin • "Jerusalem 2012," Program e. V, Berlin
Selected Group Exhibitions
2008 "Athensville," Art Athina, Athens • "Club Internet 1-2," <http://www.clubinternet.org/> • New Life Berlin Festival, Berlin • "Pole Shift," Project Gentili, Berlin • "Rundgang," Städelschule, Frankfurt
2007 "Wild Night," BW, Berlin • "Becks Fusions," Insititute of Contemporary Arts, London • "Ich Weiss Du Kommst Aus Mitte," Kuenstlerhaus Bethanien, Berlin

Ziad Antar
Born 1978, Saida, Lebanon / Lives and works in Saida, Lebanon and Paris
Education American University of Beirut (BA Agricultural Engineering), 2001 / Ecole Supérieure des Etudes Cinematographiques (BA Cinema Studies), 2003
Selected Group Exhibitions

2008 "Filmprogamm 5: Libanon II," Haus der Kulturen der Welt, Berlin / "Lieux de Vie: Mémoire et Phantasme de L'Enracinement," Abbaye St André Centre d'Art Contemporain, Meymac, France / "New Ends, Old Beginnings," Bluecoat Gallery, Liverpool / "Rereading the Future: International Triennial of Contemporary Art," Prague / Taipei Biennial
2007 "White Space: Black Space," Blank Prospective Art Space, Paris
2006 "La Cabane," Palais de Tokyo, Paris
2005 "Mémoires Vives," Le Plattform, Berlin

Cory Arcangel
Born 1978, Buffalo, New York / Lives and works in Brooklyn
Education Oberlin Conservatory, (BA Music), 2000
Awards and Professional Experience
2006 Creative Capital Grant
2005 Jury Prize, New York Underground Film Festival
2002 New Radio and Performing Arts Commission
2001 NYSCA New Media Grant (sponsored by Harvestworks Digital Media)
2000 New Radio and Performing Arts Commission (with funding from the Jerome Foundation)
Selected Solo Exhibitions
2008 Galerie Thaddaeus Ropac, Salzburg, Austria / Team Gallery, New York City
2007–08 Northern Gallery for Contemporary Art, Sunderland, England

2005–06 "Super Mario Movie," collaboration with Paper Rad, Sorry we're closed, Brussels
Selected Group Exhibitions
2008 "Color Chart," Museum of Modern Art, New York City
2007 "Her(his)tory," Museum of Cycladic Art, Athens / "Passion Complex: Selected Works from the Albright-Knox Art Gallery," 21st Century Museum of Contemporary Art, Kanazawa, Japan / "Speed 3," Instituto Valenciano de Arte Moderno, Valencia, Spain / "Sympathy for the Devil: Art and Rock and Roll since 1967," Museum of Contemporary Art, Chicago
2005 "Artbase," New Museum, New York City
2004 "Seeing Double: Emulation in Theory and Practice," Solomon R. Guggenheim Museum, New York City / Whitney Biennial Whitney Museum of American Art, New York City

Museum of Modern Art
2008 "Successive Approximation," Perry Rubenstein Gallery, New York City
2007
"For Sale," Cristina Guerra Contemporary Art, Lisbon
"Words Fail Me," Museum of Contemporary Art, Detroit
2006
"Dream and Trauma: Works from the Dakis Joannou Collection," Kunsthalle and MUMOK, Vienna
"Mafia or One Unopened Packet of Cigarettes," Standard-Oslo, Oslo
"Panic Room," Deste Foundation, Athens, Greece
2004
"The Primary Pleasures of Eating, or Drinking, or Looking, or Sex," Adobe Books, San Francisco

Tauba Auerbach
Born 1981, San Francisco / Lives and works in San Francisco
Education Stanford University, 2003
Awards and Professional Experience
2008 SECA Art Award, San Francisco Museum of Modern Art
2010 Eureka Fellowship (announced 2007)
Selected Solo Exhibitions
2008 "Passengers," Wattis Institute for Contemporary Art, San Francisco / "The Uncertainty Principle," Standard-Oslo, Oslo
2007 "The Answer/Wasn't Here," Jack Hanley Gallery, San Francisco
2006 "Yes and Not Yes," Deitch Projects, New York City
Selected Group Exhibitions
2009 SECA Award Show, San Francisco

Wojciech Bąkowski
Born 1979, Poznań, Poland
Lives and works in Poznań, Poland
Education Academy of Fine Arts, Poznań, 2005
Awards and Professional Experience
2003 First Special Award, Polish-Wide Festival of Author's Animated Movies (OFAFA), Krakow
Selected Solo Exhibitions
2008 "Are you going with me? Where? In dark fuck," Leto Galery, Warsaw
2007 Author's Animated Film Show, NoD, Prague / "Corpses," BIOS Festival, Brzezno, Poland / "Jesus Child," Arsena, Poznan
Selected Group Exhibitions
2007 "International Night of the Child," Art Center Lodz, Poland
2006 "Polish Movies," Centre Culturel de Rencontre Abbaye de Neumunster, Luxembourg

468

Young Polisach Art Show, Uppsala, Sweden
2004 "RAP," IF Museum, Poznan / "Sodomici,"
ON Gallery, Poznan / "Tokyo New York Festival,"
Arsena, Poznan

Dineo Seshee Bopape
Born 1981, Polokwane, South Africa / Lives and
works in Cape Town, South Africa
Education Durban Institute of Technology, 2004
Awards and Professional Experience
2004 Merit Award, Durban Institute of
Technology
Selected Solo Exhibitions
2008 "Love Strung," KZNSA Gallery, Durban
2007 "Non in Mind (Fictions Unending): *Dream
Weaver* and Other Stories," Marthouse Gallery,
Amsterdam
2005 "Keep it to Yourself," KZNSA Gallery,
Durban
Selected Group Exhibitions
2008 "In Transition: Russia 2008," National
Centre of Contemporary Art, Moscow / "ZA,"
Centre for Contemporary Art, Sienna, Italy
2007 "Cape '07," Iziko South African National
Gallery, Cape Town
2006 "De Grote Oversteek," Stedelijk Museum
Zwolle, Netherlands
2005 "Urban Edge," Durban City Hall / "Urban
Twothousandandfive: Five Urban Women's
Stories," African Art Centre, Durban
2004 "Amnesty International International
Women's Day Workshop," Indian Documentation
Centre, Durban
2003 "Samp and Beans," Bean Bag Bohemia,
Durban

Mohamed Bourouissa
Born 1978, Blida, Algeria / Lives and works in
Paris
Education
Ecole Nationale Supérieure des Arts Décoratifs de
Paris, 2006 / La Sorbonne, Paris, 2004
Awards and Professional Experience
2007 First Prize, Rencontres Internationales de la
Photographie, Arles, France
2009 Residency, University of Barcelona
2007 Residency, Galerie Photographique du
Château d'Eau, Toulouse, France
Selected Solo Exhibitions
2009 Finnish Museum of Photography, Helsinki /
French Cultural Center, Rio de Janeiro, Brazil
2008 Galerie Les Filles du Calvaire, Paris / Pauza
Galerie, Cracovie, Poland
Selected Group Exhibitions
2008 "Iconoclastes : Les Territoires de l'Esprit,"
Galerie Anne de Villepoix, Paris / "Portraits et
Paysages du XXIème Siècle," Espace ING, Brussels
2007 "Generation," Les Filles du Calvaire
Gallery, Brussels
2006 Diploma Presentation, La Maison Rouge,
Fondation de Galbert, Paris
Photography Festival, Lianzhou, China
2005 "Antre-entre, Acte I," Galerie Lez'art,
Hermé, France
2004 "Il fait beau plusieurs fois par jours," mobile
theater, Saint-Lunaire, France

Kerstin Brätsch
Born 1976, Hamburg, Germany / Lives and works
in New York City and Berlin
Education Columbia University, New York City,
2007 / University for the Arts, Berlin, 2007 /
University for the Applied Arts and Sciences,

Hamburg, 2001

Awards and Professional Experience

2004–07 Studienstiftung des Deutschen Volkes

2006 Agnes Martin Fellowship Award / "Auslandsförderung," Studienstiftung des Deutschen Volkes

Gamblin Award

2005 Förderpreis für Junge Kunst, Kulturamt Bremerhaven / Fulbright Award / Helmut Thoma Prize

Selected Solo Exhibitions

2009 Balice Hertling, Paris

Selected Group Exhibitions

2008 "Kerstin Brätsch, Tue Greenfort, Jordan Wolfson," Salon 94 Freemans, New York City / "Nothing is exciting. Nothing is sexy. Nothing is not embarrassing.," MUMOK, Vienna

2007 "Eva's Arche und der Feminist," Passerby, New York City / "Exposition No. 1," Galerie Balice Hertling, Paris / "Fractured in Aspect," Andrew Kreps Gallery, New York City

2005 "North Room," Derek Eller Gallery, New York City

2004 "Implosion," Room 500, Münich / "Kastalia," Project Space Holzmarktstrasse, Berlin

Cao Fei

Born 1978, Guangzhou / Lives and works in Beijing

Education Guangzhou Academy of Fine Arts, 2001

Awards and Professional Experience

2005 Beijing Fellowship, German Federal Cultural Foundation (Kulturstiftung des Bundes)

Selected Solo Exhibitions

2008 "RMB City," Lombard-Freid Projects, New York City

2007 "Whose Utopia?," Orange County Museum of Art

2006 "What Are They Doing Here?," Fu Shan Osram Factory, Guangzhou, China

2005 "CosPlayers," Courtyard Gallery, Beijing, China

Selected Group Exhibitions

2008 "Art is for the Spirit: Works from The UBS Art Collection," Mori Art Museum, Tokyo / "Montage: Unmonumental Online," New Museum, New York City

2007 "China Power Station: Part 2," Astrup Fearley Museum of Modern Art, Oslo

2006 New Photographers 2007, Cannes Lions Festival, France

2005 Tirana Biennial, Tirana, Albania / "Unspeakable Happiness," Museo Tamayo Arte Contemporáneo, Mexico City

2003 Biennial of the Moving Image, Geneva, Switzerland

2002 Gwangju Biennial, South Korea

Carolina Caycedo

Born 1978, London / Lives and works in Isabela, Puerto Rico

Education Los Andes University, Bogotá, 1999

Awards and Professional Experience

2006 Residency, Mass MoCA, North Adams, USA

2004 Residency, Fortaleza 303 / M&M Projects, San Juan, Puerto Rico

2002 Cultural Diversity Award, Space Studios and London Arts, London

2001 Arts Council Year of The Artist Residency, Liverpool

Selected Solo Exhibitions

2009 "Exile," Fondazione March, Padova, Italy

2007 "Plante Bandera," Galeria Comercial, San Juan, Puerto Rico
2005 "Break It," Ibid Projects, Vilnius, Lithuania
2003 "Break Dance Season," Espacio La Rebeca, Bogotá
Selected Group Exhibitions
2009 Poligraphic Triennial, San Juan, Puerto Rico
2008 "Same Democracy," Neon Campbase, Bologna, Italy
2007 "Disco Copperston," Locus Projects, Athens
2006 Whitney Biennial, Whitney Museum of American Art, New York City
2005 "Tropical Table Party," Santa Monica Art Centre, Barcelona
2004 "Localismos," Historic Centre Foundation Perros Negros, Mexico City
2003 Caribbean Biennial, Museum of Modern Art, Santo Domingo, Dominican Republic
2002 "Da Ponta Cabeca," I Ceara Biennial, Museo Dragao do Mar, Fortaleza, Brazil

Chu Yun
Born 1977, Jiangxi, China / Lives and works in Shenzhen, China
Education Fine Arts Academy, Sichuan, 1997
Selected Solo Exhibitions
2007 "Smile of the Matter," Vitamin Creative Space, Guangzhou
Selected Group Exhibitions
2008 "Asking for It," Glasgow School of Art / "Our Future: The Guy & Myriam Ullens Founda-tion Collection," UCCA Ullens Center for Con-temporary Art, Beijing / "Sprout from White Nights," Bonniers Konsthall, Stockholm
2007 "Mahjong," Museum der Moderne, Salzburg
2006 International Ink Biennial of Shenzhen, Xiangning Museum of Art, Shenzhen
2005 "Unspeakable Happiness," Museo Tamayo Arte Contemporáneo, Mexico City
2002 Pingyao International Photography Festi-val, Pingyao, China

Keren Cytter
b. 1977, Tel Aviv / Lives and works in Berlin
Education De Ateliers, Amsterdam, 2004 / The Avni Institute, Tel-Aviv, 1999
Awards
2006 Baloise Art Prize, Art Basel, Switzerland
Selected Solo Exhibitions
2008 "Keren Cytter," Stuk Kunstcentrum, Leuven, Belgium
2007 "The Victim," MUMOK, Museum Mod-erner Kunst Stiftung Ludwig, Vienna
2006 "Repulsion," Noga Gallery, Tel Aviv
2004 "My brain is in the wall," Stedelijk Museum Bureau, Amsterdam
Selected Group Exhibitions
2008 "Television Delivers People," Whitney Museum of American Art, New York City
2007 Hertzelia Biennial, Hertzelia, Israel / Moscow Biennial of Contemporary Art
2006 "All Hawaii Entrees / Lunar Reggae," Irish Museum of Modern Art, Dublin
2005 Filmblik Program, Filmhuis, Den Haag, Netherlands
2004 "Videozone," Video Biennale, Tel Aviv
2003 "Good Question," Studiokatendrechtstraat 66, Rotterdam
2001 "Shoes," Left Bank, Tel Aviv

Mariechen Danz
Born 1980, Dublin / Lives and works in Los Angeles
Education California Institute of the Arts, 2008 / University of Fine Arts, Berlin, 2005 / Gerrit Rietveld Academy, Amsterdam, 2003 / University of Fine Arts Berlin, Germany, 2004
Awards and Professional Experience
2008 Interdisciplinary Grant, California Institute of the Arts
2002–05 Cusanuswerk Scholarship for Art, Bonn, Germany
2004–06 Cill Rialaig Art Residency, County Kerry, IrelandSelected Solo Exhibitions and Performances
2008 *Fossilizing the Body Border Disorder: A Diorama*, performance, California Institute of the Arts
Mapping the Subaltern: A Subjective Geography, performance with Alvaro Guillen, Wight Biennial, New Wight Gallery, Broad Art Center, Los Angeles
2007 *Gospel of Bully*, performance, Kasselerkunstvereinsheim, Kassel, Germany
2005 *Heartattack*, performance, Areal 28 Projects, Berlin
Selected Group Exhibitions
2008 "Group Effort," Wight Biennial, New Wight Gallery, Broad Art Center, Los Angeles
2007 "Twelve Artists from Germany," Dangerous Curve Gallery, Los Angeles
2006 "Lieber Friedrich," Kasseler Kunstverein, Kassel, Germany
2005 "Muse Heute," Kunsthalle Bremen, Bremen, Germany
2003 "Peepshow," Gallery Arti et Amicatae, Amsterdam

2002 "Trilemma," Kunstverein, Potsdam, Germany
2001 "Zwischen Tür und Angel," Zionskirche Berlin
2000 "Projekt M," Kunsthaus Strodehne, Brandenburg, Germany

Faye Driscoll
Born 1976, Venice, CA / Lives and works in Brooklyn
Education
Tisch School for the Arts, New York University, 1997 / Los Angles County High School for the Arts, 1993
Awards and Professional Experience
2009 Djerassi Residency Program, Woodside, California
2008 The Greenwall Foundation Grant
HERE Artist Residency Program
2007 Artist-in-Residence, BAX/Brooklyn Arts Exchange
Selected Performances
2008 *837 Venice BLVD*, HERE Arts Center, New York City
2007 *Wow Mom, Wow*, Dance New Amsterdam, New York City and the Michigan Womyn's Festival, Walhalla / *You Should Dance To Music*, Catch Performance Series, Galapagos, Brooklyn
2006 *Bite Your Lip*, BAX/Brooklyn Arts Exchange, New York City / *Eyes, Eyes, Eyes*, Hotfest of Queer Performance, Dixon Place, New York City
2005 *Cold Blooded Old Time*, ODC Theater, San Francisco / *Maybe You Could, The Marsh Theater*, San Francisco / *Yeah You Are, Dancenow Festival*, Joe's Pub, New York City

Ida Ekblad
Born 1980, Oslo / Lives and works in Oslo
Education Mountain School of Art, Los Angeles,
2008 / The National Academy of Art, Oslo, 2007
Selected Solo Exhibitions
2008 Fotogalleriet, Oslo
Selected Group Exhibitions
2008 "Lights On," Astrup Fearnley Museum of
Art, Oslo
2007 "The Moon is a Harsh Mistress," The
Green Gallery, Milwaukee / "Tower," W 139,
Amsterdam
2006 "The Copy and Paste Show,"
Rhizome/New Museum, New York City / "Giving
People What They Want," Glassbox, Paris

Haris Epaminonda
Born 1980 Nicosia, Cyprus / Lives and works in
Berlin
Education Royal College of Art, London, 2003 /
Kingston University, London, 2001
Awards and Professional Experience
2007–08 Residency, Kuenstlerhaus Bethanien,
Berlin (sponsored by UNDO Foundation, Cyprus)
2005 Residency, Can Serrat, El Bruc, Barcelona
2003 The William Latham Award
2002 The Linklaters Award
2002 Residencey, Cite Internationale Des Arts,
Paris
2000 Residency and Exchange Programme,
Hongik University, Seoul
Selected Solo Exhibitions
2008 "Haris Epaminonda," Künstlerhaus
Bethanien, Berlin / "Tarahi IIII, V, VI," Circus,
Berlin
2007 "Present Future," Artissima 14 solo state-
ments with Domobaal Gallery, Turin

2006 "Haris Epaminonda," Domobaal Gallery,
London
Selected Group Exhibitions
2008 Berlin Biennial / "Tank TV," Tate Mod-
ern, London
2007 "Balance," 1/9 Unosunove Gallery, Rome
2006 "Fresh," Macao Museum of Art, China
2005 "No Man's Land," Palace Heights, Dublin
2004 "Fraicheur de Vivre," Apeejay Media
Gallery, New Delhi
2003 10th RCA Secret Show, Royal College of
Art, London
2002 "Haris, Chris, Daniel," Cite Internationale
des Arts, Paris

Patricia Esquivias
Born 1979, Caracas / Lives and works in Guadala-
jara
Education California College of the Arts, 2007 /
Skowhegan School of Painting and Sculpture,
2006 / Central Saint Martins College of Art and
Design, Bachelor in Arts, 2001
Awards and Professional Experience
2007 Artissima Present Future Illy Award /
Barclay Simpson Award / East Award / EAST
International Fellowship
2006 Skowhegan School of Painting and Sculp-
ture Fellowship / Fulbright Scholarship / Merit
Scholarship, California College of the Arts
2005 Mexican Government Grant and Residency
at O.P.A. Guadalajara
2004 Workshop with Mireya Masó, Murcia,
Spain
Selected Solo Exhibitions
2008 "Folklore," Murray Guy, New York City
2007 "Reads like the Paper," Maisterravalbuena
Galería, Madrid

2006 "Folklore," DF Arte Contemporanea, Santiago de Compostela

2003 "Fútbol de Papel," Ler Devagar, Lisbon

Selected Group Exhibitions

2008 Berlin Biennial of Contemporary Art
"Of this tale I cannot guarantee a single word," Royal College of Art, London
"Self Storage," California College of the Arts, San Francisco

2007 EAST International, Norwich, England / "Pensée Sauvage: On Human Freedom," Frankfurter Kunstverein, Frankfurt

2006 Certamen Internacional Artes Plásticas Pollença, Pollença, Mallorca

2005 "Air Container," Museo Raúl Anguiano, Guadalajara, México

Mark Essen

Born 1986, Los Angeles / Lives and works in Brooklyn

Education Bard College, Annandale-on-Hudson, 2008

Awards

2007 Sidney Peterson Award for Experimental Cinema, Staatliche Hochschule für Gestaltung Karlsruhe, Germany

Selected Solo Exhibitions

2008 Light Industry, New York City

Selected Group Exhibitions

2008 Death by Audio, New York City / F.I.L.E., São Paulo, Brazil / The Silent Barn, New York City

Ruth Ewan

Born 1980, Aberdeen, Scotland / Lives and works in London

Education Edinburgh College of Art, 2002

Awards and Professional Experience

2008 Cocheme Fellowship, Byam Shaw School of Art, London

2006 EAST International Award

2002 Andrew Grant Bequest Travel Scholarship / The Loomshop Gallery Award

Selected Solo Exhibitions

2007 "Did you kiss the foot that kicked you?," Artangel, London / "Ours is the World Despite All," Northern Gallery for Contemporary Art, Sunderland

2006 "Psittaciformes Trying to Change the World," Studio Voltaire, London

2005 "Voluntary Commemoration," Royal Infirmary, Edinburgh, 2003

Selected Group Exhibitions

2007 "Germinal," Ancient and Modern, London / Pilot 3, Bevilacqua Foundation, Venice

2006 EAST International, Norwich Gallery, Norwich

2005 "Grate Britain," Cell Project Space, London

2004 "The Birthday Party," Collective Gallery, Edinburgh / "The Medium is Tedium," Collective Gallery, Edinburgh

2003 "Flix," Rubicon Gallery, Dublin

Brendan Fowler

Born 1978, Berkeley, USA / Lives and works in Los Angeles

Education Sarah Lawrence College, 2002

Selected Solo Exhibitions

2008 "Last Disaster/first BARR," Rivington Arms, New York City / "Untitled," 2nd Cannons, Los Angeles

Group Exhibitions

2008 "History Keeps Me Awake at Night: A

Genealogy of Wojnarowicz," P.P.O.W. Gallery, New York City

2006 "Kamp 48," John Connelly Presents, New York City / "This Talk We Have, This Talk We Had, This Talk We Have/Have Had," David Kordansky Gallery, Los Angeles

2004 "Majority Whip," White Box, New York City

2002 "Session The Bowl," Deitch Projects, New York City

2001 "Sunshine," Alleged Gallery, New York City

Selected Performances

2007 The Kitchen, New York City / John Connelly Presents, New York City

2005 REDCAT, Los Angeles (with Georganne Deen) / "Beautiful Losers," Orange County Museum Of Art

Luke Fowler

Born 1978, Glasgow / Currently lives and works in Glasgow

Education Duncan of Jordanstone College of Art, Dundee, 2000

Awards and Professional Experience

2008 Residency, Gierson Archive, Stirling

2006–07 Residency, Internationales Künstlerhaus Villa Concordia, Bamberg, Germany

2005 Residency, Kenchington/Gilbert Scott, Balfron, Scotland

2008 Derek Jarman Award

2004 Donald Dewar Prize

2002 NIFCA, Helsinki

Selected Solo Exhibitions

2008 Kunsthalle Zurich

2006 "Pilgrimage From Scattered Points," The Modern Institute, Toby Webster Ltd., Glasgow

2004 "Fowler/Koper," Supportico Lopez, Naples

2001 "UTO: The Technology of Tears," Casco Project Space, Utrecht, the Netherlands

Selected Group Exhibitions

2008 "The Rooms," Tate Modern, London

2007 "Fantastic Politics: Art in Times of Political Crisis," Museum of Contemporary Art, Oslo / "Twilight Adventures in Music," Whitechapel Art Gallery, London / "Whenever It Starts It Is The Right Time," Frankfurter Kunstverein, Frankfurt

2006 "Normalisering," Rooseum Centre for Contemporary Art, Malmö / Tate Triennial, Tate Britain, London

2003 "It doesn't matter what you know because this is real life," Gavin Brown's enterprise, New York City

LaToya Ruby Frazier

Born 1982, Pittsburgh / Lives and works in New Brunswick, NJ

Education Syracuse University, 2007 / Edinboro University of Pennsylvania, 2004

Awards and Professional Experience

2008 Residency, Center for Photography at Woodstock

2007 Skowhegan School of Painting and Sculpture Fellowship / Master's Prize Award, School of Visual Performing Arts, Syracuse / Art Start Art-in-Education Partnership Grant, Syracuse / Skowhegan School of Painting and Sculpture Residence

2006 Geraldine Dodge Fellowship Award, College Art Association, New York City

Selected Solo Exhibitions

2006 "The Notions of Family," Community Folk Art Center, Syracuse, NY

2002 "Their Struggle Without A Home," Edinboro University, Bates Gallery, Edinboro, PA

2001 "Expressions of Saint Clair," Edinboro
University, Bates Gallery, Edinboro PA
Selected Group Exhibitions
2008 "Dark Milk," Milk Contemporary, Copen-
hagen Denmark / Invitational Exhibition of
Contemporary Art, National Academy, New York
City / "Educating Artists Photography in Review,"
Light Work, Syracuse, NY / "En Foco New Works,"
10 Longwood Art Gallery, Bronx / 2007 "Keeping
Up With the Joneses," Schroeder Romero, New
York City / Language Arts Exhibition, Delavan
Art Gallery, Syracuse, NY / Syracuse University
MFA 2007, SU Galleries, Syracuse, NY
2006 Converge SPAS Gallery, RIT, Rochester,
NY / Everson Biennial, Everson Museum, Syra-
cuse, NY / Joyce Elaine Grant Photography
Exhibition, Texas Women's University, Denton,
TX / Queer Eye Harbor Gallery, University of
Massachusetts, Boston, MA
2005 "Breaking the Ice" Hartell Gallery, Cornell
University, Ithaca, NY / "Emerging Artists Light
Work," Syracuse, NY / "Made in New York,"
Schweinfurth Memorial Art Center, Auburn, NY /
SPE Regional Conference Exhibition, Cornell
University, Ithaca, NY / Visual Studies Workshop,
Rochester, NY
2004 Spark Open Spark Contemporary Gallery
Space, Syracuse, NY
2003 October Evenings Meadville Council for
the Arts, Meadville, PA / Photography Club
Exhibition Edinboro University, Bates Gallery,
Edinboro, PA / Women's Art Exhibition, Edinboro
University Center, Edinboro, PA
2002 Ellesworth Art Festival, Shady Side Arts
Festival, Pittsburgh PA / Erie Art Museum Annual
Spring Erie, PA

Cyprien Gaillard
Born 1980, Paris / Lives and works in Paris
Education L'Ecole Cantonale d'Art de Lausanne,
2005
Selected Solo Exhibitions
2008 "Glasgow 2014," Museum Fridericianum,
Kassel
2007 "Homes & Graves & Gardens," Centre
d'art et du Paysage de l'Ile de Vassivière, Vas-
sivière, France
2006 "The Lake Arches," Laura Bartlett Gallery,
London
2005 "One Shot By...Nuke," Galerie Nuke, Paris
Selected Group Exhibitions
2008 Berlin Biennial / "Painting the Glass
House: Artists Revisit Modern Architecture," The
Aldrich Museum of Contemporary Art, Ridgefield,
Connecticut
2007 Athens Biennial / Lyon Biennial / "The
Collection One," Museum Boijmans van Beunin-
gen, Rotterdam
2006 "Getting Along," Island 6 Art Center,
Shanghai / "L'Usage du Monde,
" Musée d'art Moderne et Contemporain, Rijeka,
Croatia
2004 "Nuke," Anciennes Usines Sprint Court,
Paris
2003 "Moph," Parko, Tokyo

Ryan Gander
Born 1976, Chester, England / Lives and works in
London
Education Rijksakedemie van Beeldende
Kunsten, Amsterdam, 2002 / Jan van Eyck
Akademie, Maastricht, 2000 / Manchester
Metropolitan University, Manchester, 1999
Awards

2007 Dena Foundation Award

2006 ABN AMRO Art Award

2005 Baloise Art Statements Prize, Art Basel

2004 Cocheme Fellowship, Byam Shaw School of Art, London

2003 Prix de Rome for Sculpture

2002 Fellow of Arts Council England

Selected Solo Exhibitions

2009 Boijmans Museum, Rotterdam

2008 STORE Gallery, London

2007 "Short cut through the trees," MUMOK, Vienna

2006 Massimo De Carlo, Milan

Selected Group Exhibitions

2008 "AWOL: Bienniale of Young Artists," META Cultural Foundation, Bucharest / "Life on Mars: 55th Carnegie International," Carnegie Museum of Art, Pittsburgh

2007 "For Sale," Cristina Guerra Contemporary Art, Lisbon

2006 "Objet a Part," Centre d'Art Contemporain, Noisy le Sec, France

2005 "T1 Triennial," Castello di Rivoli Museo d'Arte Contemporanea, Turin

2004 "Loose Associations," Foksal Gallery, Warsaw

2003
"Catch Me," Onufri, National Gallery of Albania

Liz Glynn

Born 1981, Boston / Lives and works in Los Angeles

Education California Institute of the Arts, 2008 / Harvard College, 2003

Awards and Professional Experience

2007 Joan Mitchell Foundation Associate Artist Fellowship

2006 Vermont Studio Center Residency

2004 Alfred Alcalay Prize

Selected Solo and Collaborative Exhibitions and Performances

2008 *The 24 Hour Roman Reconstruction Project*, performance, Machine Project, Los Angeles / "Pick Up the Pieces," California Institute of the Arts

2006 "Liz Glynn: r.r.r.," Center for Integrated Media, Valencia

Selected Group Exhibitions

2008 "The Graduation," Union Station, Los Angeles

2007 "Bodily Function," Stevenson Blanche Gallery, Valencia / "Late Night Snack," Beta Level, Los Angeles

2006 "Flex Your Textiles," John Connolly Presents, New York City / "Summer Thunder," Art Gotham, New York City

2005 "ARTSHOW," 486 Broadway, New York City / "VoxEnnial," Vox Populi, Philadelphia

2003 "what have we done," Carpenter Center for the Visual Arts, Cambridge

Loris Gréaud

Born 1979, Eaubonne, France / Lives and works in Paris and Ho Chi Minh City

Education Beaux-Arts de Cergy, National School of Art, France, 2002

Award Ricard Award, Espace Paul Ricard, Paris, 2005

Selected Solo Exhibitions

2009 Yvon Lambert, New York City

2008 "Cellar Door," Palais de Tokyo, Paris

2006 Institute of Contemporary Arts, London

Selected Group Exhibitions

2007 Moscow Biennial / "Ruins / Emotional Landscapes," Safn Museum, Reykjavik

2006 "Hysteria Siberiana," Galerie Cristina Guerra, Lisbonne / "Repeat Redux," Whitney Museum of American Art, New York City
2005 "Off Shore," Espace Paul Ricard, Paris and Capc Musée de l'Art Contemporain, Bordeaux "Yoko Ono's Water Event," Astrup Fearnley Museum of Modern Art, Oslo
2004 "Inhabituel," Dena Foundation, Centre Culturel Français, Milan
2003 "Meanwhile in the Real World," Chapelle de la Sorbonne, Paris

Shilpa Gupta
Born 1976, Mumbai / Lives and works in Mumbai
Education Sir J. J. School of Fine Arts, Mumbai, 1997
Awards and Professional Experience
2004 Artist of the Year, South Asian Visual Artists Collective / Canada Transmediale Award / Berlin Sanskriti Prathisthan Award, New Delhi International
Selected Solo Exhibitions
2007 "Recent Works," Apeejay Media Gallery, New Delhi / "Recent Works," Sakshi Gallery, Mumbai
2006 "Recent Works," Bose Pacia Gallery, New York City
2005 "Recent Works," Provisions Library, Resource Center for Activism and Arts, Washington, D.C.
2003 "Blessed Bandwidth.net," Web art commission, Tate Online
Selected Group Exhibitions
2007 "Edge of Desire," National Gallery of Modern Art, Mumbai, and National Gallery of Modern Art, Delhi / "Politics of Fear," Albion Gallery, London / "Private/Corporate IV," Daimler

Chrysler Contemporary, Berlin
2006 Liverpool Biennial
2005 Fukuoka Asian Art Triennale, Fukuoka Asian Art Museum, Fukuoka City
2004 "I love my India," Total Museum, Seoul
2003 "Body City," The House of World Cultures, Berlin / Biennial of Moving Images, Centre Pour l'Image Contemoraine, Geneva

Emre Hüner
Born 1977 Istanbul, Turkey / Lives and works in Istanbul
Education Brera Academy of Fine Arts, Milan, 2004
Selected Group Exhibitions
2008 "Home Works IV: A Forum on Cultural Practices," Ashkal Alwan, Beirut / "NèoFutur: Pour des Nouveaux Imaginaires," Les Abattoirs, Musée d'Art Moderne et Contemporain, Toulouse / "Sammeln und Orden in der Gegenwartskunst," Kunstmuseum Solothurn, Solothurn, Switzerland
2007 Istanbul Biennial
2005 "Apart," 1.60, Tirana, Albania
2003 "Emre Huner, Jonatah Manno, Isacco Vasapollo," Placentia Arte, Piacenza, Italy

Matt Keegan
Born 1976, Manhasset, New York / Lives and works in New York City
Education Columbia University, New York City, 2004 / Skowhegan School of Painting and Sculpture, Maine, 2001 / Carnegie Mellon University, Pittsburgh at Auckland Institute of Technology, New Zealand, 1998
Awards and Professional Experience
2005 Rema Hort Mann Grant
2003 Agnes Martin Sculpture Fellowship

1999 Artists Space Independent Projects Grant
1998 Andrew Carnegie Scholar, Carnegie
Mellon University
Selected Solo Exhibitions
2008 "Now's the Time," Anna Helwing Gallery,
Los Angeles
2007 "Any Day Now," D'Amelio Terras, New
York City
Selected Group Exhibitions
2008 "Imaginary Thing," Aspen Art Museum /
"Pawnshop," organized by e-flux, New York City,
for Museum Boijmans Van Beuningen Rotterdam
2007 "Alabama" (collaboration with Leslie
Hewitt), Office Baroque Gallery, Antwerp /
"Elastic Paintings and Transparent Partition,"
Forde, L'Usine, Geneva / "M R A I T C T H A A N
M D Y," Mandrake, Los Angeles
2006 "Supports," Roger Bjorkholmen Galleri,
Stockholm
2005 "Shape Shifters," China Art Objects, Los
Angeles
2004 "Hung, Drawn, and Quartered," Team
Gallery, New York City

Tigran Khachatryan
Born 1980, Yerevan, Armenia / Lives and works in
Yerevan
Education Yerevan Academy of Arts, Yerevan,
Armenia, 2004
Awards and Professional Experience
2007 Residence Arts Visuels, "Saison est oust ,"
Die, France
Selected Solo Exhibitions
2003 "Instinct to Create," ACCEA, Yerevan
Selected Group Exhibitions
2008 "Diagnosis/Interdiagnosis," Union of
Artists, Yerevan

2007 "Armenie contemporaine: une actualite de
l'art video," Lyon Museum of Contemporary Art /
"STILL HERE: Humour in Post-Communist
Performance Video," ARTSPACE, Sydney
2006 "Armenian international style" Akanat art
gallery, Yerevan,
2001 Venice Biennale

Kitty Kraus
Born 1976, Heidelberg, Germany / Lives and
works in Berlin
Education Universität der Künste, Berlin, 2006
Awards and Professional Experience
2008 Blauorange Art Prize
Selected Solo Exhibitions
2008 Kunsthalle Zürich, Zurich
2007 Gabriele Senn, Vienna
2006 Galerie Neu, Berlin
Selected Group Exhibitions
2008 "Fais en sorte que je puisse te
parler/Mache, dass ich zu dir sprechen kann/Act so
that I can speak to you," Kamm, Berlin / "The Skat
Players," Vilma Gold, London / "Une Saison à
Bruxelles," Dépendance, Brussels
2007 "Filaturen," Sies + Höke Galerie, Düssel-
dorf / "Kitty Kraus, Jonas Lipps, Blinky Palermo,"
Allsopp Contemporary, London
2006 "Optik Schröder: Werke aus der Sammlung
Schröder," Kunsthalle Braunschweig and Gavin
Brown's enterprise, New York City

Adriana Lara
Born 1978, Mexico City / Lives and works in
Mexico City
Education
Koninklijk Academie Van Beldende Kunsten, The
Hague, 2001 / Escuela Activa de Fotografía,

479

Mexico City, 2002
Awards and Professional Experience
2007 Apoyo para Publicaciones, Fundación Colección Jumex
2004–05 Jovenes Creadores, FONCA, México
Selected Solo Exhibitions
2008 "Cosas/Things," GaGa (House of/Casa de), Mexico City
2007 "380 ," Galeria Comercial, San Juan, Puerto Rico"A problem has occurred," Air de Paris, Paris
Selected Group Exhibitions
2008 "Galeria Sentimental," Tensta Konstall, Stockholm / "This is not a Void," Galeria Luisa Strina, São Paulo
2007 "Pawn Shop," e-flux, New York City / "The Space Between," Drorit Gur-Arie, Petach-Tikva Museum, Israel
2006 "La mamain et la Putain," Eva Svennung, Galería Air de Paris, Paris / "Looking to something to look at," Frederick Janka, Mambo Jambo Gallery, New York City
2005 "Creación en Movimiento," FONCA, Morelia and Mexico City2003 / "GNS," Palais de Tokyo, Paris

Elad Lassry
Born 1977, Tel Aviv / Lives and works in Los Angeles
Education University of Southern California, Los Angeles, 2007 / California Institute of the Arts, Valencia, 2003
Awards and Professional Experience
2007 John Jones Prize, London
Selected Solo and Two-Person Exhibitions
2009 Whitney Museum of American Art, New York City
2008 "The Artist Moving Image Exhibition,"

Bath, England
2007 "She Takes These Pictures of His Wife Silhouetted on a Hillside," Cherry and Martin, Los Angeles
Selected Group Exhibitions
2008 California Biennial, Orange County Museum of Art, Newport Beach, CA / John Connelly Presents, New York City / Museum of Contemporary Art, St. Louis / "Past Forward," 176, London
2007 "I am Eyebeam," Gallery 400, University of Illinois at Chicago
2006 "LA25," Skadden, Los Angeles
2005 "Defense: Body and Nobody in Self Protection," Sweeney Art Gallery, UC Riverside, CA
2002 "You'll Be My Footage," Wedge Gallery, Los Angeles

Liu Chuang
Born 1978, Hubei, China / Lives and works in Beijing
Education Hubei Institute of Fine Arts, 2001
Selected Group Exhibitions
2008 "Forever Young," Anne+ Art Project, Paris / "Homesickness," T Space, Beijing / "Insomnia," BizArt Art Center, Shanghai / "Poznan Mediations International Biennale of Contemporary Art," Poznan, Poland / "Terminus," para/site art space, Hong Kong / "There Is No Story To Tell," Tangren Gallery, Beijing
2007 "China Power Station: Part 2," Astrup Fearnley Museum of Modern Art, Oslo / "Slash Fiction," Gasworks, London

Guthrie Lonergan
Born 1984, Los Angeles / Lives and works in

Hollywood
Education University of California, Los Angeles,
2006
Selected Group Exhibitions
2008 "Montage: Unmonumental Online," New
Museum, New York City / "Netmares/Netdreams,"
Current Gallery, Baltimore / "Reset/Play," Art-
house, Austin / "The New Normal," Artists Space,
New York City, and Huarte Centro de Arte
Contemporáneo, Huarte, Spain / "The Program,"
Dallas Video Festival
2007 "nothin' special," Version Festival, Chicago
/ "Our Distance From Things," Telic Arts Ex-
change, Los Angeles / "Show 12" (with Kevin
Bewersdorf), And/Or Gallery, Dallas

Tala Madani
Born 1981 in Tehran, Iran / Lives and works in
Amsterdam, the Netherlands
Education Yale University School of Art, 2006 /
Oregon State University, 2004
Awards and Professional Experience
2007 Kees Verwey Fellowship / Residency at
The Rijksakademie van Beeldende Kunsten,
Amsterdam
2006 Visual Arts Fellowships at The Fine Arts
Work Center, Provincetown, MA
2005 Schickle-Collingwood Prize, Yale University
2003 Oregon State University President's Award
for Excellence in Art
Selected Solo Exhibitions
2008 "ASS·AS·SIN: hashish anyone?" Lombard-
Freid Projects, New York City
2007 "Smoke and Mirrors," Lombard-Freid
Projects, New York City
Selected Group Exhibitions
2008 "Works on Paper," La Maison Jaune,

Patricia Low Contemporary, Gstaad,
Switzerland
2007 "Size Matters: XS: Recent Small-Scale
Paintings," Hudson Valley Center for Contempo-
rary Art, Peekskill, NY

Anna Molska
Born 1983, Prudnik, Poland / Lives and works in
Warsaw
Education Academy of Fine Arts Warsaw, 2003 /
Staatliche Akademie der Bildenden Künste,
Stuttgart, Germany, 2004
Awards and Professional Experience
2008 Eastern European Residency Exchange,
Art in General, New York City
2004 Erasmus-Sokrates Scholarship, Staatliche
Akademie der Bildenden Künste
Selected Solo Exhibitions
2006 "Cross-eyed Perspective," Ursula Walbroel
Gallery, Düsseldorf, Germany
Selected Group Exhibitions
2008 Berlin Biennial / "New Films from Poland,"
New Museum, New York City / "Paso Doble,"
Split, Croatia / "Photography," BWA Zielona Gora,
Poland
2007 "Biopower," c2c Gallery, Prague / "Samsung
Art Master 4," Center for Contemporary Art,
Ujazdowski Castle, Transvizuala, Gdynia, Poland

Ciprian Muresan
Born 1977, Cluj, Romania / Lives and works in
Cluj
Education
University of Art and Design, Cluj-Napoca
Romania, 2000
Awards and Professional Experience
Co-editor of VERSION, an artist-run magazine,

<www.versionmagazine.com> / Editor of *IDEA art
+ society* magazine, <www.ideamagazine.ro>
Selected Solo Exhibitions
2007 "Expulsion from Paradise," Raster Gallery,
Warsaw / "I Believe I Can Fall," Kontainer Gallery,
Los Angeles
Selected Group Exhibitions
2008 "Days Become Nights" (with Adrian
Ghenie and Serban Savu), Galerie Hussenot, Paris
/ "Signals: A Video Showcase–Mash Up," Orange
County Museum of Art, Newport Beach, CA
2007 "Across the Trees," David Nolan Gallery,
New York City
2006 "Cluj Connection," Haunch of Venison,
Zurich / "Czeslaw Milosz 'To Allen Ginsberg,'"
Dvir Gallery, Tel Aviv
2004 The Young Artists' Biennial, Bucharest,
Romania

Ahmet Öğüt
Born 1981, Diyarbakir, Turkey
Lives and works in the Netherlands and Turkey
Education Yildiz Teknik University, Istanbul,
2006 Hacettepe University, Ankara, 2003
Awards and Professional Experience
Residency, The Rijksakademie van beeldende
kunsten, Amsterdam, 2007–08 / IAAB, Basel, 2005
Selected Solo Exhibitions
2007 "Softly But Firmly," Galenja Miroslav
Kraljevic, Zagreb, Croatia
2006 "Ahmet Öğüt and Borga Kanturk," Platform
Garanti Contemporary Art Center, Istanbul /
"Light Armoured," YAMA, Istanbul
2005 "Ahmet Öğüt," Mala Galerija / Museum of
Modern Art, Ljubljana, Slovenia
Selected Group Exhibitions
2008 "Car Culture," Scottsdale Museum of

Contemporary Art
2007 "Pensa-Piensa-Thing," Centre d'Art Santa
Monica, Barcelona / "Petroliana," Moscow Museum
of Modern Art at Petrovka
2006 "Normalization," Rooseum Center for
Contemporary Art, Malmo, Sweden
2005 "This May Be What Parallel Play Looks
Like," Sculpture Center, New York City
2004 Yugoslav Biennial of Young Artists
2003 "I am too sad to kill you!," Istanbul Con-
temporary Art Museum
2002 "The Pavement: Under the Beach,"
Istanbul Contemporary Art Museum

Adam Pendleton
Born 1980, Richmond, VA / Lives and works in
New York City
Education Artspace Independent Study Program,
Pietrasanta, Italy, 2000
Awards and Professional Experience
2008 Residency, Studio Museum in Harlem,
New York City / Residency, Isabella Stewart
Gardner Museum, Boston
Selected Solo Exhibitions
2009 "Black Dada," Haunch of Venison, Berlin
2008 Indianapolis Museum of Contemporary Art
2007 "Rendered in Black and Rendered," Rhona
Hoffman Gallery, Chicago
2005 "History, Part 1," Roberts and Tilton, Los
Angeles
Selected Group Exhibitions
2008 "After 1968," High Museum of Art, Atlanta
/ "Freeway Balconies," Deutsche Guggenheim,
Berlin / "Object, The Undeniable Success of
Operations," Stedelijk Museum Bureau Amsterdam
2007 "Resistance Is," Whitney Museum of
American Art, New York City / "Sympathy for the

Devil: Art and Rock and Roll," Museum of Contemporary Art, Chicago
2006 "Message Personal," Yvon Lambert, Paris
2004 "Seven (More Things We Like)," Conner Contemporary Art, Washington, D.C.

Stephen G. Rhodes
Born 1977, Houston, TX / Lives and works in Los Angeles
Education Art Center College of Design, Pasadena, 2005 / Bard College, Annandale-on-Hudson, 1999
Selected Solo Exhibitions
2007 "Recurrency," Guild & Greyshkul, New York City / "Ruined Dualisms," Overduin and Kite, Los Angeles
Selected Group Exhibitions
2008 "KABUL 3000 Love Among the Cabbages," Zero, Milan / "Nobody Puts Baby in a Corner," Isabella Bortolozzi, Berlin / "Shape of Things to Come: New Sculpture," Saatchi Gallery, London
2007 "Between Two Deaths," ZKM Center for the Arts and Media, Karlsruhe, Germany / "Post Rose," Galerie Christian Nagel, Berlin / "USA Today," The State Hermitage Museum, St. Petersburg
2006 "Dualism 2," ArtRock, Rockefeller Center, New York City
2005 "LA Weekly Biennial," Track 16, Los Angeles

James Richards
Born 1983, Cardiff, Wales / Lives and works in London
Education LUX Associate Artists Program, 2008 / Chelsea School of Art and Design, 2006
Awards and Professional Experience
2007 Residency at no.w.here lab, London

Selected Solo Exhibitions
2008 "Nought To Sixty," Institute of Contemporary Arts, London
Selected Group Exhibitions
2008 "Against Nature," Vegas Gallery, London
2007 "Invisible Mend," Lounge Gallery, London / "Love Me or I'll Kill You," Norwegische Britsche Freundschaft, Berlin
2006 "Between the Sheets," Proud Gallery, London / "Incidents," Mathew Bown Gallery, London
"Paradise," Tactile Bosch Studios, Cardiff / "The Tactile Bosch Artists Collective," Biennale Fringe Program, São Paulo, Brazil
2005 "Coagulation," Tactile Bosch Studios, Cardiff

Emily Roysdon
Born 1977, Easton, MD / Lives and works in New York City
Education University of California Los Angeles, 2006 / Whitney Independent Study Program, New York City, 2001 / Hampshire College, Amherst, 1999
Awards and Professional Experience
2008 Lower Manhattan Cultural Council, Swing Space / Residency, International Artists Studio Program, Stockholm
2006 Hoyt Award, Department of Art, UCLA / Residency and Visiting Scholar, New York University
2005 Emerging Artist Book Grant, Printed Matter Inc., New York City / Residency, Printed Matter Inc., New York City
Selected Group Exhibitions
2008 "History Keeps Me Awake at Night," P.P.O.W., New York City / "The Way That We

Rhyme," Yerba Buena Center for the Arts, San
Francisco
2007 "Act Out," Studio Voltaire, London / "Exile
of the Imaginary: Politics/Aesthetics/Love,"
Generali Foundation, Vienna
2006 "Bunker or no Bunker: Por una Profiláxis
del Sujeto," Galeria Ramis Barquet, Monterrey,
Mexico / "Eat the Market," Los Angeles County
Museum of Art, Los Angeles / "From Mini-FM to
Hacktivists," Govett-Brewster Art Gallery, New
Plymouth, New Zealand
2005 "Can I Get a Witness," Longwood Arts
Project, Bronx Museum of Art

Kateřina Šedá
Born 1977, Brno, Czech Republic / Lives and
works in Brno and Prague
Education Academy of Fine Arts, Prague, 2005 /
Secondary School of Applied Arts, Brno, 1999
Awards and Professional Experience
2005 Essl Award (Main Prize) / Jindřich Chalu-
pecký Award
2004 Tranzit Award
2003 AVU (Academy of Fine Arts) Studio Award
2002 AVU (Academy of Fine Arts) Studio Award
Selected Solo Exhibitions
2008 "It Doesn't Matter," Renaissance Society,
Chicago
2007 "1+1," ArratiaBeer, Berlin / Taxi im Palais,
Innsbruck, Austria
2006 Modern Art Oxford
Selected Group Exhibitions
2008 "For Every Dog A Different Master,"
Konsthalle in Gavle, Sweden / "Where Are Lions
Are," Para/Site Art Space, Hong Kong
2007 "As In Real Life," Gallery P 74, Ljubljana,
Slovenia / "Auditorium, Stage, Backstage: An

Exposure In 32 Acts," Franfurkter Kunstverein,
Frankfurt, Germany
2006 "Local Stories," Modern Art Oxford
2005 "Zvon 2005 (Bell 2005)," City Gallery,
Prague
2003 "D_m um_ní (House of Art)," Brno House
of Art, Brno
2002 "Ticho prosím, maluji! (Quiet, Please! I'm
Painting)," Galerie u Prstenu, Prague

Josh Smith
Born 1976, Okinawa, Japan / Lives and works in
New York City
Education University of Tennessee, Knoxville,
1998 / Miami University, Oxford, Ohio 1996
Selected Solo Exhibitions
2008 "Hidden Darts," MUMOK Museums-
Quartier, Vienna / "Josh Smith: Collages," Galerie
Catherine Bastide, Brussels / "Josh Smith: Zurich
Abstraction," Galerie Eva Presenhuber, Zurich
2005 "Faces," Taxter and Spengemann Gallery,
New York City
Selected Group Exhibitions
2008 "Book/Shelf," Museum of Modern Art,
New York City / "The Third Mind: Carte Blanche
a Ugo Rondinone," Palais de Tokyo, Paris
2005 "The Uncertain States of America," Astrup
Fearnley Museum of Modern Art, Oslo, Serpentine
Gallery, London, and Galerie Rudolfinum, Prague,
Czech Republic / "USA Today," Royal Academy
of Arts, London, and The State Hermitage
Museum, St. Petersburg
2006 "Wade Guyton, Seth Price, Josh Smith,
Kelley Walker," Kunsthalle Zurich
2005 "Lesser New York," Brooklyn
2004 "Collection (or, How I Spent a Year)," P.S.1
Contemporary Art Center, Queens, New York

Ryan Trecartin
Born 1981 in Webster, TX / Lives and works in Philadelphia
Education BFA, Rhode Island School of Design, 2004
Selected Solo Exhibitions
2009 Migros Museum für Gegenwartskunst, Zurich
2008 Hammer Museum, Los Angeles
2007 "I-Be Area," Elizabeth Dee Gallery, New York City
2006 "I Smell Pregnant," QED, Los Angeles
Selected Group Exhibitions
2008 Busan Biennale, South Korea / "Freeway Balconies," Deutsche Guggenheim, Berlin / "Television Delivers People," Whitney Museum of American Art, New York City
2007 "Between Two Deaths," ZKM Karlsruhe, Germany / Milan Triennial
2006 "Action Adventure," Canada Gallery, New York City / "USA Today: Works from the Saatchi Collection," Royal Academy of Arts, London / 2006 Whitney Biennial, Whitney Museum of American Art, New York City

Alexander Ugay
Born 1978, Kyzilorda, Kazakhstan / Lives and works in Almaty, Kazakhstan
Education State University Kirgizia in Low, 2002
Selected Group Exhibitions
2007 Venice Biennale / "Plug In," Vanabbemuseum, Eindhoven, the Netherlands / "The Dream of Reason," Temporary/Contemporary, London
2005 Istanbul Biennial / "And Others…," The I. Bishkek International Exhibition of Contemporary Art, The State Museum of Fine Arts, Bishkek, Kyrgyzstan / "The Tamerlane Syndrome: Art and Conflicts in Central Asia," Orvieto, Italy
2004 "Videoidentity," Central Asia Video Festival, SCCA-Almaty
2002 "No-Mad's Land," The House of World Cultures, Berlin

Tris Vonna-Michell
Born 1982, Rochford, UK / Lives and works in London and Stockholm
Education Hochschule für Bildende Künste/Städelschule, Frankfurt, 2007 / Glasgow School of Art, Fine Art BA, Glasgow, 2005
Selected Solo Exhibitions
2007 "Papierstau," Center Kurfürstenstraße, Berlin / Witte de With, Rotterdam
2006 "Faire un Effort," Palais des Beaux-Arts, Brussels / Tschoperl, Frankfurt
Selected Group Exhibitions
2009 "It Repeat Myself Under Stress,"MOCAD Museum of Contemporary Art, Detroit / "Altermodern" Tale Triennial, Tate Britain
2008 Yokohama Triennial / Berlin Biennial / "The Trades of Others,", T293, Naples
2007 "Aspen 11 (Part 3)," Neue Alte Brücke, Frankfurt / "Ausstellung der Sommerakademie," Zentrum Paul Klee, Bern / "KölnShow2," European Kunsthalle, Cologne / "The Moment You Realize That You Are Lost," Galerie Johann König, Berlin / "The Present Order," Museum de Hallen, Haarlem, the Netherlands
2006 "Cuts," Galerie der HfbK, Hamburg / "Wight Biennial: Anxiety of Influence," New Wight Gallery, UCLA, Los Angeles
2005 "Wanderlust," Newberry Gallery, Glasgow School of Art, Glasgow

Jakub Julian Ziolkowski

Born 1980, Zamosc, Poland Lives and works in Cracow

Education Jan Matejko Academy of Fine Arts, Faculty for Painting and Drawing, Cracow, 2005

Selected Solo Exhibitions

2009 Centre d'art Contemporain, Geneva

2008 Hauser & Wirth, Zurich

2007 "Demi Volte," F.A.I.T. Gallery, Cracow

2006 Hauser & Wirth, London

Selected Group Exhibitions

2008 "I Won't Grow Up," Cheim & Read, New York City / "psych: Ned Vena, Jonas Wood, Jakub Julian Ziolkowski," Galerie Dennis Kimmerich, Düsseldorf, Germany / "Schüttelreime," Office Baroque Gallery, Antwerp

2007 "Very Abstract and Hyper Figurative," Thomas Dane Gallery, London / "Who remembers where they are from?," Galerie Martin Janda, Vienna

2006 "Djordje Ozbolt, Jakub Julian Ziolkowski," Munich, Germany / "Galerie Patrick Seguin invites Hauser & Wirth," Galerie Patrick Seguin, Paris

2005 "Silent Stories," Galerie Martin Janda, Vienna

Icaro Zorbar

Born 1977, Bogotá, Colombia / Lives and works in Bogotá

Education Universidad Nacional de Colombia, Bogotá, 2006 / Universidad Nacional de Colombia, Bogotá (Television and Cinema Production), 2003

Awards and Professional Experience

2008 Cisneros Fontanals Arts Fundation, Miami

2006 Merit Award, Master's Thesis, Universidad Nacional de Colombia, Bogotá

2004–06 Full Fellowship, Master of Fine Arts,

Universidad Nacional de Colombia, Bogotá

2003 Merit Award, Bachelor's Degree, Universidad Nacional de Colombia, Bogotá

Selected Group Exhibitions

2008 "Medias Promesas," Fundación Gilberto Alzate Abendañ, Bogotá / Arteaméricas Maryll Lynch Art Fair, Miami / "Interrogating Systems Grans and Commissions," Cisneros Fontanals Art Foundation, Miami

2007 "Sincronías," Museo de Arte Moderono, Buenos Aires

2006 "Once," MFA Exhibition, Universidad Nacional de Colombia, Bogotá

2005 "Exposición Relacional," Galería Santa Fe, Bogotá / "Artrónica III," Muestra internacional de artes electrónicas, Biblioteca Luis Ángel Arango, Bogotá / "Salón Regional de Artistas," Casa de Juan de Vargas, Tunja, Colombia / "Curator's Choice," Centro Colombo Americano, Bogotá

Selected Bibliography

Compiled by Brian Sholis

"A Portrait of 'Generation Next': How Young People View Their Lives, Futures and Politics." Pew Research Center, January 9, 2007 <http://people-press.org/report/300/a-portrait-of-generation-next/> (accessed November 30, 2008).

Abcarian, Robin and John Horn. "Underwhelmed By It All." *Los Angeles Times*, August 7, 2006.

Ambroz, Julian S. "Marketing to Millennials." *Folio: The Magazine for Magazine Management*, June 2008.

Appiah, Kwame Anthony. *Cosmopolitanism: Ethics in a world of Strangers*. New York: W.W. Norton, 2006.

Arora, Raksha. "China's Generation Tech." Gallup, April 12, 2005 <http://www.gallup.com/poll/15814/Chinas-Generation-Tech.aspx/> (accessed November 30, 2008).

---.. "Young Urban Chinese on the Move." Gallup, May 31, 2005 <http://www.gallup.com/poll/165 28/Young-Urban-Chinese-Move.aspx/> (accessed November 30, 2008).

---. "China's 'Gen Y' Bucks Tradition." Gallup, April 19, 2005 <http://www.gallup.com/poll/159 34/Chinas-Gen-Bucks-Tradition.aspx/> (accessed November 30, 2008).

Asthana, Anushka. "They Don't Live for Work ... They Work to Live." *Guardian*, May 25, 2008.

Begley, Sharon and Jeneen Interlandi. "The Dumbest Generation? Don't Be Dumb." *Newsweek*, June 2, 2008.

Bourdieu, Pierre. *The Rules of Art*. Cambridge: Polity Press, 1996.

---. *The Field of Cultural Production: Essays on Art and Literature*. Cambridge: Polity Press, 1993.

---. "'Youth' is Just a Word." In *Sociology in Question*. London: Sage, 1993.

boyd, danah. "Facebook's Privacy Trainwreck: Exposure, Invasion, and Social Convergence." *Convergence: The International Journal of Research into New Media Technologies* (14:1), 2008.

---. "Why Youth (Heart) Social Network Sites: The Role of Networked Publics in Teenage Social Life." In *Youth, Identity, and Digital Media*, ed. David Buckingham. Cambridge: MIT Press, 2007.

---. "danah boyd," <http://www.danah.org/> (accessed November 30, 2008).

Brooks, David, "The Outsourced Brain." *New York Times*, October 26, 2007.

---. "The Organization Kid." *Atlantic*, April, 2001.

Cannon, Carl M., "Generation 'We'–The Awakened Giant." *The National Journal*, March 7, 2007 <http://www.nationaljournal.com/njmagazine/nj_20070310_4.php/> (accessed November 30, 2008).

Cole, Jennifer and Deborah Durham, eds. *Generations and Globalization: Youth, Age, and Family in the New World Economy*. Bloomington: Indiana University Press, 2007.

489

Crabtree, Steve. "Latin Americans: Dignity Denied to Region's Youth." Gallup, April 15, 2008 <http://www.gallup.com/poll/106 507/Latin-Americans-Dignity-Denied-Regions-Youth.aspx/> (accessed Novemer 30, 2008).

Dyk, Deirdre van. "Who's Holding the Handbag?" *Time*, March 3, 2008.

Edmunds, June and Bryan S. Turner. *Generations, Culture, and History*. Buckingham: Open University Press, 2002.

Eisenstadt, Shmuel Noah. *From Generation to Generation*. New York: Free Press, 1956.

Evans, Claire L. "Universe." *Urban Honking*, November 28, 2008 <http://www.urbanhonking.com/universe/> (accessed November 30, 2008).

Faiola, Anthony. "When Escape Seems Just a Mouse-Click Away." *Washington Post*, May 27, 2006.

Feuer, Lewis S. *The Conflict of Generations: The Character and Significance of Student Movements*. New York: Basic Books, 1969.

Foner, Nancy. *Ages in Conflict: A Cross-cultural Perspective on Inequality Between Old and Young*. New York: Columbia University Press, 1994.

"Generations Divide Over Military Action in Iraq." Pew Research Center, October 17, 2002 <http://people-press.org/commentary/?analysisid=57/> (accessed November 30, 2008).

"Generation Why?" *Harper's*, June, 2008.

Gordinier, Jeff. *X Saves the World: How Generation X Got The Shaft But Can Still Keep Everything From Sucking*. New York: Viking Penguin, 2008.

Gould, Emily. "Exposed." *New York Times Magazine*, May 25, 2008.

Gradirovski, Sergei and Neli Esipova. "Lost Childhood: Russians Pessimistic About Conditions Facing Youth." Gallup, Janurary 5, 2007 <http://www.gallup.com/poll/260 59/Lost-Childhood-Russians-Pessimistic-About-Conditions-Facing-Youth.aspx/> (accessed November 30, 2008).

Green, Penelope. "Yours for the Peeping." *New York Times*, November 4, 2007.

Greenberg, Anna. "New Generation, New Politics." *American Prospect*, October 2003.

Halbwachs, Maurice. *On Collective Memory*. Translated by Lewis A. Coser. Chicago: The University of Chicago Press, 1992.

Hammer, Joshua. "How Two Lives Met in Death." *Newsweek*, April 15, 2002.

Heidegger, Martin. *Being and Time*. Translated by John Macquarrie and Edward Robinson. New York: Harper Perennial Modern Classics, 2008.
Herbert, Bob. "Here Come the Millennials." *New York Times*, May 13, 2008.

---. "The Next 20 Years: How Customer and Workforce Attitudes Will Evolve." *Harvard Business Review*, July–August 2007.

---. *Millennials Rising: The Next Great Generation*. New York: VintageBooks, 2000.

---. *Generations: The History of America's Future, 1584 to 2069*. New York: William Marrow and Company, Inc. 1991.

Hume, Marion. "Not Your Mother's China." *Time*, March 3, 2008.

---. "Shanghai Postcard." *Time*, March 3, 2008.

Hussey, Andrew. "The Paris Intifada." *Granta* 101, 2008.

Kertzer, David I. "Generation as a Sociological Problem." *Annual Review of Sociology* (9), 1983.

Huntley, Rebecca. *The World According to Y: Inside the New Adult Generation.* New South Wales: Allen & Unwin, 2006.

Kamenetz, Anja. *Generation Debt: Why Now Is a Terrible Time to Be Young.* New York: Riverhead Books, 2006.

Kane, Tim. "Who Bears the Burden? Demographic Characteristics of US Military Recruits Before and After 9/11." The Heritage Foundation, Center for Data Analysis, November 7, 2005 <http://www.heritage.org/research/nationalsecurity/cda05-08.cfm/> (accessed November 30, 2008).

Larenaudie, Sarah Raper. "Under Cover." *Time*, March 3, 2008.

---. "Riyadh Postcard." *Time,* March 3, 2008.

Lyons, Linda. "Angst Aplenty: Top Worries of Young Americans." Gallup, July 15, 2003 <http://www.gallup.com/poll/8845/Angst-Aplenty-Top-Worries-Young-Americans.aspx/> (accessed November 30, 2008).

McEwen, William J. "Marketing to China's 'Generation Y.'"

Gallup, March 15, 2005 <http://www.gallup.com/poll/15271/Marketing-Chinas-Generation.aspx/> (accessed November 30, 2008).

Madland, David and Amanda Logan. "The Progressive Generation: How Young Adults Think About the Economy." Center for American Progress, May 6, 2008 <http://www.americanprogress.org/issues/2008/05/progressive_generation.html/> (accessed November 30, 2008).

Mai, Mukhtar. *In the Name of Honor: A Memoir.* New York: Washington Square Press, 2007.

Maxfield, Betty D. "Army Profile: FY 05." United States Army, September 30, 2005 <http://www.armyg1.army.mil/hr/docs/demographics/FY05%20Army%20Profile.pdf/> (accessed November 30, 2008).

Mead, Margaret. *Culture and Commitment.* New York: The Natural History Press, 1970.
Nagourney, Adam and Megan Thee. "Young Americans Are Leaning Left, New Poll Finds." *New York Times*, June 27, 2007.

Navarro, Mireya. "Everyone Wants to Be Taking Pictures." *New York Times*, November 18, 2007.

Newman, Jill M. "Leading Generation Y." United States Army War College Strategy Research Project, 2008.

Nussbaum, Emily. "Say Everything." *New York Magazine,* February 12, 2007.

Nyiri, Zslot. "Baltic Youth Yearn for Greener Pastures." Gallup, October 23, 2006 <http://www.gallup.com/poll/25096/Baltic-Youth-Yearn-Greener-Pastures.aspx/> (accessed November 30, 2008).

Palfrey, John and Urs Gasser. *Born Digital: Understanding the First Generation of Digital Natives.* New York: Basic Books, 2008.

"Public Knowledge of Current Affairs Little Changed by News and Information Revolutions." Pew Research Center, April 15, 2007 <http://people-press.org/report/319/public-knowledge-of-current-affairs-little-changed- by-news-and-information-revolutions/> (accessed November 30, 2008).

Quart, Alissa. *Branded: The Buying and Selling of Teenagers.* Cambridge: Perseus Books, 2003.

Rich, Motoko. "Study Links Drop in Test Scores to a Decline in Time Spent Reading." *New York Times*, November 19, 2007.

---. "Literacy Debate: Online R U Really Reading?" *New York Times*, July 27, 2008.

Safer, Morley. "The 'Millennials' Are Coming." *60 Minutes*, May 25, 2007 <http://www.cbsnews.com/stories/2007/11/08/60minutes/main 3475200.shtml/> (accessed November 30, 2008).

Samuels, David. *Only Love Can Break Your Heart*. New York: The New Press, 2008.

Samuels, David. "Shooting Britney." *Atlantic*, April 2008.

Schofield, Hugh. "La Haine: Schools, Synagogues, and Hundreds of Cars Burn. It's Paris 2005." *Independent*, November 6, 2005.

Stack, Megan K. "Young and Proudly Pro-Putin." *Los Angeles Times*, December 25, 2007.

Stelter, Brian. "Television Starts to Court the Young Voter." *New York Times*, August 18, 2008.

Shirky, Clay. "Gin, Television, and Social Surplus." In *Here Comes Everybody*, April 26, 2008 <http://www.herecomeseverybod y.org/2008/04/looking-for-the-mouse.html/> (accessed November 30, 2008).

Tapscott, Don. *Growing Up Digital: The Rise of The Net Generation*. New York: McGraw-Hill, 1999.

"To Read or Not to Read: A Question of National Consequence," National Endowment for the Arts Research Report 47 <http://www.nea.gov/research/ToRead.pdf/> (accessed November 30, 2008).

Toyama, Michiko. "Generation No Logo." *Time*, March 3, 2008.

"Trends in Attitudes Toward Religion and Social Issues: 1987–2007." Pew Research Center, November 2007 <http://pewresearch.org/pubs/614/religion-social-issues/> (accessed November 30, 2008).

Twenge, Jean M. *Generation Me: Why Today's Young Americans Are More Confident, Assertive, Entitled—and More Miserable Than Ever Before*. New York: Free Press, 2006.

United States Department of Defense. "Military Casualty Information." <http://siadapp.dmdc.osd.mil/personnel/CASUALTY/castop.htm/> (accessed November 30, 2008)

Walker, Rob. *Buying In: The Secret Dialogue Between What We Buy and Who We Are*. New York: Random House, 2008.

Watters, Ethan. *Urban Tribes: A Generation Redefines Friendship, Family, and Commitment*. New York: Bloomsbury, 2003.

White, Patrick. "The Class of 2012: Mr. Google's Children." *Globe and Mail*, October 11, 2008.

Wright, Evan. "Quentin's Kung-Fu Grip." *Rolling Stone*, October 30, 2003.

---. "The Battle for Baghdad." *Rolling Stone*, July 10, 2003.

---. "The Killer Elite." *Rolling Stone*, June 26, 2003.

---. "The Face of Modern Warfare." *Rolling Stone*, April 3, 2003.

Winograd, Morley and Michael D. Hais. *Millenial Makeover: MySpace, YouTube and the Future of American Politics*. New Brunswick: Rutgers University Press, 2008.

Yang, Wesley. "The Face of Seung-Hui Cho." *n+1* (6), 2008.

Young, Molly. "Kickstart My Heart," *n+1*, January 23, 2008, <http://nplusonemag.com/kickstart-my-heart/> (accessed November 30, 2008).

"Youth, Generations, and Social Change." Special issue of *Journal of Social Issues* (54:3), 1998.

List of Nominators

This list is composed of curators, academics, critics, and artists known for their work with and knowledge of emerging artists. These contributors were asked to recommend young artists they felt represented a generational shift in contemporary art. 150 informers were asked to each recommend three names to the curatorial team; ten correspondents were asked for more focused and extensive research, each one suggesting up to twenty artists.

Correspondents:

Negar Azimi, Senior Editor, *Bidoun*, New York

Cecilia Brunson, Curator, InCubo, Santiago, Chile

Colin Chinnery, curator, artist, and writer, London and Beijing

Doryun Chong, Associate Curator, Visual Arts, Walker Art Center, Minneapolis

Christine Eyene, curator; Publishing Director, *Africultures*

Michele Faguet, Founder and Director, Especio, La Rebeca, Bogotá

Eungie Joo, Director and Curator of Education and Public Programs, New Museum, New York

Deeksha Nath, art historian, critic, and curator, New Delhi

Daria Pyrkina, Founder and Director, Moscow International Biennial of Young Art

Polly Staple, Director, Chisenhale Gallery, London

Informants:

Ateqqa Ali, Assistant Professor Department of Communication and Cultural Studies, National College of Art, Lahore, Pakistan

Markus Andresson, curator and filmmaker, Reykjavik

Nadja Argyropoulou, Curator, 2009 Athens Biennial

Sonia Becce, curator; member of Advisory Committee of CIFO, Buenos Aires

Tobias Berger, critic and curator, Hong Kong

Daniel Birnbaum, critic and curator; Dean, Städelschule, Frankfurt; Director, 2009 Venice Biennale

Rob Blackson, Curator, Reg Vardy Gallery, Sunderland, UK

Francesco Bonami, Manilow Curator at Large, Museum of Contemporary Art Chicago; Curator, 2010 Whitney Biennial

Iara Boubnova, curator; Founding Director, Institute of Contemporary Art, Sofia

Nicolas Bourriaud, writer and theorist; curator 2009 Tate Triennial, London

AA Bronson, artist and Director, Printed Matter, New York

Guillermo E. Brown, jazz musician, New York

Rashida Bumbray, Assistant Curator, The Kitchen, New York

Rosina Cazali, critic and curator, Guatemala

Elizabeth Cerejido, artist, Miami

Luca Cerizza, art historian and curator, Berlin

Howie Chen, artist, and co-founder, Dispatch, New York

Carolyn Christov-Bakargiev, Chief Curator, Castello di Rivoli, Turin; Artistic Director, Documenta 13

Stuart Comer, Curator of Film and Events, Tate Modern, London

Sarah Cook, Curator and Co-Founder, *CRUMB*, Newcastle, UK

Daniell Cornell, Curator of American Art and Director of Contemporary Art Projects, Fine Arts Museum of San Francisco

Silvia Karman Cubiñá, Director and Chief Curator, Bass Museum of Art, Miami Beach

Dean Daderko, curator, Brooklyn

Régine Debatty, blogger, we-make-money-not-art.com, Italy

Ann Demeester, Director, de Appel, Amsterdam

Nikola Dietrich, Curator, MGK Basil, Frankfurt and Berlin

Corinne Diserens, curator; Artistic Advisor, Associate Carla Blanca Editions, Marseille

Aleksandra Domanovic, artist, and co-founder of VVork.com, Berlin

Abdul Dube, photographer and designer; founding member of MOPP, Cape Town

Yvette Dunn, curator, Cape Town

Yilmaz Dziewior, curator; Chair of the Hochschule fur Bildende Kunst, Hamburg

Jacob Fabricius, curator, publisher, and writer, Copenhagen

Cecilia Fajardo-Hill, curator and art historian, Miami

Hu Fang, Artistic Director, Vitamin Creative Space, Guangzhou

Annie Fletcher, curator, Amsterdam

Richard Flood, Chief Curator, New Museum, New York

Anna-Catharina Gebbers, curator, Berlin

Julieta González, curator, San Juan

Katerina Gregos, curator and critic, Mechelen, Germany

Ulrike Groos, writer and curator, Düsseldorf

Andrea Grover, curator; Founding Director of Aurora Picture Show, Houston

Inti Guerrero, Curator in Residence at Capacete Entretenimentos, Rio de Janeiro

Bruce Hainley, critic and writer, Los Angeles; Contributing Editor, *Artforum*

Ed Halter, critic and co-founder of Light Industry, New York

Hou Hanru, Director of Exhibitions and Public Programs and Chair of the Exhibitions and Museum Studies Program, San Francisco Art Institute

Geir Haraldseth, curator, Berlin

Vít Havránek, curator and Project Leader, Tranzit, Prague

Jörg Heiser, critic; Associate Editor, *Frieze*, Berlin

Sirje Helme, curator and writer, Estonia

Sofia Hernández Chong Cuy, curator, New York and Paris

Jennifer Higgie, critic; Co-Editor, *Frieze*, London

Matthew Higgs, artist and writer; Curator and Director, White Columns, New York

Jens Hoffmann, curator and writer; Director, CCA Wattis Institute for Contemporary Arts, San Francisco

Michael Ned Holte, critic and curator, Los Angeles

Henriette Huldisch, writer and curator, Berlin; Curator Whitney Biennial 2008

Suhjung Hur, curator and writer, Seoul

C. Krydz Ikwuemesi, painter, writer, and curator, Nigeria

Gregor Jansen, art historian; Head of ZMK, Karlsruhe, Germany

Kathrin Jentjens, curator, Cologne

Gianni Jetzer, Director, Swiss Institute Contemporary Art, New York

Paddy Johnson, blogger, artfagcity.com, Brooklyn

Caitlin Jones, curator and writer, Brooklyn

Aylin Kalem, curator, writer, and lecturer; Co-Founder, boDig, Istanbul

Stefan Kalmár, Director, Kustuerein Munich

Xenia Kalpaktsoglou, curator; Artistic Director, XYZ, Athens

Mami Kataoka, Curator, Hayward Gallery, London; Senior Curator, Mori Art Museum, Tokyo

Inés Katzenstein, curator, critic, and writer; Curator, Buenos Aires Museum of Latin American Art

Eva Khachatrian, curator; Co-Director, Department of Fine Arts at the Armenian Center for Contemporary Experimental Art, Yerevan

Heejin Kim, curator, Insa Art Space, Seoul

Udo Kittelmann, Director, Nationalgalerie, Berlin

Guillermo Kuitca, artist, Buenos Aires

Lisette Lagnado, curator and writer, São Paulo

Thomas Lawson, Dean, California Institute of Arts, Valencia

Olia Lialina, artist, theorist, and curator, Stuttgart

Arshiya Lokhandwala, curator and critic, Founder of Lakeeren Contemporary Art Gallery, Mumbai

Raimundas Malasauskas, Curator, Artist Space, New York

Francesco Manacorda, Curator, Barbican Art Gallery, London

Chus Martinez, Curator, MACBA, Barcelona

Midori Matsui, curator and art historian, Tokyo

Gerald Matt, Director, Kunsthalle Wien, Vienna

Gene McHugh, Editorial Fellow, Rhizome, New York

Mariangela Méndez, critic and curator, Bogotá

Mihnea Mircan, Curator, National Museum of Contemporary Art, Bucharest

Viktor Misiano, curator and art historian; Editor in Chief, *Moscow Art Magazine*, Moscow

Akiko Miyake, writer and curator; Co-Founder and Programme director, Centre for Contemporary Art, Kitakyushu, Japan

Naeem Mohaiemen, artist and writer, Dhaka, Bangladesh, and New York

Stephanie Moisdon, critic and curator, Co-Founder BDV (Bureau des vidéos); Chief Editor, *Frog* Magazine; Lecturer, University of Lausanne, Switzerland

Jessica Morgan, Curator of Contemporary Art, Tate Modern, London

Tom Morton, Curator, Hayward Gallery, London; Contributing Editor, *Frieze*

Tumelo Mosaka, Associate Curator of Exhibitions, Brooklyn Museum

Gerardo Mosquera, curator, critic, and art historian, Havana; Adjunct Curator, New Museum, New York

Ceci Moss, writer, musician, DJ, and curator; Senior Editor, Rhizome, New York

Hanne Mugaas, curator, New York

Edi Muka, curator, Tirana, Albania, and Stockholm; Co-Founder and Co-Director, Tirana Biennale; Lecturer, Academy of Fine Arts, Tirana

Jorge Munguía Matute, Curator of Education, Museo Tamayo Art Contemporaneo, Mexico City

Will Munro, artist, Toronto

Joanna Mytkowska, Director, Warsaw Museum of Modern Art

Hans Ulrich Obrist, curator and writer; Co-Director of Exhibitions and Programme and Director of International Projects, Serpentine Gallery

Marisa Olson, artist, curator, and Rhizome contributing editor, New York

Tobias Ostrander, Contemporary Curator, Museo Tamayo, Mexico City

Sean O'Toole, journalist and writer, Johannesburg; Editor *Art South Africa*

Yevgeny Palamarchuk, poet, musician, curator, and video-artist, Kaliningrad, Russia

Dan Perjovschi, artist and writer, Bucharest

Lisa Phillips, Toby Devan Lewis Director, New Museum, New York

Jenelle Porter, Associate Curator, Institute of Contemporary Art, Philadelphia

Alisa Prudnikova, Director, National Centre for Contemporary Arts, Ekaterinburg, Russia

Loyiso Qanya, Curator, Cape Africa Platform, Cape Town

Edwin Ramoran, Director of Exhibitions and Programs, Aljira, Newark, New Jersey

Gabriela Rangel, Director of Visual Arts, The Americas Society, New York

Yasmil Raymond, Curator, Walker Art Center, Minneapolis, Minnesota

Prerana Reddy, Director of Public Events, Queens Museum of Art, New York

Billy Rennekamp, artist, New York

Katherin Rhomberg, curator, Vienna; Artistic Director, 2010 Berlin Biennial

Ana Riaboshenko, artist and curator, Tbilisi, Republic of Georgia

José Ignacio Roca, Head of Contemporary Exhibitions, Angel Arango Library, Bogotá

Astrida Rogule, Head of Collections Department, Contemporary Art Museum, Riga, Latvia

Contributor Biographies

Bennett M. Berger

is Professor Emeritus of sociology at the University of California, San Diego. He is the author numerous books, including *Working-Class Suburb: A Study of Auto Workers in Suburbia* (University of California Press, Berkeley and Los Angeles, 1960) and *Survival of The Survival of the Counter Culture: Ideological Work and Everyday Life Among Rural Communards* (Berkeley University of California Press, 1981).

Pierre Bourdieu

(1930–2002) was a French sociologist, anthropologist, and philosopher. He held the Chair of Philosophy at the Collège de France and was the founder, with Luc Boltanski, of the interdisciplinary journal *Actes de la recherche en sciences sociales*. He is best known for his book *Distinction: A Social Critique of the Judgment of Taste* (1979; Harvard University Press, 2001), which is a detailed analysis of the relationship between taste and social standing.

Lakshmi Chaudhry

is a contributing writer for the *Nation*. Her writing has also appeared in *Wired*, *In These Times*, the *Village Voice*, and *Salon*. She is the author, with Robert Scheer and Christopher Scheer, of *The Five Biggest Lies Bush Told Us About Iraq* (Seven Stories Press, 2003).

Lauren Cornell

is the Executive Director of Rhizome and Adjunct Curator at the New Museum. Previously, Cornell worked as an independent curator and writer in London and New York. From 2002–04, she served as Executive Director of Ocularis, an organization dedicated to avant-garde cinema, video, and new media. At Rhizome, she oversees and develops the organization's programs, all of which are devoted to the presentation, interpretation, and preservation of art engaged with emerging media technologies. As Adjunct Curator, she has collaborated to produce exhibitions, such as "Unmonumental: The Sound of Things" and "Montage: Unmonumental Online" as well as monthly performances, talks, and panels through the New Silent Series.

Caleb Crain

is a writer of both fiction and nonfiction. His essays and reviews have appeared in the *New Yorker*, the *New York Review of Books*, the *New Republic*, the *Nation*, and the *New York Times Book Review*. His book *American Sympathy: Men, Friendship, and Literature in the New Nation* was published by Yale in 2001, and his novella *Sweet Grafton* was published in the winter 2008 issue of *n+1*. His blog, Steamboats Are Ruining Everything, can be found at steamthing.com.

Massimiliano Gioni

is the Director of Special Exhibitions at the New Museum and the Artistic Director of the Nicola Trussardi Foundation in Milan. At the New Museum he recently curated the group show "After Nature" and "Paul Chan: The 7 ~~Lights~~." Gioni curated the Berlin Biennial with Maurizio Cattelan and Ali Subotnick (2006), co-curated Manifesta 5 (2004), and organized the Zone for the 50th Venice

Biennale (2003). In Milan he has presented solo exhibitions and public art projects by, among many other artists: Paweł Althamer, Maurizio Cattelan, Urs Fischer, Fischli and Weiss, Paola Pivi, and Tino Sehgal.

David M. Halbfinger
and Steven A. Holmes
are staff reporters for the *New York Times*.

Laura Hoptman
is the Kraus Family Senior Curator at the New Museum. Previously, she was Curator of Contemporary Art at Carnegie Museum of Art where she organized the 54th Carnegie International exhibition. As a curator of drawing at The Museum of Modern Art, she organized exhibitions including "Drawing Now: Eight Propositions" (2002) and "Love Forever: Yayoi Kusama" (1998). At the New Museum, she team-organized the opening exhibition "Unmonumental," (2007) and has curated survey exhibitions of paintings by Tomma Abts (2007) and Elizabeth Peyton (2008). In addition to catalogues accompanying her exhibitions, Hoptman is the author of *Yayoi Kusama* (Phaidon Press, 2000) and the co-editor of *Primary Documents: A Sourcebook for Eastern and Central European Art since the 1950s* (The MIT Press, 2002). She has written frequently for magazines in the US, Europe, and Asia.

Samir Lukka, Sanjana, Peerzada Arshad Hamid, Morgan Harrington, Anand St Das, Sumana Roy, Shobhita Naithani, Ka Shaji, Arshad Said Khan, and Nisha Susan
are contributing writers for *Tehelka*, an independent weekly news magazine published in India. Shoma Chaudhury is the features editor.

Karl Mannheim
(1893–1947) was a Hungarian sociologist. He is recognized as one of the founding fathers of classical sociology. He was a professor of sociology at Johann Wolfgang Goethe University Frankfurt am Main until 1933, when Nazis ousted him. After relocating to England, he taught sociology at the London School of Economics and the Institute of Education at the University of London. His major works include *Structures of Thinking* (1922–24; Routledge, 1998) and *An Ideology and Utopia: An Introduction to the Sociology of Knowledge* (1929; Kessinger Publishing, LLC, 2008).

Tracy McVeigh
is the Foreign Editor of the *Observer*, London.

Robert L. Moore
is a professor of anthropology at Rollins College and Director of International Affairs at the college's Holt School.

Grigory Okhotin
is a freelance journalist and the director of strategy and development at Mezhdunarodnaya Kniga, the Russian Web bookstore. He has worked as an editorial writer at *Vedomosti Newspaper*, and as a writer for the Web site Polit.Ru.

José Ortega y Gasset
(1883–1955) was a Spanish philosopher and activist. He was the founder of the publication *Revista de Occidente* and the Institute of Humanities in Madrid. He was also active in Spanish politics, serving as the leader of the republican intellectual opposition under the dictatorship of Primo de Rivera, and playing a role in the overthrow of King Alfonso XIII in 1931. His most famous works, *España invertebrada* (Invertebrate Spain), (1922; Howard Fertig, 1974)

and *La rebelión de las masas* (The Revolt of the Masses), (1932; W.W. Norton & Company, 1994) were originally published as essay series in the newspaper *El Sol*.

Evan Osnos
is Beijing Bureau Chief of the *Chicago Tribune* and a contributor to the *New Yorker* magazine. His coverage of China has been honored with the Asia Society's Osborn Elliott Prize for Excellence in Journalism on Asia, the Overseas Press Club award for coverage of the environment, and the Livingston Award, for foreign reporting. He was also a contributor to "Hidden Hazards," a *Tribune* project that won a 2008 Pulitzer Prize and a George Polk Award.

Allen Salkin
is a staff reporter at the *New York Times*. His writings have appeared in publications such as *New York Magazine, Details, Heeb, Yoga Journal*, and the *Village Voice*. His book, *Festivus: The Holiday for the Rest of Us*, was published in 2005 by Grand Central Publishing.

Clay Shirky
is a writer, consultant, and educator. He is an adjunct professor at New York University's graduate Interactive Telecommunications Program (ITP), and his writings have appeared in numerous publications, including *Business 2.0*, the *New York Times*, the *Wall Street Journal*, the *Harvard Business Review*, and *Wired*. His book *Here Comes Everybody: The Power of Organizing Without Organizations* was published by Penguin Press in 2008. His writings can be found online at shirky.com.

Brian Sholis
is a freelance writer and editor who also produces public programs for cultural institutions. He contributes regularly to *Artforum*, where he is Artforum.com Editor at Large, and has published reviews in the *Village Voice, Parkett, Bookforum*, and *Print*, as well as essays in numerous museum exhibition catalogues.

Sabrina Tavernise
is the Istanbul bureau chief of the *New York Times*. She has previously reported for the *Times* from Iraq, Lebanon, and Russia.

Clive Thompson
writes regularly about science and technology as a contributing writer for the *New York Times Magazine*, and as a columnist for *Wired*. His writings have also appeared in publications such as *New York Magazine, Details*, and *Slate*. He publishes the blog collisiondetection.net.

Tony Thomson
is writer and former crime correspondent for the *Observer*, London. His book, *Reefer Men: The Rise and Fall of a Billionaire Drug Ring*, was published in 2008 by Hodder & Stoughton Ltd.

Eric Wilson
is a style reporter for the *New York Times*.

Ethan Zuckerman
is a fellow of the Berkman Center for Internet and Society at Harvard Law School. He is also the founder of Geekcorps, a nonprofit organization that seeks to promote stability and prosperity in the developing world through the use of information and communication technologies.

Curators' Acknowledgments

We would like to thank all of the artists for their enthusiastic collaboration.

In addition, we are indebted to all of the lenders for their generosity, including Gilbert and Doreen Bassin; Rosa de la Cruz; Silvia Cubiña; The Dakis Joannou Collection, Athens; Martin and Rebecca Eisenberg; Marcia Eitelberg; The Fabric Workshop and Museum, Philadelphia; Stacey Fabrikant; La Gaia Collection, Busca, Italy; Goetz Collection, Munich; Susan D. Goodman Collection; Hort Family Collection, New York; Sara Kier; Fondation Louis Vuitton pour la Création, Paris; Jon Miller; The Moore Space, Miami; John Morace; Shirley Morales; Musée national de l'histoire et des cultures de l'immigration, CNHI; Craig Robins; Dianne Wallace; and the Zabludowicz Collection.

We would like to extend a special thanks to all of the galleries for their support throughout this process, including Ancient and Modern, London; Annet Gelink Gallery, Amsterdam; BaliceHertling, Paris; Black and White Gallery, New York; Cosmic Galerie, Paris; D'Amelio Terras, New York; David Kordansky Gallery, Los Angeles; Deitch Projects, New York; Elizabeth Dee, New York; Galerie les filles du calvaire, Paris; Foksal Gallery Foundation, Warsaw; Franco Soffiantino Arte Contemporanea, Turin; Haunch of Venison, New York; Hauser and Wirth, Zurich; Jan Mot, Brussels; Jessica Silverman Gallery, San Francisco; Laura Bartlett Gallery, London; Leto Gallery, Warsaw; Lombard-Freid Projects, New York; Luhring Augustine, New York; Marthouse Gallery, Amsterdam; Mesler&Hug, Los Angeles; The Modern Institute, Glasgow; Murray Guy, New York; Nicodim Gallery, Los Angeles; Overduin and Kite, Los Angeles; Pilar Corrias Gallery, London; Plan B, Cluj; Rodeo Gallery, Istanbul; Tanya Bonakdar Gallery, New York; Gallery T293, Naples; Taro Nasu Gallery, Tokyo; Team Gallery, New York; and Yvon Lambert, Paris.

Lastly we would like to thank all of the nominators and our colleagues for sharing their expertise and a wealth of information.

— Lauren Cornell, Massimiliano Gioni, and Laura Hoptman

"The Generational: Younger Than Jesus"
is made possible by a generous grant from
The Andy Warhol Foundation for the Visual Arts.

Major support is provided by the Friends of the Generational, co-chaired by
Maja Hoffman and Dakis Joannou; Steering Committee Members Lonti Ebers
and J. Bruce Flatt, Lorinda Ash Ezersky and Peter Ezersky, Ken Kuchin, and
Randy Slifka; and Friends Shelley Fox Aarons and Phil Aarons, Hilary and
Peter Hatch, Gael Neeson and Stefan Edlis, Toby Devan Lewis, and Lisa Schiff.

Additional significant support is made possible by the Toby Devan Lewis Emerging Artists
Exhibitions Fund, Fundación Almine y Bernard Ruiz-Picasso para el Arte,
Horace W. Goldsmith Foundation, Robert Mapplethorpe Photography Fund, and
the Trust for Mutual Understanding.

Special thanks also to the New Museum's Leadership Council:
Cesar Cervantes, Dimitris Daskalopoulos, Nathalie and Charles de Gunzburg,
Maria and João Oliveira-Rendeiro, Cindy and Howard Rachofsky, Patrizia Sandretto
Re Rebaudengo, Ellen and Michael Ringier, and Pamela and Arthur Sanders.

Support for artist travel and participation provided, in part, by the Cultural Services of
the French Embassy in the United States, the Mexican Cultural Institute of New York,
and the Office for Contemporary Art, Norway.

Support for the accompanying publications is made possible by the J. McSweeney
and G. Mills Publications Fund at the New Museum.

Exhibition credits current as of March 1, 2009.